D0149254

READING
AMERICAN
PHOTOGRAPHS

READING AMERICAN PHOTOGRAPHS

Images as History
Mathew Brady to Walker Evans

Alan Trachtenberg

 HILL AND WANG

The Noonday Press
New York

For Leo and Jane Marx
and
in memory of Warren Susman

Contents

Photographs

Preface

This is a book about interpretations of America—what certain artists have had to say about their society through photography. The book covers a hundred years of history, from the appearance of photography during a depression in 1839 to the publication of Walker Evans's *American Photographs* in 1938, in the midst of another depression. The period spanned by these events was witness to fundamental change. It saw violent upheavals and wrenching conflicts—civil war, imperial conquest of the West, class and racial antagonisms, a flood of new immigrants, the rise of great cities, the erosion of rural culture. The book opens and closes in times of hardship and unrest—signs of the economic inequalities and social dangers which have plagued modern America in the era of the photograph. The history of photography belongs to this larger history, was influenced by it and in turn influences how we perceive and understand it. My purpose is to explore some of the ways which this is so.

One way photographs seem to belong to this or any history is as illustrations of the past, of the look of people, events, and things. I am interested in something quite different—not the scenes or persons depicted but the point of view of the photograph itself, the interpretation it allows viewers to make of its subject. This is not to belittle the sheerly depictive function, the value to historians of what photographs simply show. The poet and philosopher Paul Valéry affirmed this empirical value when he remarked, on the centenary of photography in 1939, that "the mere notion of photography, when we introduce it into our

meditation on the genesis of historical knowledge and its true value, suggests this simple question: *Could such and such a fact, as it is narrated, have been photographed?*" Valéry's simple question points to the great revolution in consciousness brought about by photography: the creation of a mechanical medium of vision which surpasses the human eye in accuracy and impartiality. The camera, he writes, overcomes our predisposition "not to see some of the things before us, and to see others which are not there." Photographs show us "what we would see if we were uniformly sensitive to everything that light imprints upon our retinas, and nothing else."

True enough. But while the camera has undeniably altered our sense of the past by showing us the actual look of things and persons (within the limits, of course, of adjustments of lens, light, and perspective imposed by the photographer), there is still the question of how we make sense of what we see. The historical value of photographs includes depiction but goes beyond it. Siegfried Kracauer helps us formulate a deeper connection between photography and history by emphasizing the role of interpretation. Photographers and historians face in common an "opaque mass of facts." While Valéry sees photographs as supplemental and corrective to history, Kracauer, in *History: The Last Things Before the Last* (1969), explores the tension between facts and meanings, between visual details in themselves and the significance discovered in and through them. To serve as history, facts must be made intelligible, must be given an order and a meaning which does not crush their autonomy as facts. The historian's task resembles the photographer's: how to make the random, fragmentary, and accidental details of everyday existence meaningful without loss of the details themselves, without sacrifice of concrete particulars on the altar of abstraction.

The historian employs words, narrative, and analysis. The photographer's solution is in the viewfinder: where to place the edge of the picture, what to exclude, from what point of view to show the relations among the included details. Both seek a balance between "reproduction and construction," between passive surrender to the facts and active reshaping of them into a coherent picture or story. Ordering facts into meaning, data into history, moreover, is not an idle exercise but a political act, a matter of judgment and choice about the emerging shape of the present and future. It may be less obvious in the making of a photograph than in the writing of a history, but it is equally true: the viewfinder is a political instrument, a tool for making a past suitable for the future.

Kracauer's analogy between photography and history can be extended even further. Photographers have another resource in addition to the

viewfinder for making sense of the pulsating life in front of the lens. They can order the photographs themselves, arrange them in sequences, compose them in certain ways, perhaps accompanied by a written text, to express a particular meaning. In some cases the meaning seems imposed by the text, by juxtaposed captions or narratives; in others, it seems to arise from the images themselves, from the dialogue among them, and between them and the viewer's own experience. In all cases, as Kracauer observes, the relation between images and imputed meanings is fraught with uncertainties, for, like opaque facts, images cannot be trapped readily within a simple explanation or interpretation. They have a life of their own which often resists the efforts of photographers and viewers (or readers) to hold them down as fixed meanings.

I have chosen several constructions, groups of images shaped or edited as albums, books, or photo-stories—works presented for viewing or reading as an ensemble of interactive images. My purpose is not to query why photographers made their pictures in this or that way, but to ask what the pictures presented in sequences say about their subjects, how the images reflect upon the "opaque mass of facts" of their time. By "American photographs" I mean photographs which take America as their subject—photographs, that is, whose political motives lie close to the surface. I have chosen works, moreover, of sufficient intelligence, insight, subtlety, and beauty to reward our treating them as important American art.

My principal aim is to uncover within these ensembles what Kenneth Burke calls an "attitude toward history," an intelligible view of society implicit in the internal dialogue of images and texts, and their external dialogue with their times. After a prologue which sets the stage by examining early conceptions of the social and cultural role of photography, the five chapters treat specific moments of conflict and change. Chapter 1 deals with the daguerrean era, with the intersecting antebellum crises of political unity and personal identity illuminated by Mathew Brady's images of "illustrious Americans." Daguerreotype images of the non-illustrious, of slaves and criminals, are also included, along with Walt Whitman's efforts to depict, with the aid of a daguerreotype portrait, a new type of democratic American. The second chapter considers the efforts of Brady and other Northern photographers— Alexander Gardner, George Barnard, A. J. Russell—to interpret the Civil War in albums shaped as narratives with the help of written texts. How the physical and political facts of the war resisted pictorial and written interpretation is the chief concern of the chapter. The next chapter follows the story of Western exploration just after the war, and looks at the new role of the camera as an adjunct of science, industrial

enterprise, and imperial expansion. An album of photographs by Timothy O'Sullivan made in conjunction with the geological survey led by Clarence King is the main subject. The fourth chapter leaps quickly ahead into the early twentieth century and examines the split which emerges among serious photographers between the "camera work" of Alfred Stieglitz and the "social work" of Lewis Hine. Both notions emerged in response to a growing apprehension of the metropolis as a new force in American life. The last chapter deals with the depression years of the 1930s, and focuses on Walker Evans and his book of 1938. *American Photographs* culminates the development traced and analyzed in the book, and helps us recognize in that development an important tradition in American art. The epilogue ventures a summary statement.

The selections in the book are tightly focused, and some readers may regret exclusions—Francis Benjamin Johnson, Edward Weston, Paul Strand, Berenice Abbott, Dorothea Lange, to name just a few. I have chosen the path of detailed discussion of relatively few texts rather than a more cursory survey of many. The sacrifice, for better or for worse, is for the sake of testing and exemplifying a way of reading photographs, not as pictures alone or as documents but as cultural texts. The value of photographs as history lies not just in what they show or how they look but in how they construct their meanings.

My argument throughout is that American photographs are not simple depictions but constructions, that the history they show is inseparable from the history they enact: a history of photographers employing their medium to make sense of their society. It is also a history of photographers seeking to define themselves, to create a role for photography as an American art. How might the camera be used for social commentary and cultural interpretation? Consisting of images rather than words, photography places its own constraints on interpretation, requiring that photographers invent new forms of presentation, of collaboration between image and text, between artist and audience.

For the reader of photographs there is always the danger of over-reading, of too facile a conversion of images into words. Speaking of "the camera's affinity for the indeterminate," Kracauer remarks that, "however selective," photographs are still "bound to record nature in the raw. Like the natural objects themselves, they will therefore be surrounded by a fringe of indistinct multiple meanings." All photographs have the effect of making their subjects seem at least momentarily strange, capable of meaning several things at once, or nothing at all. Estrangement allows us to see the subject in new and unexpected ways. Photographs entice viewers by their silence, the mysterious beckoning of another world. It is as enigmas, opaque and inexplicable as the living

world itself, that they most resemble the data upon which history is based. Just as the meaning of the past is the prerogative of the present to invent and choose, the meaning of an image does not come intact and whole. Indeed, what empowers an image to represent history is not just what it shows but the struggle for meaning we undergo before it, a struggle analogous to the historian's effort to shape an intelligible and usable past. Representing the past, photographs serve the present's need to understand itself and measure its future. Their history lies finally in the political visions they may help us realize.

Acknowledgments

My interest in studying American photographs in their historical context can be traced back some thirty years, to a student paper I wrote on Alfred Stieglitz in a seminar taught by Leo Marx at the University of Minnesota on "Technology and American Culture." The ideas exchanged in that class, and, just as important, the spirit of inquiry and commitment it fostered, have been a decisive influence. I have much more than his contributions to this book, than his reading of sections of the manuscript, to thank Leo Marx for, but at least for that. Jerome Liebling was also present at the beginnings of this project, and I have learned much from him, from his wide-ranging knowledge of the history of the medium and from his own exemplary work as an artist in photography.

The untimely death in 1985 of another friend and examplar, Warren Susman, deprived the manuscript of the kind of response—one can only call it ferocious and loving—I had grown to take for granted from this amazing man. I am grateful that he was at least able to see some of the early drafts. The book was written with Warren's voice in my ear. The late Jay Leyda was also unstintingly generous in sharing with me his extraordinary scholarship in American film, photography, and literature.

In the course of completing the manuscript I have incurred many other debts I take great pleasure in acknowledging. Robert Byer read the manuscript carefully and deeply, and taught me much about my own arguments. His responses were learned and astute, and I owe him

a special debt of gratitude. Charles Feidelson once more gave my work the benefit of his critical eye, and once more I happily express my appreciation. I appreciate David Rodowick's reading the manuscript and giving me an encouraging report. William Gladstone, John Hill, Leslie Katz, Howard Lamar, Jerry Liebling, Grant Romer, Martha Sandweiss, Richard Schiff, Maren Stange, William Stapp, and Zev Trachtenberg read sections of the manuscript, and the book has profited from their responses. I want also to thank Burton Bledstein, Craig Owens, and Sally Stein for helpful comments along the way. Working with Arthur Wang is always a heartening experience. He is as severe a friendly reader as one can hope for, always insisting that I try again to say what I mean. Every page has benefited from his shrewd skepticism.

I have been fortunate in my readers, critics, and editor; they are not responsible for defects of argument, errors of fact, or infelicities of expression which may remain in the book.

The book would not have been possible without the help of many curators, librarians, and archivists. Jonathan Heller of the Still Photographs Division of the National Archives; Jerrold Maddox, formerly with the Prints and Photographs Division, the Library of Congress; George Miles, Curator of Western Americana, Beinecke Library, Yale University; Weston Naef, Curator of Photographs at the Getty Museum; and William Stapp, Curator of Photographs at the National Portrait Gallery, have all been generous with their time and knowledge. I want also to thank Garnett McCoy, formerly director of the Archives of American Art, and his staff; the staff of the International Museum of Photography at the George Eastman House, especially librarian Rachel Stuhlman, archivist David Wooten, Kathy Ritter, and Greg Drake; Beverly W. Brannan and Carl Fleischhauer of the Library of Congress; the staff of the Beinecke Rare Book and Manuscript Library, Yale University. John Hill, executor of the Walker Evans Estate, has been consistently helpful. Glen Reiter, at an early stage of research, and Susan Williams, more recently, have provided excellent assistance in research; with her admirable skills in research and her wonderful good humor, Ms. Williams has been indispensable.

Many of the ideas in the book were first worked out in courses at Yale University and elsewhere, and I am grateful to more students than I can enumerate for helping me see and think more clearly. Earlier versions of several chapters first appeared in the following publications: "Brady's Portraits," *Yale Review* (Winter 1984); "Albums of War," *Representations* (Winter 1985); "Ever—the Human Document," in *Lewis Hine and America* (Millerton, N.Y.: Aperture, 1977); "Walker Evans's America: A Documentary Invention," in *Observations* (Carmel, Calif.: Friends of

Photography, 1984); "From Image to Story: Reading the File," in Carl Fleischhauer and Beverly W. Brannan, eds., *Documenting America* (Berkeley, Calif.: University of California Press, 1988). I am grateful to the publishers of these works for permission to reclaim them. A National Endowment for the Humanities fellowship in 1979–80, a Rockefeller Humanities Fellowship in 1983–84 concurrent with a residence at the Woodrow Wilson Center, and a month's residence in 1987 at the Rockefeller Foundation Research Center at Bellagio, Italy, allowed me time and space for research and writing. Research grants from Yale University have helped defray sundry expenses. I am grateful to these institutions for their support.

It remains to thank my family for their material support, their prodding, and their tolerance. My wife, Betty, stood by the project from the beginning; she helped bring the book to light.

Hamden, Connecticut
February 1989

*Every image of the past that is not recognized
by the present as one of its own concerns
threatens to disappear irretrievably.*
—WALTER BENJAMIN

History is always the interpretation of the present.
—GEORGE HERBERT MEAD

READING
AMERICAN
PHOTOGRAPHS

Prologue

Whatever new object we see, we perceive to be only a new version of our familiar experience, and we set about translating it at once into our parallel facts. We have thereby our vocabulary.

—RALPH WALDO EMERSON
"Art and Criticism" (1859)

I

IN A PAMPHLET in 1855 on the elements of photography, James E. McClees, a Philadelphia daguerreotypist, deplored the "endless variety of names" by which the medium had come to be known: "Daguerreotype, Crystalotype, Talbotype, Calotype, Crystalograph, Panotype, Hyalograph, Ambrotype, Hyalotype, etc., etc., etc." All were useful terms, designating particular variations in the basic process of fixing the image on the ground glass of a camera obscura—the process discovered separately by Niepce and Daguerre in France and William Henry Fox Talbot in England, and revealed to the world in 1839. But the Babel of names confused things, and McClees was not alone in feeling that "the sooner the art becomes divested of the quackery of terms the better." Like others, he wished to settle the matter of a generic name and place a final seal of certainty upon the medium. McClees based his choice of "photography"—the term had been in limited use since 1839 on etymological correctness, for was not the medium a way of writing with light?[1]

Early attempts at establishing a legitimate vocabulary for the medium reflect deeper attempts at comprehension. From its birth the medium had aroused contradictory responses. Pictures seemed both reassuringly familiar and disconcertingly new, recognizable as pictures, but with a difference. Witnesses to Daguerre's first pictures on the silver-coated

metal plate of the "daguerreotype" thought they were monochrome drawings or aquatint engravings. "Who will assure us that they are not drawings in bistre or sepia?" asked one journalist. "M. Daguerre answers by putting a magnifying-glass into our hand, whereupon we perceive the smallest folds of a piece of drapery and the lines of a landscape invisible to the naked eye."[2] Unlimited mirror-like detail made all the difference. If these miniature images resembled handcrafted pictures, they also surpassed them at their own game of reproducing the visible look of things.

The dialectic of strange and familiar, of astonishment mingling with recognition, points to the predicament into which the medium was born, a predicament of comprehension. The problem of the name embodies a larger problem of knowledge: by what "parallel facts," in Emerson's phrase, should the process be translated and brought into our vocabulary? At stake was not the abstract question of the "nature" of the medium but the question of its practices, its social uses, including its legal status.[3] The selection of the term "photography" placed the new process among the familiar practices of making legible inscriptions, the parallel crafts of writing and drawing. Lexically, photography means a kind of pictographic writing, communication through images. Images, moreover, of a particular kind. The dilemma of naming derives partly from the fact that the novelty of the device overshadowed the familiar form of its picture. Niepce and Daguerre and Talbot had aimed only at fixing the images which form themselves in the camera obscura. The device was long familiar. Aristotle noted that light coming through a small aperture casts upon a surface opposite the opening an inverted image of the scene before the aperture, an image visible in a darkened room. Eleventh-century Arabian savants used a device modeled on this principle for astronomical observations. Renaissance painters outfitted a similar device, a camera obscura, with a focusing lens to help them trace perspective lines. Long before 1839, the camera image had come to seem second-nature, the true look of reality which painting attempted to imitate.[4]

Rather than the work of light alone, the camera image was, however, the product of a lens designed in a certain way to produce a certain effect. Photography confirmed the image as natural, for was not the process instantaneous and automatic, unmediated by hand? It was easy to forget that the construction of the camera box, the design of the lens, the shape of the frame—all were "tied," in Hubert Damisch's words, "to a conventional notion of space and of objectivity whose development preceded the invention of photography, and to which the great majority of photographers only conformed." As Damisch puts it:

"The photographic image does not belong to the natural world. It is a product of human labor, a cultural object whose being . . . cannot be dissociated from its historical meaning and from the necessarily datable project in which it originates."[5]

Just as the novelty of fixing the image delayed recognition of the conventional basis of the picture, so the image's familiar aspects kept from view the other side of the equation: photography's radical difference from handmade pictures. Daguerre's magnifying glass disclosed more than the astonishing truth that the machine-made image does not dissolve into brushstrokes or pencil lines, that it continues intact, mirror-like, to the limits of its metal base. The glass revealed the equally revolutionary irrelevance of manual skill in producing the illusion of reality. Photography transferred the skills of the hand to an inanimate apparatus. What the hand had learned from centuries of training now belonged to a mechanism. The new process excluded the hand and freed the eye to serve in its place. By taking aim through the camera, the eye could now concentrate the hand's traditional knowledge of composition and style into a swift, instantaneous act. "The daguerreotype does not demand a single manipulation," the French scientist François Arago explained in 1839, "that is not perfectly easy to everyone. It requires no knowledge of drawing, and is not dependent upon any manual dexterity."[6]

This extraordinary event—a process of objectifying human skills into "dead" machinery identical in its logic to the mechanization of the means of production in the same era—did not necessarily change the character of pictures produced by photography. The old and familiar remained the chief source of imagery. But within the familiar conventions, unfamiliar powers of reproduction revealed by Daguerre's magnifying glass came to the fore. In the early years, photographers asserted, as their claim to a legitimate trade in portraits, their greater ability to execute the same illusions of reality attempted by painters. The appeal of lifelikeness, as Baudelaire lamented in 1859, lay at the heart of photography's enormous popularity in the mid-nineteenth century in the form of cheap, mass-produced pictures.[7]

Lifelikeness, the mirror effect, had another radical implication. It suggested a new relation of pictures to time. The photographic image, conventional and familiar in form, bore within it a disruptive event— the signification, as Roland Barthes formulated it, of the camera's *having been* at the actual scene of the image at some precisely datable moment in the past.[8] Each photograph represents a nonrepeatable event. Unlike a painting or drawing, which conflates the duration of its making with the inner subjective time of the maker's memory and mental processes,

the making of the photographic image occurs at once. The determinable, datable character of the photograph and its machine-like exactness of whatever detail falls within the lens's focus give the camera image a privilege among images in regard to the past. Each photograph bears a distinct and unique message.

How have American photographers and their audiences read and acted upon those messages? How have they put the "having been" of the medium into a *significant* (because signifying) relation to a commonly shared present? How, under what circumstances (social and intellectual) of collective life, and *why*, have they employed the medium to make sense of their times—in effect, to "make" the history they lived by? Photographic images do not become history automatically. Destined by the medium's technology to represent a specific moment in the past, they are also free to serve any representational function desired by a photographer and his audience. It is by virtue of motives, desires, and choices beyond the medium itself that images become tokens of a relation between then and now, between the "having been" and the "is." Images become history, more than traces of a specific event in the past, when they are used to interpret the present in light of the past, when they are presented and received as explanatory accounts of collective reality. They become history when they are conceived as symbolic events in a shared culture.

Between an exposed photographic plate and the contingent acts whereby people read that inscription and find sense in it lies the work of culture, of the wider history within which the medium achieved its name as *light writing*. The story of how American photographs have performed as history within American culture goes back to the earlier pictorial art before the appearance of the new medium. Painting prepared the way for the photograph—superbly exemplified in a remarkable self-portait by a Philadelphia artist, Charles Willson Peale, whose career as artist, scientist, and fervent supporter of the democratic cause in 1776 embodied the broad cultural program of revolutionary Enlightenment in the late eighteenth and early nineteenth centuries. Reading American photographs can profitably begin with a reading of Peale's 1822 painting, a compelling reflection upon the American artist and his tasks at a time of cultural transition.

II

While planning "The Artist in His Museum," completed in 1822, Peale wrote that "the Design should be expressive that I bring forth into public view, the beauties of Nature and art."[9] A self-portrait to com-

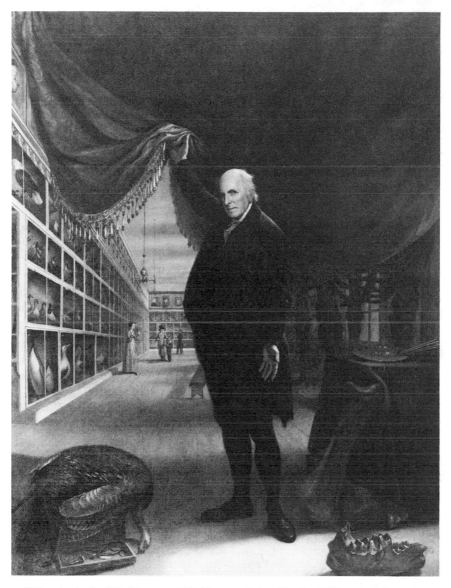

1. "The Artist in His Museum." Self-portrait by Charles Willson Peale, 1822

memorate his eighty-first birthday, commissioned by the American Museum in Philadelphia, which he had founded in 1784, the canvas elucidates Peale's conception of his mutual labors as artist and collector of natural specimens. It depicts the conceptual world of art into which photography would appear seventeen years later—a world in which art seems comfortable in its task of providing exact copies of visible nature.

We see the artist at the entrance to his museum, the threshold broadened at the bottom to resemble the proscenium of a stage—an effect produced also, of course, by the curtain he lifts and by his theatrical gestures. At the outset, then, the viewer encounters a figure in black identified by the title of the painting as "the artist," but by his performance seeming also an impresario, a showman. He stands, moreover, in a space that seems to be a workshop as well as a stage, taxidermist's tools together with the dead turkey and fragments of bone suggesting the place where the objects displayed behind the curtain— the stuffed creatures in their cases and the reconstructed mastodon skeleton—were worked on, and the palette and brushes linking this foreground space to the painted portraits at the top of the cases in the rear, and to this painting itself, the artist's self-portrait.

Museums display objects for the sake of study. A place of study suggests *studio* or workshop. A museum is also "the seat of the Muses," a place of *making* as well as showing. Thus, by title and symbol, the painting identifies the artist as servant of the Muses, maker of things which did not exist before, though as imitations they *seem* real. The artist stands between his raw material and the finished art, between things unsorted and unclassified and things rearranged, reassembled, placed in compartmental spaces in the long corridor of display and instruction—"to display," as Peale described the purpose of his museum in 1800, "by visible objects the harmony of the universe."[10] The artist's gesture in raising an edge of curtain implies the didactic purpose. He displays his skills of imitation not for their own sake but to teach us to see and know the order of things in the world beyond the enclosed space, the outside world, whose only living sign is the pale light illuminating the space behind him, the Long Room of the Philadelphia museum. The four figures in the deep space of the painting act out attitudes proper to the viewing of the painting itself: close attention, study, and astonishment.[11]

Peale designed his painting to teach us how to think about art as well as about nature, art in relation both to nature and to human skill. The lesson concerns the role of art in making visible the order of nature. Following Linnaeus's designations of class and genus as the principle governing universal order, the painting illustrates the artist in his task

of illuminating the unity of nature, a unity based on a coherent structure of forms rising from the simplest to the most complex—the "great chain of being" of Enlightenment thought. Thus the serial ranking of specimens in the Long Room of the museum: lower order of creatures—ducks and penguins—on the bottom, rising through songbirds and birds of prey to the row of portraits of distinguished public figures at the top. Art clarifies the system, brings it to view. To make the order of things visible requires two commensurate acts: clarity of representation, and formal placement of the represented thing within a strictly defined spatial form. In a lecture on the Linnaean system in 1799, Peale remarked that it provides "the master key of a grand Pallace by which we can step into each of the apartments and open any of the Cabinets, to become acquainted with their contents."[12]

The key is both mental and tangible—the abstract system of classification, and the physical brushes, palette, taxidermist's tools. The link between seeing and knowing requires, then, thought and action, ideas and labor—gathering specimens and preparing them for display, as worked-over objects or as painted images. Without such acts, the world remains a random clutter, "jumbled together," Peale wrote. In the painting the turkey and the bones represent the jumble outside the "Pallace" of the Long Room, whose strict linearity represents the reconstruction of true order. The museum shows the disorganized world of experience transfigured and clarified by art, the combined arts and crafts of taxidermy, archaeology, and painting. It is right, then, that Peale should include the workshop in his representation of the museum, of himself "in" the museum. The artist assertively portrays himself as the mediator of the world's truth, one who not only creates a copy of things, "a world in miniature," but reveals the true order hidden within things, an invisible order he brings to view.

Art, then, stands revealed as consisting of craft and the communication of knowledge. True to his Enlightenment values, Peale portrays himself overtly not as a romantic artist whose pictures project his interior life, his private visions, dreams, or emotions, but as an Age of Reason man of useful skills, a public figure performing a high intellectual task of civic importance. Placing himself in a mediating posture between the workshop, its tools and its raw materials, and the museum, the space of exhibition and instruction, he chooses a theatrical mode—the proscenium, the curtain, his gestures—in order to project the image of the artist as a responsible citizen sharing his skills and serving the cause of truth. The mode also provides a role for the viewer as spectator, centered before a stage, poised for both entertainment and instruction.

In its overt lesson, Peale's didactic portrayal of the artist prefigures

the role adopted by early photographers in America: the link between art and craft, the civic role and the notion of art as exact imitation. Art makes knowledge *sensible*, Peale argues, available to the eyes and the touch, pleasurable as well as useful. Into this mold photographers would pour their own ambitions for public acceptance.

Yet, once we make out the explicit theme of Peale's painting, riddles begin to assault us. The two-part structure of the canvas poses one question. Why does he drop the curtain over most of the mastodon's skeleton? Why, in a painting so committed to lucidity, does he dramatically block our vision of one whole quadrant of the canvas? The vertical division between a well-lighted and an obscure area, moreover, corresponds to the split between the front or apron-workshop with its random objects and the receding geometricized space of the Long Room. The objects in front are painted in trompe l'oeil, as illusions of real objects lying there. The rear of the canvas follows strict rules of perspective. Why does Peale employ different systems of representation in separate areas of the canvas? And how are we to understand the fountain of light bursting from the dome of the artist's head? What is its source?

In regard to the vertical division, the Quaker woman serves as the connecting link between the two spaces. From her gesture of astonishment we deduce that what is hidden from our view behind the curtain is not only windows, the source of the light in the Long Room, but the reconstructed skeleton of a prehistoric creature of awesome dimensions. What light falls upon—the stuffed animals in their cases, the portraits above, and everything in the foreground—can be studied and known, as the other visitors in the Long Room indicate by their postures of attention and contemplation. Is the skeleton shrouded from view because the animal it represents can be known only by conjecture to the mind if not the eye? Are certain items in the natural order beyond reliable knowing, capable of apprehension only subliminally, by skeletal reconstruction and by their "sublime" effect such as that evinced by the startled woman?

The relation between foreground and background raises additional questions. Compare the objects on the floor with those in the rear. Jawbone, shank, turkey: each is depicted descriptively, as a discrete entity; we see them as things, isolated unique objects. They represent only themselves, not genus or class. In the rear, objects are classified. We see and know them in their relations to each other—relations not of individuals but of classes. Each specimen of a particular group is interchangeable with all others in that class; they stand for each other, and cumulatively for the class, the abstraction which confers representational value on each. The stuffed animals have lost their animate life

to gain a "rational" life as *specimen*, interchangeable with all others in the same class. The categorized items lose what the foreground objects still so obdurately possess, their intractable "thisness."

The painting depicts this difference in status through a different mode of depiction in each case: a perspectival mode in the rear; what can be called an optical or descriptive mode in the front.[13] Viewing the rear, we stand as if before a window, looking from a distance into a space we do not occupy; the smallness of the human figures enhances the illusion of distance, distance unaccountably vast from the presiding figure of the artist who appears in the foreground, illuminated from a light source different from that which bathes the interior and casts lateral shadows.

These schisms in the field of the painting derive paradoxically from the argument it exemplifies: the illustration of the making of a miniature world whose schema corresponds with and makes visible the order of the universe. It is a dynamic story of the process of art, the transformation of unique things such as we see in the front into specimens such as we make out in the rear. The story requires a front-rear division between jumble and order, and by bringing that division to view, Peale discloses a chasm within the system of explanation his painting provides. Intellectual interest governs the geometrically precise rendering of what lies behind the curtain, but what lies in the foreground represents *painterly* interest. The foreground objects catch and hold our eye (less than our mind) with their detailed rendering, their trompe l'oeil presence. Against the ordered array of objects in the rear representing genus and class, they stand forth as discrete and individual, as sensuous things of *this* world. Peale's museum is rent, in short, by an intellectual contradiction manifest as compositional discordance. The logical relation of parts of the canvas brushes up against the visual relations. A precarious balance holds the parts together, the system represented in the rear threatening to fall back (or, as it were, forward, into the workshop) into its original components of discrete objects—genus and class into thing, order into disorder, lucidity into obscurity, knowledge into mystery. While not imminent, a sense of potential collapse into origins—ultimately, into the painter's medium displayed in the foreground objects— looms over the painting. Raising the curtain becomes a Promethean act of defiance.

The central figure of the artist embodies another contradiction. Comprised of darkness and light, obscurity and illumination, he has a head and eyes that shine, a body that merely occupies black space. Peale explained that he chose to show himself in "my black suit contrasted to the light of the Long room, with all the shadows inclining to the front

of the picture." But what is the source of the light? He "made a bold attempt," he writes, to place the light behind him,

> and all my features lit up by a reflected light, beautifully given by the mirror, the top of my head on the bald part a bright light, also the hair on each side. That you may understand me, place yourself between a looking glass and the window. Your features will be well-defined by that reflected light. A dark part of a curtain will give an astonishing brightness to the catching lights, and thus the whole figure may be made out with strong shadows and have catching lights.[14]

Peale composed himself standing before a mirror, a strong light at his rear focused by the mirror upon his bald pate. Translated into the picture, this arrangement suggests that the light comes from what is the darkest section of the curtain: an impossibility, or a paradox. The light we see has no demonstrable source in the picture; seeming to emanate from the artist's head itself, light deceives, is a trick of mirrors. The effect is stunningly ambiguous. The "mirror of nature" implied by the painting's overt theory of imitation coexists with a magician's mirror which conjures illusions and distorts appearances.

Where exactly *is* this artist—in his museum, a place of rationalist enlightenment, or in a theater of illusions, of artful deception? Is he a copyist (art as science) of nature's grand order, or a magician (science as art) casting spells as his body swirls on his forward toe? Similar questions would be directed to the photographer a few years later. Peale's painting suggests by its ambiguities that questions about the sources of imitation lurked within the cultural ambiance of American art in the years before photography. Are pictures literal, scientifically accurate copies of the world's order? Or are they deceptions, tricks played against the credulity of our eyes? Does art, or representation as such, clarify or mystify? Are pictures to be trusted? Indicating a shift in thinking about the role of art in an increasingly commercial, urban society—a shift from museum to theater, from study to spectacle—such questions would shortly fall to the photographer and become the new medium's burden.

III

In a few years another figure in black would appear with different tools—wooden box, glass lens, chemicals, silver-coated copper plates, vials and flames, and darkened chambers. Some suspected this figure, the daguerreotypist, of alchemy and necromancy, the lifelike image he brought out on a blank plate coated with polished silver a piece of black magic. "It appears to me a confusion of the very elements of nature,"

New Yorker Philip Hone recorded in his journal in 1839, unconsciously evoking one of the sources of photography, as McClees would remark in 1855, in the discoveries by "the Alchemic philosophers" of "the property in certain salts of silver of rapidly blackening by exposure to light."[15] "The real black art of true magic arises," exclaimed the popular writer N. P. Willis half mockingly.[16] Many years later one of the early daguerreotypists, Abraham Bogardus, wrote:

> I remember the public estimate of the "dark room"; they thought the operator conducted some hocus-pocus affair in there. "Say, now, Bogardus, what do you do in there, do you say something over it?" I remember when a prominent merchant who had had a daguerreotype taken was asked how it was done. He said you sat and looked at the glass (lens) until you "grinned yourself on the plate."[17]

The aura of alchemy surrounding the daguerreotype seemed, moreover, to arouse never quite forgotten taboos against graven images and likenesses, icons, reflections, mirrors—against imitation as such, as Jean Baudrillard writes, for "it makes something fundamental vacillate."[18] In *The House of the Seven Gables* (1851), Hawthorne draws on these associations by having his artist, Holgrave, first display a daguerreotype in a garden near Maule's Well, a fountain paved with a mosaic of colored pebbles, whose waters are thought to be bewitched. "The play and slight agitation of the water, in its upward gush, wrought magically with these variegated pebbles, and made a continually shifting apparition of quaint figures, vanishing too suddenly to be definable"—exactly the effect of the daguerreotype.[19]

A copper plate coated with highly polished silver, bearing a floating image developed in fumes of mercury and toned in gold, the daguerreotype contained within itself the alchemical hierarchy of metals, from low to high, from base to noble. It also resembled a looking glass, another object charged with magical associations. By a slight shift of focus from the image to the surface on which it appears, beholders see their own reflections.[20] A doubling of image upon image: the viewer's image, mobile and immediate, superimposes itself upon the fixed daguerrean image. The effect was apparitional in another sense as well: at the merest tilt of the plate, the photographic image flickers away, fades into a shadowed negative of itself while still entangled in the living image of the beholder. The primary image comes to seem evanescent, suspended in a depthless medium. Moreover, as in a mirror, the daguerrean portrait appears reversed right to left, which meant that you could look at your own image in the past, as if in a mirror-once-removed, mingled with the image of yourself at this very moment.

Suspicion of occult practices eventually faded, dispelled by the young profession, though never entirely. The photographer came to seem familiar: another artist fulfilling the goal represented in Peale's painting: reproducing things in the world, making imitations, copies, perfect replicas. It was thought that photography, with its ability to reproduce mirror-like reflections of the world, would extend and refine the painter's resources of imitation. Its capacity for exact reproduction of things seemed limitless; no tangible subject, not the moon or the stars, could escape its fixating lens. But were its pictures really copies of the world such as painters made, or copies of another kind, another order of picture?

"There was never anything like it," remarked a daguerreotypist in 1858 who signed himself "Shade," about his first successful picture in 1842. "For hours I have held it, carefully noting all the soft minutiae of light and shade: and still the little rough-edged silver tablet was a joy forever, discovering some merit of complete similitude hitherto unnoted; it seemed inexhaustible, yielding new pleasure as often as consulted."[21] But what kind of thing was it, with its inexhaustible similitude? Daguerreotypes resembled pictures made by hand, but their uncanny reality seemed to the wonder-struck initiates an inexplicable excess, an elusive surfeit. They seemed to represent the world, in shape and texture if not in color, the way the world was customarily seen in painted or drawn or engraved representations—only more so, with more minutely detailed textures, more sharply delineated shapes and forms, a closer approximation of the thing itself. But were they in fact *representations* as that word was normally understood by viewers of works such as Peale's painting—pictorial copies or replications of real things? Did they belong to art, to the long tradition of two-dimensional picturing of the sensible world, the making of illusion on flat surfaces? Or were they something else—magical emanations, not pictures at all but pieces of the world transferred by light to a plate—like shadows or footprints? The daguerreotype seemed to *possess* its sitters.

The most common figure of speech was that, through the camera, "nature paints herself." If so, could the resulting image be claimed as *anyone's* intention? If the world inscribes itself through the "pencil of nature," art, in the sense of making, would no longer seem an appropriate or relevant category. The automatic, unflinching, and remorselessly unselective mirror-like character of the camera image seemed to sever the link to art, to set photography free from traditional practices of picturing—fatally so, it seemed to many skeptics and denigrators. But the obverse argument, born in the very language by which early writers received photography into existing systems of thought, dis-

agreed: the common suffix "type" signified that photographs were pictures impressed upon a surface, as in printing. Their difference is a difference of means, not substance—not an ontological but an instrumental difference.

American reaction to the new medium recapitulated European response. "They resemble aquatint engravings," Samuel F. B. Morse wrote in a letter after seeing Daguerre's work—the first recorded reaction by an American—"for they are in simple chiaro oscuro. But the exquisite minuteness of the delineation cannot be conceived. No painting or engraving approached it." Morse's letter, published in the New York *Observer* on April 20, 1839, plays on similiarity and difference: the pictures of interiors are "Rembrandt perfected," but the representation of "minuteness" fits no existing category. Like Daguerre, he applies a magnifying glass to the miniature image:

> In a view up the street, a distant sign would be perceived, and the eye could just discern that there were lines of letters upon it, but so minute as not to be read with the naked eye. By the assistance of a powerful lens, which magnified fifty times, applied to the delineation, every letter was clearly and distinctly legible, and so also were the minutest breaks and lines in the walls of the buildings; and the pavements of the streets. The effect of the lens upon the picture was in a great degree like that of the telescope in nature.
>
> Objects moving are not impressed. The Boulevard, so constantly filled with a moving throng of pedestrians and carriages, was perfectly solitary, except for an individual who was having his boots shined. His feet were compelled, of course, to be stationary for some time, one being on the box of the boot-black and the other on the ground. Consequently, his boots and legs are well defined, but he is without body or head because these were in motion.[22]

The first item perceived in this view of a Paris boulevard is a *sign*, a set of legible words. But a curiously photographic form of illegibility follows in the next paragraph. Supremely accurate on one hand, on another the photograph simply erases what is there, annihilates the throngs, decapitates the solitary remaining figure, leaving only boots and legs. These ghostly effects call into question Morse's initial confidence that "exquisite minuteness of delineation" is an adequate statement of the medium's capacities.

Less than a year after Morse's letter, Edgar Allan Poe also applied a magnifying lens to explain the daguerreotype. How, he asked in a brief article in January 1840, can one describe the effect of these unimaginably truthful images? "All language must fall short of conveying any just idea of the truth." The daguerrean image achieves an unprecedented "identity of aspect with the thing represented."

For, in truth, the Daguerreotyped plate is infinitely (we use the term advisedly) is *infinitely* more accurate in its representation than any painting by human hands. If we examine a work of ordinary art, by means of a powerful microscope, all traces of resemblance to nature will disappear —but the closest scrutiny of the photogenic drawing discloses only a more absolute truth, a more perfect identity of aspect with the thing represented. The variations of shade, and the gradations of both linear and aerial perspective are those of truth itself in the supremeness of its perfection.

"Identity of aspect with the thing represented"—here, Poe argues, lies the utter and complete difference between handmade pictures and the daguerreotype. To call the image a mirror image is not, for Poe, a metaphor but a statement of equivalence. "Perhaps, if we imagine the distinctness with which an object is reflected in a positively perfect mirror, we come as near the reality [of the daguerreotype] as by any other means."[23] In its function as a mirror lay the image's most radical challenge to the representational system portrayed by Peale and evoked by Morse.

Poe did not elaborate the implications of his mirror allusion. The fullest argument for the uniqueness of photographic images appeared almost twenty years later, in three articles between 1859 and 1863 in the *Atlantic Monthly* by the Harvard savant and wit, medical doctor and man of letters, Oliver Wendell Holmes. An enthusiastic member of a network of amateurs who exchanged their pictures with each other, Holmes writes in these essays about the form of photography known as stereography—a way of joining two images in an instrument called the stereoscope (from the Greek words for "solid" and "to see"), to produce an illusion of three-dimensional space. Thrilled by this new application of science to vision, Holmes himself had invented an inexpensive popular stereoscope. The extraordinary reality produced by these instruments helps account for his exuberant figurative language. Photographs can now be seen as "forms," exact tracings of the actual subject, as skin outlines the body it clings to. Images are membranes, films, effigies cast off by things themselves. The time will soon come "when a man who wishes to see any object, natural or artificial, will go to the Imperial, National or City Stereographic Library, and call for its skin or form, as we would a book at any common library."[24]

The stereoscope had first appeared in the 1830s, before photography, but clearly part of the same impulse toward optical experiment which gave rise to the fixed image. Based on the principles of binocular vision—the fact that each eye records a slightly different image, fused by the brain into a single image that allows us to perceive the difference between objects near and far—the first stereoscopes used mirrors and

refracting prisms to produce an illusion of solidity by bringing together two separate drawings of geometrical shapes. By the early 1840s, photographs replaced drawings, and within a decade the stereoscope would become the rage throughout the world.

In 1849 Sir David Brewster, who had invented the kaleidoscope, devised a simpler stereoscope with decentered magnifying lenses for viewing two small photographs of the same scene made a few inches apart. Demand for stereo viewers rose dramatically after their display at the Crystal Palace Exhibition in 1851, and with the introduction of paper prints a few years later, stereographs flooded the market. "No home without a stereoscope" was the motto of the London Stereoscopic Company, founded in 1854.[25] With the mass publication of stereo views of every imaginable subject on earth and in the heavens, the stereoscope became the first universal system of visual communication before cinema and television.

Stereographic viewing offered the photograph not as a formal, traditional picture but as a singular illusion of solid objects in space. Stereo photographers composed their pictures in small, compact cameras with two parallel short focal-length lenses which could make "instantaneous" or stop-action pictures. The chief object was simulation, to create illusions of real things in real space. "The effects of stereoscopic representation," explained Brewster in 1856, "are of a very different kind" from those created in two-dimensional pictures. The stereoscopic effect "is due solely to the superimposition of the two plane pictures by the optical apparatus employed, and to the distinct and instantaneous perception of distance by the convergence of the optic axes upon the similar points of the two pictures which the stereoscope has united." It has nothing to do with the conventional methods of creating perspectival effects in drawing and painting.[26]

Holmes's idea of a visual library draws on a notion close to the heart of Western thought since the ancient Greeks, that all knowledge derives from the eyesight, that we know as much as we see (the word "theory" derives from the Greek word for "sight"), and that the world consists of visible objects which define themselves to our eyes by their differences and similarities of appearance in space. The magnified photographic image formed in the stereoscope fills the entire range of vision— unframed, unbordered, boundless, as if the eye were there before the very scene. Like peep boxes, the stereoscope produced replica-like illusions of reality—"so lifelike," wrote the English photographer Claudet, "as to be almost startling."[27] The stereoscope allows the photograph to be seen with such enhancement of detail, in "frightful amount," as Holmes put it, that "the mind feels its way into the very depths of the

picture."²⁸ Holmes described the effect as "half-magnetic" and "dream-like."²⁹ The eye activates the mind to "feel" what it sees, to know the scene not through abstractions of language but directly: a new form of reading, a new kind of library. In the stereoscope the photograph became a perfect simulacrum, the world itself transposed into a living image, and the viewer into a passive, disembodied spectator of an illusory, detached, and immaterial world.

The irrepressible Holmes added another twist which, as Harvey Green and Allan Sekula have remarked, draws on the language of capitalist political economy.³⁰ Playing on popular anxieties about inflated paper money since the crash of 1837 (aggravated by another bank failure in 1857), Holmes offered the stereographically enhanced photograph as a new form of security between an image and what it claims to represent. "There may grow up something like a universal currency of these bank-notes, or promises to pay in solid substance, which the sun has engraved for the great Bank of Nature." The figure of speech recalls an advertising gimmick some daguerreotypists used in the hard times of the 1840s, of distributing handbills in the form of imitation banknotes. One appeared in Boston about a decade before Holmes's article: "Chases Daguerrian Bank . . . Will pay on demand Likenesses . . . unsurpassed by any in the world and warranted never to change."³¹

Just as the number inscribed on dollar bills represents a promise on the part of the bank to exchange the note for a fixed amount of gold or silver, the photograph represents "solid substance." The idea is that a photograph stands to its referent the same way paper notes stand to the monetary value inscribed on their faces and guaranteed by the promise of species payment—a promise honored too often in the breach for the comfort of Americans in creditor classes in these years. Holmes based his metaphor of photographs as cash on a verbal play whereby photography abolishes matter and transfers its substantive value to images:

> *Form is henceforth divorced from matter.* In fact, matter as a visible object is of no great use any longer, except as the mould on which form is shaped. Give us a few negatives of a thing worth seeing, taken from different points of view, and that is all we want of it. Pull it down or burn it up, if you will.³² [Holmes's italics]

Holmes fills out the conceit by proposing that library collections, or image banks, be created through a "comprehensive system of exchanges."

By carrying to a comic extreme the idea of the photograph as an exact objective copy made without intervention of human desire or will

or interest, Holmes implies that value or meaning resides entirely in the image itself, which can then be distributed as absolute knowledge. This notion, as Sekula observes, abstracts what Marx called "use value" from the image, the labor embodied in its production, and the cultural values represented by its material referents, and makes it over into an object, like money, of universal exchange. Conceived as an objective mechanical process which destroys (or replaces) what it copies, photography itself, Holmes insists, guarantees the value of images as visible truth.

Holmes calls "the divorce of form and substance" achieved by the photograph the "greatest of human triumphs over earthly conditions," and foresees no end to the "transformations to be wrought." "Let our readers fill out a blank check on the future as they like—we give our endorsement to their imaginations before hand." Holmes cannot resist elaborating his marketplace conceit: "Matter in large masses must always be fixed and dear; form is cheap and transportable."[33] Fanciful as it is, his obsessive linking of photographs and money suggests that the idea of the photograph as a surrogate reality arose from a need within the dominant ideology of the times. Holmes conceives of the effect of the photograph as identical to that of money—the transformation of tangible values ("substance") into intangible tokens of exchange ("form"). Only, where money in the bourgeois economy is a commodity in its own right, its stated values always fluctuating in a money market, the photograph is imagined to remain constant, always referring to the very "substance" it has annihilated. As Sekula remarks, the notion is "bizarre." Yet it is plausible in a era of extended crisis. The metaphor which transferred an elusive solidity of reference from money to photographs subliminally promised stability in the antebellum world of inflated money, shaky confidence, and conflicting values. Holmes's figurative language unwittingly snares a truth.

But is a photograph as good as hard cash, a solid guarantee that what it shows is always the same, always there, always reliable? Holmes's metaphors express a hope rather than a proven truth. Yet the same metaphor which depicts photographs as money cuts the ground from under the hope. Even gold fluctuates. The market betrays the very idea of a solid substance, a reliable measure of absolute value. Holmes's analogy of images as cash ironically turns out to be truer than he realized. Like money and other commodities, photographs shift and slide in meaning. They may seem to offer solid evidence that objects and people exist, but do they guarantee what such things *mean*? The lesson of the photograph, as early photographers came quickly to learn, was that meanings are not fixed, that values cannot be taken for granted,

that what an image shows depends on how and where and when, and by whom, it is seen. The connection between photography's image-world and the real world or *Lebenswelt* of everyday life defines a problem—a question rather than a certain answer.

Holmes's hope survives in the popular belief that photographs can be seen, handled, and swapped as if they were tokens of an absolute reality, as if they can be taken at face value. Early in 1988 *The New York Times* reported that somewhere on a desolate prairie near Bismarck, North Dakota—in the "middle of nowhere"—"the Federal Government is selling pictures of everywhere."[34] The Earth Resources Observation Systems Data Center—EROS—maintains an archive there of some six million images, "non-military" satellite and aerial photographs of practical use to geographers, city planners, relief and public interests groups, and whoever would like to see the fires at Chernobyl, or their own back yards from hundreds of miles in outer space. EROS seems the triumph of Holmes's imperial vision, and perhaps an ironic commentary on the ancient myth of passion: a central archive of millions of images, and growing at the rate of twenty thousand per month. Machine-made images with awesome qualities of resolution, they are a far cry from what Alfred Stieglitz meant when he said that when he makes photographs he makes love. Their purpose is to keep track of things, to identify this and that, to monitor the world. EROS represents photography triumphant: the instantaneous reproduction of the world. The unerring mechanical eye replaces the ancient god of love, and photography, in the guise of a disembodied automatic eye, assumes the name of myth. Emerson's famous figure of speech, the "transcendental eyeball" ("I am nothing; I see all; the currents of Universal Being circulate through me; I am part and parcel of God"), has come true in the function of a machine: another irony. To submit the myth of the unerring objective camera to the test of historical analysis is one of the purposes of this book.

Illustrious Americans

Other men are lenses through which we read our own minds.
—Emerson, *Representative Men* (1844)

I

NEWS OF Daguerre's success in fixing an image arrived in New York in the spring of 1839.[1] Within days and weeks many Americans claimed their own success, or luck, and some began at once to explore the invention's commercial possibilities. The time was not propitious for new enterprises. Two years earlier the economy had crashed in one of the worst depressions in the nation's history. The panic of 1837—a financial collapse triggered by wildly inflated paper money issued by local and state banks, and the frenzy of speculation it produced—had shattered confidence, slowed investments, and brought in its long wake chronic hard times and unemployment. Hard currency, gold and silver coin, remained scarce, and the economy limped along until the discovery of gold in California in 1849 (followed ten years later by the opening of silver veins in Nevada), which shored up the monetary system.[2] Itself a form of "hard" currency—a copper plate coated with silver, guaranteed to hold its value as a picture of a real, "hard" subject—the American daguerreotype flourished in just these years. If you want to know "who makes money in these Jeremiad times," asked a New York correspondent in a Washington newspaper in 1843, it is "the *beggars* and the *takers of likenesses by daguerreotype*."[3]

Many of the earliest daguerreotypists, itinerants following the well-worn paths of portrait painters or limners through the countryside, or setting up shops in cities, came from the ranks of craftsmen accustomed to forges, metals, small tools, electricity, and magnetism—blacksmiths,

cobblers, dentists, watchmakers, chemists, and inventors of all sorts. The new enterprise also raised hopes of work and income for many others suffering in the "Jeremiad times" of the 1840s. A generation later, in 1870, the Boston photographer Albert Sands Southworth recalled the "absurd, blind, pell-mell rush" into the vocation, often temporary, of making likenesses by means of the camera. In an address before the annual meeting of the National Photographic Association, he reminded his audience of the promiscuous social origins of what was now an established national profession:

> From the accustomed labors of agriculture and the machine shop, from the factory and the counter, from the restaurant, the coach-box, and the forecastle, representatives have appeared to perform the work for which a life-apprenticeship could hardly be sufficient for a preparation for duties to be performed, of a character to deserve honorable mention.[4]

In the earliest days, experimenters and entrepreneurs troubled themselves less with "honorable mention" than with learning the process and making a recognizable picture.

Albert Southworth cherished the esteem and honor he had earned with his partner, Josiah Hawes, for the originality and beauty of their daguerrean portraits. By the time of Southworth's remarks in 1870, and due in part to the widely respected character of the Southworth and Hawes studio in Boston, American portrait photography had become a profession of unquestioned dignity. It had outgrown lowly origins, overcome suspicions of alchemy and "hocus-pocus," and enjoyed the prestige and profits of a thriving trade.

It had all begun with the astonishingly brief era of the daguerreotype. By the close of the 1850s, the unique daguerrean image had all but disappeared from commercial trade, replaced by the so-called wet-plate process (the freshly coated glass plate had to be exposed and developed before the emulsion dried), which allowed unlimited paper prints to be made from a negative. The daguerrean era was brief but brilliant, not only for the unsurpassed luminosity and illusionary power of its images, but for the clarity of its logic: the shaping of a new technology of vision to meet the needs of a culture undergoing vast and rapid change.[5]

During the 1840s, two kinds of daguerrean practices developed side by side: that of the rural and small-town itinerant, in many cases a former limner or miniaturist traveling the countryside; and the city entrepreneur with an established gallery, hired hands, and the desire for recognition as a "professional."[6] Professionalization went by trial and error—resistances to overcome, suspicions to allay, and new habits to institute. Especially in the countryside, the mysterious process chal-

lenged credulity and seemed magical indeed. "I don't much like pictures of that sort," exclaimed the rural maiden Phoebe in Hawthorne's *House of the Seven Gables* (1851), turning away from a picture made by the itinerant Holgrave, "—they are so hard and stern; beside dodging away from the eye, and trying to escape altogether. They are conscious of looking very unamiable, I suppose, and therefore hate to be seen . . . I don't wish to see it any more."[7] The face Phoebe finds painful to gaze upon is that of the false-seeming Judge Pyncheon, and her reaction serves in the novel to dramatize her intuitive sense of his evil character. But Hawthorne alludes to two well-known facts about the daguerreotype itself: that the image flickered—a result of the highly polished mirror-like plate it lay upon (or within); and that the sitter's constrained posture during an exposure of a minute or more often resulted in a distinctly unamiable look—an open-eyed stare, a grimace, a look of pain.

Phoebe's suspicion of the apparitional image evokes a not uncommon moment in the early career of photography in America, a moment of shudder and refusal. Hints of the preternatural, of magic mirrors and animate images, added a tremor of fear to the understandable bewilderment caused by the stilted look of many early daguerrean portraits. T. S. Arthur, in a humorous essay in 1849 in *Godey's Lady's Book*, tells of a farmer so frightened by the photographer's preparations he "dashed down stairs as if a legion of evil spirits were after him," and of sitters who suffer the "illusion that the instrument exercises a kind of magnetic attraction, and many good ladies actually feel their eyes 'drawn' toward the lens while the operation is in progress!"[8] The effect was uncanny— a sensation Freud suggests arises when something new reminds us of something we realize we had forgotten—"something familiar and old-established in the mind that has been estranged only by the process of repression."[9] One of Freud's examples is the recurrence of an emotion associated with "the old, animistic conception of the universe," the pre-Judeo-Christian belief that "the world was peopled with spirits of human beings."[10] Uncanny sensations such as Phoebe experiences suggest the recurrence of the belief that likenesses—shadows, reflections, mirror images—are detached portions of living creatures, their soul or spirit.[11] Freud's insight into the way the psyche allows itself pleasurable terrors of the uncanny in order to reinforce its defensive repressions suggests a role for the daguerreotype, particularly with its overtones of alchemy, in initiating Americans into a new age of science and industrial technology, in which railroads, telegraphs, and steam-powered machinery also seemed driven by magical, perhaps demonic, forces.

The image which causes Phoebe to shudder also points to another facet of the daguerrean experience: the unflattering honesty of the lens.

Holgrave, Hawthorne's artist-hero, had shown her an example of his consistently unsuccessful efforts to produce an image of Judge Pyncheon suitable for engraving as a campaign portrait. Candidate for governor, he cannot hide his treachery; before the lens, his public, smiling mask drops away. Thus Hawthorne evokes the typically grim aspect of early daguerreotypes to represent the judge's unmaskable truth.

Holgrave's trials would have struck a familiar chord among his fellow daguerreans. Accounts of similar frustrations, failures, stubbornly displeasing results abounded in the popular press and the photographic journals which began to appear in the early 1850s. Aspiring professionals wrestled with the problem: how to arrange their sitters and manipulate the often fickle medium to produce not just a picture but a pleasing one—not just a likeness but a portrait. The problems were technical and social, problems in chemistry, physics, optics, and in the public image of the craft. It was not at all self-evident in 1839 that the medium was suited to likenesses; Daguerre and others were certain it was not. Many felt that long exposure times necessitated by the first lenses rendered the medium better suited to views and still-lifes, which indeed proved to be the major French use of the medium.[12] Most fatal was the frank and unstinted report of detail. "The Daguerreotype will never do for portrait painting," pronounced Lewis Gaylord Clark in 1839. "Its pictures are quite too natural, to please any other than very beautiful sitters. It has not the slightest knack at 'fancy-work.' " An anonymous writer concurred: without the means to flatter by correcting natural "imperfections," the photographer's portraits "are in a manner permanent mirrors, in which our self-love does not always permit us to look with pleasure." Because of "the cadaverous-looking specimens, which were exhibited everywhere," concluded the French scientist N. P. Lerebours, "the very idea of a portrait by the daguerreotype, excited a repulsive feeling."[13]

To bend the powers of the camera toward a trade in portraits took exacting labor—at first to modify technique, then style. Daguerreotypists adopted freely from the repertoire of styles in painted miniatures and engraved or lithographed portraits widely circulated in the 1830s and 1840s by an expanding publishing industry—body posture, angle of the head, props such as personal items, and (more rarely) background.[14] Studios were also workshops of invention, similar to contemporary mills and factories, in which entrepreneur mechanics adopted traditional tools for new purposes to meet new market prospects.[15] Within months of Daguerre's announcement, an unending stream of inventions flowed through the patent office. A detailed history of early experimentation would show efforts to achieve distinct ends defined by the potential

market in portraits, changes in the process and apparatus to produce a daguerrean equivalent to the popular miniature portrait, a form tracing back to Elizabethan times. These changes included machine-driven buffers to better polish and sensitize the silver-coated copper plate which would bear the image, thus quickening exposure time and enhancing clarity; lenses designed specifically for portraits, in place of the slower telescope lens used by Daguerre; mirrors and filters to control natural lighting; and, virtually from the beginning, the application of color tinting to heighten the illusion of reality.[16]

By the early 1840s, a trade in camera-made portraits had emerged with typical American entrepreneurial audacity and inventiveness. In a brilliant example of a new technology absorbing an old craft-based form, replacing its methods while retaining its substance and styles, the daguerreotype entered into a one-sided rivalry with the painted miniature portrait. Adopting methods of applying tints of color—patents for such processes were issued as early as 1842—the daguerreotype rapidly replaced the miniature in popularity, and many painters abandoned the meticulous craft of fashioning miniature likenesses for the speedier, and more magical, process of daguerreotypy.[17] In outward appearance the typical daguerrean product proved identical to its predecessor—small embellished case, gold-plated overmat, protective glass over the portrait image inscribed now by light on polished silver rather than paint on ivory or porcelain. The new product did not so much sweep away the miniature as swallow it up, its sentimental uses as keepsake and charm, convenient for carrying on one's person or secreting away in a private drawer—as Hepzibah cherishes the precious miniature of her unfortunate brother Clifford, in Hawthorne's *House of the Seven Gables*. Daguerreotypists appropriated to themselves the aura of painstaking craft and domestic sentiment associated with the painter of miniature portraits.[18]

By the early 1850s, professional daguerreotypists were insisting publicly, through their newly founded journals and in advertisements, that amiable and pleasing images required the same craft and sensibility as painted miniatures, with the addition of mastery of chemistry and optics, the science of light. Their rhetoric reveals a sensitivity to the needs and desires of their customers as well as a commercial self-interest. Feeling pressed by competition from below, from the in-and-out "picture factories" which had sprung up in the larger cities, the established photographers tried to secure the "better" clientele by shaping the medium as an institution of urban middle-class life. Joining this economic self-interest to the cultural and political interests of their clientele, they appealed to the superior taste of superior people. The prominent New

York photographer Mathew Brady, for example, issued the following "Address to the Public" in 1853:

> Being unwilling to adandon any artistic ground to the producers of inferior work, I have no fear in appealing to an enlightened public as to their choice between pictures of the size, price and quality which will fairly remunerate men of talent, science, and application, and those which can be made by the meanest tyro. I wish to vindicate true art, and leave the community to decide whether it is best to encourage real excellence or its opposite; to preserve and perfect an art, or permit it to degenerate by inferiority or materials which must correspond with the meanness of the price.[19]

Brady's words respond also to the underlying challenge faced by rising professionals of the camera to prove themselves artists and not mere mechanics. What stood in the way of the prestige they desired was the attitude expressed by Henry James, Sr., in 1855 that the true artist "must infuse his personality to elevate the gift he possesses high above that of a mere mechanical power . . . elevating the cause of genuine art above that mere daguerreotype faculty of ever presenting one exact copy of nature."[20] Brady's flattery of his customers' discrimination in choosing the quality studios matched the flattering image he and his colleagues tried to achieve in their portraits.

The challenge of the intractable countenance, the face which would not relax or mellow or glow with "expression," formed the core of an emerging middle-class discourse on the daguerrean portrait, a discourse of instruction and advice to both operators and sitters: how to arrange the body, where to allow the light to fall, what background and furniture to provide, what to do with sitters' hands and legs and eyes, with linen and wool and lace.

> The posture of the person sitting for the portrait should be easy and unconstrained; the feet and hands neither projecting too much, nor drawn too far back; the eyes should be directed a little sideways above the camera, and fixed upon some object there, but never upon the apparatus, since this would tend to impart to the face a dolorous, dissatisfied look.[21]

The look was all-important, and what to do with the eyes, the key problem. To avoid the blankness of expression, or the pained scowl of a direct, frontal look into the camera, the Frenchman Lerebours advised photographers to have their sitters gaze "*vaguely* at a distant object." He also prescribed that sitters occupy themselves "with a serious or pleasing thought, according to the expression that may be desired."[22] Sitters were encouraged and cajoled to *will* themselves, as it were, into a desired expression—in short, a role and a mask which accord with one's self-image.

The term "expression" came to represent the chief goal of the portrait: a look of animation, intelligence, inner character. The true art of portrait making lay in the capture of an inner essence, an "expression" of "character." What is "necessary and requisite," explained Albert Southworth in 1870, is more than the perfection of technique, but something "of a far higher order in the scale of qualifications": "genius" for the art of observation, "acquaintance with mind in its connection with matter," "discipline of mind and vision." The true photographic artist will feel "another sense," something "unfelt and unknown to the uninitiated." "Conscious of something besides the mere physical, in every object in nature," the artist feels "the soul of the subject itself." While "the whole character of the sitter is to read at first sight," said Southworth, "defects are to be separated from natural and possible perfections . . . Nature is not all to be represented as it is, but as it ought to be, and might possibly have been."[23]

The profession developed a rationale which held that the true daguerrean artist looked through surfaces to depths, treated the exterior surface of persons as signs or expressions of inner truths, of interior reality. The argument developed directly in response to views held by painters and others that, however valuable daguerreotypes might be as "memorials," in the words of the painter Rembrandt Peale (son of Charles Willson Peale), they lacked the "skill, taste, mind, and judgment" evident in paintings—the representation of a sitter's inner life.[24] The challenge arose, however, from other sources as well. Can a person's inner life be recorded, no matter how artful and sensitive the photographer, in an image which represents no more than an instant of time? Can what you look like at any given instant tell what and how you are?

To fix a portrait image, the profession argued, should be equivalent to fixing character. As Karen Halttunen has shown, mainstream culture in the 1840s harbored an obsession with "character," how to achieve it, how to show it and preserve it, and most of all how to recognize it in others. Anxieties about "confidence men and painted women," she argues, revealed a state of mind increasingly alarmed by the "world of strangers" of American cities, its hidden dangers and temptations—and fearful that appearances may not reflect real motives and intentions.[25] Drawing on a rhetoric of sentiment, portrait photography developed a system of references to meet this "antebellum crisis of social confidence," and provided as important and widespread an agency for overcoming such anxieties as popular manuals on character, conduct, and success. What was needed was confidence that the eye could reliably discern inner character from outer appearance. Some writers on photography articulated a system based on the popular fads of phrenology and

physiognomy, which claimed to derive knowledge about inner traits from external evidence—in phrenology, from the configuration of the brain as traced by bumps on the skull. Photographers adopted the notion that the exterior of a person might reveal inner character, and conventionalized it in a sentimental repertoire of expressive poses. In fact, the conventional poses addressed social more than moral categories, identifying character with role. Lawyers, for example, should stand in such a way before the lens, orators and preachers in another, poets should be seated at their desk, and so on. The aim was to have each sitter look like a conventional image of his or her social role.

Just beneath the surface of the conventional system lay a fear of betraying too much by one's look—a fear obverse to the popular hope of the age, that "character" was indeed a deep inscription within the self which could be relied upon. Character, wrote one commentator, is "like stock in trade," a form of self-reproducing capital.[26] "*Expression* is a direct emanation of the face," explained a writer in the *Daguerreian Journal* and, in suggesting why some sitters are always displeased by results, slides into popular theories of moral character:

> Years spent in coquetry and caprice, in folly and frivolity, the entire abandonment to self-worship, and the entire neglect of mental culture, cannot pass without leaving an unlovely record on the face, and a background of embittered feeling, which no artistic power can render attractive. Stereotyped then, are the motives of the *past*.[27]

Here lay a rationale for Holgrave's frustrations with Judge Pyncheon's face—and Hawthorne's strategy of enlisting the daguerreotype in his novel's exposure of a hidden crime and ancestral sin.

"In this fact [the face's revelation of inner character] lies a valuable security for social order," wrote Marcus Aurelius Root in 1864,

> insuring, as it does, that men shall ultimately be known for what they are. In vain do the profligate, the base, the wicked, and the selfish mimic those outward indications which pertain naturally to the pure, the good, and the generous. The inward unworthiness, despite all effort, will glare through the fleshly mask.[28]

The confidence "that men shall ultimately be known for what they are," with its hint of a secular day of judgment, contained an anxiety on the same score, a fear deflected into another use of the camera for identification—in this case, of criminals and prisoners. As early as 1846, the year he began making portraits of "illustrious Americans," Mathew Brady photographed prisoners at Blackwells Island for illustrations in a book on how phrenology can be used to "reform" criminals.[29] A decade later *American Journal of Photography* described the "Rogues'

Gallery" maintained by the New York Police Department as another instrument, like the railroad and telegraph, in an emerging "science of thief-taking." "As soon as a rascal becomes dangerous to the public, he is taken to the Rogues' Gallery, and is compelled to leave his likeness there, and from that time he may be known to any one." Visibility assured security for citizens by raising fear in criminals, whose reward for pledging to reform is that "their likenesses are turned to the wall."[30] In 1870 Southworth described "photographing disputed or questioned handwriting," pictures of fraud he had introduced as viable court evidence in Massachusetts in the late 1850s. "Besides civil questions and suits, very important criminal cases often depend on questioned writings, anonymous letters, etc. The larger part of my time for some years past has been taken up in this business"—an interesting complement to his portraits which "read" the "whole character" of the sitter at a glance.[31] Anonymity is no disguise before the camera, and handwriting as material a betrayal of identity as facial expression.

The handbooks encouraged sitters to collaborate with photographers in the making of desirable portraits. A new kind of mutuality developed between sitter and portraitist based on the recognition, subversive though it was to the authority of the artist-operator, that power over the image lay finally in the will, the attention, the ability of the sitter to strike and hold a pose. "The artist stands aside and lets you paint yourself," Emerson noted in 1841, thus making the daguerreotype "the true Republican style of painting": "If you make an ill head, not he but yourself are responsible."[32] Collaboration extended to size of plate, design of case, shape of the overmat which cropped and accented the image in distinct ways, oval or square or octagonal or elliptical. The result was not merely an image but a palpable object, a hand-held *thing*, an encased miniature of a living presence in a fixed and formal space. The near-universality of the experience of sitting for one's daguerreotype circulated throughout America a new regard for visibility, for one's own image as a medium of self-presentation. The millions of surviving daguerreotypes, mostly unidentified by maker or sitter, show people learning a new way of seeing themselves in the eyes of others, seeing oneself as an image. A new form of social identity begins to emerge, to take shape and body, in these earliest photographs.

Becoming used to the new experience meant absorbing certain ideas and values related to the specific commercial forms of the trade in portraits. In the final stage of the daguerreotype in America, in the early 1850s, "daguerreotype factories" sprang up in cities across the country. Speed of delivery, cheapness, and standardization (of poses, formats, cases, and overmats) threatened to flood the urban markets,

lowering prices, and, in the eyes of aspiring professionals, demeaning the prestige of the business. Behind the burgeoning of the trade lay a manufacturing industry increasingly mechanized in its methods and complex in its business structures.[33] Edward Anthony, for example, who had abandoned his practice as a daguerreotypist in the later 1840s for the less competitive, more profitable trade in supplies, set up a multi-process factory in a vast building at the Harlem Rail Road Depot in New York City. A 1854 catalogue extensively described its divisions: an "apparatus manufactury" for cameras, stands, plate holders, etc., woodwork in one room, metal parts in another; a "case factory" subdivided into sections where the body itself, the leather cover, the inner cushions, the gilding, and the stamped brass mat were produced— the latter "by means of powerful presses, driven by steam."[34] The catalogue includes woodcuts of each process, as well as of some two hundred and twenty pieces of apparatus, almost three hundred varieties of cases in over six hundred kinds of finish and design, more than a hundred kinds of frames for larger half-plate or whole-plate images (from 4×5 to 8×10 and larger), roughly the same number of mattings— and about fifty different kinds of gold lockets, brooches, and rings.

The catalogue provides an index to a key feature of the widespread commercial portrait—its use in a system of conspicuous display, in Veblen's terms, to signify invidious class distinctions. Domestic and public uses represented another distinction crossing over lines of social class. Two distinct products evolved: "memorial" pictures of "our near and dear," in Root's words, and likenesses of "the great and the good," designed for exhibition and reproduction. The most common daguerreotype, the sixth-plate, or $2\frac{3}{4} \times 3\frac{1}{4}$, fit conveniently in the palm of the hand, intimate in scale, convenient to touch and hold (lockets and pins, also common, offer greater intimacy: attachment to the body). Portraits made for public display in galleries or as engravings in periodicals or books were usually larger, too large to be held conveniently, framed for exhibition rather than encased for private viewing and touching. Its subjects may be seated or standing, shown in three-quarter views or full-face, but typically they gaze away from the lens. The public figure presents himself—the figure is almost always male, except for famous performers such as Lola Montez, and the wives of eminent citizens—to be looked upon as a familiar object.

By the 1850s the profession of photography had refined a theory and claimed a mission consonant with other pedagogical institutions of "character" in respectable society. The acceptance of a moral purpose and mission helped define an institutional place for photography within the realm of art, broadly defined (it was understood to be a "practical"

2. Oliver Wendell Holmes. Daguerreotype by Southworth and Hawes Studio, Boston, *c.* 1850

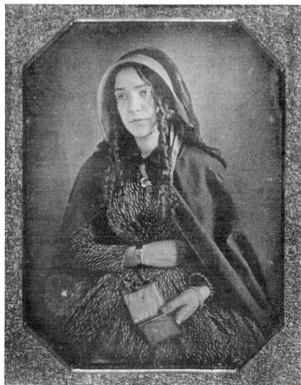

3. Memorial portrait: a woman in mourning, holding daguerreotype of a seated child. Artist unknown, 1840s

art, an art of utility). Root put most directly and vividly the moral terms of photography's social mission. He argued that "in this competitious and selfish world of ours," the photographic portrait has a distinct and significant role to play. Keeping close in view "these literal transcriptions of features and forms, once dear to us," provides a "benediction" by their strengthening of "the social feelings." Memorial images assured harmony at home. Public portraits inculcated the civic virtues required by the Republic:

> But not alone our near and dear are thus kept with us; the great and the good, the heroes, saints, and sages of all lands and all eras are, by these lifelike "presentments," brought within the constant purview of the young, the middle-aged, and the old. The pure, the high, the noble traits beaming from these faces and forms,—who shall measure the greatness of their effect on the impressionable minds of those who catch sight of them at every turn?[35]

Writing in 1864, Root articulates the terms on which the institution of photography had already made a place for itself within American life—and, in the process, acclimated the powers of the medium to conventional ideas of what a portrait is, looks like, and does.

The division Root describes between portraits which memorialize loved ones and those which celebrate public figures defines a significant feature of the social mission the medium had assumed for itself. Within the distinction there lies, however, a bond, a symbiotic relation, which helps better clarify the way the public portrait was supposed to perform its mission. For example, the hand-held daguerreotype was thought to exercise its appeal by a form of sympathetic magic—the likeness producing a sense that its original sitter was present. In popular fiction an erotic element often rose to the surface. Daguerreotypes cast a spell; heroes fall in love with likenesses, and presto, the original appears.[36] Daguerreotypes are magic amulets; in one popular novel, dedicated to "Professor Plumbe," an encased image saves the life of the hero, who then wins the heart of the young woman in the portrait.[37] Fictional daguerreotypes arouse longings for absent loved ones and in one sensational story become a kind of video screen on which the hero can watch his inamorata undress for bed, his heart beating wildly.[38]

But one does not fall in love with public portraits—the sort Holgrave attempts of Judge Pyncheon. Less intimate, the public portrait was understood to work its effects through a magnetic or hypnotic attraction. Its goal was to stimulate a desire to identify with the qualities represented by the sitter, to emulate, as Roman portrait busts inspired their viewers to do, an exemplary life. The public portrait was, of course, the more formulaic and standardized. Too large to be held comfortably in the

palm of the hand or secreted within pocket or bosom, it offered a more strictly visual and distant experience.

The differentiation between "memorial" and "emulatory" daguerreo-types contributed significantly to the increasing separation, in the antebellum era, of private from public, feminine from masculine, the widening distance of domestic scenes from the political spheres of action and belief. In the larger cities, daguerreotype galleries served as salons where people gathered as a "public" to gaze at pictures of "the great and the good," to see and to be seen. "Already the daguerreotypes of the most important public figures adorn the saloons of noted artists," remarked a writer in 1846. "You have only to enter and you find yourself in a miniature President's levee." In 1849 T. S. Arthur observed that daguerreotypists "are limning faces at a rate that promises soon to make every man's house a Daguerrean Gallery." With its Roman association with senatorial debate, "gallery" came to signify in the cities of antebellum America the political province of a new art—the place where the public daguerreotype might exert its magnetic powers on behalf of a beleaguered Republic.[39]

II

In the crafting of the mythos of the public portrait, which included a public image of the image maker, no American played a greater role than Mathew Brady.[40] Brady leaped into prominence the moment he took up the camera as a young man of twenty-two, in 1844, and posted himself as proprietor of the Daguerrean Miniature Gallery at Broadway and Fulton Street. It was the first of his New York galleries; by 1860 he would have moved his quarters several times, always to a more attractive and spacious location farther uptown. And in the 1850s he would open a branch gallery in Washington, seeking trade among congressmen, senators, Presidents and their cabinets, and famous visitors. In a newspaper interview with a reporter for the New York *World* in 1891, Brady declared that, "from the first, I regarded myself as under obligation to my country to preserve the faces of its historic men and mothers."[41] More than any other American, Brady shaped the role of the photographer as a national historian, one who keeps records of the famous and the eminent, as well as the run-of-the-mill citizen. He did not originate the idea of making a vast collection of such records—Edward Anthony and John Plumbe had preceded him—but Brady carried it forward with more boldness, energy, and success than anyone else.[42] While continuing a regular walk-in trade in his New York and Washington galleries, he devoted most of his time and energy in the

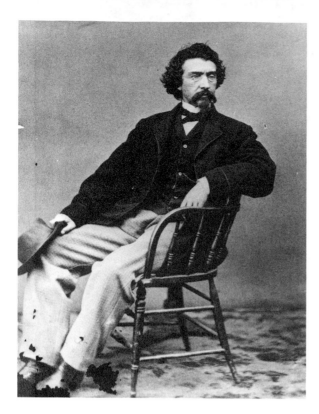

4. Mathew Brady shortly before the Civil War. From a glass negative made in Brady's Washington gallery, possibly by Alexander Gardner, 1861

decade before the Civil War to soliciting celebrated sitters. Like his predecessors among painters at royal courts, Brady sought and gained prestige, a reflected glory, from the eminence of his clients, adopting the practice of European aristocratic art to a new medium and a republican society. With the public portrait, Mathew Brady defined the first significant public role for American photographs.

Who was Mathew B. Brady? His past, before his arrival in New York in 1839, is vague in outline and thin in detail. He was born, he told the New York *World* in 1891, "near 1823–24," in upstate New York, "in the woods about Lake George," and he added laconically, "My father was an Irishman," as if that fact alone disposed of antecedents. The break with past, place, and family corresponds so neatly with the profile of popular American myth that we may easily overlook the actual social process it typifies: the unsettling change entailed in the transition from an agrarian to an urban society. "Among democratic nations," observed Alexis de Tocqueville in the 1830s, "new families are constantly springing up, others are constantly falling away, and all that remain change their condition; the woof of time in every instant broken and the track of generations effaced."[43] The few surviving details suggest that as a

country boy in the city of merchant princes Brady experienced firsthand the conditions which gave rise to a need for the kind of reassuring images his several galleries would provide: the abruptness of his appearance in New York in 1839 at age sixteen or seventeen, without skills or definite ambitions, taking lodging and meals in boardinghouses and hotels, working as a clerk in A. T. Stewart's department store, venturing into a small business of his own as a manufacturer of jewelry cases, until in 1844 he found his proper line of work.[44]

The picture of the untutored country boy does not, however, fit the known facts perfectly. An early friendship in upstate New York with the painter William Page made all the difference. While still a boy, Brady met and grew "extremely attached" (in his own words in 1891) to the painter, who was twelve years his senior. Brady recalled visiting Page's studio in Albany, picked up "many ideas of art" along with gifts of drawings as "tokens of esteem."[45] "He took an interest in me," Brady recalled in the 1891 interview, "and gave me a bundle of crayons to copy." The young Brady arrived in New York already educated in art, or acquainted with the craft of drawing, and perhaps with ambitions in that direction. Was Page's own move to New York to study with Samuel Morse the occasion for Brady's move? In any case, Brady remembered that Page introduced him to Morse, from whom he may have learned the daguerrean craft—though no firm evidence exists to show a continuing personal relation with either of the painters.[46]

From Page and Morse, Brady would have learned important lessons— for example, that art is a sacred calling, the highest expression of spiritual values. Page was devoted to the transcendental teachings of Washington Allston (who had been Morse's mentor), to Emerson and Swedenborg, and he may have taught his young pupil that the spiritual character of art lay in its fusion of the artist's insight with the natural object before him, an idea eagerly taken up by daguerreotypists such as Albert Southworth in their quest for a vocabulary suited to the status of artist. Another idea current among painters at the time was that art served an important moral function. By its lofty themes and harmonious compositions it refined the senses, cultivated sensibility, elevated the mind and the emotions—and thus served the spiritual life of the Republic. The public needed to be taught, however, to appreciate the noblest productions of art—not the "face painting," which both Page and Morse scorned as the lowest of artistic genres (yet the most profitable). Confined to a specific likeness, portraiture limited the moral and didactic range possible within the art of painting, as the eighteenth-century British painter and expositor of principles of art, Joshua Reynolds, had taught: "A history-painter paints man in general; a

portrait-painter, a particular man, and consequently a defective model."[47] Morse was particularly bitter about having to earn his living by painting faces: "I cannot be happy unless I am pursuing the intellectual branch of art. Portraits have none of it; landscape has some of it; but history has it wholly."[48] Historical narratives, biblical scenes, allegories: these genres stood at the peak of the hierarchy Reynolds had formulated. They offered opportunities for generalized moral lessons not available in the "literal record," as Page called it, of the portrait. About photography Page wrote that, while the camera may be useful as an aid to drawing, it is a "misapprehension of the object of art" to think that "reproduction of nature" by itself can achieve it. "Soul" can "never be made visible through a machine-rendered body, however perfect in its kind that may become."[49]

From his mentors, then, Brady would have learned that the new medium faced a critical problem of justification as an art. Complicating the problem was the unembarrassed use of the camera as a kind of sketching tool by painters such as Page. In the eyes of the easel painter, the very literalness which made the medium attractive for sketching purposes prevented it from rising to the level of serious art. How might photography find a respectable place for itself? Portraiture provided a solution. Low in the scale of value to begin with, based entirely on the desire for likeness: this indeed was an appropriate field for the photographer—"among the arts of taste and utility," as one writer put it. In a public letter addressed to Morse in 1855, Brady spoke of the "paramount importance" of seeing the daguerreotype primarily as "an auxiliary to the artist."[50]

Moreover, the historical intent Brady soon began to claim for his project, begun in 1845, of making and exhibiting portraits of distinguished citizens, drew its justifications from the very hierarchy of value that photography implicitly challenged. Likenesses of the famous as a record of history may seem a futile compromise with Morse's view that "just as the epic excelled all other forms of verse by addressing itself to the sublime side of our nature, so history painting stood pre-eminent because it calls forth similarly noble feelings." But by following in the traditional use of portraits to celebrate the powerful and the wealthy, Brady's practice, which was shared widely in the profession, accommodated the medium to the view proposed by Reynolds that if portraits be made, they ought to be made with an air of generalization and historical allusion so as to diminish the force of mere likeness.

"Brady of Broadway" came to stand for an aura of public distinction in portraits of the celebrated and the illustrious. It also stood for a system of production and ownership which emerged in the late 1840s

as typical of commercial photography in the big cities. A brand name, "Brady" did not necessarily signify that he himself performed the labor of making the portrait. In 1851, *Photographic Art-Journal* remarked that "Mr. Brady is not operating himself, a failing eyesight precluding the possibility of his using the camera with any certainty."[51] In an essay on Brady earlier that year, in the opening issue of a journal in which a portrait of Brady, identified as the "fountainhead" of the profession, appeared as the frontispiece, the journalist and art critic C. Edwards Lester had made a veiled reference to this commonly known fact by describing Brady's particular "genius": "While he offered inducements to the best operators and chemists to enter his studio, he supervised every process himself, and made himself master of every department of the art."[52] Odd as it may seem, an affliction presumably fatal for a photographer seems not to have troubled either the public or the profession. Even while noting that "as a mere lad he was attacked with a violent inflammation of the eyes, and came near losing his sight," the *American Phrenological Journal* in May 1858 said of Brady that his bumps revealed an "immense development of the perceptive group of organs." "You see everything that comes in sight, and remember forms remarkably well, also distances, outlines, and dimensions."[53] Seeing, the phrenologists imply with some measure of validity, might not be a function of the eyes alone but also of the body as a whole sensory entity.

Lester cleverly negotiates the difficulty of Brady's weak eyes by invoking, without irony, *light*, "the grand mystery into which the whole art of Daguerre resolves itself." Not the eye but light itself is the artist, and the medium only the means by which "the invisible hand of Nature herself might, with her own cunning pencil, by her silent and mysterious operations, trace the forms of creation in all their delicacy, witchery and power." The solution nicely allows the medium to remain what it unequivocally is, a means of automatic transcription, while allowing a role for "genius." While "the work is done by Nature itself," "everything depends upon the skill with which the elements are prepared to make way for the hand of Nature." Like supervision, preparation allows an artistic role even for the half blind, if he be "a man of sensitivity and genius." The clinching mark of Brady's genius appears in the "new and tremulous interest" he experiences "in every repeated result, when, after preparing his plate, he stepped aside to wait in silence for Nature to do her work." In that silence appears his "refined fancy," his "sensitive spirit," his "veneration and hope, to see how the eternal laws of nature" manifest themselves in a picture he can then sign, display, and sell as his own.[54]

Brady may best mirror his times in that he himself appeared as an

image, a created role, a representation of such a figure of the master portrait photographer as he and his audience conspired to believe. He sported a Vandyke beard and arranged to be the most often photographed photographer of his day. The epithet "Brady of Broadway" was part of the picture, as much a product of his gallery-studio as actual portraits stamped with his mark. The Brady self-image fused picture making with entrepreneurship, exhibition with showmanship: a distinctly antebellum amalgam through which appeared the contours of a new public life of images.

"Mr. Brady," the *American Phrenological Journal* informed its readers in 1858, "like all men who have impressed themselves with a powerful originality upon an age prolific in such characters, is a self-made man, and owes his present exalted position and remarkable artistic and business success mainly to his own unaided efforts and devotion to a high conviction and purpose." The chart of his head had already made this conclusion foregone: "The development of your brain indicates a great amount of force of character." Adding luster to Brady's phenomenal fame in the 1850s was the well-publicized fact that he embodied in his person the American success story his portraits celebrated. In 1851 he brought home the top medal for portraits from the Crystal Palace Exhibition in London, and continued to win prestigious awards.

Brady cast himself in the role of producer and impresario, stage manager of a new kind of theater. With entrepreneurial insight he grasped the mutuality of need and opportunity that lay as a potential source of fortune in photography. The product that bore Brady's name was more than a picture; it was a system of intelligibility. By making his own name a symbol of social power, success, celebrity—and devotion to the nation—he created a structure of meaning for the act of sitting before his portrait lens. "Brady of Broadway" signified both a place and a process, a place which took its character from the process of transformation it embodied and the values of success Brady himself typified. Embracing a diversity of figures, male and female, ardent abolitionists, patrician Whigs, self-made millionaires, scholars, generals and priests, merchants and authors, the place signified a miniature world, a symbolic America. Of course, exclusions are notable: factory workers such as those in the employ of Anthony and Company; farmers, including those in chattel slavery in the South; servants; rowdies and others beyond the pale of respectability. The Brady place corresponded to an idea of American society shared by the established and the rising classes. And the work of the place, the making of portraits, was to embody that idea in visual form, to launch images into the world as tokens of an ideology so secure as to seem natural: the ideology of American success.

During the 1850s Brady moved his gallery several times, each successive place a more lavish expression of success. The direction was implicit in the place he opened in 1844, the Daguerrean Miniature Gallery at Broadway and Fulton Street. On the top floor, under skylights especially installed (he was one of the first in New York to make use of this source of lighting), the studio was outfitted with the tools of the trade: cameras, headrests and clamps, curtains, mirrors and screens, and the paraphernalia of retouching and tinting. The public was directed up the stairs by a painted hand pointing the way. Glass cases with samples of recent work stood on either side of the street-level entrance near one of the most crowded and frenzied corners in the shopping and small-manufacturing center of the city—"hidden there in a chaos of hair-dressers, glove-dealers, and miscellaneous men of bazaars," a writer in *The New York Times* reminisced in 1860.[55] The gallery adjoined two other institutions of distraction and entertainment: Barnum's American Museum, and the elegant Astor House, where Brady often lived (before his marriage in 1852, he seems to have moved regularly among hotels and boardinghouses).

Brady's first gallery was renowned as a meeting place where people of all classes and grades of cultivation mingled freely. "People used to stroll in there in those days," recalled a writer in *Harper's* many years later, "to see what new celebrity had been added to the little collection, and the last new portrait at Brady's was a standing topic of conversation."[56] Predominantly a place of work, of craft, of the undisguised making of something, his first gallery soon became a gathering point and meeting place, similar to Barnum's Museum and the Astor House. All were places to stroll, to allow people a change of pace from the crush of the street—places to see and be seen. And in some measure each was a place of both putting on and encountering appearances, a place of illusion and recognition, a place where the very making of illusion could be witnessed.[57]

In 1853 Brady moved to another Broadway location farther uptown. It represented a rise in the world, and a new phase in the evolution of the gallery. In two or three years the wet-plate process would expand the possibilities of characterization through portraiture. Subjects might stand with relative ease, strike a variety of poses, present a less constrained demeanor to the camera. From the custom-making of life-size photographs finished to resemble canvases, to the mass production of the small hand-held card, the carte de visite (the form in which Brady distributed perhaps his most famous portrait, the Cooper Union picture of Lincoln during the campaign of 1860), the new process also introduced a greater degree of rationalized division of labor. Distinct spatial

divisions now separated the realms of craft, of commerce, and of exhibition. The new gallery was divided into reception room and gallery, business office (including an area in which frames, cases, and other paraphernalia were displayed), a "ladies' parlor," and "operating rooms," where the actual sitting and, in a discreet corner, the developing took place. Plate cleaning, electroplating, and storage of chemicals were confined to rooms on upper stories.

The most dramatic development was the metamorphosis of the original "front" into a "reception room." This was the gallery proper, the chamber which transported the public from the street into the world of the photograph. Newspaper reports of Brady's grand opening in 1853 depict a parvenu elegance: "specimens" framed in rosewood and displayed in gilt showcases at the door; reception rooms two flights up, entered through "folding doors, glazed with the choicest figured cut glass, and artistically arranged. The floors are carpeted with superior velvet tapestry, highly colored and of a large and appropriate pattern. The walls are covered with satin and gold paper. The ceiling is frescoed, and in the centre is suspended a six-light gilt and enameled chandelier, with prismatic drops that throw their enlivening colors in an abundant profusion. The light through the windows is softened by passing the meshes of the most costly needle-worked lace curtain, or intercepted, if occasion requires, by shades commensurate with the gayest of palaces, while the golden cornices, and festooned damask indicate that art dictated their arrangement." The gallery had become a feminized parlor, a simulacrum of domestic space. Rosewood tête-à-têtes, easy chairs, marble-top tables, all "multiplied by mirrors from ceiling to floor." And, recalling Peale's Museum, on the walls, "Daguerreotypes of Presidents, Generals, Kings, Queens, Noblemen and *more nobler men*—Men and Women from all nations and professions."[58] Not a museum of natural history, however, but a theater of desire, the gallery had become a new kind of city place devoted to performance: the making of oneself over into a social image.

The reception room was initiatory; it received the sitter and provided a mood for transformation. Handbook and journal advice for aspiring proprietors of portrait galleries gave the "reception room" the special role of inducing the sitter to relax, unwind, and prepare a self-image. Brady's new quarters followed the rules exactly. "Our mortal coil incloses and shields something of infinitely greater worth and beauty than itself," explained E. K. Hough in the *American Journal of Photography* in 1858. "Is a view of the immortal part beyond the reach of photography? Surely the soul shows its features in the face." But how can this sentimental goal be achieved? "Outward expression is the revelation of

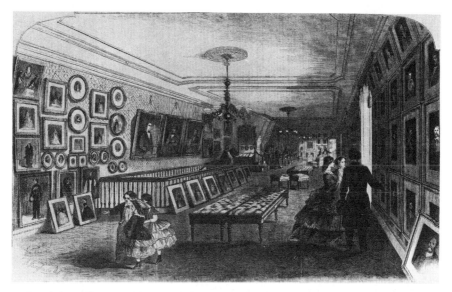

5. Brady's gallery at Tenth Street and Broadway, New York. *Frank Leslie's Illustrated Newspaper*, January 5, 1861

inward feeling," he explains, "and moods of mind and sentiment are very much under the influence of what affects the senses."[59] The means, then, are sensuous and material, a manipulation and control of light, of atmosphere, of setting: the remaking of the site of the photographic work into the illusion it is the work of the camera to reproduce. In 1864 Root advised that all signs of the workshop be removed from sight, chemical effluvia suppressed or counteracted by the aroma of flowers and the perfumes of fragrant waters. The eye should be soothed with soft and pleasing colors, the ear charmed with the melody of singing birds, and the mind diverted by paintings, engravings, and statuettes. The reception chamber should resemble a "temple of beauty and grandeur . . . so that those entering therein may inhale a spirit which shall illumine their faces with the expression which the true artist would desire to perpetuate."[60]

When in 1861 Brady moved into even more sumptuous quarters at Tenth and Broadway, near A. T. Stewart's palatial new department store and Grace Church, *Frank Leslie's Illustrated Newspaper* voiced a common perception: "We have watched his gradual upward flight from place to place, and each change has been for the better until improvement has culminated in his present unrivalled location." The journal described the "countless exquisite pictures which fill every available inch of the walls" as "a portrait-history of the times."[61] Figures from "every

department of public" appeared there: bankers, millionaires, clergymen, scholars, lawyers, doctors, orators, statesmen. The *Times* compared him to Balzac, "for all the types of New York and America have given each other a *rendezvous* in this *Ruhm-Halle*, or Hall of Renown." "Hostile editors here stand side by side, on their best behavior," "the smiling queenliness of all manner of lovely or celebrated women . . . kept all in order and refined." "If the men themselves whose physiognomies are here displayed," the *Times* continued, "would but meet together for half an hour in as calm a frame of mind as their pictures wear, how vastly all the world's disputes would be simplified; how many tears and troubles might mankind still be spared!"

In 1861, on the eve of the Civil War, Brady stood at the pinnacle of contemporary fame. *The New York Times* referred to him as "the prince of photographers on our side of the water." And in 1863, during the war which Brady had rushed to cover, as if fulfilling the urge to add scenes of history to his collection of historical faces, *Harper's Weekly* raised him to the height reserved for the most sacred of republican figures: "When the history of American photography comes to be written, Brady, more than any other man, will be entitled to rank as its Father."[62] His galleries belonged with Barnum's American Museum as places not to be missed. Said *Harper's*: "Nowhere else can so extensive and in one sense so valuable a collection of art treasures be witnessed. For the past twenty years there has hardly been a celebrity in this country who has not been photographed here." For at least a decade, until the guns of war in 1861 shifted the pursuit of profit from the battlefields of Broadway to those of Bull Run, Antietam, and Gettysburg, a portrait marked "Brady of Broadway" was recognized as one of the choicest popular-art commodities of the age. His signature carried instant recognition and prestige. Indeed, explained *Harper's*, Brady provided nine-tenths of the portraits it published as engravings: "materials for history of the highest value."

Brady's successive galleries are an index of his own rise to fame and wealth. Barely forty years old in 1861, he himself stood among the celebrated and illustrious of the day, a man of fame and more than middling wealth—with mining stocks and real estate to his name. In the course of the Civil War and the decades which followed, he would lose his fortune and be beset by creditors. Forced to declare backruptcy, he would sell much of his collection at auction to pay storage fees. That is another story. But for the moment Brady the proprietor of the best-known gallery in America seemed the epitome of the photographic profession. His galleries offered an important symbolic space in lower Manhattan—a place of poise and stillness, a surrogate home, within a

swirling world of boardinghouses, shops, hotels, theaters, museums of curiosities. A "palace of light," Brady's gallery and his "silent yet eloquent camera" drew on images and values of sentimental culture to make it seem possible that the nation would hold together against unpromising odds. The gallery offered an illusion of the unity increasingly challenged by the restless, dangerous streets of New York and the acrimony and bitterness of the corridors of state. By 1861 his collection of the "noteworthy" had grown to about ten thousand images. Said *Frank Leslie's Illustrated Newspaper* about his display of such images: "The dead are brought back to life here so faithfully and so perfectly that those who knew them in the flesh can scarcely fail to recognize the impress of their shadows on the magic glass." In that glass the Republic could view itself in the mirror of time: "From the rude forefathers of the country, to the men who built up the superstructure of the republic on the foundations which they laid, and down to the men of the present day, when our power is spreading abroad with electric speed."

An enshrinement of national icons analogous to that of Roman household gods, the gallery performed a quasi-religious function in a republican culture which had overthrown a system of deference based on social station and birth. Here calculation and competition might cease momentarily. Here hung ghostly images more real and nurturing than the shadows flitting on the streets and in the marketplace, for they held out the hope of at least one certainty: an unmistakable historical self, a point of reference among phantoms. Brady's gallery offered an alternative to that solitary confinement within one's own heart that Tocqueville perceived as a threat to the Republic: "Not only does democracy make every man forget his ancestors, but it hides his descendents and separates his contemporaries from him; it throws him back forever upon himself alone and threatens in the end to confine him entirely within the solitude of his heart." Tocqueville describes an affect upon the ties between self and community (and family) characteristic not just of abstract "equality" but of acquisitive capitalism, a society of market exchanges, fluid boundaries, and boundless aspiration. He describes Brady himself, who imprinted upon his place his own social ambition which breaks with fathers and then mourns to recover what it has lost. As Caleb Lyon of Lyonville put it in "Stanzas, Suggested by a Visit to Brady's Portrait Gallery":

> Like a spirit land of shadows
> They in silence on me gaze,
> And I feel my heart is beating
> With the pulse of other days.[63]

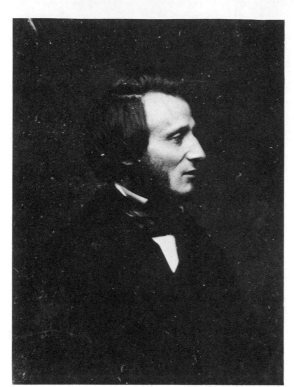

6. Cyrus Field, promoter of the first transatlantic cable (1858). Daguerreotype made by the Brady studio, New York, 1850–55

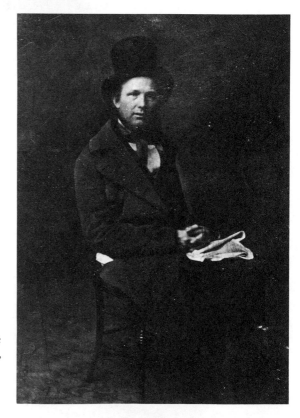

7. Horace Greeley, editor and publisher. Daguerreotype made by the Brady studio, New York, c. 1850

III

In 1850, Mathew Brady published *The Gallery of Illustrious Americans*—twelve daguerreotype portraits of "representative" Americans, rendered as lithographs by Francis D'Avignon.[64] C. Edwards Lester provided a "Salutation" and biographies to accompany each portrait. The idea derived from popular encyclopedias of biographies illustrated with engraved reproductions of paintings.[65] The twelve engravings Brady published in 1850 portrayed several categories of eminence: Presidents (Zachary Taylor, Millard Fillmore), senators (John Calhoun, Daniel Webster, Silas Wright, Henry Clay), generals (John C. Frémont, Winfield Scott, Lewis Cass), an artist (Audubon), a historian (Prescott), a minister and poet (William Ellery Channing—whose image is based on a daguerreotype of a painted portrait). Issued monthly to subscribers, with binding into a permanent volume optional at the end of the year, each individual print met with immediate praise in press notices fulsomely reprinted in a "Fly-Leaf" edited by Lester which accompanied each engraving. Praise fell as much upon the lithographer as on the daguerreotypist, with good reason: the lithographs are the most faithful representations of daguerrean images yet produced in America.[66]

"Daguerreotypes by Brady—engraved by D'Avignon" on the title page raises a genuine question of authorship—a question which points up the character of the work as a mixed mode. Just as the public gallery space is reconstructed in a bound volume that can be experienced in private, so the unique daguerreotype is transformed into an image reproducible by mechanical (lithographic) means. By taking a step backward, as it were, to the older form of lithography, the publication looks ahead to the future capability of unlimited images from the same negative, and further, to the halftone process of mechanical reproduction which appeared in the late 1880s.[67] The dual authorship reflects the historical cusp in which the book lies, between (in Walter Benjamin's terms) the "cult" and "exhibition" value of the unique work of art and the "political" value of mechanically reproduced and mass-distributed images.[68] The fact that it consists of printed images reinforces the overtly political message of the volume. *The Gallery of Illustrious Americans* represents the first ambitious photographic project to take America itself as subject and theme. Alluding to national events in 1850, the work claims a civic function for American photographs by inserting images into a political scene in a manner similar to that of earlier engraved portraits of leading citizens. Image and word together constitute a single text, a political text reflecting a patrician concern about values and symbols at the basis of nationhood.

Upon opening *The Gallery of Illustrious Americans*, one is struck at once by its air of solemnity: the look of men touched by destiny. In each face we see male public figures in moments of abstraction from pressing affairs, perhaps deep in thought or caught in reverie—in any case, unaware of being seen. Indifferent to spectators (an effect achieved by looking anywhere but into the lens) is the way in which men of eminence should be seen—apprehended, as it were, in a moment of pretended timelessness. Not only would an intimate gaze into the eyes of a viewer be unseemly, but the distant look, the guise of introspection or reflection, allows the characteristic lines of the face and the weight of the body to display themselves without distraction. Unawareness is precisely the mode befitting the illustrious performing as American icons.

Such fictions have a long history, reaching back to Roman busts and neoclassical portrait paintings—a formal look preserved and popularized by lithography. The attempt of photographers to mimic the traditional style of eminence and dignity was often mocked, however, by creased flesh and wrinkled clothes the camera cannot but record—let alone warts, baggy eyes, and freckles. In the daguerreotype, faces float toward us from the recesses of the mirrored surface as traces of a moment, the passage of light over a breathing surface of recessed planes. Lithographed, especially in the elegant style for which D'Avignon was famous, the daguerrean image is drained of its vitality in the processed picture, product of the engraver's interpretation. The lithographs abstract lineaments, produce a general likeness in place of the original vibrancy and presence; they point to the living figure as if it consisted of how it looks in the medium of ink, not how the person was during the few seconds of exposure—a transitory appearance retained in the medium of silver. By effacing the daguerrean mirror effect, the engraving makes the look be the man—exactly what the formal public photograph intended but, as Holgrave rued, could not always achieve.

We are struck also, on first opening the *Gallery*, by an unexpected homogeneity: each image an oval medallion centered on the page, each face turned at a three-quarters angle and centered in the opening, each figure gazing toward the distance (the poet-orator Channing the sole exception), and most clad in plain republican garb of dark coat, waistcoat, stiff white shirtfront, collar and scarf, and no hands showing, except Calhoun's securing the front of his cape (General Scott's uniform, Audubon's open collar, and Prescott's flowing cravat are other sartorial exceptions). Light falls from above, the effect created by Brady's northern-exposure skylights, on brows and cheekbones, catchlights skillfully rendered by D'Avignon on noses and chins and in eyes. Backgrounds are plain, except for a distant landscape added by the

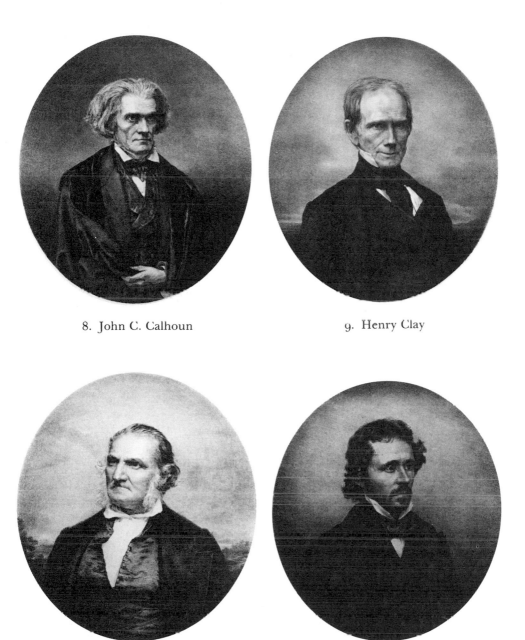

8. John C. Calhoun

9. Henry Clay

10. John J. Audubon

11. John C. Frémont

Lithographs by Francis D'Avignon from daguerreotypes made by the Brady studio. The Gallery
of Illustrious Americans

engraver to locate Audubon in an appropriate natural setting, and the faint hint of a horizon and rolling hills behind Clay. Notwithstanding these exceptions, we can say that the images have no spatial specificity; they are etched flat against the picture plane and float toward us as if from an ethereal realm without measurable depth or demarcations. The uniform appearance derives partly from the medallion design imposed upon the normal rectangular shape of the daguerreotype, an effect which evokes the busts of ancient Rome and suggests an interchangeability of parts, a form accessible to all citizens. Like Roman statues, the *Gallery*'s faces project a public space, a space for viewing men in the guise of republican virtue: *gravitas, dignitas, fides*.

The style accords well with the neoclassical air of the *Gallery*, with Lester's rhetoric, and with the didactic purpose of the ensemble. We can better understand the homogeneous style and its didacticism in light of Tocqueville's remark that in a democracy, where uniforms and other signs of rank and class count for little, people recognize "no [overt] signs of incontestable greatness and superiority." Without signs such as uniforms or elaborate dress, authority loses one of its securities. "It is not only confidence in this or that man which is destroyed," Tocqueville concludes, "but the disposition to trust the authority of any man whatsoever. Everyone shuts himself up tightly within himself and insists on judging the world from there." What is left but the face, the countenance in portrait?

The American adaptation of the classical inheritance—in architecture, dress, manners—provided the diction, the allusions, the tone and air of Lester's prose and D'Avignon's version of Brady's pictures: a ready language of word and image. The challenge is to present exemplary living figures in light of the past, in an imagined relation to the Founding Fathers and the ultimate Father himself, Washington. Thus Lester in his "Salutation":

> The first half of the century has now drifted by, and the dim form of its successor is hastening on, bringing we know not what mysterious changes. We contemplate the past with gratitude and exultation, because it is secure. And we wish before those great men who have made it illustrious are gone, to catch their departing forms, that through this monument of their genius and patriotism, they may become familiar to those who they will never see.

The diction adopts a popular American rhetoric associated with reproduced portraits. In 1835, for example, upstate New Yorker William Stoddard commented in *The Rural Repository*: "Need I say more for the art that permits posterity to stand in the presence of Washington [he refers to Gilbert Stuart's well-known portrait] . . . and in this vast

household of liberty, makes the remotest descendents familiar with the forms and faces of those who laid down all for their country, that it might be dear to their children."[69]

In Lester's prose, "familiar" evokes not only the intimate viewing of the hand-held daguerreotype, not only its typical vividness of presence, but additional sentimental associations with the domestic sphere and its pictures of absent relatives and friends. The didactic rhetoric and pedagogical frame transpose the twelve illustrious Americans into a figurative domestic circle in which all are familiar and thereby familial. Lester's next paragraph makes clear how, through the figure of the Father, the image of family supports the explicit terms Union, Republic, America.

> In this Gallery, therefore, will be grouped together those American citizens, who from the Tribune and in the Field, in Letters and the Arts, have rendered the most signal service to the Nation, since the death of the Father of the Republic. As there is nothing sectional in the scope of this work, it will be comprehensive in its spirit; and it is hoped that it may mark an era in the progress of American Art, and bind the Union still more firmly together. Neither Art nor Literature can afford to give up to party what belongs to mankind. In our judgments of public men we shall endeavor to anticipate the awards of posterity. In America, more than in any other country, death is needed to sanctify the memory of the great.

Figure not only of ultimate virtue, stability, and domesticity but symbol of the state, Washington provides a father figure and a model of character at a particular moment of need: the threat here specified as threat of division, sectional and partisan. "Union Now and Forever," echoing Webster's celebrated Reply to Hayne, inscribed in gold leaf on the vellum cover of *The Gallery of Illustrious Americans*, prepares the reader for the ritual of emulating—what William R. Taylor calls "the worship of exemplary heroes"—awaiting in the book.[70]

Does it make a difference that these engraved images are of photographs rather than paintings (except in the case of Channing)? In its allusion to "departing forms," "the awards of posterity," and in the curious remark that in America "death is needed to sanctify the memory of the great," the Salutation subliminally evokes the daguerreotype. Clearly, the twelve were very much alive when their photographs were made. Yet Lester implies that we see them as if already dead, already translated into monuments for posterity. His rhetoric requires at least a figurative death, a dying into a fixed image, as precondition for illustriousness; his subjects must die in order to live forever.[71] And while the figure of the hero immortalized in the memory of his deeds stored within a tangible image, in stone or ink, belongs to the conven-

tional lexicon of patriotic speech, the rhetorical trope of heroes at once alive and dead becomes literal, in photography. For the image registers not simply a likeness to be remembered (a pen or brush might have accomplished as much) but the irrefutability of a life before a lens. While a painting represents an artist's perception, bias, and skill, the daguerreotype reproduces what appeared before a lens at a particular moment and never again—its appearance is simultaneous with its disappearance, its death. Because each photograph contains, in Roland Barthes's words, an "imperious sign" of future death, portrait images seem to make real the paradox that the illustrious are both alive and dead, living now and living forever.[72] The melancholy frequently noted in daguerreotypes may arise from an unconscious recognition that in its very fixity and stillness the photographed body expresses the sitter's mortality—and reminds us of our own.

Like D'Avignon's lithographs, Lester's prose diffuses the daguerrean effect, transforming whatever is ambiguous and indecisive into conventional heroic rhetoric. Bearing the burden of explicitness, the biographies, several paragraphs in length, direct our eyes to what is exemplary and worthy of emulation in the image; pendants of the biographies, the images assume an unwavering meaning. The press praised Lester's biographies for their "fervor, truth and national feeling," while consistently describing them as "impartial" and "chaste"—terms for nonpartisan, nonsectional, and noncontroversial. In Congress, from January to September of 1850, a fateful debate raged that would result in the makeshift "Compromise of 1850," the spirit of which Brady and Lester implicitly endorse. In the midst of bitter controversies and heated debate over sectional and partisan issues, the *Gallery* prominently makes a national gesture by embracing Democrats and Whigs, North, South, and West, farmer, planter, and entrepreneurial classes.

It was presumably in the early months of 1849, when Southern threats of secession raised fears of paralysis in the central government, that Lester and Brady laid plans for the *Gallery* and chose the Whig President, the Virginian Zachary Taylor, for the first portrait, followed, in order, by the South Carolinian Democrat and spokesman for states' rights, John Calhoun; the most prominent conservative Whig spokesman for Northern capitalism, Daniel Webster of New Hampshire; former Governor of New York and staunch Jacksonian Democrat, Silas Wright; and the venerable Whig and anti-secessionist upon whom Northern moderates of both parties rested hopes for a compromise, Henry Clay.[73] Only in the biography of Clay does Lester make a direct reference to the crisis: "Now, while discord is threatening the Union, he seems to have been preserved by Providence to add to his long life of public

services, the crowning glory of being the savior of his Country"—and to remind Taylor of his pledge to be "President of the Nation and not of a party." Slavery, states' rights, territorial expansion, tariffs, and free soil are never mentioned. The *Gallery* does, however, address these unspoken issues by pretending they do not exist as *issues*, only as "discord," as "drift" toward danger. "Union" is raised as an ultimate value and Washington as its avatar; and *amor patriae* and filial piety become the vehicle for a nonpartisan view of America, a view that rests its case on the power of "lives," of "character." Of course, by not taking a stand, the *Gallery* implies the very stand of Clay and Webster: compromise on a middle ground. Lester eschews all discussion of specific matters, making the negotiated resolution seem a natural emanation from the spirit of the Father incarnated in his "leading" sons: the "*second* fathers."

Familiar symbols chart the course of Lester's biographies and cast their spell upon the images. Combining panegyric with chronicle, the words and images comprise a single composite biography of an ideal citizen. While each text furnishes the traditional encomium, the portrayal of "character," details of a life, and generalizations drawn from it, distinct ideological themes and motifs dominate each biography. The twelve texts form a seamless discourse on American virtue in Roman guise: Virginia as "the mother of the Gracchi of the Republic"; the rural schoolhouse as "the Portico of the people"; Webster's mind as "Doric substantiality." On Silas Wright's death: "How great a citizen has Rome lost"; as for Calhoun: "In dragging to the dust the pillars of the Roman Republic, Caesar heard the shout of the mob at his heels. Cato walked solitary through the Forum, and Brutus fell on his own sword. But the fame of Calhoun has interwoven itself with the history of the Nation, and is therefore immortal."

The underlying theme is of triumph over circumstance, hardship overcome: Webster's humble birth in the "wilds of New Hampshire"; the "hard labor" of Silas Wright's father; Frémont's travails in the mountain wilderness of the West; Prescott's blindness and his pain. And Audubon: "He has seen the knife of the Savage whetted for him: stepped on venomous serpents: started the Cougar from his secret lair . . . and he has laid himself down famishing, to wait, like Elijah, till he was fed by the birds of heaven." Old Testament allusions, recalling the New England heritage, helped define a unifying center, a middle ground of North and South, Yankee and Cavalier. Virginia "has moulded the South, as New England has moulded the North and West—whilst the mingling of the descendents of the Cavaliers and the Pilgrims has shaped the character of the men who are now laying the foundations

of great empires on the Pacific." North and South share two experiences fundamental to the nation: fighting Indians and adoring Washington. The former is a matter of destiny: the extirpation of "savagery" in the path of "civilization." The latter points to the political lesson for 1850: Washington transcending his Virginian origins to represent the nation. Thus Lester praises Daniel Webster's "portrayal of the character of that great Deliverer" in a eulogy delivered on February 22, 1832, "which completed the century of Washington."

The spoken lesson derived its power, of course, from what was left unspoken, the underlying cause of the sectional conflict and the national crisis: slavery. The word "slavery" does not appear but makes itself felt by indirection. "And yet he is the gentlest of Husbands," Lester writes of Calhoun, "the tenderest of fathers, the most humane and indulgent of masters." Sympathetic to abolitionism and author of an anti-slavery book, Lester on this occasion restrained his moral judgments—presumably on behalf of the illusion of unity he and Brady wished to convey: a unity founded on values represented by white male leaders and achievers. Black Americans held in slavery, for whom Calhoun represented "master," remain voiceless, unseen, unillustrated. Just as their invisibility haunted the rhetoric of a "virtuous" republic, so the aura of virtue in *The Gallery of Illustrious Americans* veiled the fear at the heart of the book—fear of disunion descending into fratricide.

IV

It is clear that the very anxieties underlying the sentimental culture of antebellum America shaped the evolution of the daguerreotype portrait in both its memorial and its public or emulatory modes. Brady's book addresses and sublimates fear of political disunion, itself a sublimation of even deeper or at least corollary fears, of unbridled individualism and its effects upon home and family, the core values seen as upholding Union. Hawthorne's *House of the Seven Gables*, almost exactly contemporary with Brady's *Gallery*—the novel was written late in 1850—identifies the arch-threat to national happiness in Judge Pyncheon's overweening ambition, in his smiling deceit barely disguising his underlying violence and criminality. Like Brady, Holgrave practices civic portraiture, only his examples are negative. They reveal Judge Pyncheon's hypocrisy, and in the case of the portrait made just after the judge chokes to death on his own blood, prove beyond cavil (the photograph as legal evidence) that an ancient family disease, allegorical sign of an inherited fatal greed for property and power, was the *natural* cause of death. Brady follows the Whig program of linking virtue with

eminence, family, and the heroic past; the Democrat Hawthorne has Holgrave divest the judge of his public face, and replaces his image with that of the humble Uncle Venner, whose daguerreotype hangs at the threshold of Holgrave's gallery as an example of democratic (if not republican) illustriousness. Hawthorne has fewer illusions than Brady and Lester of the equivalence of fame and virtue.

The fusion of art with science in Holgrave's final evidentiary portrait of the dead judge indicates another facet of the camera's imputed power as a safeguard of public safety and security—by cold, systematic classification of character flaws, the obverse of emulation. Another project in the same year of crisis, 1850, also employed the daguerrean lens in search of irrefutable scientific truth, with results profoundly disturbing to the dream of a unified nation projected by Brady.

In March 1850, Louis Agassiz, celebrated Harvard natural scientist and widely admired Cambridge intellectual, arranged through the good offices of Dr. Robert W. Gibbes for a local daguerreotypist in Columbia, South Carolina, J. T. Zealy, to take a series of pictures of African-born slaves at nearby plantations. Zealy made the pictures in his studio, turned them over to Gibbes, who shipped them to Agassiz at Harvard, where in 1976, at the Peabody Museum of Archaeology and Ethnology, they were found in a storage cabinet. They are among the most extraordinary daguerreotype portraits made in America.

The Zealy pictures present what Brady in the same year chose not to see and show: the faces and bodies of black slaves.[74] Agassiz had visited several plantations in 1850 while in South Carolina to address a meeting of scientists in Charleston on the topic of the "separate creation" of the human races. That notion, which denied the unity of mankind, seemed to provide a scientific or natural basis for racial inequality and slavery. After the meeting, at which the Harvard scientist thrilled his Southern audience by endorsing the doctrine that mankind had no common origin, Agassiz expressed interest in examining African-born slaves. Like Peale before him, he sought "natural" specimens, only to very different ends. He wanted firsthand evidence of anatomical uniqueness, and also to see if these distinct traits would survive in American-born offspring. "Agassiz was delighted," wrote Gibbes, "with his examinations of Ebo, Foulah, Gullah, Guinea, Coromantee, Mandingo, and Congo Negroes," satisfying himself that "they have differences from other races."[75] He asked Gibbes to arrange for photographs, and took his leave. Zealy's pictures would supplement his anthropometric evidence with visible proof of "natural" difference in size of limbs and configuration of muscles, establishing once and for all that blacks and whites did not derive "from a common center."[76]

The Zealy daguerreotypes reflect the unusual circumstances of Agassiz's request. They show a conventional studio setup with a patterned carpet and the headrest stand usually hidden behind the sitter's back. The daguerreotypes themselves feature the gold-plated overmat and wooden case typical of the commercial artifact. However, the persons portrayed here are standing naked: not "representative" in Brady's sense of an imagined and desired America, but examples or specimens of a "type"—a type, moreover, of complete otherness. It is difficult to view these images now without a sense of outrage at the indecency of the poses and the system of bondage they reflect—the absolute power of masters over the bodies of their slaves. The response is heightened by the extraordinary fact of male nudity, of genitals presented directly to the daguerrean eye in what must have been a genteel Columbia, S.C., daguerrean gallery or "parlor," of women asked to disrobe not for prurient purposes but for "science." The inevitably prurient effect makes a further comment on the master-slave relation—had they been made available to Agassiz's Harvard colleagues (of course, we do not know for certain that they were not), these images may well have cast more fuel upon abolitionist passions.

Yet they are compelling daguerreotypes in which something important, even fundamental, in the daguerrean experience comes through over and above the outrage. In spite of the coerciveness they represent— or perhaps, in an ironic reversal of intention, because of it—they possess a power of communication that reveals more than most conventional portraits. They show the medium's capacity for a visual report at once new yet remarkably ancient. They can be likened to the art which Sheldon Nodelman argues first emerged in portrait statues of late antiquity. In "How to Read a Roman Portrait," Nodelman speaks of the complex achievement of Roman portrait statues, their representation in a single face of a dual identity: a social persona and an actual individual, an "official mask" and its "distorted inflection" by "involuntary, hence spontaneous, twitching of the smaller muscles" of the face. By their composure and formality, the Roman figures seem to project "acute awareness of the spectator," Nodelman notes. "For the first time in the history of art, the subject of the portrait reflects an awareness of being portrayed . . . He feels . . . the gaze of the spectator upon him." The subject's awareness of being in the presence of a spectator who shares his space and "narrative time" opens a wedge between mask and self, persona and person—between self-presentation and self-awareness. This acutely strained double awareness signals back to us our own presence as spectators, "the pressure of our own gaze upon the portrait subject."[77]

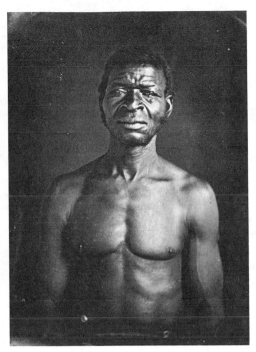

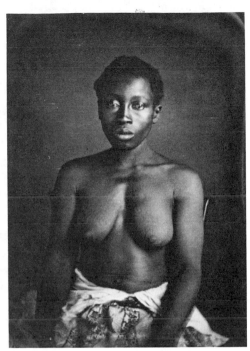

12. "Jack (driver), *Guinea*. Plantation of B. F. Taylor, Esq., Columbia, S.C."

13. "Delia, country-born of African parents, daughter of Renty, *Congo*"

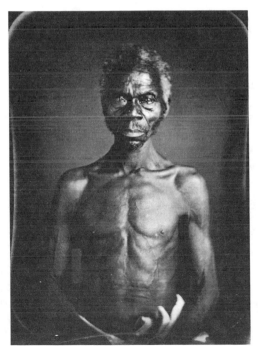

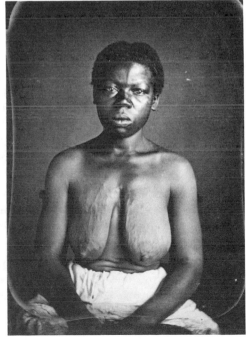

14. "Renty, *Congo*, on plantation of B. F. Taylor, Columbia, S.C."

15. "Drana, country-born, daughter of Jack, *Guinea*. Plantation of B. F. Taylor"

Daguerreotypes by J. T. Zealy, Columbia, S.C., March 1850

Like the Roman busts, Zealy's portraits of Jack the Driver and Renty, of Delia and Drana, confront us with a humanity which we, in Nodelman's words, "strive to comprehend" by seeking a "deep-lying ultimate center of selfhood." In his account of the effect of the "great eyes" in late Roman heads, Nodelman might well be speaking of these very images:

> We encounter unqualified presence, no longer limited by empirical time, place or contingent experience. No faces had ever been so totally, unqualifiedly present as these that accept no distance from us, no social pretense or merely personal, psychological obstacle: none that had ever been so naked, stripped of everything but that one thing through which all else exists and is here declared the unqualified essence of humanity.[78]

The gaze as a sign of an "inward presence" which calls forth the viewer's own "unqualified perception": this states precisely the effect of Zealy's pictures and helps us understand the logic of our response.

Without a public mask to mediate their encounter with the lens, the eyes of the enslaved Africans can only reveal the depths of their being—for, as naked slaves, they are permitted no social persona. In the absence of the clues which define Brady's portraits as formal, heroic, at once individual and illustrious, and yet in the presence of certain conventional signs—the carpet, the stand, the case and framing mat—we confront a disturbing contradiction. The illustrations are trapped within a system of representation as firmly as the sitters are trapped within a system of chattel slavery. And they powerfully inform us of our own entrapment. We know how to view conventional portraits—but to gaze upon naked bodies, male and female, of persons dispossessed of themselves, is another matter. The effect even now can be confusing, erotic response mingling with moral disgust and outrage. Above all, the pictures suggest a potentially subversive power within the daguerrean effect of immediacy—including its eroticism—a power to subvert the very conventions of portraiture which the works of commercial studios shaped. Often we feel a similar effect in anonymous images found in old shops or studied in collections—an uncanny rapport with vibrant shadowy traces of persons on a silver-coated plate, who continue to live in spite of stilted poses and stiffness. The Zealy pictures reveal the social convention which ranks blacks as inferior beings, which violates civilized decorum, which strips men and women of the right to cover their genitalia. And yet the pictures shatter that mold by allowing the eyes of Delia and the others to speak directly to ours, in an appeal to a shared humanity. This represents an extraordinary achievement. Zealy allowed the camera and the silver plate simply to show the event.

16. "L.W. is a female who has been long notorious in New York for her depravity and abandonment of character." Engraving after a lost daguerreotype by Brady. *Rationale of Crime* (1846)

These pictures invite comparison to a group of images produced by Mathew Brady in 1846—of inmates at the Blackwells Island Penitentiary. He made the pictures for publication as engravings in the American edition of the Englishman Marmaduke Sampson's *The Rationale of Crime*, a "treatise on criminal jurisprudence considered in relation to cerebral organization" (in short, phrenology).[79] Their purpose was to show how to read a criminal head—to detect a biological source of social behavior, so the behavior might be reformed with reliable predictability. Zealy's pictures have a similar but different rationale: zoological classification. While Brady's images have us see the minutely individual determinants of social behavior, Zealy's convert individuals to tokens of a type—a different order of humanness. Both groups of images represent their subjects through what Foucault calls the "eye of power," an eye in which visibility reduces persons to information. For inmates of institutions (the prison, the slave plantation), "visibility is a trap," a subjection to an external order.[80] In both cases the eye of the lens applies relentless scrutiny for the sake of data and control.

What the slave and criminal images have in common is a system of explanation which makes the difference between free citizen and incarcerated criminal or enslaved black seem "natural" and proper. In public Agassiz opposed slavery, though aware that his theory of separate "centers of creation" would be seen as a defense of the system. Yet his language betrays more than a scientific motive in his theorizing. At the meeting in Charleston before he set Zealy to his task, Agassiz accepted

the "obligation" "to settle the relative rank among these races, the relative value of the characters peculiar to each."[81] His diction suddenly changes, becomes moral and judgmental. "The indomitable, courageous, proud Indian—in how very different a light he stands by the side of the submissive, obsequious, imitative negro." It is "mock-philanthropy and mock-philosophy to assume that all races have the same abilities . . . and . . . are entitled to the same position in human society." Consider Africa: "There has never been a regulated society of black men developed on that continent. Does not this indicate in this race a peculiar apathy, a peculiar indifference to the advantages afforded by civilized society?" Rather than treating blacks as equals, we should be guided, Agassiz argues, by "a desire to foster those dispositions that are eminently marked in them"—the disposition, presumably, to subservience, to the hewing of wood and the carrying of water.

What Stephen Jay Gould calls Agassiz's "advocacy of social policy couched as a dispassionate inquiry into scientific fact" parallels the pedagogy at the heart of *The Rationale of Crime*: a reading of the visible skull as a clue to destiny, to a "natural" explanation of the pithy social histories encapsulated in the texts accompanying each image. Crime is mistakenly considered a moral event rather than a disease, an effect of "natural causes." If, as phrenology taught, "individuals act in obedience to the operation of physical causes in themselves," can we hold them responsible? Thus, writes Elizabeth Farnam, matron at Blackwells Island, in her introduction to Sampson's text, "persons addicted to crime" lack that mental soundness by which normal people "perceive and adhere to the highest standard of rectitude which society requires."[82] Criminals are no more than exceptions to normal behavior; they suffer from excessive propensities in one direction. "Under influences adapted to appeal to [their] better powers," they might develop a moral character in accord with that "highest standard of rectitude" which Mathew Brady had already devoted himself to serve, as maker of an American pantheon, a gallery of the illustrious.[83]

In 1864, the Civil War still an interminable bleeding wound, Reverend H. J. Morton, D.D., asked in an essay on "Photography as a Moral Agent" what part photography had yet to play "in the moral history of the world," and his reply began: "It is employed to detect and defeat crime, to distribute intelligence [information], to perfect knowledge." Farther down we read: "It brings the world face to face with its great men, its orators, its poets, its statesmen, its heroes."[84] This perhaps unconscious inversion of what Brady would have thought the more correct priority is a slip which betrays a forbidden wish. The anthropometric images of Agassiz and Zealy, and the phrenological pictures

of Brady implicitly refer to a code of rectitude presumed to make distinct the line between right and wrong, crime and obedience, and, by extension to the racial hierarchy, black and white. The detection and defeat of crime, of sources of disorder in defective moral faculties—or the absence of such faculties, as in the case of the other kind of people, blacks—emerges as the hidden corollary to the explicit message of Brady's *Gallery*: to preserve the Union against political disorder or crime (as secession would be called in 1861). Crime, disruption, potential chaos: Lester's "dim shape of the future" and its "mysterious changes" harbored cultural demons within the more visible political dangers on the horizon of 1850.

Photography seemed a moral agent because of its apparent alliance with what Hawthorne's Holgrave calls the "wonderful insight in Heaven's broad and simple sunshine." But confidence in the sun's *natural* moral illumination rested on *practical* theories of congruence between surfaces and depths, appearances and realities, theories such as physiognomy, phrenology, anthropometricism. Not the unaided sun but a system of interpretation supported Root's assurance, for example, that "men shall ultimately be known for what they are," that "inward unworthiness, despite all effort, *will* glare through the fleshly mask."[85] Just as it takes a historical-political narrative to explicate the meaning of Holgrave's portraits of the fated judge.

By allowing their subjects to gaze through the lens directly at us, the Zealy portraits immobilize the physiognomic theory which supports Root's confidence. Stripped of everything deemed intrinsic to selfhood and "character," if not humanness itself, they are simply themselves—what we see. The photographer takes no pains to "portray" them or to elicit an expression. By obeying his commission to present them as bodies rather than persons, as biological specimens, Zealy allows them to be as they are: black slaves constrained to perform the role of specimen before the camera. The absoluteness of their confinement to this role has the unintended effect of freeing their eyes from any other necessity but to look back at the glass eye staring at them. Their gaze defies the scrutinizing gaze aimed at their nakedness, and challenges the viewer of these daguerreotypes to reckon with his or her responses to such images.

We are challenged, in short, to reciprocate the look in their eyes, or to accept the overt assumption of the pictures, that these human beings possess less humanity than we do. Our viewing of the pictures becomes an imaginary form of what Hegel described as the "master-slave relation," the intersubjective dialectic between persons in unequal social positions. By stripping these figures of all but their bodies (and eyes),

the pictures depict the base degradation of such relations. They also encompass the possibility of imaginative liberation, for if we reciprocate their look, we have acknowledged what the pictures most overtly deny: the universal humanness we share with them. Their gaze in our eyes, we can say, frees them. And frees the viewer as well. Zealy's sitters are the illustrious Americans who beyond all others force us to self-recognitions which in turn illustrate the key predicament of antebellum America. The pictures imply more than the cruelties of slavery. They make starkly visible what is usually hidden within the cultural ideals of American selfhood and identity—the weighted distinctions of race, gender, and social class which contradict the republican credo of equality, and the uncontainable erotic energies which lie as a further threat to convention within the credo.

V

" 'I have it: Brady! Brady!' " Walt Whitman exclaimed one evening in 1889 in his Mickle Street house in Camden. The aged poet had forgotten the name momentarily, but when a visitor remarked that "we might some day have a W. gallery," it returned in a flash of memory:

> What you have just said brought into my mind certain hours, talks of the old times—with them Brady's name . . . Brady had galleries in Washington: his head-quarters were in New York. We had many a talk together: the point was, how much better it would often be, rather than having a lot of contradictory records by witnesses or historians—say of Caesar, Socrates, Epictetus, others—if we could have three or four or half a dozen portraits—very accurate—of the men: that would be history—the best history—a history from which there would be no appeal.

Was that Brady's notion? "No: mine, I suppose: I suppose I spun that out—reeled it off: but I know that we discussed it—that it was occasioned by conversations we had together."[86]

Brady and Whitman deep in conversation about history and photography: the image brings back the excitement and speculation of the new medium's initial stage of untested possibilities. In the 1840s Whitman wrote frequently for a number of Brooklyn newspapers, and in his accounts of rambles in the metropolis across the river he often commented on new, interesting sights, on art exhibitions and buildings under construction, on streetcars and the colorful, zestful crowds—and on the new portrait galleries. In a piece in the Brooklyn *Evening Star* in February 1846, he noted:

> Idling along, some stop at the lower corner of Fulton street to look at Gent Morris's good natured countenance, daguerreotyped by Brady, who

has his rooms there. By the bye, Mr. B. is a capital artist, and deserves every encouragement. His pictures possess a peculiar life-likeness and air of resemblance not often found in works of this sort. —His portraits of several well known characters at the corner always attract attention. I commend him to your Brooklyn gentry.[87]

In a piece in the Brooklyn *Eagle* in the same year, on a visit to John Plumbe's gallery, also on lower Broadway, Whitman again stressed the illusion of a "peculiar life-likeness" in the displayed daguerreotypes. "What a spectacle!" he exclaimed. "Ah! what tales might those pictures tell if their mute lips had the power of speech!"[88]

These early jottings about the daguerreotype offer a clue to what may have transpired in his talks with Brady. In the galleries, past moments come back to life with an almost magical animation. The pictures lining the walls of Plumbe's create "the impression of an immense Phantom concourse—speechless and motionless, but yet *realities*. You are indeed in a new world—a peopled world, though mute as the grave." "Time, space, both are annihilated, and we identify the semblance with the reality."[89] The past becomes present, and history a living experience— all by virtue of the daguerreotype's lifelikeness, its power of mute speech: the paradox of an image whose stillness animates, whose silence speaks.

There is no record of Whitman's reaction to the *Gallery of Illustrious Americans*, to its translation of the voice of the original daguerreotypes into the language of lithography. In translation, Brady's daguerrean images lose their magical presence. The tales they tell are, as it were, in the voice of a ventriloquist. D'Avignon's prints and Lester's biographies impose on the original daguerreotypes another notion of history— not the idea of the past magically returning to life, but an idea of the past as an ideological message. In his responses to Brady's and Plumbe's daguerreotypes in 1846, Whitman felt the image as a presence, not a message—a vibrant experience, not a fixed meaning. By imposing meanings, in the softening style of the lithographs and in the political rhetoric of the biographies, the *Gallery of Illustrious Americans* loses touch with the living gallery experience Whitman described with such fervor. Published as engraved prints, Brady's daguerreotypes sacrifice their paradoxical vividness in order to perform a political mission for the medium.

Five years later, in 1855, Whitman also published an engraved version of a daguerreotype, to serve a different political purpose. It is included in a curious slim green volume of unusual poetry which appeared in Brooklyn on July 4, 1855. Readers—there were at first only a few— would have been struck less by the absence of an author's name than

by the frontispiece: an engraved daguerrean portrait showing a standing male figure from the knees up. His head cocked, his rough broadcloth blouse open at the collar, and a slouch black hat tilted carelessly on his head, his right arm crooked, with his knuckles resting on his right hip thrust slightly forward, the other hand snug in left trouser pocket—by costume and posture the figure depicts an American workingman in a suggestively seductive pose. The image shows no background; the figure emerges as if from nowhere, appears on the page as if he might have been there always, waiting to be seen. It is hard to tell whether the look in his eyes and his posture invite our attention or defy it: a nameless author in an ambiguous image.

"As seems very proper in a book of transcendental poetry," the Boston Brahmin writer Charles Eliot Norton noted in a review in September 1855, "the author withholds his name from the title page, and presents his portrait, neatly engraved on steel, instead. This, no doubt, is upon the principle that the name is merely accidental; while the portrait affords an idea of the essential being from whom these utterances proceed."[90] Norton's tone suggests he takes some offense even as he is bemused. Inscribing one's "essential being" in the form of an image rather than a name may be fine for a book of transcendental poetry, but not for the polite drawing rooms presumed to be the proper environment for books of poetry. Indeed, by depicting the author so informally, so shamelessly attired for the out-of-doors rather than the library or study, the portrait must have seemed an affront to gentility.

"Statesmen, lawyers, clergymen, and public speakers generally," Marcus Aurelius Root would state in 1864, may properly be shown in a standing posture, but

> suppose you were required to represent a historian or poet, a romancer or an editor; in short, any person whose chief excitations of intellect are experienced, and his favorite labors performed, while wielding the pen at the desk. To place such a one in a standing position would well nigh certainly defeat the end desired; since he would be more likely to feel embarrassed and awkward than inspired with enthusiasm, in consequence of the novelty and strangeness of his attitude.

Embarrassment and awkwardness are precisely what the untitled frontispiece does not project. Just the opposite—defiant comfort in a posture of insouciance and open sexuality. The slouching figure in the 1855 volume seems as much a mockery of the claim in works like Brady's 1850 publication that Roman *dignitas* defines the true American as the idea that poetic inspiration occurs at a desk.

In Whitman's frontispiece lay a dissent, in other words, not only from the design of books and the portrayal of authors, but from ideas about

17. Frontispiece of the first edition of Walt Whitman's *Leaves of Grass*, 1855. Engraving by Samuel Hollyer after a lost daguerreotype by Gabriel Harrison, 1854

public decorum and cultural propriety. What is most defiant about the image is not its costume and posture but what it offers in place of the conventions it scoffs: the picture of a standing workingman-poet. That image launches a challenge: who better represents or illustrates the typical American—the "illustrious Americans" of the public portraits, or such proudly unconventional figures and their unconventional poems? At ease with himself, touching his own body, deferential to no one and accessible to all, the figure opposite the title page gives credence to the words of the Preface: "The messages of great poets to each man and woman are, Come to us on equal terms, Only then can you understand us, We are no better than you, What we enclose you enclose, What we enjoy you may enjoy."

In the poems which follow, Whitman fills out this claim of equality with his readers. "What is commonest, cheapest, nearest, easiest, is Me," he writes, arguing that his experience represents everyone's experience. He will embrace all people, he writes in the Preface, "without ignominious distinctions." "I know that what answers for me an American must

answer for any individual." He is not interested in a defense against crime or in upholding the social order. "What living and buried speech is always vibrating here, what howls restrained by decorum," he writes, and identifies himself as "Walt Whitman, an American, one of the roughs, a kosmos." By making this figure visible, the portrait performs a political act.

In medieval emblem books, the text draws a lesson from an opening figure. In this case, the text that follows the image frustrates the expectation of a clear and concise lesson. The poems interpret the emblem image by indirection, never mentioning the picture by name. Yet its presence is felt:

> Apart from the pulling and hauling stands what I am,
> Stands amused, complacent, compassionating, idle, unitary,
> Looks down, is erect, or bends an arm on an impalpable certain rest,
> Looking with side-curved head curious what will come next,
> Both in and out of the game and watching and wondering at it.

Or: "I crowd your sleekest and best by simply looking toward you . . . I carry the plenum of proof and everything else in my face." The physical figure at the threshold of the poem provides a tangible point of reference for such allusions.

In a traditional emblem book the picture is often a visual allegory consisting of figures that stand for ideas, for a meaning we are lured into puzzling out: typically, a general observation about virtue or love or beauty or honor. While Whitman's poet finally names himself in the first long, untitled poem as "an American, one of the roughs, a kosmos," he also denies that any single expression, any fixed image defines or identifies him. "My final merit I refuse you. I refuse putting from me what I really am." The "Me myself," the protean speaker declares over and again, cannot be known from any particular utterance or appearance. Can the frontispiece, then, be taken as a reliable portrait? What does it mean, after all—as the poet implies by his refusal to say "what I really am"—to say that a still, fixed portrait represents one's self?

"Who then is that insolent unknown?" Whitman asked in one of his own unsigned reviews. "We may infer," wrote another reviewer in the New York *Tribune* (23 July 1855), "that he belongs to that exemplary class of society sometimes irreverently styled 'loafer.'" Nine years earlier, in 1846, Whitman wrote about his visit to the Plumbe gallery: "There is always, to us, a strange fascination, in portraits. We love to dwell long upon them—to infer many things, from the text they preach—to pursue the current of thoughts running riot about them."[91] He wanted the portrait to provoke inference, to awaken desire for dialogue. Many

years later Whitman explained that he had deliberately omitted his name from the 1855 edition of *Leaves of Grass*. It would have been "sacrilege to put a name there," he said—like "putting a name on the universe. It would be ridiculous to think of *Leaves of Grass* as belonging to any one person: at the most I am only a mouth-piece." The unnamed image declares the book open to all. "I like the feeling of a general partnership—as if the *Leaves* was anybody's who chooses just as truly as mine."[92]

The book demands our participation, in short, in a manner Whitman wants us to believe differs from the normal way of reading poetry. By inducing inference about its identity, the portrait becomes part of the poem—its opening lines, its motto. In another unsigned review, Whitman provided an example for readers to follow in interpreting the image: "An American Bard at last! One of the roughs, large, proud, affectionate, eating, drinking, and breeding, his costume manly and free, his face sunburnt and bearded, his posture strong and erect." He calls the book "a reproduction of the author. His name is not on the frontispiece but his portrait, half length, is. The contents of the book form a daguerreotype of his inner being."[93] The picture, being from a daguerreotype, declares the method as well as the author of the book.

In 1888 Whitman described how the original, now lost, daguerreotype, came about, "from what could be called a chance." The time was the summer of 1854.

> I was sauntering along the street: the day was hot: I was dressed just as you see me there. A friend of mine—Gabriel Harrison (you know him? ah! yes!—he has always been a good friend!)—stood at the door of his place looking at passers-by. He cried out to me at once: "Old man!—old man!—come here: come right up stairs with me this minute"—and when he noticed that I hesitated cried still more emphatically: "Do come: come: I'm dying for something to do." The picture was the result.[94]

Gabriel Harrison was also a writer, and with Whitman, a member of the left-wing faction of the Brooklyn Democratic Party. He and Whitman shared an interest in politics, art, theater, poetry, and nature. "You cannot look upon anything in nature," Harrison wrote, "without being reminded of some peculiar and beautiful result if daguerreotyped; even the small blade of grass . . ."[95] They also shared a romantic idea of America, an exuberance for freedom and equality, and a passion for developing a native American art. Drama was Harrison's first love; friend of Forrest, champion of Kean, he himself performed on stage and managed theaters. Only recently proprietor of his own photographic studio, he had gained a reputation working in the 1840s as perhaps the finest "operator" in New York. He may well have made the earliest

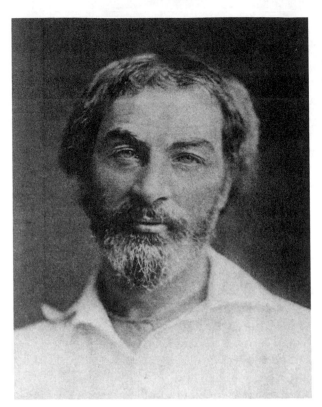

18. Daguerreotype of Walt Whitman, known as "The Christ likeness," by Gabriel Harrison, 1854

known pictures of Whitman ascribed to the Plumbe gallery—two formal studio daguerreotypes showing a young man-about-town. It is likely he also made one of the famous pictures of his close friend Poe. Surviving pictures he made of his family, including his son as "young America," show a flair for improvisation, for informal yet theatrical poses. But he was best admired for prize-winning pictures in another genre, allegorical compositions known as "descriptive daguerreotypes," such as a picture of three young women representing "Past, Present, and Future," which took one of the gold medals for the Lawrence studio at the Crystal Palace Exposition in 1851. "He is now almost universally known as the *Poet Daguerrean!*" we read in the *Photographic Art-Journal.* "Indeed the poets have taken him into their special favor."[96]

Is "Walt Whitman," the 1855 picture and the persona of the poems (he had been Walter Whitman until then, and the book's copyright uses *that* name), another of Harrison's "descriptive daguerreotypes," less a portrait of a specific person than a fiction, a picture of someone representing himself in a certain way—a mute text from which one might infer many things? Another image made on the same occasion

was dubbed by Whitman's friends "The Christ likeness." Together the two images disclose two facets of the same physiognomy, each a distinct fact of nature which might prove a "peculiar and beautiful result if daguerreotyped." But the conception of each of these pictures was probably not Harrison's alone. Sadakichi Hartmann remarked that Whitman never gave himself over to the camera passively, always struck his own pose.[97] In his last years in Camden the crippled poet loved nothing more than poring over pictures of himself with friends, explaining details, jogging memories—and reflecting on the many Walt Whitmans who met his eyes: "I meet new Walt Whitmans every day. There a dozen of me afloat. I don't know which Walt Whitman I am."[98]

Few nineteenth-century writers—Mark Twain is an exception—courted the camera as obsessively as did Whitman. He was, he claimed, always himself before the lens: "I don't fix up when I go to have the picture taken," he explained to his young disciple Horace Traubel. "I think the greatest aid is in my *insouciance*—my utter indifference: my going as if it meant nothing unusual." Meaning nothing can mean everything, however, for each picture, each spontaneous pose, represents another opportunity for self-discovery, for the revelation of another facet of his capacious self. "You shall stand by my side and look in the mirror with me," he stated in the 1855 Preface. In the opening poem of the book he confesses: "I dote on myself, there is that lot of me and all so luscious." His pictures took on epithets of their own—"The Christ likeness," the "Quaker picture," "my sea-captain face," the "Lear photo," the "Laughing Philosopher," and, inevitably, "the mysterious photograph." But none is the "Me myself," none the final, definitive Whitman.

After 1855, Whitman filled in the blank on the title page of his expanding book, of which he would issue nine editions in his lifetime. In 1876 he replaced the cold typeface bearing his name with an engraved signature. All editions opened with a frontispiece portrait, never the same, all showing him as he looked contemporary with the book. Signature and image provided organic expressions of the living author. As the book grew and changed, so the face aged, its lines deepened, the hair grayed. "An attempt, from first to last, to put a Person, a human being (myself, in the latter half of the Nineteenth Century, in America) freely, fully and truly on record," he described his book in 1885—"my definitive *carte visite* to the coming generations of the New World."

Whitman imagined his book as if it were a living daguerrean image. "This is no book," he wrote in the 1860 edition,

Who touches this, touches a man.
(Is it night? Are you alone?)
It is I you hold, and who holds you,
I spring from the pages into your arms—decease calls me forth.

Descending from speech into writing, from breath into the metaphoric death of cold type, the poet springs forth in the same way an absent person becomes present through an image. Image becomes presence. The photograph preserves the fleeting moment exactly as a fleeting moment. In what came to be Section 42 of "Song of Myself," the 1855 edition reads:

My words are words of a questioning, and to indicate reality;
This printed and bound book . . . but the printer and the printing-office boy?
The marriage estate and settlement . . . but the body and mind of the bridegroom?
and also of the bride?
The well-taken photographs . . . but your wife or friend close and solid in your arms?

Not the picture or representation reveals the self, but the questioning of the picture, the *touching* of it, the effort to imagine what lies behind it, antecedent to it—the absent bodily figure in the portrait seeming a physical presence and close to us, by means of the photograph.

There is an implicit politics in this logic. The emblematic picture begins a process of inference which both defends the "Me myself" and makes "I and this mystery" a universal experience—the basis of equality, the ground of a republicanism beyond the theories of emulation embodied in Brady's *Gallery of Illustrious Americans*. Karl Mannheim speaks of the exchange of eyes, the "look," as a form of egalitarian "ecstasy"—the ecstasy of identifying with the physical point of view of another, seeing through the other's eyes into one's own, as the psychological basis of a truly democratic culture.[99] Whitman puts into the form of his 1855 book the theory of ecstatic (and erotic) democracy implicit in the poems—a theory and a form which clarifies the effect of Zealy's daguerreotypes: the experience of looking into the eyes of Jack and Delia and seeing oneself as equal to them.

Whitman shaped a poetry in 1855 designed to encourage such experiences, and to explain their political meaning as an alternative to the conventional system of representative government:

Other states indicate themselves in their deputies . . . but the genius of the United States is not best or most in its executives or legislatures, nor in its ambassadors or authors or colleges or churches or parlors, nor even in its newspapers or inventors . . . but always most in the common people.

Who best typifies the nation, its representatives or its "common people"? If the Preface argues that a new American poetry must throw aside European traditions, including those of meter and rhyme in poetry, it also insists on transcending the political system of representation. Whitman offers his poetry as the vehicle whereby the "common people" can free themselves from the political forms which delude them into thinking that voting is enough. Not "in the committees that were supposed to stand for the rest but in the rest themselves" are we to find "the harmony of things with man." "Cleaving and circling here swells the soul of the poet yet it is president of itself always." The poem, he promises, will address "those in all parts of these states who could easier realize the true American character but do not," who accept themselves as represented by "the swarm of cringers, suckers, doughfaces, lice of politics, planners of sly involutions for their own preferment to city offices or state legislatures or the judiciary or congress or the presidency."

Whitman's language in the 1855 Preface reflected his anger at the turn of American politics since the Compromise of 1850—the rejection of the Free Soil platform by the Democratic Party in 1852, its endorsement of the loathsome Compromise and its rejection of further agitation over slavery, and the choice of party-faithful Franklin Pierce for the Presidency. Pierce's election deepened Whitman's disillusion with the party system, and his loss of faith that the "illustrious Americans" had the best interests of the common people in mind. His outlook on representative government and political leaders had changed profoundly since his days, in the late 1840s, as a political journalist and ardent Democratic campaigner.

The change in outlook which contributed to Whitman's abandonment of politics for poetry in the early 1850s also affected his conception of photography and its political uses. It is not that he rejected Brady's idea of the "illustrious American," but by 1855 he had redefined it, rejected its emphasis on established leaders and dignitaries, proposed instead a conception of "illustrious" without restriction by wealth, vocation, gender, or race. The daguerrean experience helped him achieve the new image of himself as the poet of democracy, and of his potential audience. Brady, who stood apart from partisan conflicts in the 1850s, eager to photograph any and all of the participants, remained in Whitman's memory as the "capital artist" who kept an unequaled record of the history of the times. In 1870 the poet wrote a letter to several Washington newspapers supporting the bid by his old friend to sell his collection of representative Americans to Congress.

The addition of these authentic likenesses and eloquent mementoes, not only of the common persons, struggles and ambitions but of the general close where all alike terminate; these typical men gathered together from opposing parties and convictions, representing in their varieties and oppositions after all a Common Country—seems to me peculiarly appropriate to the Library of the Capital.[100]

Brady's gallery remained for Whitman, as for the photographer, testimony to a "Common Country."

As early as 1846 Whitman recognized the daguerrean gallery as a new cultural form and absorbed it into the poetry he was then beginning to compose. An early notebook poem titled "Pictures" evokes the gallery as a metaphor for his imagination peopled with images.[101] Throughout his career he returned to this fragment, splicing parts of it into other poems, and finally in 1880 published the original six lines virtually as they stood. He called the poem "My Picture-Gallery."

> In a little house keep I pictures suspended, it is not a fix'd house,
> It is round, it is only a few inches from one side to the other;
> Yet behold, it has room for the shows of the world, all memories!
> Here the tableaus of life, and here the groupings of death;
> Here, do you know this? this is cicerone himself,
> With finger rais'd he points to the prodigal pictures.

The cicerone might be Whitman in the guise of Brady. But Whitman's gallery, in outward appearance like Brady's, has this difference: it makes a space in which we can imagine Zealy's black men and women standing freely among the others, embraced within the commonality of the "Common Country." Whitman met Brady on the ground of their mutual commitment to American illustriousness. But the poet saw further than the photographer. To pursue the inner principle of American illustriousness to its logical end, Whitman perceived, one must transgress those very conventions by which the photographer had made equality a theme rather than an act, an iconic illusion. Whitman grasped what the Zealy portraits compel us to see, that the portrait conventions which bore the ideal of American republicanism were equivalents to actual social barriers that segmented the Republic and mocked its declared ideals, interfering with their realization. His own 1855 portrait rests on the same perception; it replaces emulation with ecstatic encounter: an act of transgression and affirmation. Whitman's imaginary gallery mirrors the Broadway gallery most perfectly by inverting it.

Albums of War

Unknown, inkstand, knife, letter and seventy-five cents

A. Calhoun, diary

Unknown Corporal, ambrotype of female

Unknown, "Soldier's Pocket Book"

Unknown, pipe

Sergeant L. H. Lee, two combs, diary, and bullet that killed him
—"List of Articles Taken from the Bodies of
the Soldiers Removed to the Soldiers' National
Cemetery," *Revised Report made to Legislature of
Pennsylvania, Relative to the Soldiers' National
Cemetery at Gettysburg* (1867)

The real war will not get into the books.
—WALT WHITMAN, *Specimen Days*

I

ON AUGUST 17, 1861, not quite a month after the battle of Bull Run near Manassas, Virginia, *The New York Times* reported that "Mr. Brady, the Photographer, has just returned from Washington with the magnificent series of views of scenes, groups, and incidents of the war which he has been making for the last two months." The first real bloodletting of the war, Bull Run had been a disaster for the Union Army. "Caught in the whirl and panic of the retreat of our Army," as the *Times* put it, Brady lost his way in the woods and was rescued by a group of tough New York Zouaves, who gave him a sword he buckled under the linen duster memorialized three days later in a self-portrait he made as soon as he returned to Washington. Brady had photographed encampments and troops on his way to Manassas, though whether he made any battlefield pictures at Bull Run, or whether any negatives survived the

71

rout, remains unclear. The pictures referred to by the *Times* were most likely made elsewhere, and even though *Humphrey's Journal* noted that "his are the only reliable records at Bull's Run," no specific battlefield image is mentioned. Still, the language is significant: "The public is indebted to Brady of Broadway for numerous excellent views of 'grim-visaged war,' " noted *Humphrey's*, for "Brady never misrepresents." "He is to the campaigns of the republic what Vandermeulen was to the wars of Louis XIV."[1] The *Times* agreed: Earned with "arduous and perilous toil," Brady's pictures "will do more than the most elaborate descriptions to perpetuate the scenes of that brief campaign."[2]

("Brady's pictures" did not mean pictures made by Brady himself but those he displayed or published, for the most part with E. and H. T. Anthony of New York, though he also issued war images under his own imprint. Organizer of one of several corps of private photographers, collector of images made by others, a kind of archivist or curator of the entire photographic campaign of the war, Brady played many roles, swarmed with ambiguities, in the war. For the sake of simplicity, I use "Brady's pictures" to refer to images with his name on them—not as a term of credit or attribution.)

The disaster of the North's initial campaign—the Union generals had expected to reach Richmond and bring a quick end to the war—taught Lincoln the first of many tragic lessons in the imponderables of warfare. Brady's precarious escape also brought home to photographers the dangers of covering the battlefield, especially with the clumsy array of equipment required by the wet-plate process. Brady had outfitted himself with two wagons of cameras and chemicals—the process required that the camera be planted, the lens focused, the plate coated, exposed, and developed while still wet, all within precious moments at the scene of the "view" to be made. Not surprisingly, few signs of actual battle appear in any Civil War pictures. They show preparations and after-maths, the scene but not the event. Nevertheless, the ravage and destruction they depict are eloquent testimony of the violence which preceded the picture. As the *Times* noted, they "perpetuate" a physical sense of war, what it must have been like had we been there—tokens of spent violence.

But they are not just windows to the past. Made under trying conditions with slow, cumbersome equipment, they reveal the limits and conventions of the medium as much as the look of the war. They demand critical attention to a context, which includes not only the state of photography but the character of the war and the efforts of Americans to see and comprehend it. Precisely because their meaning has *seemed* so direct and self-evident, the photographs pose a double question of

comprehension: How were they understood at the time, and how should they be understood today?

We have a clue to contemporary responses in the language employed by the *Times* and *Humphrey's Journal*. While the word "perpetuate" recalls the memorializing function of daguerreotypes, "views" alluded to another kind of picture. *Humphrey's* compares Brady to a painter of historical battle scenes, and the *Times* refers to scenes, groups, incidents: each a term for a picture made by pen or brush out-of-doors. A striking number of the war photographs call up associations with genre paintings or drawings: staged scenes showing an artillery battery at work, or soldiers relaxing in camp. Of course, a close look will turn up a blurred hand, a slouching figure, a pair of eyes staring blankly at the lens— signs of the camera no amount of composition can hide. But it is noteworthy that Civil War photographers frequently resorted to stagecraft, arranging scenes of daily life in camp to convey a *look* of informality, posing groups of soldiers on picket duty—perhaps moving corpses into more advantageous positions for dramatic close-ups of littered battlefields. This is hardly surprising, considering the unprecedented assignment—as new to photography as the military actions employing new long-range weapons were new to warfare. The first modern war in its scale of destruction—close to half a million casualties— and in the use of mechanized weaponry, including steel-plated naval vessels, trenches, and, in Sherman's march through Georgia in 1864, a scorched-earth policy, the Civil War presented challenges to comprehension in all manner of word and picture. For photographers the problem of making sense of battles raging in woods and fields was compounded by problems of equipment as well as access to battlefields, which required permission, usually withheld until fighting ceased. Large cameras on tripods, lenses designed for landscape views, the necessity of preparing the glass plate in a portable darkroom, then rushing with it to the camera—all these physical barriers to spontaneous pictures of action encouraged a resort to easily applied conventions of historical painting, casual sketches, and even studio portraits. "The photographer who follows in the wake of modern armies," noted the London *Times* in December 1862, "must be content with conditions of repose, and with the still life which remains when the fighting is over . . . When the artist essays to represent motion, he bewilders the plate and makes chaos."[3]

This is not to say that the photographs are stilted or unconvincing. However composed and staged, they bear witness to real events. To hold before one's eyes a vintage albumen print made at Gettysburg or Antietam or Charleston is to realize the truth of Paul Valéry's observation

that, once the camera appeared, our sense of what suffices as a historical account was altered forever.[4] The photograph takes us back to the original moment when light fell upon these surfaces, these bodies and guns and fields; we all but feel the same rays of light in our own eyes—an experience lost through the halftone screens of reproduced images. We see the war not as heroic action in a grand style but as rotting corpses, shattered trees and rocks, weary soldiers in mud-covered uniforms or lying wounded in field hospitals—as boredom and pain.

The presence of artifice derives in part from the subject itself. War creates a special burden for the representational arts. For example, Brady's display in August 1862 of "The Dead of Antietam" (he hung a placard with these words at the door of his gallery on Broadway) inspired the *Times* to say that he had brought "home to us the terrible reality and earnestness of war." These pictures, issued by Brady without credit to the actual photographer, Alexander Gardner, were the most vivid and gruesome images of dead combatants (they were Confederate soldiers) yet shown to the public.[5] The reality they depict is the reality of violence, the effects of shells and bullets on human flesh and bone. There is a shocking ultimacy about such pictures. But do they show "war"? Did they help their viewers comprehend the full story of Antietam, including the role of the battle in the political conflict between the Union and the Confederacy? Is it possible for pictures to do both, to convey the "earnestness of war" and its *form*? Can any single photographic image bring home the reality of the whole event? The same question can be asked of photographs of any event, it might be said. Yes, but in the case of war the normal gap between sense experience and mental comprehension is stretched to an extreme.

Photography gave a new twist to the problem. Grand-style history painters such as Benjamin West had solved the problem by depicting the death of generals as the summary event of a war, or, as in Emmanuel Leutze's *Washington Crossing the Delaware* (1851), giving prominence to a symbolic hero. Operating on the scene, without opportunity for advance planning or for retrospective decisions about pictures already taken, and without the means to idealize persons and actions, photographers in the Civil War focused on the mundane, on camp life, on drills and picket lines and artillery batteries. They saw the war essentially in its quotidian aspects, as a unique form of everyday life. Traditional forms of heroic representation were not available, and inappropriate in any case. The strength of the pictures lies in their mundane aspect—their portrayal of war as an event in real space and time—a different conception of the very medium within which war takes place: not the mythic or fictional time of a theater, as in Benjamin West's famous

Death of General Wolfe, but the real time of an actual camp or battlefield.

This singular achievement of the photographs was accompanied, however, by a loss of clarity about both the overall form of battles and the unfolding war as such and the political meaning of events like the corpse-littered field of Antietam. In this the photographs help us see a more general problem posed by wars waged by nation-states in the nineteenth century. Employing mass conscript armies drawn from the population at large, wars became, during the Napoleonic campaigns, a new kind of political event, requiring a supportive populace. The Prussian officer and theorist Karl von Clausewitz states in his classic *On War* (1832) that Napoleon had brought warfare close to its absolute state as organized violence aimed at the total destruction of the enemy forces. Thus, the battles raging in Europe after the French Revolution, to 1815, made it possible to see more clearly the nature of war, its resemblance to commerce, for example, in the calculation of probabilities it required, and to politics in the balance of forces it entailed.[6] Most of all, Clausewitz stressed the difficulties of comprehending the course of events in the dead of battle, the demands placed upon the eyesight on the part of commanders, and the near-impossibility of seeing and knowing simultaneously.[7] Clausewitz had in mind the effect of the havoc of battle on body and mind at once. How can one *experience* the chaos of war and describe it rationally at the same time? How was it possible to see photographically, in single, segmented images, and to see politically or historically, as it were, with an eye to the meaning of the transcribed scenes, their meaning within a war itself so difficult to see intelligibly? The inevitable fragmentation of the photographic report coincided with the fragmented information by which political leaders, generals, soldiers, and public alike confronted a new form of history represented by the Civil War—history as events ruled more by chance than design, and occurring within battlefields thick with smoke.[8]

In *Battle-Pieces* (1866), the book of poems written "in an impulse imparted by the Fall of Richmond," and dedicated to "the memory of the three hundred thousand who, in the war to keep the Union, fell under the flag of their fathers," Herman Melville produced one of the few contemporary literary works which recognized the war's terrible paradox. He explained his complex intention in a prefatory note: "The events and incidents of the conflict—making up a whole, in varied amplitude, corresponding with the geographical area covered by the war—from these but a few themes have been taken, such as for any cause chanced to imprint themselves upon the mind."[9] He aims not for the elusive whole, which, as the poems' titles suggest, can be known more reliably as a geographical area than as a complete reality; it is

random thoughts which "chanced" into mind that he is after. The poems are named chiefly after battles and places, but attempt to convey an aspect of the inner life of the event. In "The March into Virginia," his poem on Bull Run (or "the First Manassas," as the Confederates named it), Melville describes the young soldiers as "they gayly go to fight," some of whom "Shall die experienced ere three days are spent— Perish, enlightened by the vollied glare." *Enlightened* by fiery death: a bitter irony lost on those, Melville implies, who still see in war "a belaureled story." "What like a bullet can undeceive," he says in "Shiloh." This war put an end to pageantry and glory; its mechanization has converted warriors, as Melville put it in another poem, "A Utilitarian View of the Monitor's Fight," into "operatives"—another word for mechanics or workers: "No passion; all went on by crank, / Pivot, and screw." But would the event "undeceive" the nation about war?

Compare Hawthorne on the "metal-clads": "All the pomp and splendor of naval warfare are gone by. Henceforth there must come up a race of enginemen and smoke-blackened cannoneers, who will hammer away at their enemies under the direction of a single pair of eyes." Both Melville and Hawthorne give expression to feelings and perceptions about factory labor in general, and link the war to the industrial system, to its heartless, mechanizing, and, in the case of Hawthorne's "single pair of eyes," tyrannical effects. Both writers portray soldier-operatives as submissive, machine-like creatures under a dictatorial eye.[10]

While Melville followed the war at home, Walt Whitman rushed to the front in search of a wounded brother, witnessed the ravage, and stayed to nurse the wounded. From his firsthand perspective he concluded, in *Specimen Days* (1882), that "the real war will never get in the books." "Future years will never know the seething hell and the black infernal background of countless minor scenes and interiors, (not the official surface-courteousness of the Generals, not the few great battles) of the Secession war; and it is best they should not." Something inexpressible lies buried in the war's "lurid interiors."[11]

Melville's book offended reviewers with its apparent coldness and detachment. Charles Eliot Norton in *The Nation*, hailing James Russell Lowell's patriotic "Commemoration Ode" as the "finest work of our generation," found Melville's book too "involved and obscure," "weakened by incongruous imagery." "It is only the highest art that can illustrate the highest deeds," Norton stated. "Is it possible," wrote William Dean Howells in the *Atlantic Monthly*, "—ask yourself, after running over all these celebrative, inscriptive, and memorial verses— that there has really been a great war, with battles fought by men and bewailed by women?" The trouble is that Melville "has not often felt

the things of which he writes."[12] He does not express, that is, the familiar elevated sentiments proper to the occasion.

An idea common in the North even during hostilities was that the war would be a "sacred" memory. With his gift for the eloquent cliché, C. Edwards Lester voiced this in his 1863 *Light and Dark of the Rebellion*:

> Let every scene worth remembering be recorded by each looker-on. Let every man tell how the battle which he saw raged . . . Let no well-authenticated fact be lost. For we must not forget . . . that, while we are straining our vision with these strange sights, we become the sacred depositories of materials from which the artists of a later age will mature their sublime and finished pictures.

Lester settles for one half of Clausewitz's paradox: the war can *only* be represented. But if his prose betrays no sign of shudder, his remark about "strange sights" may be taken as a euphemism at least. He goes on to suggest a certain enormity of facts, of speed of event: "We have been making history faster than all the pens could write it." Or all the lenses could see it: having to "pass in review before the honest face of the Daguerrean lens" [a factual error; Lester uses the term as a figure of speech], this war has in a sense "been compelled to write its own annals." But "without the "magic touch of the pen" to render it "instinct with life and radiant with significance," what the lens records can only be "a lifeless and meaningless mass of material." "The empire of the pen can never be broken."[13]

In their fragmentary presentation of the war, their individual vividness at the expense of a blurred vision of the whole, the photographs may have conveyed a subliminal message of inexpressible interiors—not the stuff of romantic myth or heroic legend. Muffled by the blanket of patriotic gush, that message may have gotten through in any case, for after the war the public quickly lost its eagerness to see the pictures. It took Mathew Brady a decade to persuade Congress they were important enough to purchase, and for almost a generation they passed from public view. In the 1880s, however, at a time when many rued the absence of male heroism in an age of business and materialism, a torrent of reproductions flooded the illustrated press as popular interest in the war revived. In 1882 one of the most prolific of the Civil War photographers, Captain A. J. Russell, wrote that camera images "will in truth teach coming generations that war is a terrible reality."[14] Judging from the revival of such images starting in the 1880s, the public relished the terror—or found ways to deny it. A Hartford firm, Taylor and Huntington, sold sets of stereopticon slides made from Brady's war views. Such slides could be projected at home or on large screens in theaters.

A brochure for sales agents makes the pitch: "From college president to boot-black,—none are too high or too lowly to be interested in the scenes revealed by these lenses. It is thrilling history of our great war brought right before them; it is no guess-work, it is the real thing just as the camera of the government photographer caught it; as exact as a reflection in a mirror."[15]

Stephen Crane's *The Red Badge of Courage* (1895) rode the crest of this revived interest, and also made use of the reproduced photographs. He credited the four volumes of *Battles and Leaders of the Civil War* for help in his descriptions of combat and of soldiers.[16] But his conception of "the real thing" could not have differed more from the popular revived version of the war. Crane's novel shares the irony of Melville's "The March into Virginia," and takes a view of "real war" close to Whitman's. And a paradox like Clausewitz's governs the book: the body's pain in battle undercutting the mind's incessant effort to comprehend, to "tell" the pain in a meaningful way. Henry Fleming marches off to war with dreams of glamorous heroism, and returns enlightened by the bloodied wound which reminds him of his fear and cowardice, his "red badge." Stephen Crane portrayed battle as an initiation into the ironic knowledge that courage is not "heroic" but animalistic, a reflex of self-defense and aggression.[17]

The American novelist Harold Frederic said of Crane's novel that, in depicting a war, better for the artist to rely on imagined rather than "real" experience; to be there is so overwhelmingly confusing that the attempt to say "what he really saw," rather than "what all his reading has taught him that he must have seen," proves the undoing of a writer. The problem of representation expressed by Frederic parallels Fleming's more general moral predicament: to connect his body's experience with the dreams of martial glory with which he sped to battle. Frederic drives home his point with an analogy to photography:

> In the same way battle painters depict horses in motion, not as they actually move, but as it has been agreed by numberless generations of draughtsmen to say that they move. At last, along comes a Muybridge, with his instantaneous camera, and shows that the real motion is entirely different.[18]

By making sequential pictures, the English-born photographer Eadweard Muybridge proved in the 1870s that a horse's legs leave the ground all at once, and an ancient convention was undone—as were the conventions of battlefield prose after Crane, who studied photographs as the equivalent of firsthand accounts.

Interest in the war and its images culminated in 1911 in a ten-volume

Photographic History of the Civil War, assembled by Francis Trevelyn Miller, editor of the *Journal of American History*, on the fiftieth anniversary of the firing on Fort Sumter. By now Lester's "sacred" memory had become habitual rhetoric. About the ritualized memories of the war which entered popular culture in the twentieth century, historian Oscar Handlin notes: "The war was transmuted from the bitter conflict it had been into an episode of high adventure." "Every base element vanished; only nobility remained, as if those who survived could thus banish the guilt of having failed those who died. Above all, if the war were to bind Americans in national unity, both sides had to seem right." The war came to seem "an experience Americans shared rather than one that had divided them."[19]

Editor-in-chief Miller's introduction in 1911 to the ten volumes reassures us that the empire of the pen remained quite intact. Arguing that "these time-stained photographs" are the only unarguable facts to survive the war, he proceeds to smother them in literary imagery:

> This [the Civil War] is the American epic that is told in these time-stained photographs—an epic which in romance and chivalry is more inspiring than that of the olden knighthood; brother against brother, father against son, men speaking the same language, living under the same flag, offering their lives for that which they believe to be right. No Grecian phalanx or Roman legion ever knew truer manhood than in those days on the American continent when Anglo-Saxon met Anglo-Saxon in the decision of a constitutional principle that beset their beloved nation. It was more than Napoleonic, for its warriors battled for principle rather than conquest, for right rather than power.[20]

Miller overlooks the fact of secession, dispels the notion that it was a "War of the Rebellion," and passes over the destruction of half a million combatants. Social upheaval and the overthrow of slavery emerge as events shaped by literary convention—a romantic, chivalric epic. The *Photographic History* pays "tribute" to that "American character" which proved itself by surviving fratricidal battles and reestablishing national unity. Former foes now gather "about these pages in peace and brotherhood, without malice and without dissension." Handlin contradicts this reading. "It is a misreading of their experience," he states, "not to recognize that in the four years of war millions of Americans really hated one another and really wanted to kill one another and that the drama they acted out on the battlefields was less one of gallantry and courage than of hatred."[21] Paradoxically, Miller is blind to any but a romantic interpretation: "The vision is no longer blinded, but as Americans we can see only the heroic self-sacrifice."

The *Photographic History* confirmed the popular belief that pictures

defined the war, made it real, a collective memory of incontrovertible meaning. "The only war of which we have an adequate history in photographs," the Civil War is, to another of the book's editors, "practically an open book."[22] A book, moreover, as "lifelike" as a "vitascope" (cinema) and as untaxing to read: "These vivid pictures bring past history into the present tense."[23] But pictures demand captions, and the ten volumes supply them in abundance, often based on memories fifty years old, along with essays on various battles, armies, leaders, and sundry other aspects of the war, including the photographic corps. The texts, Miller informs us, provide the necessary "mental pictures" to assure the proper interpretation of the photographs.[24]

In that phrase, "mental pictures," lies the crux of the problem of picturing war: how to correlate the physical with the mental, an unspeakable experience with the need to comprehend, to explain, to justify. The inherent problem of representing battle was exacerbated by controversy and confusion about the meaning of the war as a political and moral event. Four years of brutal fighting, half a million casualties, devastation of land and cities: was it "fratricidal conflict," rebellion spawned in conspiracy, holy crusade, struggle between two nations? Except for a minority of abolitionists, Northern leaders deferred as long as possible facing or even naming slavery, let alone race hatred and doctrines of inferiority. The paucity of blacks in the *Photographic History*, or elsewhere in the photographic record, their appearance on the margin of scenes, parallels their status within the mental pictures that screened the mind from the full social and political facts of the war. Somewhere between what the lens depicts and what the caption interprets, a mental picture intervenes, a cultural ideology defining what and how to see, what to recognize as significant. To recover the Civil War photographs as history requires, then, that we first bring unacknowledged mental pictures into focus.

II

The largest mental picture concerned history itself, what it consisted of, where it could be found, how we can know and represent it. "Among the sun-compellers," remarked *The New York Times* in November 1862 on the appearance of *Brady's Photographic Views of the War*, "Mr. Brady deserves honorable recognition as having been the first to make Photography the Clio of the war." Clio, goddess of story and retrospection; photography, rendering a frozen present out of each passing moment: what can it mean to hail the camera in the name of the Muse? One meaning seemed self-evident. As early as June 1861, *Frank Leslie's*

Illustrated Weekly announced that "long before the commencement of hostilities we made extensive arrangements for thoroughly illustrating every event that might arise out of the national difficulties," alerted "artists and photographers in all the cities and towns within the probable circle of hostilities," and by the following year had already issued *Frank Leslie's Pictorial History of the American Civil War* with the opening statement: "We conceive that the country advances to the enactment of a page of History."[25] The difference between a page of history and a page of newsprint notably diminished as mass-produced woodcuts (of sketches and photographs) conjoined happily with "national difficulties" to produce the first mass-circulation market for history in the guise of "news."

Especially in the North, the media encouraged a sense of "history" happening here and now, of its consisting of the events themselves. In 1850 Lester's text for Brady's *Gallery* implied a moment of stasis between past glories and a dim, mysterious future. Now the glare of battle dispelled the shadows of the past, and Lester was not alone in anticipating a new crop of heroes to confirm the country as a single nation. War provides the occasion for historical action: "Our nation must be consolidated; and nothing can do it but to create a common interest, whether for attack or defense, the heroism of every nation has been the only sentiment out of which nationality has been created."[26] The early months witnessed an exhilarating sense of opportunity for new moral leadership shared alike by New England patricians like Oliver Wendell Holmes and New York Free-Soilers like Lester.[27] In his First Inaugural Address, Lincoln put the issue with eloquent simplicity:

> The dogmas of the quiet past, are inadequate to the stormy present. The occasion is piled high with difficulty, and we must rise with the occasion. As our case is new, so we must think anew, and act anew. We must disenthrall ourselves, and then we shall save our country. Fellow citizens, we cannot escape history.

The history we cannot escape includes, Lincoln reminded his audience, the common inheritance of past heroism: "The mystic chords of memory, stretching from every battlefield, and patriot grave, to every living heart and hearthstone, all over this broad land, will yet swell the chorus of the Union."

By the same contradictory reasoning—disenthralling ourselves, yet responding to the mystic chords of the memory—photography became Clio. And Mathew Brady the Muse's most devoted servant. The first to organize a corps of field photographers—it included the makers of some of the most memorable Civil War pictures, Alexander Gardner, Timothy O'Sullivan, and George Barnard—Brady was also the first, as

early as 1862, to publish war images in numbered series of album cards, mounted prints, and stereographs: *Brady's Photographic Views of the War*, *Brady's Album Catalogue*, and *Incidents of the War*.[28] So unshakably identified with the Civil War photographs, his name has come to stand for all the war photographers; his actual role was obscured by his fame. He was, in fact, only one of several photographer-entrepreneurs who put a crew into the field—there were thirty-five bases of operation by August 1862, according to one historian[29]—and published the results. Recent research has raised questions about how much credit Brady actually deserves for the pictures published under his imprint—not unimportant questions, but the issue tends to skew his role as Clio's most prominent representative. Brady's name defined the entire project, part symbol, part trademark. As trademark the name possessed legal weight—his album cards, like those of others, carried both a copyright line (often bearing another name, such as "Barnard & [James F.] Gibson," the registered makers of the image) and a clear warning: "The Photographs of this series were taken directly from nature, at considerable cost. Warning is therefore given that legal proceedings will be at once instituted against any party infringing the copyright."[30] Brady's own habit of not always revealing who took the image directly from nature came into question in a falling-out with Alexander Gardner, the manager of his Washington gallery, who left Brady in 1863, and after a stint as official photographer of the Army Secret Service opened his own gallery and formed his own corps of photographers.[31]

Brady's role as Civil War historian evolved in circumstances that were rapidly altering the social and economic forms of photographic practices. The quarrel between Brady and Gardner suggests that the war years witnessed a critical transition in the business of photography. With a growing mass-communication system and the expanded use of photographs by the press, ownership of images became a more pressing matter than in the informal days of the daguerrean studios. The war inaugurated an age of large-scale business enterprises organized on a more rationalized, systematic, and corporate basis than in the earlier days of family businesses or partnerships. With his antebellum point of view, Brady failed to adjust, thinking perhaps that the charm of his name, "Brady of Broadway," would carry him through. But his casual method of giving credit to the maker of the negative, and his even more casual appropriation of any and all pictures he could lay hands on, got him into difficulty. Never a man for strict accounting, he fell into financial straits, overextended himself to finance his war project, and, after the war, could not weather the 1867 depression and went into bankruptcy.

As a medium of communication, photography itself contributed to the modernizing process reflected in its own practices. The photographs offered a new public experience: eyewitness pictures almost immediately after the events. The New York *World* noted in November 1862 that " 'Brady's Photographic Corps' . . . has been a feature as distinct and omnipresent as the corps of balloon, telegraph, and signal operators"— part of a vast, intricate network of military communication which laid the basis for the postwar burgeoning of telegraphic lines and print media.

Views of encampments, harbors, railroads, wrecked cities, battlefields strewn with corpses, enlarged expectations about the medium in a public which had been accustomed to photographs mainly as portraits—though by the late 1850s instantaneous stereographs had begun to introduce novel imagery of everyday life; for example, people in moving crowds on city streets. The public took the photograph at its word, so to speak, and the war pictures as the "real war"—Clio's work. Recently, efforts have been made to identify the site of particular images—"transporting the reader back to the moment of exposure," as William Frassanito puts it, on the assumption that "somewhere on the twenty-five square miles of battlefield at Gettysburg lies the precise location of each and every view."[32] Frassanito's meticulous research uncovered evidence that corpses may have been moved from place to place, that soldiers played dead for the camera.

But does the whole truth represented in the pictures lie in their literal content? They were received as "true" because people believed in photographic "truth." What properly concerns us is that belief, and the more particular beliefs about the Civil War which governed the responses to the photographs. As Frassanito's research reveals, Clio often found herself at odds with the indiscriminateness of the camera—what it would show about a corpse in one position or another. In earlier times the Muse told stories of heroes in hand-to-hand combat, duels fought on fields of honor. While the Muse evoked by Lincoln told of mystic chords sounding the idea of a unified nation, the actual war was less soothing. The Civil War camera disclosed debris strewn about, weary men, slovenly uniforms—soldiers not as heroes but as soldiers. The very advantage of the camera suggested a liability. What the photograph depicted originated, as everyone understood, in the world itself, not in the imagination—even if objects must be moved to realize the photographer's intention. This becomes a liability when the staging of scenes, even scenes of death, suggests the photographer's desire to satisfy a need (his own and his audience's) for order, even that of theatricality.

Making a virtue of stillness, their camera's inability to stop action,

photographers adopted the most obviously appropriate conventions. In the hierarchy of genres in the field of painting, "history" ranked highest and was understood to mean scenes of high drama enacted by symbolic figures. To stage scenes like that of Washington crossing the Delaware would be palpably ludicrous. The minor modes of drawing and sketching, casual and anti-heroic, offered more likely solutions. The sketch conveys life in motion: spontaneous, fluid, quotidian. The artist in his sketchbook does not portray grandeur but gesture, the flair of motion, the changing patterns of subjects unaware of performing a role before an audience. The staged informality often adopted by Civil War photographers thus counted on association with handmade sketches by artists in the field like Alfred Waud and Winslow Homer which were made into woodcuts and popularized in the periodical press.[33]

We "can look," writes Robert Taft, "upon 'Yank' or 'Reb' in the routine of his daily life during his non-sanguinary moments."[34] Not in all the images by any means, but in a significant number, these routines appear to be self-conscious performances, the soldiers acting out the appearance of spontaneity. In the London *Times* review of Brady's 1862 publication—it appeared in two volumes, one of "war-scenes," the other of "portraits," opening with Lincoln "sitting in company with an ink-bottle"—we read of "easy groups . . . creditable to the skill of the artist." The critical British eye notes how "slovenly" the Federal soldiers look, "men with unbuttoned coats, and open collars, and all sorts of head-gear . . . their overalls gathered halfway up the leg." In an extended account of "the most agreeable subject in the volume" of war scenes, the reviewer describes a captured Confederate officer sitting with a Union officer—it is the then Captain George Armstrong Custer—who was a college friend and cousin,

> while a negro boy, barefooted, with hands clasped, is at the feet and between the knees of his master, with an expression of profound grief on his shining face. The Confederate, in his coarse grey uniform, sits up erect, with a fighting, bulldog face and head; the Federal, a fair-haired, thoughtful-looking man, looks much more like a prisoner; the *teterrima causa belli*, who appears to think only of his master, is suggestive enough.[35]

Suggestive, we should add, of a rehearsed pose obedient to an image of servility cherished by soldiers in blue and gray alike.

Not only do staged compositions enact unstated ideologies and betray unconscious wishes; their motifs often clash with countervailing details. The photographs often transmit contradictory messages, the idea of history as heroic action at odds with sheer mundane event. The camera reveals war as earnest indeed—so much so that the pictures Brady

displayed on Broadway in August 1862 had the effect of "a few dripping bodies, fresh from the field, laid along the pavement." "But there is a poetry in the scene," the *Times* continued consolingly,

> that no green fields or smiling landscapes can possess. Here lie men who have not hesitated to seal and stamp their convictions with their blood—men who have flung themselves into the great gulf of the unknown to teach the world that there are truths dearer than life, wrongs and shames more to be dreaded than death . . . Have heart, poor mother; grieve not without hope, mourn not without consolation. This is not the last of your boy . . . [there] is reserved for him a crown which only heroes and martyrs are permitted to wear.[36]

The swift dissolve from corpse to martyr displays the same compensatory logic by which photographers projected a desired motif upon an intractable scene.

The war pictures challenged mental pictures long in place, and photographers strove to keep order and impose coherence. In his memorandum to Congress in 1869 describing his wartime collection, Brady fell naturally into a language of epic recitation: "The pictures show the Battle-fields of the Rebellion, and its memorable localities and incidents: such as Military Camps, Fortifications, Bridges, Processions, Reviews, Siege Trains, Valleys, Rivers, Villages, Farm Houses, Plantations, and Famous Buildings of the South: together with Groups and Likenesses of the prominent actors, in the performance of duty; before and after the smoke of battle; around bivouac fires; in the trenches, and on the decks of iron-clads—the whole forming a complete Pictorial History of our great National Struggle."[37] Another method of keeping details within the bounds of an orderly system of knowledge is evident in the catalogues in which publishers listed their pictures. An 1862 catalogue of "Brady's Photographic Views of the War" opens with "the celebrated collection of portraits, well known in Europe and America, as 'BRADY'S NATIONAL PHOTOGRAPHIC GALLERY,' " a listing whose archival form—its classification by vocation and social type such as "Statesmen, Lawyers, Physicians, & Others," "The Clergy," "The Stage," "Prominent Women"—provides a pattern for the war views that follow. The numbered images are organized chiefly by place—"Views at and near Bull Run," "Views and Camp Scenes near Yorktown" (and sub-classes such as "Views of Groups" and "Views of Batteries"). While the entries for portraits give names and vocations, the war views make do with spare details: "363. Northeast view of Battery No. 1, at Farahold's House, York River, Mounting 5 100-pounds and 1 200-pound Rifled Guns"; "559. Killed at the battle of Antietam."[38]

Publishers like Brady and Gardner understood that, without an

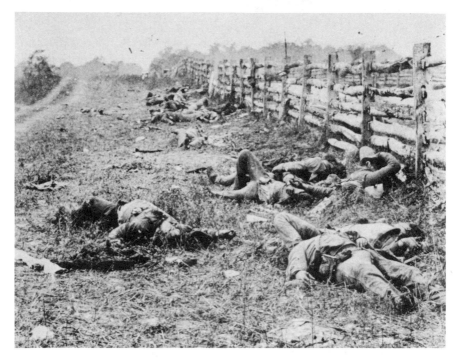

19. "The Dead at Antietam." Possibly by Alexander Gardner. "The bodies of
the dead which are strewn thickly beside the fence just as they fell shows that
the fighting was severe at this point on the bloody day September 17, 1862."
Text from Brady's Lecture Book, plate 84, in Roy Meredith's *Mathew B. Brady*

20. "Pine Cottage," soldiers' winter quarters. Brady collection

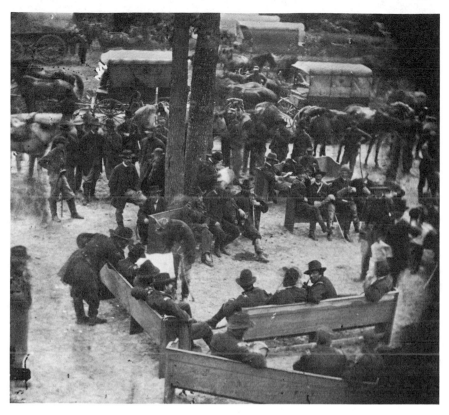

21. An unrehearsed event: Grant's council of war, near Massaponax Church, Virginia. "It has been a disastrous day for the Union Troops; the losses have been heavy, and nothing apparently gained. General Grant is bending over the bench looking over General Meade's shoulder at a map." Text from Brady's Lecture Book, plate 15

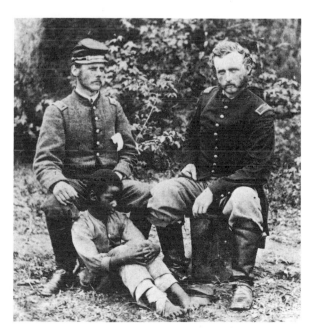

22. Captain George A. Custer (*right*) with a Confederate prisoner and his slave boy

encompassing structure, individual images remained dangerously isolated and misleading. The structure endows each image with what Foucault calls "enunciability," the power to make a meaningful statement. Viewed at random, images lose their power to speak, except inchoately, like the sense-defying experience of battle itself. Organized into a catalogue or sequence, single images can be viewed as part of a presumed pattern, an order, a historical totality. Moreover, in its own prosaic way, by delineating an emergent whole and projecting a totality, the archival catalogue reveals a literary motive: to comprehend this unfolding event as epic in scale and meaning. Brady's 1862 album appeared in just this light. The corps of photographers, wrote the New York *World*, "have threaded the weary stadia of every march; have hung on the skirts of every battle-scene; have caught the compassion of the hospital, the romance of the bivouac, the pomp and panoply of the field-review—aye, even the cloud of conflict, the flash of the battery, the after-wreck and anguish of the hard-won field."[39]

Photographers and publishers understood that their images mediated the daily experience of the war for the populace at home. Whether translated into wood engravings and lithographs in the daily press and in periodicals or offered for sale as freshly made prints, mainly in stereo-card or carte-de-visite format, the photographs were destined for home consumption. Photographers composed their views, edited and arranged their catalogues and sequences, with domestic audiences in mind. If a single term can explain the encompassing form or mode of photographic reporting, it appears in the following account of Brady's 1862 pictures: "They present a panorama of the war," stated *The New York Times*, "faithful as is everything that comes from the studio of the Sun." Panorama implies more than the scale of the event. The term refers explicitly to the tangible panoramas which provided popular entertainment before the war, larger-than-life scrolls of historic battles and famous landscapes unfolded on a stage before a live audience. Staged panoramas gave the illusion of immediacy, the viewer being there— what Dolph Sternberger has called "this mirage of the moment," an illusion, different from narrative continuity, of separate events joined together by their sensuous vividness alone.[40] The panorama provided a conceptual vehicle for the mass of photographs, an implied form into which they fit, or which they were assumed to fill out image by image, in lieu of an integrating story.

The panoramic mirage was most potent in the stereoscope, in its "appearance of reality," as Oliver Wendell Holmes put it, "which cheats the senses with its seeming truth."[41] The stereoscope transformed the

bourgeois drawing room into a theater for private panoramic viewing, spectacles for the pleasure of the hungry eye and the sedentary body. Stereographic views offered spatial illusions analogous to actual panoramas. "I pass, in a moment, from the banks of the Charles to the ford of the Jordan," Holmes wrote, "and leave my outward frame in the arm-chair at my table, while in spirit I am looking down upon Jerusalem from the Mount of Olives." He anticipated that "the next European war will send us stereographs of battle."

> The time is perhaps at hand when a flash of light, as sudden and brief as that of the lightning which shows a whirling wheel stand stock still, shall preserve the very instant of the shock of contact of the mighty armies that are even now gathering.

It is with a certain gleeful expectation of another stereoscopic spectacle that Holmes looks forward to these pictures: "The lightning of clashing sabres and bayonets may be forced to stereotype itself in a stillness as complete as that of the tumbling tide of Niagara as we see it self-pictured."[42] Holmes foresaw that the panorama offered just what was needed for domestic viewing of images of war. Issued in series with accompanying text or caption, stereographs brought the war home to Americans more effectively than other photographic modes, precisely because their illusion of closeness held the war at bay, at the distance of a spectacle performed as if for parlor viewing.

Like the stereograph, the album (from a word meaning "blank") had emerged only recently, an adaptation of the genteel visiting book as a popular form for storing and displaying cartes de visite.[43] The earliest albums offered slotted pages for the insertion of cards within proscenium-like openings, a theatrical frame for portraits which show a greater use of props—drapes, columns, ornamented chairs, and desks and podiums—than was common in the daguerrean studio. Issued in carte-de-visite format as well as larger prints, *Brady's Album Gallery* allowed purchasers to arrange the war views as they wished, or simply to follow the numbers printed on each of the cards. In his catalogue, Brady used topical categories, not temporal sequences, not narratives. Though it is difficult to know how widely the practice was followed, personal albums permitted their owners to assemble sequences on their own, to recompose the order as desired. Like stereographs, album cards allowed the construction of private panoramas. In images captured by the camera and delivered to the public, the war created for the first time a mass audience bent to simulacra of the same illusory scenes.

III

"Let him who wishes to know what war is," stated Oliver Wendell Holmes in the *Atlantic Monthly* in July 1863, "look at this series of illustrations," which, he adds, "we owe to the enterprise of Mr. Brady of New York."[44] They were the same pictures made by Gardner discussed by *The New York Times* in August 1862. The remark launches an extraordinary digression, an irruption of the war within an otherwise jaunty article, "Doings of the Sunbeam," on photography as a process, an industry, and a hobby. Until the Antietam pictures emerged, Holmes had betrayed no particular sense that a war was then in progress, that it was going badly for the Union, that casualties were mounting, that accounts of bloodshed and gore had become commonplace in the daily news—all the more surprising, for Holmes knew of these details firsthand. The previous year he had rushed to the site of the Antietam battle in search of his wounded son, a disheartening experience he had recounted in the *Atlantic* in December 1862. That essay, "My Hunt after 'The Captain,'" described the journey of an anxious father through a landscape ravaged by war. At one point, finding himself in a field where battle had occurred, he decided, like any tourist, to gather "mementos of my visit." He "picked up a Rebel canteen, and one of our own,—"

> but there was something repulsive about the trodden and stained relics of the stale battle-field. It was like the table of some hideous orgy left uncleared, and one turned away disgusted from its broken fragments and muddy heel-taps.

He settles for "a bullet or two, a button, a brassplate from a soldier's belt," and a sealed letter he proceeds to open and read to us: "Tell John that nancy's folks are all well and has a very good Little Crop of corn a growing."[45]

The Antietam pictures of the same battlefield remind him of that earlier experience. "It was," he says in the 1863 article, "so nearly like visiting the battle-field to look over these views, that all the emotions excited by the actual sight of the stained and sordid scene, strewed with rags and wrecks, came back to us, and we buried them in the recesses of our cabinet as we would have buried the mutilated remains of the dead they too vividly represented." Holmes's revulsion at the "terrible mementos," his need to lock them safely away "in some secret drawer" conveniently at hand in his study, leaves a powerful impression— perhaps a delayed reaction to his son's hurt. Like others of his caste (it was he who coined the phrase "the Brahmin caste of New England"),

Holmes had initially welcomed the "war fever," seeing in it a splendid opportunity for "our poor Brahmins" to toughen themselves in the manly arts and better prepare for national leadership (his son would go on to be an esteemed Supreme Court justice).[46] In the *Atlantic* essay on his son, he had kept at bay emotions that welled up at the sight of the photographs a year later—indeed, he remarks that perhaps "some wandering photographer" would take a stereoscopic picture "to show how gracefully, how charmingly," the steeples of Frederick look "nestle[d] among the Maryland hills," and of a "rustic fence" near Elizabethtown, and offer them as additional "mementos of my journey"—as if the grace and charm of the pastoral landscape would make the other sights go away.

Why now, in the "Doings of the Sunbeam," do the photographic "remains" excite such a reaction? *The New York Times* noted, in its review of the same pictures on display on Broadway, that "with the aid of the magnifying glass, the very features of the slain may be distinguished," and described visitors "bending over" more closely to scrutinize the images. We can imagine Holmes in the same posture. Shattering the pleasure of that "dream-like exaltation" and disembodiment of which he had written in an earlier essay on the stereograph, these relics of dismemberment reembodied the viewer as one who "sickens at such sights." As if they were the "mutilated remains" themselves, the images must be buried from sight.

Burial does not come easily. Undeniably, Holmes writes, the photographs represent actuality. Unlike the fallible hand of a human artist, the "honest sunshine" provides at least "some conception of what a repulsive, brutal, sickening, hideous thing" war is. But Holmes finds a way, before shoving them into a "secret drawer," to soften their visual effect. Rather than the recourse to banal sentimentality of the *Times*, Holmes invokes morality, the rectitude of the Northern cause. His logic is worth recapitulating. "The end to be attained justifies the means, we are willing to believe; but the sight of these pictures is a commentary on civilization such as a savage might well triumph to show its missionaries." Is "civilized" warfare, he asks, any less "savage"? No reply is required; the rhetorical effect alone suffices, leading to a counterpoint:

> Yet through such martyrdom must come our redemption. War is the surgery of crime. Bad as it is in itself, it always implies that something worse has gone before. Where is the American, worthy of his privileges, who does not now recognize the fact, if never until now, that the disease of our nation was organic, not functional, calling for the knife, and not for washes and anodynes?[47]

The bringing together of medical, religious, and legal allusions into a single metaphor suggests another way of seeing and using the repulsive photographs of war. By linking war with surgery, the "crime" of rebellion (which surpassed even the sin of slavery) with organic disease, the knife with martyrdom and redemption, the metaphor adds a sacred aura to the photographs. If what is "repulsive, brutal, sickening, hideous" represents surgical martyrdom, then are not the photographs vestiges of symbolic surgery, the remains of the remains—relics of that which we refuse to look at, yet cannot avoid seeing?

What makes these pictures so difficult to look at are not only the shattered bodies flung here and there but what they might portend— the unspeakable question: Was union worth the cost? What must be buried is just such a thought. Indeed, Holmes seeks peace of mind beyond all knowledge of the "real war"—a way of preserving poise, the urbane mark of the Brahmin's supreme cultivation and eligibility for leadership.

After recovering his calm, Holmes continues with the main business of "Doings of the Sunbeam." The essay had opened as a behind-the-scene tour of one of the "principal establishments in the country, that of Messrs. E. and H. T. Anthony, in Broadway, New York"—the publishers of Brady's pictures (including the very Antietam pictures, though Holmes neglects to say so). Holmes wants here to establish "what a vast branch of commerce this business of sun-picturing" has become. The photography trade has become an elaborate manufacturing enter- prise, complete with steam power, mass production, and unskilled wage labor. Observing how albums are manufactured and images mounted in the back rooms of the Anthony establishment, Holmes casts his curious eye upon the "operatives," many of them young women:

> A young person who mounts photographs on cards all day long confessed to having never, or almost never, seen a negative developed, though standing at the time within a few feet of the dark closet where the process was going on all day long. One forlorn individual will perhaps pass his days in the single work of cleaning the glass plates for negatives. Almost at his elbow is a toning bath, but he would think it a good joke, if you asked him whether a picture has lain long enough in the solution of gold or hyposulphite.[48]

Holmes then proceeds to describe in detail his own attempts at exactly those tasks of production which the nature of the assembly line prevents its operatives from learning or even wishing to learn: the preparation and exposure of the wet-plate negative, the development of the negative, and the making of the print. "Every stage of the process," he boasts, "from preparing a plate to mounting a finished sun-print, we have

taught our hands to perform, and can therefore speak with a certain authority to those who wish to learn the way of working with the sunbeam." "Those" are not likely to include, at least as Holmes describes their sullen lack of interest in such matters, the operatives whose labor produces materials and tools which have simplified production to the point that Holmes can remark "how little time is required for the acquisition of skill enough to make a passable negative and print a tolerable picture."

Holmes devotes the second half of this article to particular genres of both stereographs and photographs: landscapes, instantaneous city views, bird's-eye views of cities from balloons, portraits, microscopic and celestial photography, the fad of "spirit" photographs, the growing fashion of unacquainted correspondents exchanging images and developing a "photographic intimacy" as "a new form of friendship"—and the war views. He describes in effect an archive of applications of the technical processes described in minute chemical and physical detail in the first half. All the more curious, then, that he begins to weave into his text allusions to Acheron and Styx and Hades, to speak of "mysterious forces" and "that miracle" of photographic reproduction, as if the knowledge of mass production and its alienated labor resolved itself into the *mystery* of the medium. Like the images of Antietam, so the images of forlorn operatives have been buried in some secret drawer. Both repressions represent a similar refusal of knowledge, a mental picture imposed on incorrigible realities, which themselves refuse to disappear, and remain as specters haunting the site of burial.

IV

Northern photographers and publishers faced the challenge of making visible the mutilations of war without undermining faith in the cause. Holmes acts out the commonest solution: to render the debris of battle as proof of national purpose and rectitude. Another solution was sequential presentation of images—in stereograph series, for example, the number and caption printed on the back linking the scene to an implied narrative of the whole. The published album provided another solution, though more elaborate, costly, and exclusive than the stereograph series.

The most prominent of such albums are Alexander Gardner's *Gardner's Photographic Sketch Book of the War* (1866) and George P. Barnard's *Photographic Views of Sherman's Campaign* (1866).[49] Both Gardner and Barnard had worked for Brady early in the war. Barnard had been a daguerreotypist in Oswego, New York, and after working with Brady

and Gardner in the war, he became the official Union photographer of the Military Division of the Mississippi. Familiar with the writings of John Ruskin, Barnard had published an essay on "Taste" in Snelling's journal in which he insisted, like others in the same journal, that the daguerreotypist be "a cultivated artist."[50] After the war he returned to his trade in Oswego.

The contrast between Gardner and Brady could not have been greater. Intellectual, artist, socialist (a follower of Robert Owen), Mason, and Swedenborgian, Gardner also possessed skills in business management which made him an ideal foil for the more impulsive and intuitive Brady. Already skilled in photography, Gardner emigrated from Glasgow, Scotland, in 1856, intending to join an Owenite community of Glasgow workers in Iowa which he had visited twice. Those plans changed, and in New York in 1858 he sought work with Brady, who hired him at once to manage his new gallery in Washington, where he had briefly maintained a place in 1849. A master of the wet-plate process, Gardner made the Washington gallery an exceptional studio. he also kept it solvent, hiring a bookkeeper, charging fixed prices, and paying his employees on time. Gardner was passionately devoted to the Union cause and to Lincoln, whom he photographed often. Another frequent sitter, Walt Whitman, called Gardner "a man with a big head full of ideas," "mightily my friend," and "a real artist" who "saw farther than his camera." After the war he photographed briefly in the West for the Union Pacific Railroad, set up a "rogues' gallery" for the Washington, D.C., Police Department, but soon turned all his attention to the Masonic Mutual Relief Association—an outgrowth of his sundry interests in social reform and business management—and was president of the association at the time of his death in 1882. Among his generation of photographers, he was doubtless the most many-sided and accomplished.[51]

Gardner's and Barnard's books resemble each other in their unqualified support of the Union and their undisguised hatred of slavery and Southern aristocracy. Both books present their pictures within a tightly controlled framework of political interpretation and cultural affirmation. They differ in method, however. Gardner provides titles and texts for each of the hundred images in the two-volume set (along with the name of the maker of the negative and the print), while Barnard provides images (numbering sixty-one) for a narrative text which he published as a separate booklet with maps. Both works were presented as art books, their richly toned albumen prints mounted on separate pages of heavy paper with handsomely printed titles, and bound in leather. A review of Barnard's book in *Harper's Weekly* noted that "they [the prints]

are splendidly mounted and bound in a single volume in the most elegant style," and remarked that "although, from its expense, the book cannot be popular, those who can afford to pay one hundred dollars for a work of fine art can not spend their money with more satisfactory results than would be realized in the possession of these views." Justifying their expense by the excellence of their printing and bookbinding, both albums set their appeal to an audience, presumably of Republican persuasion, prepared to pay the price. The popular audience, including most war veterans, may have seen the same images as inexpensive stereographs or woodcut reproductions.[52]

Barnard's book covers a specific campaign; Gardner's, the entire war. Gardner places an extended caption opposite each image, while Barnard provides only numbers and titles and counts on the reader to consult the accompanying booklet. While both albums surround their pictures with text, the assumption is that the pictures tell the whole story, are really self-sufficient. Gardner states that "verbal representations of such places, or scenes, may or may not have the merit of accuracy; but photographic presentments of them will be accepted by posterity with an undoubting faith." Barnard's booklet which accompanies the album tells the story of Sherman's final campaign with little direct mention of the pictures. Narrative and maps help the reader to place each picture on the map and within the narrative. No explicit evidence of narrative detail need be present in the actual images—indeed, many are so bare of specifying detail that only the separate text explains their place in the sequence. In telling its story, Barnard's narrative creates a space for images that describe events or the site of an action. Continuity from image to image depends entirely on the parallel narrative. The book requires study, careful reading of the text side by side with perusal of the pictures. On the other hand, Gardner's book disregards narrative continuity; it embraces the broad patterns of fighting and movement in the war as a whole. Barnard recounts events of a single campaign; Gardner memorializes particular places, sites of battles, encampments, the fording of rivers. His captions address specific images, often adding a story or incidental detail. Without maps, without systematic effort to cover all major battles and campaigns, Gardner assumes the reader's knowledge of the shape of events—the popular narrative opening at Sumter and concluding at Appomattox. He begins *in medias res* and proceeds excursively upon a tour of the war in a series of "sketches" only casually connected by chronology.

In a brief preface Gardner explains his wish to preserve as "mementoes of the fearful struggle" images of "localities that would scarcely have been known, and probably never remembered" but are now celebrated

and "held sacred as memorable fields, where thousands of brave men yielded up their lives a willing sacrifice for the cause they had espoused." Like Holmes, he proposes remembrance of "sacrifice" as a way of remembering the dismembered, reuniting the dead with the living. Gardner, too, describes the war as disease and speaks of victory as healing: by memorializing events and places, the images help heal the nation. They offer visual equivalents to victory, and propose a way of reading traces of war on the landscape as sacral signs.

Through an elaborate title page and engraved vignettes of camp scenes, Gardner's book sets in place a mental picture embodied in the term "sketch book." With its allusion to the quick, incisive firsthand impressions made by pen or pencil, "sketch book" implies a certain latitude of structure, a casual pace, the detachment of an unhurried observer: a posture quite different from that of a wet-plate photographer in the field. The panoramic vista of the title page supposes an aesthetic unity in what follows, a view to which the reader is invited as eyewitness as if from above: camp life to the right, battle to the left, the draped flag framing the vista. And in the setting sun the vista glimpsed at bottom center suggests that the war and the nation remain in the embrace of "nature" and its cycles—the healing process of time which transforms pain into sacred memory. Moreover, the images on the title page depict military hierarchy, the officer on the right and the mounted figure on the left clearly social superiors to foot soldiers and diggers of trenches. In the two figures lounging in the foreground, however, we catch a glimpse of another order of social relations among men: wilderness, campfire, male comrades swapping tales, the rifle cradled at rest. With its conventional icons the title page suggests a structure for the pictures which follow—a place for soldiers, officers, war, and nature.

Gardner's captions opposite each picture provide assistance to the reader who may not see the image exactly in the light intended by the editor. Plate 19 shows "Antietam Bridge, Md., September, 1862." We see four covered wagons on a rude stone bridge reaching diagonally across the middle of the scene, a wooden picket fence and the sloped shingled roof of a small building in the front, farmhouses and trees clustered at the far end of the bridge, and a few soldiers relaxing on the bridge, barely specks but apparently watching the photographer. The sun is bright; shadows suggest it is early morning. The text tells us that this

> is one of the memorable spots in the history of the war, although but little suggestive in its present sunny repose, of the strife which took place

near it, on the day of the battle of Antietam. Traces of the engagement are evident in the overturned stone wall at the far end of the bridge, the shattered fences below the farmhouses, and the down-trodden appearance of the adjacent ground.

We learn what happened "on the night of the 16th of September" when "the Army of the Potomac captured this bridge after a sharp fight"; then that General Meade made his headquarters near there many months later, in July 1863, after the battle of Gettysburg, and that "very little now remains to mark the adjacent fields as a battle ground." The text interprets the image for us as a trace of past events and concludes: "Houses and fences have been repaired, harvests have ripened over the breasts of the fallen, and the ploughshare only now and then turns up a shot, as a relic of that great struggle." The "sunny repose" the caption invites us to see in the image signifies, then, a series of events leading from a violent past to a future of restored pastoral peace. The caption makes the otherwise uneventful image into a significant "relic."

Plate 16, "Inspection of Troops at Cumberland Landing, Pamunkey, Va., May, 1862," presents another kind of textual problem: how to reconcile anti-heroic detail with heroic meaning. The text begins by describing "one of the most magnificent spectacles ever seen in the army," the massing of troops upon a "barren" field "converted . . . as if by magic, into an immense city of tents." "From the hill above Toller's house," we learn, "the scene was truly grand," including a river which reflected the martial spectacle "like a mirror." But what we see is not that view. By way of apology, the caption provides a detailed reading of the image and offers a perspective on the discordance:

> Our picture, interesting as it is, gives but a small portion of the gorgeous whole. The prominent object is a mud-bespattered forge, the knapsacks and blankets of the farriers carelessly thrown on the ground beneath. In the middle-ground are some mules picketed around the wagons, hard-working, much-abused creatures, and so humorous in their antics that they are often termed the comedians of the army. Further on, a guard, their muskets stacked and knapsacks laying around. Past these, a cook sitting on a mess chest, close to the ashes of his fire, near which are the camp-kettles and a pile of firewood. On the edge of the wood the Fifth New York Volunteers, Warren's Zouaves, have encamped, and in front of them a regiment of infantry are drawn up in column of companies. As these are formed in open order, it is most likely that they are on inspection drill. Such pictures carry one into the very life of camp, and are particularly interesting now that that life has passed away.

The mud-spattered forge (symbol of the mechanical fire and brimstone of this war) and the mules bring the picture to life as a comic version of an absent "gorgeous whole." The disjunction between the gorgeous

and the mundane parallels Melville's sardonic insight in his "A Utilitarian View of the Monitor's Fight"—that "Orient pomp" no longer befitted a war fought by machines, "by crank, / Pivot, and screw, / And calculations of caloric." "The clangor of that blacksmiths' fray" resounds with the message that "warriors / Are now but operatives." The covert text within the picture suggests, then, less a missing "whole" than a wholly new picture: less of pomp and ceremony, more of mud, mules, and forges.

To better weigh the effect of text upon picture, compare one of Gardner's captions with one in the *Photographic History*. There, plate 4 of Gardner's *Sketch Book*, "Stone Church, Centreville, Va., March, 1862," appears as "Eve of the Conflict." The 1911 text describes it as a scene of troops en route to battle:

> Past this little stone church on the night of July 20, 1861, and long into the morning of the twenty-first marched lines of hurrying troops. Their uniforms were new, their muskets bright and polished, and though some faces were pale their spirits were elated, for after their short training they were going to take part, for the first time, in the great game of war.[53]

The text weaves the image into a narrative of the "eve" of the first battle of the war, a moment of lighthearted innocence, laughing young soldiers "hardly realizing in the contagion of their patriotic ardor the grim meaning of real war." The picture shows something else. We can hardly tell what the ten men visible in the image are doing except looking at the camera somewhat above them. The blurred figure on the left tells us that the exposure was of long enough duration for his movement to be recorded, while the others are more successful in holding their poses. The country looks poor, the rutted road looking like a considerable challenge to the cart behind the line of soldiers. The bare and stony foreground conveys a sense of barrenness—strange for July. It is not a scene merely stumbled upon, but chosen by a photographer who wanted us to see something, though the 1911 text in the *Photographic History* leaves in the dark what that might be.

The Gardner text is more explicit in detail. We learn that the image was made in March 1862 in the early spring, almost a year after Bull Run, and that the "Stone Church" is the center of interest. Gardner again resorts to the natural cycle, portraying the village as "perched upon the gentle slope" of a ridge, "looking across fertile fields," "an odor of wild roses and honey-suckle about it, and a genial hospitality to welcome the stranger." But "war crushed" the pastoral village, and "scarcely a vestige of its former self remains." Armies have passed through, leaving behind rifle pits, redoubts, and graves. "Guerillas have swarmed about it, cavalry have charged over its untilled fields, and

demoralized divisions have bivouacked for roll-call behind its hills." What we see are vestiges of history: the rutted road, the rocks lying about, a deserted town inhospitable to the soldier-strangers. Although the description is specific to this town, it provides a symbol for the war itself: a disruption of the peaceful self-contained world which was the American countryside. Gardner's text saturates the image, encouraging the viewer to incorporate its details into a generalized narrative of war as a disruption of nature.

Image and text seem harmoniously combined in the book's most famous picture, perhaps the most frequently reprinted of all Civil War photographs: Timothy O'Sullivan's "A Harvest of Death, Gettysburg, July, 1863" (plate 36). The title alone transposes the image from the specific to the general, to allegory and hortatorical statement: horse and rider dimly seen in the rear as the Grim Reaper materialize as if from the mist of battle.

> Such a picture conveys a useful moral: It shows the blank horror and reality of war, in opposition to its pageantry. Here are the dreadful details! Let them aid in preventing such another calamity falling upon the nation.

The text reads the blankness, writes itself upon the scene. Fixed in their final agony, the corpses seem self-memorializing; stone shafts and carvings will shortly replace them as site markers of the horror of Gettysburg. As the caption interprets it, the O'Sullivan picture embodies the central motive of the *Sketch Book*—to transform scenes of war into sacred memories, into monuments. Appropriately, Gardner's album concludes with an image not of Appomattox but of the "Dedication of Monument on Bull Run Battle-field, June, 1865" (plate 100). The monument, a classically modeled stone reminder of the stiff and bloated bodies on the field, parallels the function of the photographs themselves. The image shows not only the stone shaft in the rear but those participating in the dedication ceremony immortalized as they stand obediently for the picture.[54]

The Barnard pictures also monumentalize, though their subject is not so much "Union" or victory as Sherman himself.[55] The narrative celebrates the general as a visionary who grasps the plain logic of war: destroy the enemy. Proceeding ineluctably from the opening studio portrait of "Sherman and His Generals" to the concluding image of devastation in "Ruins of the Railroad Depot, Charleston, S.C.," the march of images creates the illusion of an unstoppable force overturning everything in its path. Not the force of righteousness or political rectitude, but naked military power—superior numbers, weaponry, and communications. Barnard does without Gardner's moralist rhetoric. In

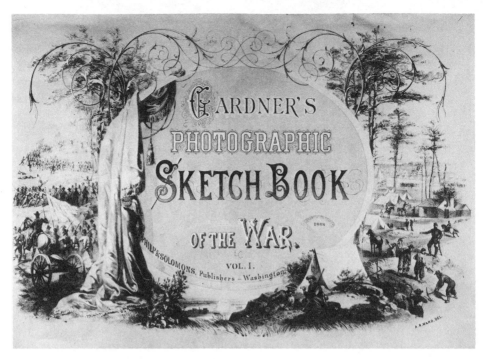

23. Title page of Alexander Gardner's *Gardner's Photographic Sketch Book of the War*

24. "Antietam Bridge, Md., September, 1862." Photograph by A. Gardner. *Gardner's Sketch Book*, plate 19

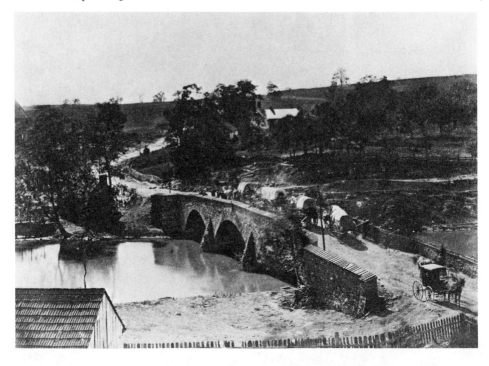

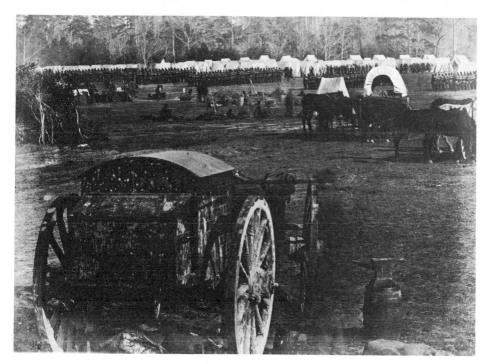

25. "Inspection of Troops at Cumberland Landing, Pamunkey, Va., May, 1862."
Negative by Wood and Gibson; positive by A. Gardner. Gardner's *Sketch Book*, plate
16

26. "Stone Church, Centreville, Va., March, 1862." Negative by Barnard and Gibson;
positive by A. Gardner. Gardner's *Sketch Book*, plate 4

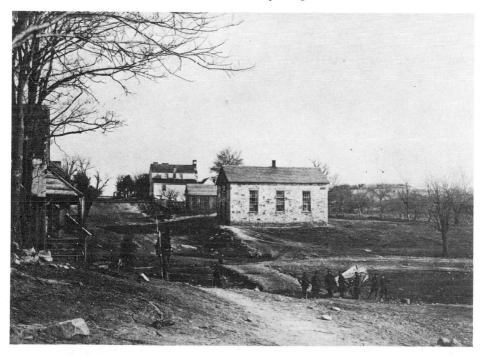

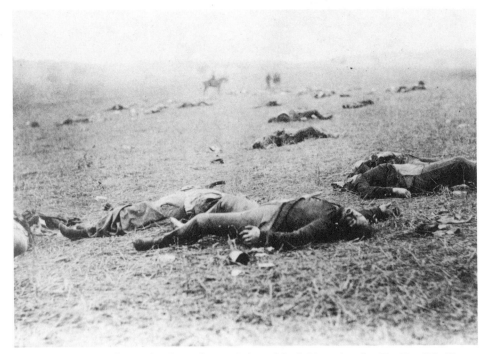

27. "A Harvest of Death, Gettysburg, July, 1863." Negative by T. H. O'Sullivan; positive by A. Gardner. Gardner's *Sketch Book*, plate 36

28. "Dedication of Monument on Bull Run Battle-field, June, 1865." Negative by W. Morris Smith; positive by A. Gardner. Gardner's *Sketch Book*, plate 100

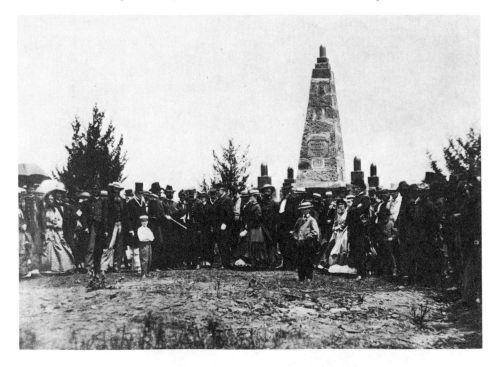

its place, a celebratory narrative and a visual rhetoric link each picture into a corresponding sequence. Shifts in camera point of view between juxtaposed pictures, for example, anticipate the shot-reverse-shot technique of cinema—one image shows a scene from a particular point of view; the next takes up a position within that scene, looks back, and makes a scene of the camera position of the first shot. We see this technique in plates 2 and 3, images of the Union staging ground at the capital at Nashville from where Sherman launched his devastating attack at the heart of the Confederacy. The dual perspective achieves a sense of space and motion; a visual site possessed parallels the narrative's message that the Union had retaken the South's "city on the hill." We not only gaze on the captured capital with pride, but we look out from it—the prerogative of victors. We survey the enemy's domain, following the line of sight of the cannon trained upon it.

Capturing the capital restores the building's neoclassicism to the Union, to a political idea enforced by guns and cameras. From the exchange of perspectives we proceed in plate 4 across a trestle bridge hastily erected by the First Michigan Engineers and the Railroad Construction Corps on the ruins of a stone bridge destroyed by the retreating enemy—a symbolically apt instance of Union skill replacing an older masonry structure with a new industrial form—into the wild landscape of the following pictures, and then to the ruins of Atlanta, Columbia, and Charleston. The concluding two images of the album show the destination to be not a physical site alone but a symbolic moment foretold in the opening picture of Sherman and his staff and the following images of the capital at Nashville. Here Barnard expresses fully his gratification at the fall of the slave South. Southern classicism in ruins echoes the devastation of the landscape. The penultimate image, plate 60, places two figures by a mirroring pond in the midst of ruins, as if contemplating the fall of empire. The final image supports this literary "rise and fall": the damaged railroad depot resembles a ruined Roman aqueduct in a desolate landscape. Thus by symbol as well as narrative the book asserts triumphant the victory of the North, its industrial trestles prevailing over decadent Southern porticoes.

Barnard's pictures accord with the message—the celebration of the North's modern, rationalized system of warfare. Sherman and his officers represent this hierarchical system. The striking paucity of soldiers and the absence of corpses in the pictures reinforce the implied presence of an abstract, strictly disciplined system. Barnard's pictures all but banish common soldiers from sight, an absent community. The text opens with a Homeric catalogue of generals under Sherman, and identifies armies

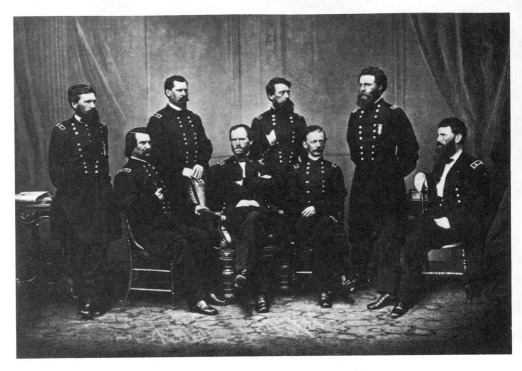

29. "Sherman and His Generals." George Barnard, *Photographic Views of Sherman's Campaign,* plate 1

30. "The Capitol, Nashville." George Barnard, plate 2

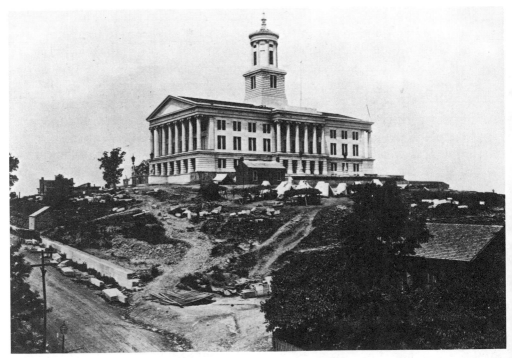

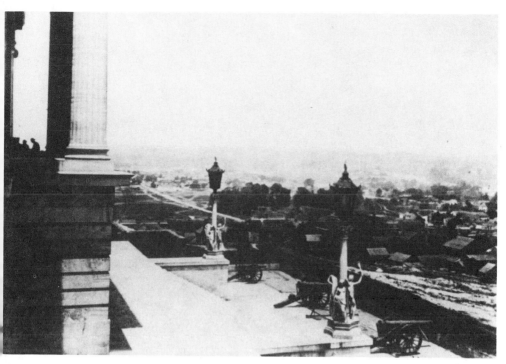

31. "Nashville from the Capitol." George Barnard, plate 3

32. "Trestle Bridge at Whiteside." George Barnard, plate 4

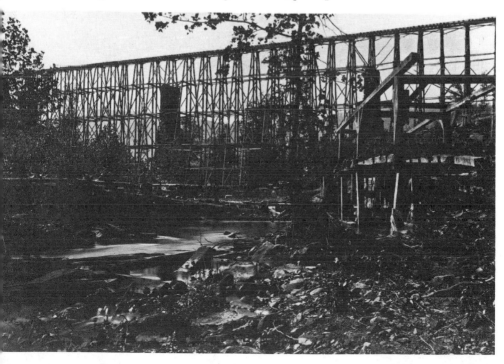

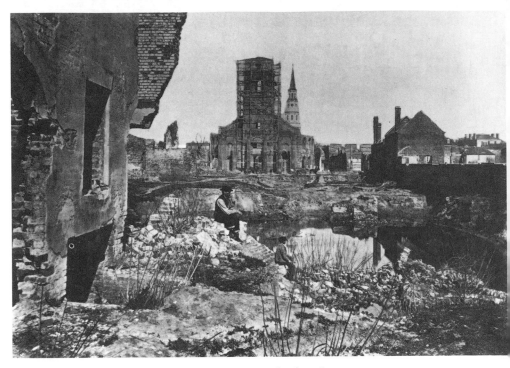

33. "Ruins in Charleston, S.C." George Barnard, plate 60

34. "Ruins of the Railroad Depot, Charleston, S.C." George Barnard, plate 61

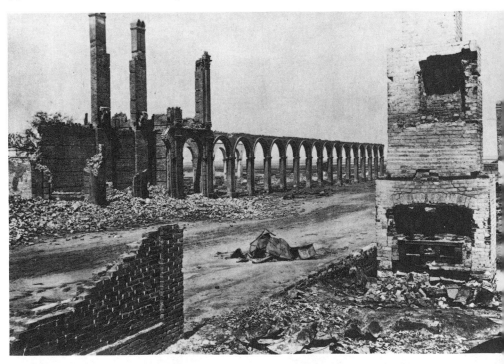

and smaller units by the name of their commanding officer—not unusual, but a sign of the new prestige which accrued to the officer corps during the war and which presaged postwar changes in the organization of businesses, industries, and private institutions. Former generals would become the heads of companies, and in the case of Grant, of the government itself. Barnard's portrayal of Sherman indirectly links the general's refinement of the system of subordination and obedience to the rise of a new industrial discipline.

War photographers took subjects other than battlefield combat. A little-known album of pictures by an official Army photographer, Captain A. J. Russell, offers an illuminating counterpart to the commercial products of Gardner and Barnard. Russell, born, like Brady, in upstate New York, had been a landscape and portrait artist in the 1850s and in the early days of the war produced a diorama based on engravings made from the Brady camp and battlefield scenes; he exhibited his "Panorama for the War for the Union" in the winter of 1861–62, and by the fall of 1862 had joined the Army as a commissioned officer. He was assigned as photographer-artist to General Herman Haupt's Construction Corps, U.S. Military Railroad. Russell also made photographs of other operations and scenes in the vicinity of Washington. He seems to have worked without much contact, if any, with Brady and Gardner. After the war he had a career as railroad photographer for the Union Pacific in the West.[56] *Photographs Illustrative of Operations in Construction and Transportation* (1863), an instruction manual by Haupt, who before the war had built the famous Hoosac Tunnel in Massachusetts, covers "experiments made to determine the most practical and expeditious modes to be resorted to in the construction, destruction and reconstruction of roads and bridges." The lengthy subtitle explains that the manual would be "sent to officers on command of Departments, Posts and Expeditions, with a view to increase the efficiency and economy of the Public Service, and especially to suggest expedients whereby our own communications can be most readily preserved and restored, and those of the enemy most rapidly and effectually destroyed."[57] Each of Russell's photographs is keyed by number to Haupt's text, which in turn refers to the image: "No. 1—Illustrates a mode of transportation which was adopted with great advantage on the Potomac in establishing a communication between Alexandria and Aquia Creek. It can be used to connect the various roads which have their termini on navigable rivers . . ." Some of the photographs are close-up views of tools or parts of rafts and bridges, or torpedoes for wrecking them. Work is the theme, the photographs representing particular tasks and tools. Most are scenes

35. "Twisting rails on Confederate railroad lines." H. J. Russell, from *Photographs Illustrative of Operations in Construction and Transportation*

36. "Wrecking device."
H. J. Russell

37. "The blanket or pontoon boats used during Civil War designed by General Herman Haupt." H. J. Russell

of actual labor, construction (or destruction) crews frozen in the performance of an act named and described in the text and made comprehensible as part of the larger picture of the construction and destruction of railroad systems. There is no narrative, no memorializing—only a sequence of photographs illustrating tasks and tools of labor.

The pictures visualize steps in certain procedures—the industrial skills and transportation-communication infrastructure by which the North eventually wore down the less industrialized enemy. The text reflects, moreover, the mentality of calculation and measurement which would turn after the war to improvements in industrial production, especially of a national railroad system, and to the disciplining of a work force:

> Forty men, working in pairs, with the material placed in front of them (see No. 70), put together twenty frames in sixteen minutes, and several of the pairs finished their frames in eight minutes. No. 71 represents the frame partly, and No. 72 entirely, finished. From five to eight minutes were consumed in tying on the blanket. From two to four minutes were required to untie and take off blankets. Five minutes were found sufficient to take frames apart and pile the sticks.

The passage anticipates the techniques of time-study refined more than two decades later by Frederick Winslow Taylor.

It is clear from the Haupt–Russell album how the Civil War served as a proto-industrial experience, introducing a new scale in organizational systems and overturning older individualistic and local patterns.[58] Not intended for a public audience, the album does not bother with high rhetoric or "Orient pomp." As unencumbered "illustrations," the photographs show actions and objects in order to demonstrate general principles of railroad construction in wartime. The text aims only at efficient production, not ideological correctness. All the more significant, then, that the Haupt–Russell pictures should also help establish a fact ignored or barely glimpsed in the other albums: the role of free black laborers in the Union effort. Of course, the presence of black laborers in the pictures is incidental. The Russell pictures simply show black men as part of a labor force—an industrial vision, not an abolitionist's.[59]

Compare Gardner's few pictures which include blacks. Plate 27, "What do I want, John Henry? Warrenton, Va., November, 1862," shows a staged scene in which a black youth stands beside a seated officer, poised to serve him a demijohn of whiskey and a plate of food. As if oblivious of his presence, three other figures, also white officers, appear in poses suggestive of the studio, their eyes sliding off at an angle oblique to the camera. The standing figure may be looking at the transaction between the black servant and his officer, though we cannot tell. The picture makes little effort to hide its stiltedness: the performance of a little scene between a master and a servant. The text provides the script. An officer asks, "What do I want, John Henry?" and the other, "that affectionate creature," offers hard liquor, which is what "his untutored nature" always suggests. The rest of the sketch fills out the portrait of "an unusual capacity for the care of boots and other attentions," a propensity for master's "spirits" and for "the other sex," and a distaste for "manual labor."

This stereotype would survive the war and provide a new rallying cry for union of North and South, as in the 1911 *Photographic History*. It appears scattered among the Civil War photographs at large. So do clusters of black refugees on the edge of Union Army camps, "contraband" (as former slaves freed by Union forces were known) gathered at depots, and portraits of black Union soldiers. On the whole, just as Northern rhetoric emphasized the cause of "Union," called the enemy "rebels" rather than slaveholders, and made the defeat of secession rather than slavery the most prominent war goal, the photographic record tends to banish blacks to the margin of visibility—their presence unacknowledged even when plainly there. The text attached to plate

94, "A Burial Party, Cold Harbor, Va., April, 1865," offers this mental picture:

> This sad scene represents the soldiers in the act of collecting the remains of their comrades, killed at the battles of Gaines' Mill and Cold Harbor. It speaks ill of the residents of that part of Virginia, that they allowed even the remains of those they considered enemies, to decay unnoticed where they fell. The soldiers, to whom commonly falls the task of burying the dead, may possibly have been called away before the task was completed. At such times the native dwellers of the neighborhood would usually come forward and provide sepulture for such as had been left uncovered.

Black troops cleaning up after those assigned "the task of burying the dead" may "possibly" have been called away. This image is Gardner's only acknowledgment, although the caption remains silent on the point, that the Union forces included former slaves—though the menial role performed here remains the starkest effect of the picture.[60]

The image resonates beyond text and frame, its grim ironies and bizarre revelations suddenly flashing before us the "remains" Holmes wished to bury: decomposing flesh and bleached bones of the dead attended by those very humans whose claim to full humanity represented an aim of the war repressed during the war itself. In a gesture so simple it eludes the author of the text, the two grand invisibilities of the war realize themselves here as one image: death as decomposition and dissolution; blacks laboring in once pastoral fields, reaping an even grimmer harvest than that envisaged in the biblical expression of "Harvest of Death." The grim image and its equivocal text show how the victors cleaned the war of its horrible debris, which continues to haunt the site of burial and monuments.

V

"None can narrate that strife in the pines," writes Melville in "The Armies of the Wilderness (1863–1864)":

> A seal is on it—Sabaean lore!
> Obscure as the wood, the entangled rhyme
> But hints at the maze of war.[61]

Of course, war will always seem a "maze," and representation inadequate. But Melville sees this as a particular difficulty for the American mind. The war was a "tempest" "bursting from the waste of Time / On the world's fairest hope, linked with man's foulest crime" ("Misgivings"). In *Battle-Pieces* he yokes together fair and foul, hope and crime, contraries

38. "What do I want, John Henry? Warrenton, Va., November, 1862." A. Gardner, plate 27

39. "Residence, Quartermaster Third Army Corps, Brandy Station, December, 1863." A. Gardner, plate 52

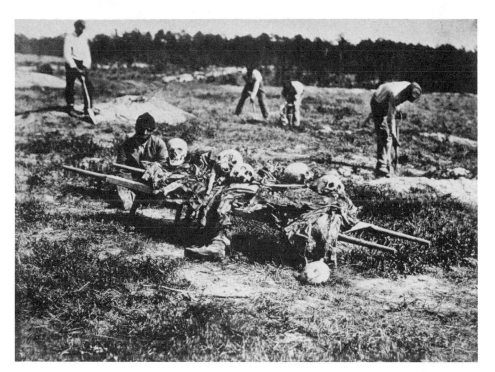

40. "A Burial Party, Cold Harbor, Va., April, 1865." A. Gardner, plate 94

through which he hopes to place the events of the war within the perspective of time and politics. The "Founder's dream," for example, rests upon "slimed foundations": not only the coexistence of freedom and slavery but also the callowness of the enthusiasm aroused by the crusade to put down the rebellion: "All wars are boyish, and are fought by boys, / The champions and enthusiasts of the state." Innocent emotions vent themselves in violence so destructive that, in "Armies of the Wilderness," the terrain itself is "Tramped like the cindery beach of the damned— / A site for the city of Cain."

Melville never doubts that the Union represents the forces of "Right," and that slavery is a crime against humanity. But he also observes, as few others did, that the Northern victory followed upon a military "scheme" that fused calculation and violence: "The resolute scheme of a heart as calm / As the Cyclone's core"—a combination whose implications for the future of the Republic he feared. Calm and cyclone, hearth and war: these are among the countless contradictory forces Melville lets loose in his book, summed up in the image of a "wind in purpose strong" which "spins *against* the way it drives" ("The Conflict of Convictions"). This perception leads to another vision:

> Power unanointed may come—
> Dominion (unsought by the free)
> And the Iron Dome,
> Stronger for stress and strain,
> Fling her huge shadow athwart the main.

It is an image of a new ship of state made of iron, like the new iron-clad battleships, and the new capital dome in Washington.[62] Glimpses of that dome appear throughout *Battle-Pieces*, symbol only of a new political order.

Melville makes a link between the problems of depicting this war and the ambiguous consequences for the Republic of its unleashed violence and centralized military-political power. He constructed his book of poems to suggest "a whole" (as he says in the preface) made up of separate incidents and events, arranging the poems to follow the order of events themselves. To convey the variety of mood and feeling represented by the events, chiefly scenes of battle, he uses a great variety of poetic modes, from narratives in ballad form to lyrical songs and requiems. Reading the book offers a difficult experience, particularly in 1866, the wounds still too fresh for the public to accept ironical reflections in place of sentimental emotion. *Battle-Pieces* expresses the perception, rare in 1866, that the battles of Shiloh and Antietam and the Wilderness made older sentiments obsolete. And the pleasure of victory, the welcome defeat of slavery, was not unmixed with foreboding about the future of the Republic. The difficulties Melville perceived in the war as a whole make themselves felt in the difficulties of reading his book.

Melville's response stood apart from the celebrations of victory, and the belief in its restoration of the old America snug and secure in the bosom of nature, which Gardner's book conveys. History proved Melville the wiser American. The war had sped the modernizing process, not only in heavier and more mechanized industrialization but in the political character of the nation. It brought into being a full-scale central state, with new powers of controlling currency, direct taxation, universal conscription, and the redefinition of citizenship, so that all Americans became subjects of the *national* state. The war destroyed not only slavery but the only area of "premodern" resistance to capitalist expansion. Seen in this light, as Eric Foner has argued, "the Civil War was, at its base, a struggle for the future of nation"—to retain its rural past (tragically compromised by slavery), or push into a future of centralized power based on a national market system. Foner and other historians suggest that neither side in the war understood fully what the war was about; each fought, in Foner's words, "to preserve a society it thought

was threatened" by the other side. For Lincoln it was the way of life of the independent artisan-entrepreneur, threatened by the spread of slavery. He did not realize that another threat lay within his own rhetoric of free enterprise and individualism—the economic forces unleashed by the war transformed the Republican slogan of "free men" into freedom for unrestricted capitalist expansion, and an end to Lincoln's utopia. Waging total war to defend an old America, Lincoln assured its demise. Thus, Foner concludes shrewdly: "Here, indeed, is the tragic irony of that conflict. Each side fought to defend a distinct vision of the good society, but each vision was destroyed by the very struggle to preserve it."[63]

The Civil War remains a paradox in the American experience, and the photographs play a role in the struggle for comprehension which continues. There is yet another role they have played, which may point to another kind of reading as well.

In *Specimen Days* Walt Whitman wrote plainly of suffering, of his efforts as a nurse at the front and in Washington hospitals to comfort and help. At Falmouth, Virginia, after the battle of Fredericksburg in December 1862:

> December 23 to 31.—The results of the late battle are exhibited everywhere about here in thousands of cases, (hundreds die every day), in the camp, brigade, and division hospitals. These are merely tents, and sometimes very poor ones, the wounded lying on the ground, lucky if their blankets are spread on layers of pine or hemlock twigs, or small leaves. No cots; seldom even a mattress. It is pretty cold. The ground is frozen hard, and there is occasional snow. I go around from one case to another. I do not see that I do much good to these wounded and dying; but I cannot leave them. Once in a while some youngster holds on to me convulsively, and I do what I can for him, at any rate, stop with him and sit near him for hours, if he wishes it.[64]

Or on his rounds in the Armory Square hospital in Washington:

> One young New York man, with a bright, handsome face, had been lying several months from a most disagreeable wound, receiv'd at Bull Run. A bullet had shot him right through the bladder, hitting him front, low in the belly, and coming out back. He had suffer'd much—the water came out of the wound, by slow but steady quantities, for many weeks—so that he lay almost constantly in a sort of puddle—and there were other disagreeable circumstances. He was of good heart, however. At present comparatively comfortable, had a bad throat, was delighted with a stick of horehound candy I gave him, with one or two other trifles.[65]

Occasionally, as when he describes "the camps of wounded" after the battle of Chancellorsville (the unnamed site of Crane's *Red Badge of*

Courage), Whitman's tolerance seems to break: "O heavens, what scene is this? is this indeed *humanity*—these butchers' shambles?" Such camps were but "a fragment, a reflection afar off of the bloody scene." Such the results of this war: "no fancy battle, no semi-play, but fierce and savage demons fighting there"—Melville's mad cyclone.[66]

Mutilated remains eventually found burial and a place in memory, but living mutilations remained in view. Amputees and shrapnel-filled veterans who returned from battle with less of a body than they brought to it presented another challenge. Neither popular albums nor stereo views offered these sights, perhaps the hardest of all to apprehend. But stored in medical libraries are albums of another sort—volumes of carte-de-visite or the somewhat larger cabinet-size pictures of the wounded. The pictures were made for the record, for use in medical schools and hospitals—clinical images often accompanied by descriptions on the back.[67] One purpose was to assist surgeons in the field in developing techniques to deal with certain cases; another was to put together a collection for the Army Medical Museum. Most were made in Army hospitals in Washington and elsewhere, others at a later date during examinations connected with disability payments. In some cases doctors themselves took the pictures, but they were made mostly by hired photographers such as William Bell, who after the war would serve, like Timothy O'Sullivan, as a survey photographer in the West.

Unknown, unseen, ignored in histories of American photography, the pictures exert a power and effect like that of the Zealy daguerreotypes. The men appear as sullen objects of scientific attention, as if detached from their bodies, witnesses rather than possessors of their wounds and scars, their memory and knowledge of pain. They watch themselves being watched, scrutinized for a formal medical record on which may depend a monthly benefit for disability. Their detachment from themselves, the objectification of their bodies even in their own eyes, is evident from the absence of embarrassment at dropped trousers to display a scar on the thigh near exposed genitalia, at missing legs or arms—or wounds still gaping in stomach or back or neck. The men are posed in a fashion that alludes to the studio situation, yet the pictures resemble bureaucratic identification pictures or mug shots—a registry of faces and bodies which tell a different story of war from that configured in the better-known albums. In addition to bodies eloquent with the effects of battle, we see soldiers in an elemental relation of dependence on the state for which they sacrificed bone or flesh or organ: a name, a number, a clinical legend. Installed in the ovals reserved for honored portraits, these images lend another meaning to the notion of illustrious Americans. Showing what was more difficult to

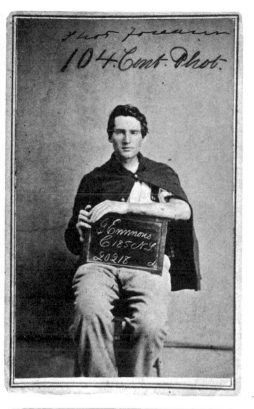

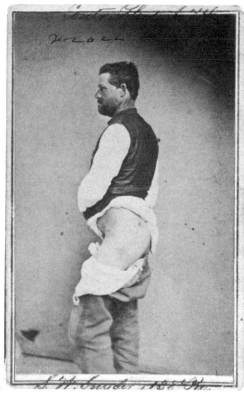

41. (*Above left*) "Shot forearm." Medical record photograph

42. (*Above right*) Flesh wound of hip. Medical record photograph

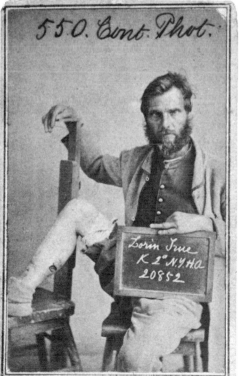

43. (*Left*) Flesh wound of leg. Medical record photograph

see and acknowledge than the grisly remains of corpses soon transfigured into stone monuments, these are the most unforgettable of the albums of war. They disclose the most immediate and least comprehensible of war's facts, that it is waged on tangible human flesh and inscribed in pain—the living wounded body as the final untellable legend.

Naming the View

Beneath our America lies buried another distinct continent,—an archaean America. —CLARENCE KING, *Systematic Geology* (1878)

I

SOMETIME in 1870 Clarence King, the brilliant young geologist then at the head of a government survey in the deserts and mountains of the Southwest, paused from his labors to fashion a charming Christmas gift for his half sister Marian and two of her friends. A small, ornamented volume of twenty-two pages, the gift book includes two poems set in type, two letters in his own hand reproduced by lithography, and twelve mounted albumen photographs (including the frontispiece). The photographs appear anonymously, though they were made by Timothy O'Sullivan, official photographer with King's survey party. King called the book *The Three Lakes: Marian, Lall, Jan, and how they were named.*[1] The two letters, "My Dear Marie" and "Dear Lall and Jan," tell how King journeyed through a dark cavern to the top of a mountain, found the lakes, and bestowed the girls' names on them, wind, trees, and rocks sighing their approval. Each of the poems describes the setting in words of myth—a "stone giant's bowl," an "ice dragon's nest," both situated "where the heart of America rises," and "trains of emigrant people" patiently move across the desert, "seeking forever the sunset." In a sequence at the end, the photographs tie the two events in a single consecutive narrative.

Including three of King himself in survey attire, each of the images can be identified from other sources as a survey photograph. Here they serve to visualize moments in the fairy-tale naming of three lakes in the mountains of Utah. Including the frontispiece, three of the pictures are

titled Lake Marian (two of them, captioned "East Humboldt Mountains," appear in a unique volume of photographs O'Sullivan assembled in 1868–69), three Lake Lall, two Lake Jan. The titles of the remaining four photographs refer to the stories recounted in the letters: "My Tent" (the same image captioned "Headquarters, Explorers, Salt Lake" in the 1868–69 album), which shows King seated by a table in his tent door, his black servant, the "good Jim" who saddles up the mules in the first letter, standing nearby; "The Dark Cañon" (the same image elsewhere is titled "Carboniferous limestone E. Humboldt Mt., Nevada, 1600 ft. deep"), which in the first letter "grew dark and narrow, its huge rocky walls towering up against the sky and covering us in deep gloomy shadows"; "Taking Breath," which corresponds to: "I tied my climbing rope and went down hand over hand like a sailor, but it was tiresome and when I found a chink I put my foot in it and rested a moment"; and the concluding picture, "Bivouac," which corresponds to: "As I cooked my solitary supper that night 'Minnie,' who was tied in the pines, looked wistfully through the falling snow . . ."

"What a pleasant joke it all was," King writes in the first letter in the book—a *jeu d'esprit* for three little girls. Slight and fanciful, the book captivates our attention not only for the glimpse it provides of the scientist King's versatility—his friend Henry Adams regarded him as "the most many-sided genius of his day"[2]—but for the tantalizing thought that, however obliquely, the romance may mirror certain features of the government survey upon which King and O'Sullivan were then engaged. On the face of it, this seems improbable, although the fanciful story of naming three lakes bears some (if distant) analogy to King's account in *Mountaineering in the Sierra Nevada* (1872) of the ascent of Mount Tyndall, which also refers to a "sublime white giant," "that old dragon's track"—and concludes: "I reverently named the peak Mount Tyndall."[3] *The Three Lakes* casts King as a romantic explorer, not as a scientist at the head of a complex expedition seeking specific knowledge of a rugged and difficult terrain. Apparently an idle whimsy, the little book makes no mention of the survey.

King's official project at the time represented one of the most significant mobilizations of energy and intellect in postwar America. At the astonishing youthful age of twenty-six, he was appointed in 1867 the first civilian head of a government survey (earlier surveys had been led by military officers). A graduate of the Yale Sheffield School in 1863, he had worked for the California Geological Survey, won admiration for his skills in the field, his innovative mind, his wit, cultivation, love of risk, and remarkable self-confidence. With the support of well-placed friends, King was able to persuade the Department of War to put him

in charge of the most meticulously planned survey of continental lands yet undertaken in the United States—the forerunner of three other surveys funded in the following years in contiguous regions of the Far West and the Southwest. Together the four projects launched in the late 1860s comprised the "great surveys" of the postwar era. In 1879 the separate undertakings were disbanded, their activities incorporated in the United States Geological Survey, and King appointed its first director.[4]

In the authorizing letter of March 21, 1867, addressed to King, Brigadier General A. A. Humphreys, Chief of Engineers, Department of War, gave King his charge "to direct a geological and topographical exploration of the territory between the Rocky Mountains and the Sierra Nevada mountains, including the route or routes of the Pacific railroad." The object, he wrote, "is to examine and describe the geological structure, geographical condition and natural resources of a belt of country extending from the 120th meridian eastward to the 105th meridian, along the 40th parallel of latitude, with sufficient expansion north and south to include the lines of the 'Central' and 'Union Pacific' railroads." Known as the "40th Parallel Survey," the project included study of "all rock formations, mountain ranges, detrital plains, mines, coal deposits, soils, minerals, ores, saline and alkaline deposits"—in addition to the preparation of "detailed maps of the chief mining districts" and a topographical map of the entire region, barometric and thermometric observations of atmospheric conditions "bearing upon the subject of refraction and evaporation." Collections in botany and geology—and the publication of detailed studies of all these matters— rounded out Humphreys's charge. After specific instruction about the disbursement of funds, the letter closed with the requirement that King post a bond for twenty thousand dollars as surety "for the faithful expenditure of such funds."[5]

Each of the four surveys included photographers in their parties— O'Sullivan and Carleton Watkins (briefly) with the King survey, William Bell and O'Sullivan with the Wheeler survey of the 100th meridian, William Henry Jackson with the Hayden survey, Jack Hillers and E. O. Beaman with the Powell survey of the Colorado River. The photographs were used in a variety of ways—published with official reports as mounted prints, heliotype reproductions, or engraved lithographs; bound in small-edition albums for government officials and congressmen; provided to publishers for use as engravings in newspapers, periodicals, and books; sold directly to the public as stereographic views. Their importance may have seemed at the time secondary to the central tasks of exploration and scientific investigation, but their public impact and

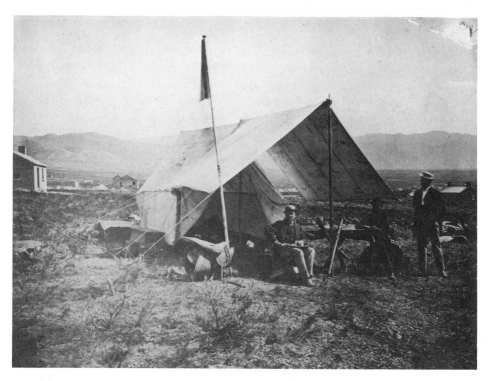

44. "My Tent." T. H. O'Sullivan

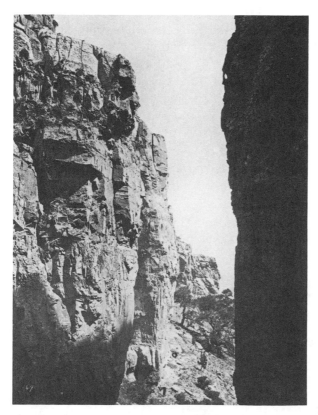

45. "The Dark Cañon."
T. H. O'Sullivan

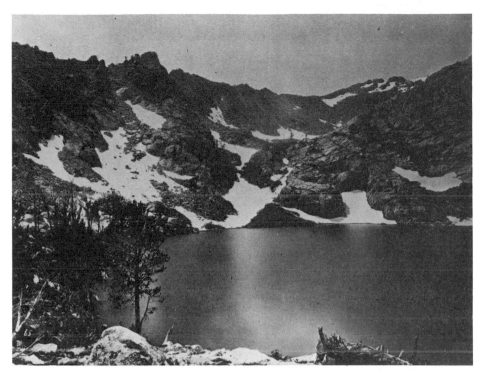

46. "Lake Marian." T. H. O'Sullivan

47. "Taking Breath."
Possibly by A. J. Russell

their continuing power in registering the meaning of the survey enter-
prises suggest in retrospect that they played an integral role in redefining
the geological survey as a modern activity.

Hardly a lark, the project was a complex bureaucratic undertaking
for which the young King bore full responsibility. Along with the
transcontinental railroad system whose route it followed, King's survey
was part of a concerted program of economic expansion implemented
by the triumphant government immediately after the Civil War. Under
a policy of stimulating private enterprise with public money and
resources, the Republican-led Congress appropriated vast sums of
money and land to fund a privately owned national railroad system.
Surveys of mineral-rich regions along the railroad routes were part of
the same economic program, in this case providing indirect subsidies
to developers, miners, timbermen, and settlers in the form of free in-
formation and maps. Centrally funded, planned, and supervised by
scientist-administrators, the surveys were direct government aid to
science and indirect aid to the private sphere. This support by Congress
was, in Henry Adams's words, "almost its first modern act of legislation."[6]
The "40th Parallel" topographers and geologists, Adams noted, "held
under their hammers a thousand miles of mineral country with all its
riddles to solve, and its stores of possible wealth to mark. They felt the
future in their hands."[7]

The aim was not just to discover what lay beneath the surface but to
describe the surface—to analyze and to map. The King survey, Adams
wrote in 1872 in a review of its reports, not only provided "the first
trustworthy representation of a highly important portion of our vast
territory" but its accurate maps "give some meaning to the geological
results."[8] A map is, of course, a kind of symbolic picture. It is one way
of "seeing" the land, and as part of the enterprise it helps clarify the
role of photographers in the "great surveys." For one of the major goals
implicit in King's charge was to produce a body of visual documents—
traverse sections and charts for geological knowledge, maps and pictures
for topographical knowledge. And the conjunction of maps and pho-
tographs within the same project suggests that *The Three Lakes* may
prove more pertinent than it might at first seem, for a map consists not
only of symbolic shapes and markers but of *names*.[9] The fairy tale tells
indirectly of the making of a map, the filling in of names. And the role
of the photographs which bear the fictional names—Marian, Jan, Lall—
is to put an image to a name and a place.[10]

King describes several acts of naming in *Mountaineering in the Sierra
Nevada*, acts of exhilarated triumph. "I rang my hammer on the topmost
rock; we grasped hands, and I reverently named the grand peak MOUNT

TYNDALL."[11] At the peak of Mount Shasta, waving the flag serves as the equivalent of ringing the hammer.

> Fred Clark and I climbed together out upon the highest pinnacle, a trachyte needle rising a few feet above the rest, and so small we could barely balance there together, but we stood a moment and waved the American flag, looking down over our shoulders eleven thousand feet.[12]

The name lays claim to the view. By the same token, a photographic view attaches a possessable image to a place name. A named view is one that has been seen, known, and thereby already possessed. Of course there was, in a sense, no question of ownership of the lands traversed by the surveys and the railroads—they belonged under the flag and laws of the nation. King had at his command a squadron of United States troops to enforce that fact, a protective shield against hostile Indians who had not yet succumbed to the logic of that flag and its laws. In their eyes the land belonged to them by virtue of another and earlier body of principles, tradition, and common use.

The conflict of law and interest between the expanding American nation and the defensive Indian nations arose from cultural antagonisms as well as economic interest. John Wesley Powell, director of one of the surveys, observed that native peoples viewed the land in a manner much different from that embodied in the survey: land was not an exploitable resource available for private ownership; it was collective property, the medium of communal life. Powell notes:

> Among all the North American Indians, when in a primitive condition, personal property was almost unknown . . . The right to the soil as landed property, the right to the products of the chase, etc., was inherent in the gens, or clan, a body of consanguinii [sic], a group of relatives . . . No other crime was so great, no other vice so abnormal, as the attempt of an individual to use for himself that which belonged to his gens in common; hence the personal rights to property recognized in civilization are intensely obnoxious to the Indian. He looks upon our whole system of property rights as an enormous evil and an unpardonable sin, for which the gods will eventually punish the wicked and blasphemous white man.[13]

The act of mapping and naming was, in the eyes of Indians, an act of trespass, not upon property but on religion, upon the sacred itself. The white man's maps threatened a whole way of life.[14]

Although King's poems in *The Three Lakes* evoke Indian legend and myth, such as the stone giant and the ice dragon, it is not clear whether he knew the aboriginal names (if any existed). But do these hints of Indian lore suggest an unconscious recognition that the new Anglo-Saxon names violate the original identity of the lakes? In *Mountaineering in the Sierra Nevada*, King confesses to uncertainty in his attitudes toward

Native Americans. He confesses that his "convictions concerning Indians" had been "tinged with the most sanguinary Caucasian prejudice." But watching a man's grief at the funeral pyre of his wife, King realizes that "not a stoical savage, but a despairing husband, stood before us. I felt him to be human." When he learns the next day that the same husband had gotten drunk that night, "I went back to camp an enlightened but disillusioned man."

> Since then I guardedly avoid all discussion of the 'Indian question.' When interrogated, I dodge, or protest ignorance; when pressed, I have been known to turn the subject; or, if driven to the wall, I usually confess my opinion that the Quakers will have to work a great reformation in the Indian before he is really fit to be exterminated.[15]

In the peaceful setting of a village, he can "find them picturesque: low conical huts, opening upon small smoking fires attended by squaws." Close up to a woman "engaged in maternal duties," he writes: "I am almost afraid to describe the squalor and grotesque hideousness of her person." Her husband, "the 'buck,'" on the other hand, caught in the act of spearing a salmon, reminds King of a statue cast in bronze.[16] The term "savage," then, holds mixed meanings for King, as in the "savage elements of sky, ice and rock" at the "lifeless" top of mountains, which make the descent into softer air and the presence of trees seem "a strange renewal of life."[17] "Savage" means for him something in nature impossible to resist and impossible to accept—a term which inflicts the consequences of a white man's dilemma upon native dwellers.

A similar ambivalence appears in the account by Josiah Dwight Whitney of the state-based California Geological Survey that tells how Yosemite Valley was renamed. In *The Yosemite Book* (1868)—which includes a sequence of twenty-four photographs by Carleton Watkins—Whitney notes that Indians of the region "had a name for every meadow, cliff and waterfall in and about the Valley." "It were much desired," he writes, "that these names could have been retained, but that is impossible; they have already almost passed into oblivion," "entirely replaced" by "names given by the early white visitors to the region." Still, "it is well known that the present Indian name of the Valley is not Yosemite, but Ahwahnee." As a sign of his lament—although he describes the remaining "digger" Indians (not native to Yosemite, incidentally) as "a miserable, degraded and fast disappearing set of beings, who must die out before the progress of the white man's civilization, and for whom there is neither hope or chance"—Whitney includes two pages of original Indian names in Yosemite and regions nearby. We learn, for example, that the original of El Capitan was Tolokonula—an imitation of the cry

of the crane; that certain rocks were once called Ummo, meaning "lost arrow"; that the North Dome was once known as Tokoya, meaning "basket," from the rounded shape of the rock. Waijau ("pine mountains") was the Indian name for Mount Whitney itself—a name bestowed a few years earlier by a party which included King.

Whitney exonerates his survey team from responsibility for the regrettable loss of native names; they simply adopted nomenclature already "in well established use" by white settlers and visitors. The surveyors, he conceded, did attach names to High Sierra peaks "previously unnamed," though he does not say how it could be known that a site was "without appellation." "We have . . . a full and ample right," he added defensively, "as the first explorers, describers and mappers of the High Sierra, to give such names as we please to the previously unnamed peaks which we locate." He passes over Waijau, the original of Mount Whitney, without comment.[18]

The new names brought the alien and unfamiliar into a familiar system of knowledge. Just as the photographs in *Three Lakes* depict the terrain as at once mythical (in the poems) and historical (in the letters), the survey photographs provide a visual parallel to the symbolic forms of the map—what historian Martin Rudwick calls a "conceptual bridge" between an abstract and a concrete visual mode. Naming and viewing complement each other. As a work of fiction illustrated with photographs, *The Three Lakes* thus clarifies one of the purposes of survey photographs: to provide visual means of following the work of the survey, particularly by giving place names a visual aspect.

II

As King's little book shows, with a change of title or caption the survey photographs were freely adopted to sundry uses. This flexibility confounds the question of their precise role within the surveys. The fact is that they probably did not have a precise scientific role. They served purposes as varied as the subjects they depict—geological formations, topographical vistas, views of Indian villages and artifacts, scenes in mining towns and in the mines themselves, waterfalls, and alkaline deserts.

Of what practical use were the pictures? For decades they lay more or less unnoticed in archives and volumes of official reports, or scattered in private collections. Recently these Western photographs have enjoyed a renaissance of interest. The Sierra Club and similar groups have adopted them for publicity, and to claim a nineteenth-century tradition of preservation. They have been the nineteenth-century American

photographs most prized by collectors, curators, and art historians—far beyond the daguerreotypes, Civil War pictures, or stereographs, if the number hung on museum walls is any indication. As a body of work, the pictures by Timothy O'Sullivan, Carleton Watkins, William Henry Jackson, A. J. Russell, and others have been described as comprising "a golden age of landscape photography" in America.[19]

It is difficult to resist the present-day notion that these pictures, in spite of their original intent, belong to landscape art. In many cases the photographers applied conventions of landscape painting, composing a view with an eye for the balance of forms and the dramatic effects of light. Much has been made of apparent differences in "style"—the way O'Sullivan tilts the picture plane to create the effect of the earth slipping away, or how Watkins allows a view to represent itself in successive planes receding into the distance across bands of foliage and rock. As a group, the photographs have been claimed as part of a major tradition of American art, a landscape tradition beginning with the antebellum Hudson River and Luminist schools, in which natural scenery certifies the nation's uniqueness, its meaning and destiny as "nature's nation."[20] Moreover, the photographs produced a generation before the recognition that the frontier no longer existed seem now to offer a final witness to pristine nature, pure and uncontaminated. That the pictures were made for government surveys and railroad companies, to further settlement and aid industries such as mining, already booming in Nevada in the late 1860s, has made them all the more poignant and precious.

But the term "landscape" remains misleading. The category implies more than subject matter and a set of pictorial conventions—that the pictures were made primarily to express an artistic conception, to display a style and sensibility. Their primary intention was provided by the project: to show this ravine, that cliff or lake, as sharply as possible. Of course, each photographer made the pictures in his own way, and some are more interesting than others. But "landscape" means more than "art"; it means a particular academic genre of painting which had little to do with the working photographer in the field. Not that he was unaware of the genre—sometimes he worked side by side with landscape painters who occasionally joined the survey parties.[21] But these photographers did not, with some exceptions, make their pictures with exhibition in mind. Some had private arrangements to sell their government-sponsored pictures for private gain. But their work did not have the same status as formal art enjoyed by painting, and there are few indications that the photographers desired to change that situation, to enter their pictures into competition in an art market.

"Landscape" distracts attention from the survey itself. It implies that

the photographs are best understood as expressions of individual styles within a conventional form. Attempts to define and interpret a distinctive style have been most prominent in the case of Timothy O'Sullivan. His Western pictures have been described, for example, as "a sustained meditation on nature and on man's relationship with it."[22] His view of "nature" and of "man" has been seen as harsh, foreboding, desperate—not unlike Herman Melville's. While other photographers depict the West as "essentially picturesque," O'Sullivan's landscapes are seen as threatening, inhospitable either to habitation or conventional pictorial landscape formulas.[23] This may or may not be the case. Like poems (and everything else), photographs are open to interpretation. But to read his pictures as if they are indistinguishable from paintings is to ignore the medium in which they were made.

For example, discussing his Grand Canyon paintings, Thomas Moran stated: "Topography in art is valueless." In painting perhaps, but in photography, topography (given the assignment of the survey photographers) is everything. Moran continues: "While I desired to tell truly of nature, I did not wish to realize the scene literally but to preserve and convey its true impression."[24] "Literally" defines the camera's work, the power of its lens, which, if the photographer wishes to produce something other than a literal account, he or she must somehow intervene to modify. Moran reveals that he sometimes painted rocks behind him as if they were in front of him, to make them seem more "strictly true to pictorial nature." While survey photographers often manipulated or staged their scenes, they did not intervene to alter the clear, exact report of the lens, nor did they attempt to convey false (even if pictorially appropriate) impressions about the lay of the land. This is not to say they did not choose their camera positions with care, did not express personal taste and pictorial preferences in how they tilted their lens boards—but by "impression," which Moran means upon the mind, they meant upon the eye as it anticipated what would appear through their camera lens upon the plate. Their art lay in a different direction from that of landscape painters—in the case of O'Sullivan, an art in which topographical exactness was one, even if not the sole, prerequisite.

About O'Sullivan in the West, John Szarkowski said in 1963: "He was true to the essential character of his medium, and true also to the requirements of his job. His primary aim was not to philosophize, but to describe the terrain."[25] Trained in Brady's New York and Washington galleries before the Civil War, O'Sullivan belonged to a generation which still thought of photography as an artisanal craft. An unsigned essay in *Harper's New Monthly Magazine* in 1869 on "Photographs in the

High Rockies"—it may have been written by O'Sullivan himself—puts the credo of the cameraman-artisan in the opening paragraph:

> Places and people are made familiar to us by means of the camera in the hands of skillful operators, who, vying with each other in the artistic excellence of their productions, avail themselves of every opportunity to visit interesting points, and take care to lose no good chance to scour the country in search of new fields for photographic labor.[26]

"Vying with each other in the artistic excellence of their productions" was taken for granted in the guild of wet-plate operators. Their pride lay in their excellence in meeting collective standards. O'Sullivan was known as one of the best—known for his skill, not his sensibility, style, or unique vision. He and his colleagues never doubted that their purpose was to make clear reports of things visible in the world. Even if their work displayed conventional aspects—what is more conventional, more imitative of painting, than the conventional studio portrait?—the real interest of the work lies in its social use as photograph. There also lay its aesthetic effects. While certain pictures may have made their appeal as landscape art, the category proves limiting, if we wish to see how such pictures as O'Sullivan made for the King survey played a role in the survey itself.

It seems unlikely that King would have asked O'Sullivan to make his own interpretations of the terrain, or that O'Sullivan would have conceived of doing so. It is true that O'Sullivan's pictures are often distinctive in their flattening of objects, their rendering of horizon lines, their glaringly bright unclouded skies. But more important as a mark of distinction, particularly in pictures produced for King, is their presentation of the survey project itself. Rather than "a boundless place of isolation," a landscape "unmarked, unmeasured,"[27] O'Sullivan's views often show survey teams at work, taking measurements, making their marks.

Often the same pictures will include pieces of photographic apparatus: dark cloths, plate holders, portable darkrooms, even cameras—deliberate signs of the Industrial Age invading nature's domain. One purpose of including cameras or survey equipment may be to suggest the scale of things in vistas without other human measurements. But the effect is more complex, and occurs with such frequency in O'Sullivan's 40th Parallel pictures as to suggest a deliberate practice. It is similar to the device used by painters—the brushes and taxidermist's tools in Charles Willson Peale's *Artist in His Museum* are a good example—to suggest that the scene before our eyes is the very place where the picture was made, as well as the location of what is pictured. The effect is complex: the

photographer shows that the picture is indeed a picture, not the real thing or scene itself, and at the same time says that the photographer was really there, placing the terrain within a context of actuality. Brady's putting himself into battlefield views has a similar effect, though perhaps not intended in just this way. Nor is it possible to know O'Sullivan's intention, but one clear effect is to align the photographer with the surveyors. They share similar tasks—measuring, marking, picturing the land. Such pictures indicate that the survey entailed creating a kind of studio in unlikely places, where data is gathered for translation into one or another kind of representation—chart, section, photograph, or written report. Photographs showing surveyors absorbed in their work of checking instruments, taking notes, sampling materials, call attention to the special character of the photographer's work: its instantaneous transformation of raw perception into a picture, a two-dimensional illusion of three-dimensional space in which something worth seeing can be seen.

From the beginning of geological and topographical excursions in Europe in the eighteenth century, survey parties included topographical artists and engineers trained to make systematic drawings. By the time of the postwar surveys, the graphic arts were established as essential adjuncts to the scientific study of the earth. Photography lent itself to manifold uses—close-ups of specimens, whether rocks or shards and Stone Age tools, and the reproduction of maps and other documents.[28] Photography was simply the most accurate means of making a likeness— "the nearest approach to a truthful delineation of nature," noted Ferdinand V. Hayden, director of one of the four Great Surveys, in the introduction to his *Sun Pictures of Rocky Mountain Scenery* (1870).[29]

The evidence is strong that survey geologists viewed photography as both accurate, and thus useful in conveying the appearance of specimens and formations, and beautiful, capable of winning the public's attention and, not incidentally, renewed appropriations from Congress. While testifying before the Congressional Committee on Public Lands in 1874, Hayden displayed the pictures collected by his "photographic party" as "essential in the preparation of our geological reports and maps," and added: "We have also found them to be very attractive to the public." Hayden found no conflict in the fact that "those illustrations" are at once "very truthful" and "will convey their scientific lesson as they have already conveyed their aesthetic lesson."[30] In *Sun Pictures*, consisting of thirty photographs made by A. J. Russell while tracking the construction of the Union Pacific Railroad in the Far West, Hayden notes that he follows "the plan adapted by Professor J. D. Whitney in his most elegant Yosemite Book," which includes Watkins's photographs "for the purpose

of illustrating the work."[31] In another example of a geologist's positive view of the camera, Karl Grove Gilbert, who worked in the survey led by Major George M. Wheeler, remarked on a lithographed reproduction of a photograph showing a sand formation in Utah: "The camera affords the greatest aid to the geologist" precisely in its ability to show such subjects and materials in their "systematic heterogeneity."[32]

Following established practices, the Western surveys employed landscape painters and topographical artists as well as photographers.[33] Geology allowed room for aesthetic emotions, for beauty and delight. Indeed, "scenery," a term applied commonly to the survey photographs, was understood to fuse a sense of particularity of locale with an aesthetic mode of perception. The 1869 article on O'Sullivan's work in the Rockies described the Humboldt Sink as "one of those peculiarities that nature presents as picturesque evidence of great volcanic convulsions."[34] The term "picturesque" or "picturesque evidence" appears often in King's own theoretical volume, *Systematic Geology* (1878). For O'Sullivan to include photographic equipment in scenes which also show surveyors at work suggests a commonality of purpose accepted by geologists and photographers alike.

III

At the end of their first season in the field, the King party returned to Washington in the winter of 1868–69, and among their labors was the preparation of photographs to be presented to various important and influential people, military leaders, and congressmen. Someone—perhaps King, perhaps O'Sullivan—assembled eighty photographs into two bound volumes, forty pictures in each, covering O'Sullivan's work in 1867–68.[35] The volumes were bound but not published, not produced for public sale, and seem to be unique—at least, no duplication of these particular pictures in this particular order exists among the several other volumes of King survey photographs. On the spine of each of the volumes prepared in 1868–69 is printed: *Photographs, Geological Explorations, 40th Parallel, Clarence King, Geologist in Charge, 1868,* the separate volumes identified as *Volume I, No. 1–40,* and *Volume II, No. 41–80.* Each individual photograph is mounted on a board which reads: "U.S. Engineer Department, Geological Exploration, Fortieth Parallel, T. H. O'Sullivan, Photographer." Unlike *The Three Lakes,* or the books published by Whitney and Hayden, the two volumes do not relate their images to a written text. Each image is numbered on its mount, and this key refers to a separate list of printed titles.

The pictures are arranged in clusters focused on regions and subjects.

Volume One includes pictures of Shoshone Falls in the Snake River Canyon in Idaho, mining activities in and around Virginia City, Nevada, and desert phenomena such as silica mounds, alkali lakes, fissure vents, hot springs and geysers, in the vicinity of Steamboat Springs, Ragtown, Truckee Desert, Humboldt Desert, Ruby Valley, and Carson Desert. Volume Two contains pictures mainly of geological formations—volcanic columns, limestone outcroppings, rhyolite hills, canyons, and lakes—in the Humboldt Mountain ranges in California, Nevada, and Utah. Survey crews appear in many of the photographs. Volume One opens with two pictures of the "explorers" in camp, and similar pictures are scattered through Volume Two.

The two volumes may have been intended as a catalogue, an inventory or archive of images to be drawn upon for reproduction as lithographs in the reports. We can guess that they were made to be seen by a limited number of people—other members of the survey party, very likely General Humphreys, and others. Still, because the volumes represent, as far as we can tell, the first attempt to put O'Sullivan's survey photographs into a coherent form, we can ask whether there is more to that form than the record of a reconnaissance through a particular terrain, the clustering of images taken at particular places and times. Is there a controlling idea, a deliberate ordering of images to express a coherent point of view?

Volume One shows a thematic grouping by location and, as we shall see, a careful placement of images within each group to suggest the development of a point of view. Volume Two is less systematic, less varied in its regions, its sequence less coherent. Volume One is the more interesting, for the point of view reflects on the activity of surveying and the role of photography within it. If *The Three Lakes* can be taken as an essay on viewing and naming, Volume One can be read as a more expansive and complex reflection upon the survey enterprise itself in a region King called an American "*terra incognita*," "a labyrinth of intricate changes."[36] The survey writings of King and other scientists, along with the remarks attributed to O'Sullivan in the 1869 *Harper's* article, help us piece together a point of view. It is the pictures themselves as they are arranged which disclose an intention. We are concerned, of course, not with why O'Sullivan made these pictures but with why they appear in this particular order.

The first impression is of diversity. There is a wide range of views, beginning with the opening two pictures of the explorers in camp, followed by a series showing Shoshone Falls from several perspectives; then there are views of mining in Nevada, followed by desert views. The pictures are as varied as their subjects: panoramic views with a

number of prominent features; closer views of singular features; scenes from different perspectives. The mining pictures introduce another range of differences: pictures made above and below ground—mining settlements viewed as part of the natural setting, and miners at work in the cramped spaces of the mines, illuminated by magnesium flares. Diversity of camera angles, of subjects, and of geographical locations conveys the idea that the camera itself, the instrument of picture making, can produce various visual results, from close-ups to panoramas. While it makes us aware, through the photographer's control, of natural scenes, it also makes us aware of the photographer's own creativity in choosing what to depict—the human and mechanical activity of camera operator. By their diversity, which calls attention to our dependency for what we see upon the photographer's choices and the camera's position, the pictures raise a question about cognition, the relation between seeing, investigating, and knowing—the question which lies at the base of the survey as a whole.

Consider the Shoshone Falls sequence. These eight pictures form the first distinctly unified group in the album. It is followed by seventeen mining pictures in and around Virginia City, hundreds of miles away from the falls. Though the captions provide no specific dates, we know from other sources that some of the mining pictures were made in the spring of 1867 and most in the winter of 1867–68, many months before the visit to Shoshone Falls in October 1868.[37] The order of the photographs deviates from the actual sequence of exploration. The governing principle, clearly, is not to represent a strict chronology of the survey.

The Shoshone sequence includes pictures of the cataract from a number of perspectives: from above, at water level, from the side, from behind. Images of the falls, of course, predominate, the powerful cascade rushing over the upper terraces to gather into a single immensity of falling water, blurred by the slowness of the film into a crashing wall of whiteness. The group begins with a long view of the entire falls and the Snake River Canyon. "In the Shoshone we have fall after fall to view as a preliminary exhibition," O'Sullivan explained in the *Harper's* article.[38] His use of the present tense raises the possibility that he is writing directly from the actual sequence of pictures, for the first picture is precisely such a "preliminary exhibition" with a comfortably seated spectator. The figure seems to be King's black attendant, Jim, in the rather incongruously formal attire (like King's) in the picture, No. 2, which precedes the Shoshone group. "The surroundings of the main fall are such that any number of views may be had of the scene," the *Harper's* article continues, in the vein of a working photographer assigned

to survey a scene. The author speaks of the "bird's-eye view" one can have by "standing upon the craggy rocks that jut out from and form the walls of the table-land above the falls," of the "grand sight of the different falls" from the same position.

The group might be taken as the photographic composite view of a spectacle, a way of making the awesome scene available to mere viewing, to the sensations of majesty and sublimity of the sort long associated with Niagara Falls. Indeed, the *Harper's* essay reinforces this idea: "From the island above the falls you may not see the great leap that the water takes, but you will certainly feel sensible of the fact that you are in the presence of one of Nature's greatest spectacles as you listen to the roar of the falling water and gaze down the stream at the wild scene below."[39] But while sublimity may well be a part of these pictures, it is clear, especially from their place within the structure of the album, that these are *survey* pictures. Several of them show the men at their tasks, No. 9 with camera equipment in the foreground. As a group, the pictures take the viewer around a natural phenomenon in order better to see its site and its geological formations. To depict the site as "a setting of grandeur in the glorious masses of rocks" is not inconsistent with survey illustrations. On the contrary, as we will see, King shows in an intense essay on the Shoshone Falls exploration how a powerful affective response might coexist with objective observation.

Before turning to King's essay, we can put the Shoshone sequence into sharper perspective by comparing O'Sullivan's Shoshone with Carleton Watkins's Yosemite. One of San Francisco's most successful commercial photographers, Watkins made his first Yosemite views in 1861 as a private commercial photographer, not as part of a survey team. He was encouraged by the capitalist Trenor Park, whose mining operations in the nearby Mariposa Estate Watkins had photographed earlier that year.[40] Watkins's 1863 publication opens with a map of the region (by King and J. T. Gardner), making the photographs a tangible part of the "conceptual bridge" between a view and its representation as a name on a map. Watkins's Yosemite views, widely distributed as prints and stereographs, helped immeasurably to confer on the place the stature of America's most stunning preserve of pristine landscape—"the one adequate symbol for all that California promised," writes Kevin Starr: "beauty, grandeur, expansiveness, a sense of power, and a sense—this in the geological history—of titanic preparation for an assured and magnificent future."[41] The symbolic resonance of the place was enhanced by the act passed by the Civil War Congress in 1864 which set aside the region "for public use, resort and recreation"—"inalienable for all time," as proclaimed in the act Lincoln signed, obliterating any

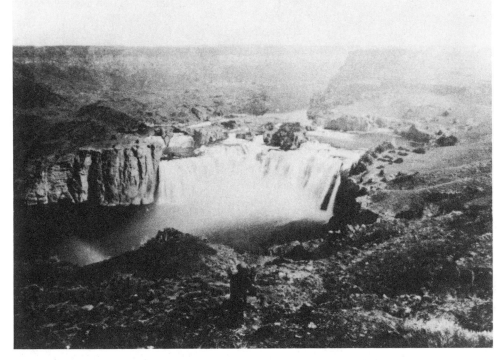

48. "Shoshone Falls," Snake River. T. H. O'Sullivan, plate 3

49. "Shoshone Falls," Snake River. T. H. O'Sullivan, plate 6

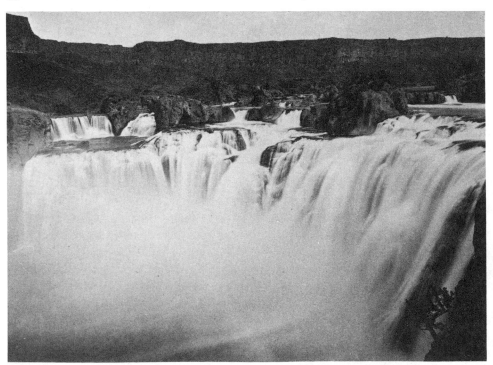

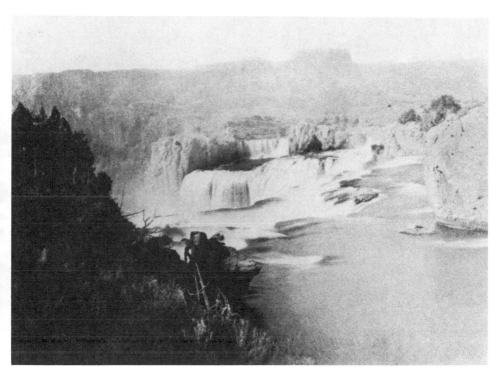

50. "Shoshone Falls," Snake River. T. H. O'Sullivan, plate 7

51. "Shoshone Falls," Snake River. T. H. O'Sullivan, plate 9

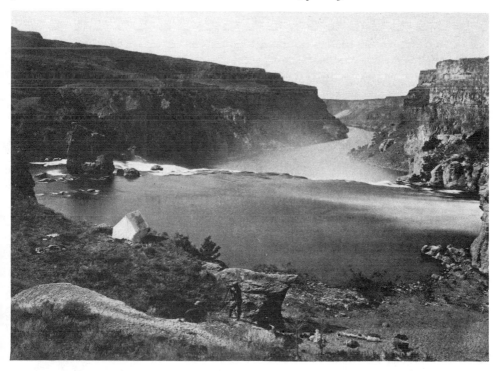

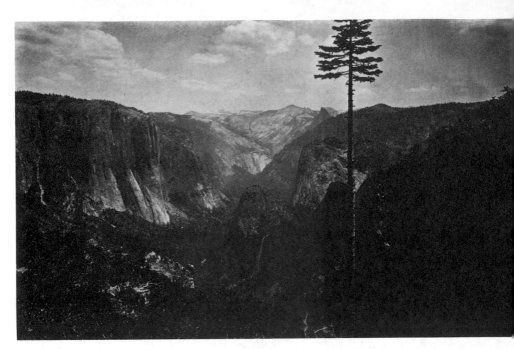

52. "Best General View, Mariposa Trail," Yosemite, 1863. Albumen print, 7⅝ × 11⅝
Carleton E. Watkins

memory of Yosemite's forcible alienation from native inhabitants whose possession of the place had been symbolized not by property lines or deeds but by their animistic names "for every meadow, cliff and water fall."

Desiring "to call the attention of the public to the scenery of California, and to furnish a reliable guide to some of its most interesting features," Whitney included in *The Yosemite Book* a group of Watkins's pictures, in the hope "they will give satisfaction to those who are unable themselves to visit the scenes which they represent"; and for those already privileged with a visit, they will serve to recall "some of the most striking points of view."[42] "It is for the traveller to decide whether he prefers getting the general views of the Valley after he had already been there, or on his way into it." In place of the 1863 map whose terrain the pictures depicted point by point in Watkins's earlier album, we have Whitney's references to specific images in his own text, to similar effect: the making of a tour, a visual traversal of a terrain identified as much by a set of viewing points as by a name. "In No. 4 we have a view down the Valley, taken midway between El Capitan and Cathedral Rock, so as to show a portion of both. This view gives a fine idea of the verticality of the walls. . . . Photograph No. 5, will show its appearance when looked at

squarely from the front, and No. 6, was taken from a point a little more distant and farther to the left."[43]

In this selection of camera positions, picture and pictured object begin to fuse, lose their separateness; we are often unsure whether Whitney speaks of the image or the thing—especially in regard to the *form* of objects. About Sentinel Rock: "Its form may be seen in the photograph, No. 9, which was taken from a point on the Merced further down the Valley"; "the form of the Half Dome may be understood from photographs Nos. 14 and 19." Not incidentally, Whitney sees an organic connection between structure and nomenclature, between natural form and unnatural name: it is the "appearance of the mass" as "an originally dome-shaped elevation" which "appears to have forced itself upon those who gave it the name 'Half Dome,' which is the one that seems to suggest itself, at the first sight of this truly marvelous crest of rock."[44] Partly, this is the geologist educating the traveler by conventional illustrative means, but in doing so, Whitney comes close to exchanging the object for its picture, to proposing the fixed image as a surrogate for a living experience of the actual scene. "We have thus conducted the traveller around the Valley, and given him as many hints as our space will admit."

What takes shape in Whitney's prose and Watkins's photographs is Yosemite in the guise of a traveler's spectacle—a way of viewing in which the aura, the mystery, arising from sheer distance between viewer and vista, dissolves into the illusion of closeness, of private possession. Moreover, the secondary message of the photograph being that it can always be remade from the same position, the new spectacular version of the place as a mechanically reproducible image becomes easily repeatable. The names attached to each picture, which displace the Indian names and dispel their aura, come to identify not just views from Watkins's fixed camera positions but conventional effects, feelings already familiar even if words cannot express them. Regretting the unavailability of a photograph registering a particularly "stupendous" view of Half Dome, Whitney writes: "Language is powerless to express the effect which this gigantic mass of rock, so utterly unlike anything else in the world, produces on the mind." Like the name, the spectacular mode of seeing served as a vehicle of possession—through the eye.[45]

By the late 1860s, spectacular viewing already threatened to become a leading recreation at the site. Writing in *Mountaineering* about his exploration of Yosemite in 1864 with the Whitney California survey party, King remarks about the already well-visited Inspiration Point: "I always go swiftly by this famous point of view now, feeling somehow

that I don't belong to that army of literary travellers who have planted themselves and burst into rhetoric."[46] He may have had in mind something like this passage by Samuel Bowles, editor of the Springfield, Massachusetts, *Republican*, who stood at Inspiration Point sometime in 1868:

> The overpowering sense of the sublime, of awful desolation, of transcending marvelousness and unexpectedness, that swept over us, as we reined our horses sharply out of green fields, and stood upon the high jutting rock that overlooked this rolling, upheaving sea of granite mountains, holding far down its rough lap this vale of beauty of meadow and grove and river,—such tide of feeling, such stoppage of ordinary emotions comes at rare intervals in any life. It was the confrontal of God face to face.[47]

Although Bowles's effusion cannot be taken as the definitive corollary of Watkins's pictures, the tourist's rapture seems at least one response they elicited.

Differences between King and Bowles, blatant as they are, better help us distinguish Watkins's Yosemite from O'Sullivan's Shoshone. King's solution to the problem of representing at once the place and himself within it is to make dramatic an issue that runs through *Mountaineering*: the issue of perception, of the dependence of knowing upon different modes of seeing. Its simplest form appears in the effects of atmosphere on aspects of the scene—for example, in the differences between June and October. The "slumberous yet transparent" sky of June offers a pastoral landscape: "You look down upon emerald freshness of green, upon arrowy rush of swollen river, and here and there, along pearly cliffs, as from the clouds, tumbles white silver dust of cataracts." Yet, in light of the knowledge of October, the June picture deceives: "All stern sublimity, all geological terribleness, are veiled away behind magic curtains of cloud-shadow and broken light." In October, "air clear as a vacuum," "the shattered fronts of walls stand out sharp and terrible . . . There is no longer an air of beauty. In this cold, naked strength, one has crowded on him the geological record of mountain work, of granite plateau suddenly rent asunder." Beauty and terror are, then, both made of "air," of the quality of light and the work of the eye. The ever-changing aspect of the scene corresponds with King's constant mobility, his fluid shifts from one observation point to another: "Lying upon a sharp neatly fractured edge, I was able to look down and study . . ." He takes scrupulous care to say where he is while looking and studying, to specify his point of view, the physical ground of his perceptions.[48]

A third element or filter that colors the view arises from a different

source: "It was impossible for me, as I sat perched upon this jutting rock mass, in full view of all the canyons which had led into this wonderful converging system of ice-river, not to imagine a picture of the glacier period."[49] Geological knowledge permits, indeed insists upon, the superimposition of one picture upon another—the invisible past upon the fluctuating image of the present. King reads the scene before him as evidence of cataclysmic natural forces and vast reaches of time, "legibly traced with the history of the past": "Granite and ice and snow, silence broken only by the howling tempest and the crash of falling ice or splintered rock, and a sky deep freighted with cloud and storm,— these were the elements of a period which lasted immeasurably long."[50] This additional factor in perception—let us call it geological imagina- tion—results in a doubled vision: not just past and present, visible and invisible, but a vanished order of cataclysm (or, in the more common term used by geologists, catastrophe) and a visible order of tranquillity. The fusion of the two perspectives—"wonderfully opposite," as King puts it, without being contradictory—results in the complexly layered texture of *Mountaineering*, its ease of movement between beauty and terror. King's apparent shifts between enchantment and disenchantment register his modern awareness of the contingent character of knowledge, its dependence upon necessarily partial acts of perception—and upon the metaphoric properties of language.

"What sentiment, what idea," King asks of his Yosemite ramblings, "does this wonder-valley leave upon the earnest observer? what impres- sion does it leave upon his heart?"[51] In a passage that serves as a bridge to an extraordinary account of the expedition to Shoshone Falls which resulted in O'Sullivan's pictures, his answer puts the divided perspective into the succinct form of "two leading ideas". "First, the titanic power, the awful stress, which has rent this solid table-land of granite in twain; secondly, the magical faculty displayed by vegetation in redeeming the aspect of wreck and masking a vast geological tragedy behind the draperies of fresh and living green." Titan, magic, mask, tragedy, draperies: these more prominent of the figures of speech in the passage reveal the underlying metaphor of drama and stagecraft through which King views natural process in all his writing, from *The Three Lakes* to *Mountaineering* to *Systematic Geology*, and his most sustained exercise in the application of metaphor to science, the lecture "Catastrophism and Evolution."[52] King employs dramatic language in order to hold both perceptions in the mind at once, the granite with its inscriptions of an awesome history, the "fresh and living green" with its enchantment and pastoral delight, without giving way (as Bowles most egregiously does) to an exclusive emotion, a single, fixed perspective. And his formulation

of these "two leading ideas" opens the appropriate space for an account of an experience several years after his explorations of Yosemite: "I can never cease marvelling how all this terrible crush and sundering is made fair, even lovely, by meadow, by wandering grove . . . ; nor can I ever banish from memory another gorge and fall, that of the Shoshone in Idaho."

What follows in King's essay is an extraordinary narrative of exploration of the Snake River Valley in October 1868. Across a sage desert, the monotony of which is "overpowering," the survey party seeks "a good outlook" upon the falls they know only by rumor and sketchy report. A "dull, throbbing" roar and the first sight of the falls shatter the monotony, as King watches "a broad river, smooth and unruffled, flowing quietly into the middle of the scene, and then plunging into a labyrinth of rocks." "A strange, savage scene," with its "circling wall" and "battlemented . . . fortress-like masses," a "forbidding gloom" heightened by "the mere suggestion of trees clinging here and there along the walls": King portrays the view as if he were gazing at a Gothic landscape by Salvator Rosa. He speaks of "the abyss of foam," of the "fatal fascination" apt to overcome the viewer, of "black precipices," and "strange, wild sounds" that rise from within the monotone of "a slow, measured beat." At night, "gleams of pale moonlight" through drifting clouds create "intervals of light and blank darkness," the lower river "veiled and unveiled again and again." The effect is of a "Dantean gulf": "A moment of this strange picture, and then a rush of black shadow, when nothing could be seen but the breaks in the clouds, the rim of the basin, and a vague, white centre in the general darkness." At the same time, King's highly pictorial language coexists without the least discomfort with a language of close observation and study: "Wherever large fields of basalt have overflowed an earlier rock, and erosion has afterward laid it bare, there is found a strong tendency to fracture in vertical lines." The purpose of "studying the falls and rocks" never disappears from the account. The morning after "sleeping on the nightmarish brink of the falls," he is abroad on "an old Indian trail" exploring the terrain with an eye to its structure and composition, the character of its basalt and the "underlying porphyritic trachyte."[53]

As assembled in the 1868–69 album, O'Sullivan's Shoshone pictures might well serve as a visual supplement to King's narrative. Both describe a spatial pattern, toward and away from the central visual emblem: "in the centre a dazzling sheet of foam." Certainly, as in the case of *The Three Lakes*, King's affective figures transfer themselves to the pictures— not as definitive meanings, however, but simply as metaphors inspired by the views. In a key passage King writes that "the eye constantly

wanders" away from the "white front of the cataract" up to "the black, frowning parapet of lava," noting "bastions" and rocks that "strikingly recall barbette batteries." Possibly recalling the inflated rhetoric of Inspiration Point, he adds: "To goad one's imagination up to the point of perpetually seeing resemblances of every thing else in the forms of rocks, is the most vulgar vice of travellers. To refuse to see the architectural suggestions upon the Snake Canyon, however, is to administer a snub to one's fancy." King confesses that the Gothic and Dantean figures are indulgences of fancy—necessary to convey his feelings, but as an admitted indulgence, not to be taken as the same kind of description as "basalt" or "trachyte," though no less true to actual experience.

King's acknowledgment of the vulgar but excusable vice of seeing resemblances everywhere brings us once more to the cognitive issue at the heart of the survey: how to picture place and object in this strange, uncharted terrain where "intervals of light and blank darkness hurriedly followed each other," and where exploration follows the route of an old Indian trail. The Dantean metaphor of the abyss served as one kind of picture, the findings about vertical fractures in basalt another, and the photographs by Timothy O'Sullivan, enacting the movement toward and around the falls even while showing the surveyors at their work of taking observations, yet another. To imagine the photographs as a supplement to King's essay is also to recover a relation—not of image to factual reality but of visual picture to verbal picture, of the visual as a "conceptual bridge" to both kinds of metaphors King employs: the geological and the Dantean.

King closes the Shoshone episode with a reprise of the entire experience:

> You ride upon a waste,—the pale earth stretched in desolation. Suddenly you stand upon a brink, as if the earth had yawned. Black walls flank the abyss. Deep in the bed a great river fights its way through labyrinths of blackened ruins, and plunges in foaming whiteness over a cliff of lava. You turn from the brink as from a frightful glimpse of the Inferno, and when you have gone a mile the earth seems to have closed again; every trace of canyon has vanished, and the stillness of the desert reigns.[54]

The compacted narrative resonates with the album sequence, which closes with a beautifully transitional image of the river below the falls, settled into tranquillity and turning a bend beyond the horizon—toward the desert, we presume—through a canyon of fantastical trachyte forms (No. 10). But if we are following the pictures with King's words as a parallel text, the next image proves an astonishment.

IV

We find ourselves not in desert stillness but in another shrieking landscape of power: in this case, the industrial power represented by factories, smokestacks, smelting works, mining shafts, and miners at work underground (Nos. 11–27). This jolting turn in the album thrusts us toward yet another Dantean Inferno. The next sequence, which postpones the desert for a tour among the dark Satanic mills of the hard-rock mining industry in western Nevada, plunges us at once into an actual history, both of the mining industry at the celebrated Comstock Lode centered at Virginia City and of the survey itself.

With these pictures we find ourselves at the epicenter of the survey's purpose and task. To see why, we need first to describe the context. King had won his prestigious assignment in 1867 partly by arguing that the economic value of the transcontinental railroad would be immeasurably enhanced by an accurate topographical map of the Great Basin as well as detailed information about mineral deposits.[55] The unexplored mountains contiguous to the railroad route, King explained, were not as barren and worthless as commonly thought, "but full of wealth All that is needed is to explore and declare the nature of the national domain."[56] In such a survey, his argument implied, science could prove its legitimacy as an instrument of social policy by demonstrating its practical value to capitalist enterprise. With all his enthusiasm for theoretical science, for converting the history of upheavals and cataclysms inscribed in rocks into theories of "systematic geology," King accepted the priority of information convertible to "wealth." There is no indication that he felt any contradiction or tension between the "pure" and the applied aspects of science, that they were anything other than two faces of the same enterprise, just as exploration and naming were one seamless activity. Later he would make a career (strangely unsuccessful) as a private consultant for mining companies and as a speculative investor. *Mining Industry* (1870), the first of the written reports published by the survey (unlike the volumes of photographs, this and other official survey reports were available for sale), was "first prepared and published," King explained, "because its subject . . . is most directly applicable to the material development of that great extent of mountain territory opened up by the Pacific Railroad."[57]

Only one photograph appears in *Mining Industry*—the lithographed frontispiece of six miners standing either patiently or glumly at the "Shaft Landing of Savage Mine" (No. 13 in the 1868 album, "Shaft Mouth, Mining Works, Virginia City, Nevada"). The report includes thirty-seven plates of precise drawings, sectional views of shaft timbering

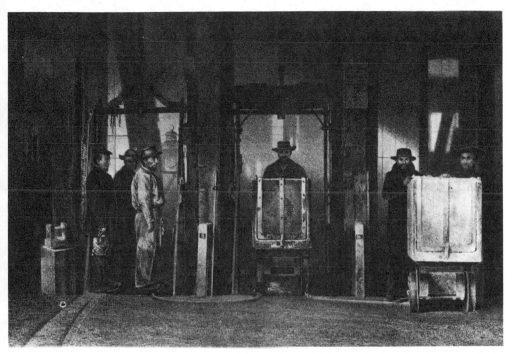

53. Frontispiece of James D. Hague's *Mining Industry*. Lithograph from a photograph by T. H. O'Sullivan

and ventilation systems, the mechanical parts of hoisting apparatus and milling equipment, along with a separate atlas of fourteen maps and geological sections in coded colors relevant to mining activities chiefly at the celebrated Comstock Lode and at other locations in Nevada and Colorado. In light of this flood of abstract visual models, the frontispiece plays an especially interesting role as a sign of what is missing: the absent literalness of the photographs, especially as assembled and arranged in the 1868 volume. Very much like King's Shoshone essay, *Mining Industry* provides, nonetheless, an implied text. O'Sullivan's mining photographs come to life when viewed alongside the treatment of hard-rock mining in the report, the geological, technological, and economic facts represented in word and drawing—a visual investigation parallel to, and interestingly divergent from, the report.

Why did King's survey concern itself with this subject, and what was his attitude toward it? The 1870 report and O'Sullivan's mining pictures together make it clear that King's interest lay not merely in general reconnaissance of mineral deposits but in a functioning industry comprised of a large number of competing private companies. The report includes contributions by King on the "geological distribution" of the region, and on the chemistry of the Washoe process of amalgamation

by Arnold Hague and S. F. Emmons. The main sections of the report, written by James D. Hague, deal with "engineering and economy," which King calls in his covering letter to General Humphreys "this grave task" in the study of "those mining districts in Nevada and Colorado which afford the most instructive results, and produce the largest yield of precious metals." Three-fifths of the volume concerns the richest, most productive district of all, the famed Comstock Lode centered at Virginia City and Gold Hill, where several large corporations and countless smaller claim holders had been extracting the wondrous silver from the bowels of the mountains since 1859.[58] The silver strike gave enormous impetus to plans for a Pacific railroad through what Henry Adams described as "the interminable, uninhabited, hideous region of the Great Basin." Reviewing *Mining Industry* in 1871, Adams noted that the discovery of silver ore led to "a feverish, or even furious, spasm of speculative excitement, during which roads and stage lines traversed the region in every direction, while mining camps, towns, and even cities shot up like mushrooms."[59] Local trade as well as the mining industry cried out for the railroad, silver now doing for rail transport what California gold had earlier done for steamboat travel across the Isthmus of Panama. In short, Comstock created the very conditions which invited the railroad, speculators, corporations, and, in their wake, the 40th Parallel Survey.

By 1870 Comstock seemed to be in trouble, its annual yield declining; there were suspicions that the vein would soon be exhausted. While the 1870 report seems at first glance an uncomplicated act of applied research describing how the silver, gold, quartz, and other minerals got to be where they are, and how the companies go about extracting and refining the ore, closer examination shows that their fears of a crisis guide the authors' research. They treat the mines not only as a geological fact but as a distinct economic community, and while they omit the information that the industry was controlled chiefly by San Francisco financial interests, absentee landlords who sought the quickest returns on their investments, that Virginia City had burgeoned into an industrial city with a predominantly foreign-born work force and a militant union movement, the dubious future of the industry is much on their minds. Moreover, by the issues addressed and by those omitted, the report speaks from the point of view of an evolving government policy. It does not refer to the "mining industry," which in the broadest definition includes the labor force, but to the ownership and management of the largest corporations. Accidents and threats to life underground, for example, are not a category, nor are working conditions: labor appears

as a "cost," with no mention of the unions organized in Virginia City as early as 1863.

The practical issues understandably concern profitability. The report turns on two questions: what can be done to increase the yield of bullion from ore, and how much longer can the corporations assume that the mines will continue to yield enough ore and profit to keep them going? Henry Adams observed that the commercial importance of the Comstock Lode alone endowed these questions with more than an abstract scientific interest: by 1870, over $100 million had been produced by the mines, and one speculator had requested of Congress funds to drill a deep tunnel to replace the shafts widely in use, in order to mine the vein at a deeper level. As a result of deeper mining and greater yield, as Adams summarized the argument, "the amount of our national debt thus [would] be indirectly decreased." We can see why King speaks of a study of the "engineering and economy" of the mines as a "grave" matter. Proponents of the tunnel assumed that richer veins lay at greater depth. One of King's purposes was to provide geological evidence pro or con. The report's specific findings—that the value of a lode is indeed likely to increase at a greater depth, though deep shafts are adequate for now to determine the issue—matter less than the focus provided for scientific research by marketplace economics, through a social policy advocating the use of public revenue to provide indirect subsidy of private enterprise.

The *Mining Industry* report to Congress delivered by the Department of War was specifically concerned with the oversight or regulation of the mining industry. It is not an overtly political document, yet a political meaning is unequivocal, for, by its focus on management and profitability, the report evokes the postwar subsidies of land and revenues to private capitalists, to railroad and mining interests, and indirect subsidies such as official and free information on potential resources and their accessibility. The mining report makes plain King's conception of the role of the survey in transferring at least the mineral resources of the public domain to private or corporate ownership. Thus, while it is not a proposal for government action or new legislation, the report on "engineering and economy" cannot be taken as dispassionate description.[60] The authors sprinkle their science with observations of direct interest to speculators, claim holders (many of whom desired only to sell out to the large companies), and managers of the mines, and speaks directly to their fears about the future of their investments.

"The Comstock Lode," Hague notes, "judged by present appearances, would hold out but doubtful promise for the future, if there were no

hope of greatly reducing the present costs of mining and milling." He proposes, in the report's most blunt suggestion, a cut in wages, adding without further explanation that such a reduction "seems unavoidable, for the high wages at present are quite out of proportion to costs of living."[61] Apparently Hague did not seek to learn the views of the miners themselves, for $4 a day had been the rallying cry in several strikes since 1863.[62] His oversight is consistent, moreover, with the report's most glaring omission: an account of working conditions in the mines. We have to read between the lines—or consult O'Sullivan's underground photographs—for any inkling of the labors which brought the Comstock treasures to market. Writing about "thermal conditions," King points out that the temperature of waters below 700 feet rise to 108 degrees Fahrenheit; that "the vapors from these hot waters fill the lower chambers of these mines, penetrating every crevice and fissure-line of the vein-material, and have converted the whole lower zone into a moist, steaming region"; that once, after a cut, "such volumes of heated water" poured in that "the miners were barely able to jump upon the cage and escape to the surface."[63] This is one of the very few mentions of miners in the entire report, other than brief mention of the "costs of labor." The numerous instances when trapped workers did not reach the cage in time, when the hoisting mechanism failed, when sudden cave-ins occurred or fires such as the major blaze that converted much of the town into an inferno in 1866: the dangers of deep mining were actually increased by the installation of untested mechanical devices during the feverish capitalization of the early 1860s. All these facts were beyond the scope of the surveyors' investigation of the "engineering and economy" of the mining district.[64]

How, then, are we to understand the choice of "Shaft Landing of Savage Mine" as the frontispiece of the official report? Alan Sekula's suggestion cannot be discounted, that in its "neatly symmetrical view . . . [of] a disciplined work crew about to descend into the depths," the picture is "full of industrial promise"—a symbol of the social order envisioned by the report.[65] This view does accord with the managerial point of view evident in the text, and indeed the lithographed version does make the figures seem more limp, more acquiescent, less individual, than the print, in which it is evident that the figures are standing in a pose, aware of the camera, even smiling slightly as if mildly amused by the situation. The transposition of print to lithograph to frontispiece reflects the process whereby the photograph comes to represent the "mining industry."

They are about to descend into, or have just returned from, a region

everyone acknowledged was a living hell. "View their work," writes a
visitor to Comstock a decade later:

> Descending from the surface in the shaft-cages, they enter narrow galleries
> where the air is scarce respirable. By the dim light of their lanterns a
> dingy rock surface, braced by rotting props, is visible. The stenches of
> decaying vegetable matter, hot foul water, and human excretions intensify
> the effect of the heat.[66]

The report on mining gives only an inkling, and the array of charts
and engineering drawings indicates nothing at all, of human experience
deep in the mines. Yet the frontispiece invites us to imagine where
these men are going, and where they have been. The report answers
such a question in its own terms—at once "scientific" and ideological.
However, O'Sullivan's photographs assembled in the 1868 volume, the
views of Virginia City on its hillside, of shafts, mills, smokestacks, and
men at work deep within the mines, offer another. Thus, if the
photographs in the 1868–69 album can be taken as supplements to the
report, a "conceptual bridge" to its abstract drawings of shafts, timber-
ings, hoists, milling plants, and geological maps and cross sections, then
we have to say that the photographs exceed the bounds of the report,
of its "engineering and economy" categories and its explicit ideology.
They present "mining industry" as a social fact, a matter of buildings
in a certain setting, and men at work.

Considering how freely King used lithographed photographs in his
strictly geological reports, we must wonder: does the use of only one
photograph in *Mining Industry* imply suppression, particularly of the
underground images, which include a collapsed section of timbering?
Did the photographs provide the wrong information that the report
itself failed to acknowledge? Are the photographs in the volume, then,
a kind of countertext to the report, too literal, too concrete to be
accommodated by the text, as similarly detailed images of waterfalls and
rock formations and desert lakes and sand dunes were obviously not
deemed to be? Unanswerable, these questions suggest at least that the
notion of the photograph as "conceptual bridge" entails not simply a
visual literalness but a social act of seeing and defining.

In the 1868 volume the mining photographs appear as a self contained
group of seventeen images between the images of Shoshone and the
desert: probably the first arrangement of industrial pictures before the
work of Lewis Hine early in the twentieth century in an order that
describes (albeit sketchily) an industrial community.[67] What is their
effect here? We see in the first seven images of the sequence a steady,

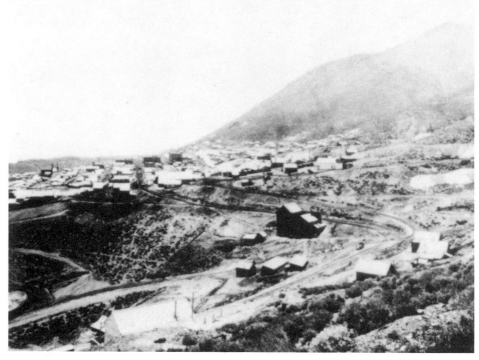

54. "Virginia City." T. H. O'Sullivan, plate 11

55. "Shaft Mouth, Mining Works, Virginia City, Nevada." T. H. O'Sullivan, plate 13

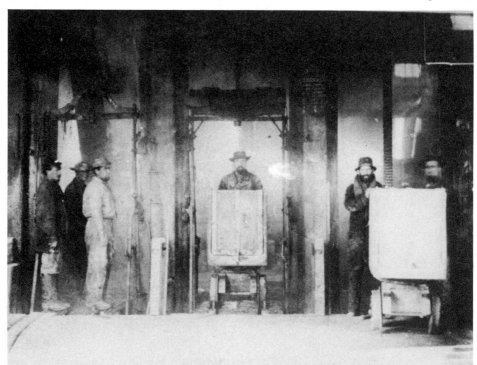

56. "Miners at work on 4th level, Savage Mine, Virginia City, Nevada." T. H. O'Sullivan, plate 16

57. "Crash of timbers in cave-in, Gould & Curry Mine, Virginia City, Nevada." Taken by magnesium light. T. H. O'Sullivan, plate 17

systematic narrowing of focus, from a distant, inclusive view of Virginia City to sharply detailed close-up images underground. Following the natural power of Shoshone, the opening shot shows a scene of social power: a city with roads and streets, houses with fences, church steeples competing with smokestacks, a view corresponding to a visitor's description of what appears to be "a great village perched upon the side of a high mountain" but actually is "a cosmopolitan city, with the diversified interests and varied social features of a large and important centre."[68] The sequence then takes us closer to the industrial city, to the shaft mouth, into the mine. There, we catch ourselves mesmerized observing laborers, so close to the shovel, pick, hammer, wheelbarrow, and precious candle (they were distributed stingily, and each miner was responsible for rationing his own limited source of light) that we can hardly avoid identifying with the miners in their cramped positions—filling in the other sensory experiences as best we can imagine (or endure) them. The last of the underground images, "Crash of timbers in cave-in, Gould & Curry Mine" (No. 17), stands as grim parallel to the imagined extinction of self provoked by Shoshone; here, the image of a leg severed from its body seems (at least this is its effect) a camera-made equivalent to the absent vision of bodies actually dismembered by such accidents. It is not surprising that King found no space for such an image in the report, for it is difficult to view these underground pictures except by taking for the moment the point of view of the laboring miner.

Emerging from the pit, the photographer takes in buildings housing the ore-reduction process, and then moves out to other communities: Gold Hill, Washoe, and, farther away, Oreana and Austin. Indeed, O'Sullivan calls attention to his camera by its swiftly changing perspectives, and in "Sugar Loaf, Washoe, near Virginia City" (No. 21), the camera itself appears, at least its surrogate, the portable darkroom situated in profile at the lower left, which resembles a camera with its bellows aimed at the view below. Whatever O'Sullivan had in mind, the effect is strong and assertive: the medium has transformed random industrial elements into a picture which brings them together in a meaningful form. The picture focuses on the sharp, straight lines of the shed in the foreground, against the airy tracery of the trusswork just behind it, static mechanical shapes set against the jagged patterns made by distant hills. Within this play of industrial against natural forms, O'Sullivan has aligned a broken arc of buildings across the middle belt of the picture, in which our eye picks out a line of words, an array of painted signs declaring Confidence, Challenge, Empire, Imperial. The names declare both private ownership (each a legally sanctioned

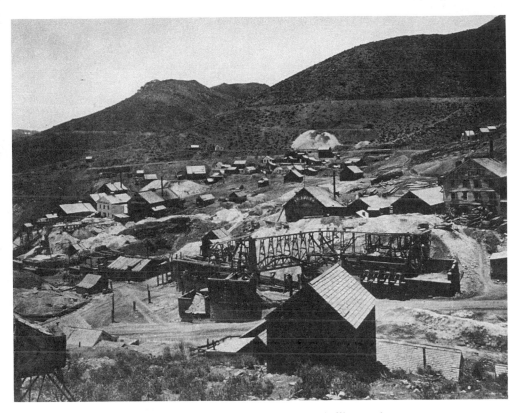

58. "Sugar Loaf, Washoe, near Virginia City." T. H. O'Sullivan, plate 21

corporation) and its self-justifying ideology, competition and expansion. Like the names of scientist-heroes King and others bestowed upon "unnamed" peaks and lakes, these more nakedly aggressive names superimpose a sophisticated social system upon an alien terrain: outward signs of the act of appropriation represented by the "mining industry," if not by the "survey" itself.

The photograph depicts a landscape in which "nature" has already been worked over, converted to "culture"—culture not as an abstract category but as the product of a specific history—and depicts itself as something made by human labor, as much a technological act as the reduction of ore to silver bullion. The photograph shows that the oppositions within which the survey performed its tasks—nature and culture, alien and familiar, nameless and named—are themselves the product of an already established and expanding cultural power, an imperial energy of which both the mining industry and the survey which serves it are leading forces. A countertext to the 1870 report from which they are (deliberately?) excluded, O'Sullivan's mining photo-

graphs play a complex role in the album. They represent history and society directly within the sequence, between the "natural" power of Shoshone and what we shall see as the peculiar power of the desert to deceive and baffle perception. The mining pictures force us to recognize that even Shoshone, even Carson Desert, cannot be understood simply as "nature" existing prior to and apart from the social activity of survey, but as the product of a distinct mode of seeing, knowing, and possessing. They disclose not only the "landscape" of the 40th Parallel as already within the domain of history and force, but the work of survey as precisely to confirm that fact, to make it real by making it graphic: by putting a view to the name.

V

King writes in *Mining Industry* about the flat regions of the Great Basin: "The depressions of the ring are dreary reaches of desert where fields of sand alternate with alkaline plains, where, in the brilliant dry air, the eye may range over expanses of desolate lowland, naked and devoid of all vegetation except those blighted-looking forms of life, the sages, which rather intensify than relieve the deathly aspect of the scene."[69] By subject alone—mounds of silica and sand, flat alkali lakes, hot springs, and gaping geyser mouths and bizarre fissures—the desert group (Nos. 28–39) lacks the visual drama of Shoshone or Virginia City, or of the mountain canyons, cool lakes, and fascinating outcroppings which predominate in Volume Two. The very aridity of the terrain feels gritty and uninviting. Fissures opening like crocodile jaws and seemingly bottomless black holes add a note of terror, of the less familiar, more deviously demonic sort than the overwhelming power of Shoshone or the claustrophobia of the shafts deep in the mines. Dry, vast, and unfathomable: the desert world seems endlessly isolated and isolating.

The pictures, however, show the forbidding terrain in a perspective which mitigates the effect. The section includes more pictures of survey activity, of acts of observation and of photography, than appear elsewhere. O'Sullivan's wagon and pieces of equipment often appear in these pictures, which also include two examples of a doubled point of view, of the same object viewed from different perspectives: examples of the camera's constructive function similar in principle to both the Shoshone and the mining sequences. Indeed, the clustering of pictures showing survey and photographic activity in precisely this terrain—a region ranging over several hundreds of miles of the Great Basin—lends a unity to the section more subtle, more complex than stillness

and threat alone suggest. For these are pictures of acts of investigation in a realm in which the deepest challenge is not so much to life but to perception, to survey itself.

The opening image offers a panoramic view at Steamboat Springs (No. 28) in which the photographic wagon, another carriage, and the tripod-supported portable darkroom form a distinct triangle pointing toward a massive silica mound in the distance. Other signs—a road crossing diagonally above the middle of the scene, a wooden house and fence barely made out in the right rear—comprise a scene in which social activity has already left its mark: not nature pure and simple, but nature already altered, if only in some small way, by human labor. With the exception of a distant view of Sou Hot Spring from a high elevation (No. 34), the other photographs in this sequence are relatively close examinations of specific phenomena: the rip-tooth fissure vents at Steamboat Springs, alkali lakes, geyser mouths and pools, pyramid-shaped tufa mounds in Pyramid Lake, and the famous sand dunes in the Carson Desert. Moreover, they are examinations of objects themselves under examination—Nos. 36 and 37 most definitively so; but even in the other pictures, figures appearing even inconspicuously, like the man regarding something in his lap—a porous rock? a photographic plate?—at the extreme right edge of No. 38, make it unmistakable that we witness a strange land under close inspection. The pictures deny any illusion of "nature" apprehended on the sly, as it were, by a camera acting as the spy of God. We witness nature undergoing a process of survey, photographic and otherwise—of translation into knowledge, into picture.

The region explored here shared some of the onus, in popular accounts, of the mythical Great American Desert, the infernal barrier, it was feared, to the steady westward march of civilization, of the agrarian republic envisioned by Jefferson and others.[70] By legend and tale, the desert was a place of unexpected wonders and optical illusions, of sudden changes in weather, evil-smelling sagebrush, hot geysers spouting from parched earth. Earlier military explorers, King stated in *Systematic Geology*, "lifted our knowledge of the Fortieth Parallel country out of the condition of myths," but "serious gaps" remained, which he took as his aim to close.[71] Mountains occupied most of his attention, but deserts posed their own order of problems, their phenomena proving so elusive. The pictures range over a lowland area in the Great Basin comprised of "immense stretches of level plains of sand and alkaline clay," marked by "detached sheets of brackish water . . . of very great picturesque and scientific interest." The origins of the "depressed, funnel-like hollows" carrying two such "sheets," depicted in Nos. 31,

59. "Silica Mound, Steamboat Springs." T. H. O'Sullivan, plate 28

60. "Fissure Vent of Steamboat Springs." T. H. O'Sullivan, plate 29

61. "Tufa Domes." T. H. O'Sullivan, plate 38

32, and 33, King notes, "is not altogether easy to account for," and he guesses from the basaltic materials on their banks that when the region was under "at least 500 feet of water," in the Lower Quaternary period, "these crater-like lakes were points of extremely powerful springs." But this is only what he is led "to suspect." The desert frustrates King's quest for materials from which he might write upon those "sheets" a dramatic narrative of origins and change: "The origin of these alkaline carbonates is among the most difficult of the chemical problems of the region."[72]

The desert sequence might be taken as a visual parallel to just such difficulties: a human figure barely discernible through the mist rising from a fissure vent (No. 29); a man reclining at the edge of a hot sulfur spring, apparently examining the water, but in a manner reminiscent of Narcissus' fatal fascination with his own reflected image; another observing figure gazing into the black pit of a geyser pool which emits a thin mist, his head cropped just at his eyes (No. 37).[73] In the latter image, what seems to be the dark shadow of the camera box makes the picturing process itself part of the picture, just as the cropped figure declares the powers of the picturing apparatus to define an arbitrary

realm of visibility. In short, this group of images represents the desert as the realm more than any other in which the acts of survey most palpably intrude upon and disturb the object of survey—in which the knower and the known lie perilously intertwined.

Take the familiar "Sand Dunes, Carson Desert" (No. 39). Its penultimate place in Volume One, just before the picture showing the explorers about to launch their skiff *Nettie* in pursuit of further surveys, suggests that it might be taken as a summary image, a condensed statement of issues explored in the preceding pictures. A photographic wagon sits near a sand dune in the Carson Desert in Nevada, one of the "trains of dunes" King described as "gradually moving eastward."[74] Portrayed from a slight elevation, the dune rises to an irregular five-peaked line sketched against pure sky—we can tell from the sun's reflection on the roof of the carriage that the sun is blindingly bright, and from the tight shadows under the wagon and the four mules that it is high noon. Wagon and animals stand waiting in a flat declivity at the base of the dune among some scraggly desert vegetation, forming a line slightly more than a third of the way up the frontal plane of the picture—and giving us a sense (inexact, but exact enough) of the scale of the dunes. Below, the sand shows signs of trampling, and a line of footprints leading from the wagon to the camera position; carriage tracks entering the scene on the right show that the wagon had moved at a slight diagonal across the face of the picture to about its center, and then made a swooping turn to its present position, facing the direction from which it had come, just to the right of and slightly below dead center of the field of vision.

Demarcated by the rigid rectangular form of the wagon and its spoked wheels, and the animal and plant forms next to it, the bottom third of the picture displays human life, activities which can be construed as a narrative of events in time. The top third shows an empty white sky, and the middle band, containing the dune itself, is all wind-shaped sand framed at the horizon by severely dark hills—top and middle both dramatically out of reach of the narrative by which we comprehend the lower part of the picture. Thus the picture encapsulates two systems of time and explanation, the human or social and the geological (itself a social construction). The dark shadows under the wagon train indicate not only that it is noon but that time is palpably present in the picture. Like sands in an hourglass, the windswept dunes suggest the passage of time, the wagon tracks and footsteps trace temporal human actions, and the photograph itself results from the opening and closing of a shutter, an irrecoverable past moment—a juxtaposition of the immensity of time measured by geologists and the immediacy of this recorded

62. "Hot Sulphur Spring, Ruby Valley." T. H. O'Sullivan, plate 36

63. "Sand Dunes, Carson Desert." T. H. O'Sullivan, plate 39

instant. The photograph depicts depiction itself—not "nature" as a pure essence, something that can be measured and mapped with godlike objectivity, but a scene already altered by those very acts. As in many photographs, a residue of information reminds us of the picture-making situation itself.

In *Systematic Geology* (1878) Clarence King stated that by deciphering rocks he hoped to learn about their origins and chart their history, to "construct a continuous piece of geological history." His scheme, he explains, "is chronological," starting in Archaean time at the bottom of "the geological column," "and proceeding without break through the Quaternary."[75] The column, a conventional image among geologists, defines time as linear, and King tells the story of the rocks of the Cordilleras (Rocky Mountain) region as just such a continuous narrative occuring in the vertical dimension. The story he tells in the language of science resembles a creation myth: how things came to be as they appear to the eye and its instruments. The mythic element is sometimes explicit in King's use of commonplace metaphors: canyons are "gateways," ridges "mural escarpments," sand and marl formations are "innumerable turrets, isolated towers, and citadel-like masses, which, when seen at a little distance, present the aspect of a great walled city, with outlying bastions and buttresses."[76] Masonry, architecture, and sculpture provide the most frequent metaphors, endowing the natural terrain with an aesthetic structure.

Metaphors are names, a way of bringing the unfamiliar into familiarity. A discourse in words rather than number, King's geology necessarily had recourse to metaphor. His "purest" science, in *Systematic Geology*, coexists with a poetic method of naming by figure of speech. King's love of Ruskin is well known: "Ruskin alone, among prose writers on the Alps, re-echoes the dim past, in ever-recurring myth-making, over cloud and peak and glacier."[77] It takes nothing away from King's science to see it fused with aesthetic inclinations, a fusion encouraged by Ruskin's view of the mutuality of beauty and truthfulness (topographical exactitude) in landscape painting. Nor is it surprising that a geologist be drawn to thoughts of "the dim past" and of myth making. It is in this light that his preference for the theory of "catastrophism" should be seen, for the language in which he espoused the theory, one of two great principles of explanation then current in the earth sciences (he uses it to account for the history of the Cordilleras), indicates a powerful attraction to metaphor and myth.

Catastrophists argued that geological change did not take place at a uniform rate, as Lyell had theorized and the British Uniformitarians

believed, but alternately between steady change and violent upheaval. The catastrophic view has been wrongfully thought of as no more than an excuse for reinstating divinely ordained floods and earthquakes within the evolutionary process. As Stephen Jay Gould points out, while the theory did provide an aura of science for some "theological apologists," catastrophism had its legitimate side and respectable scientific defenders.[78] King has been described as one of the apologists, and indeed, in his commencement lecture at the Yale Sheffield School in June 1877, "Catastrophism and Evolution," he makes a reference to "He who brought to bear that mysterious energy we call life." Otherwise, his citations are wholly within the secular field, to Darwin, Huxley, and the American paleontologist Marsh. But he concedes that the argument for catastrophism draws on sources other than scientific induction. "That the rate of physical change progressing today . . . is inadequate to produce the grander features of American geological history" is a deduction King makes from atavistic fears, from the "ancient belief" of "primeval man" in "terrestrial catastrophe"—surely the result of witnessing "certain terrible and destructive exhibitions of sudden, unusual telluric energy" (earthquakes and volcanic eruptions). "Catastrophism is therefore the survival of a terrible impression burned in upon the very substance of human memory" of "the destructive in nature." A poetic doctrine, in short, "most powerful in its effect on the imagination."[79]

The intent of King's argument is not to reject Darwin's theory of natural selection but to modify it. In periods of uniform environmental change, "the war of competitive extermination become[s] the dominant engine of change and development." But in the circumstances of catastrophe, "struggle for existence" waged among species and individuals loses its power to a struggle with the physical environment. Catastrophe changes the game. "When catastrophic change burst in upon the ages of uniformity, and sounded in the ear of every living thing the words 'change or die,' plasticity becomes the sole principle of salvation." King proposes "survival of the plastic" as the catastrophic equivalent to "survival of the fittest." The Darwinian notion of a "struggle for existence" is a "gospel of chance" which holds that "we are what we are because this brain and this body form the most effective fighting-machine the dice-box of the ages has thrown." Survival of the plastic, the same struggle redirected to the environment, converts chance to destiny:

> He who brought to bear that mysterious energy we call life upon primeval matter bestowed at the same time a power of development by change, arranging that the interaction of energy and matter which make up environment should, from time to time, burst in upon the current of life and sweep it onward and upward to ever higher and better manifestations.

> Moments of great catastrophes, thus translated into the language of life, become moments of creation when out of plastic organisms something newer and nobler is called into being.[80]

Catastrophism clarifies a linear process: from the fears of primeval man to the inevitable transcendence of superior organisms.

"Men are born either catastrophists or uniformitarians. You may divide the race into imaginative people who believe in all sorts of impending crises—physical, social, political—and others who anchor their very souls *in status quo*." But more than a quirk of temperament is involved in how King presents the theory, for his figures of speech intimate that society rather than nature is the real threat to "serenity." King delivered the lecture just weeks before a sudden upheaval—it was likened in the press to an erupting volcano, the worst bloodshed since the Civil War: what seemed a spontaneous and an unrelated series of strikes along the Eastern and Midwestern railroad systems. Violence erupted, troops were called in, pitched battles fought, and in St. Louis an entire city fell briefly under control of a socialist commune. The specter of Communism loomed in the immigrant-dominated cities—a fear of anarchy and chaos King's friend John Hay would later re-create in his novel *The Breadwinners* (1884). Lecturing just before the upheaval but in the tense atmosphere of an unsettled moment, King speaks of "the battle-field of life," the "heat of the strife," of "upheaval," "revolution," and the "terrible catastrophic engine." He describes catastrophism in language drawn from current events—for example, a railroad that "dashes against a bridge and is utterly wrecked." The imagery of Spencer's "social Darwinism" intrudes into his geological discourse—imagery of relentless struggle between men defined as strong or weak (degrees of plasticity rather than of wealth or power) and a violent environment.

Did King ten years earlier imbue Timothy O'Sullivan with his Ruskinian doctrine of nature as a spiritual presence, interlaced with the theory of catastrophism?[81] Another beguiling thought, and not implausible. But the photographs have a more complex relation to King's ideas and his literary imagination. Names and metaphors must also be counted among the instruments of measuring, mapping, and picturing at the command of the surveyors. O'Sullivan's photographs cannot be taken simply as illustrations either of facts or of ideas. The representational activities of the survey are as much their subject as nature itself—indeed, as deliberate acts of framing a view, even views devoid of human signs, the photographs themselves represent human inscription upon the blankness of nature, an equivalent to a place name. The photographs seem to say that there are no views without names—no nature except what can be seen through the lenses of culture. The paradox represented

in "Sand Dunes, Carson Desert" suggests ambiguities in the enterprise of natural science that had not yet risen to the surface of scientific discourse. The labor of survey, its daily encounter with recalcitrance, can be taken as O'Sullivan's chief subject in this album: not nature as something given but as something simultaneously made and known in the act of perception, something as contingent as the name of a view.

It is the 1868 sequence which releases, or creates, these meanings, and King himself may have been the author of that provocative album. In any case, the pictures partake of the contradictions in King's own situation, his uneasy joining of aggressive commercial-imperial motives with what his outlook defined as disinterested science and autonomous art. Arranged as a journey from natural power at Shoshone to urban-technical power in the silver mines to the desert investigations of the power of survey itself—the representational power of its measuring, mapping, and picturing instruments—the sequence reads very much like a text by King. Yet, in a way, by its desert reflections upon its own means of representation, its own resources as a technical medium of cognition, it surpasses King's own self-reflections. Even apart from the particular order of this sequence, O'Sullivan's survey photographs for Clarence King and, later, George Wheeler, introduce a new element in American photographs: a pictorial self-consciousness about the relation of aesthetic and cognitive aspects of the image. Whether or not King organized O'Sullivan's 1868 pictures, O'Sullivan was responsible at least for the pictures themselves and their extraordinary self-awareness as *survey* photographs.

The self-reflexive aspect of particular pictures is echoed in the sequential placement of the mining images of capitalist-industrial enterprise at the center of the album. Even if the intention may have been to wheedle more funds out of a development-minded Congress, the strategic location of these pictures makes a more acute statement than does King's prose about the cultural work of the survey, its role in the conversion of the "nature" Peale rearranged for the sake of classified knowledge, into a "resource" for commercial profit. O'Sullivan placed his camera at the scene of American contradiction, the place where Peale's Enlightenment quest for disinterested knowledge through science and art turns into its opposite: a quest for instrumental knowledge for the sake of private gain and imperial power, at the expense of the illustrious community about which Peale and Brady, in their separate ways, dreamed. While O'Sullivan's fame as an artist of landscape has flourished, the album has been buried in an archive for more than a hundred years, an ironic fate for a key document in the emergence of a critical art of American photographs.

Camera Work/Social Work

The traditional separation between some things as mere means and others as mere ends is a reflection of the insulated existence of working and leisure classes, of production that is not also consummatory, and consummation that is not productive.

— JOHN DEWEY, *Experience and Nature* (1925)

WHEN MATHEW BRADY died, impoverished and alone in a New York hospital in 1896, his dream of an illustrious American republic founded on eminence and character had all but faded away.[1] And with it, a sense of the photographer's obligation to record the nation's troubles along with its triumphs. Not until the disorder and dangers of the 1930s depression reawakened a desire to portray America as such, to take the nation, its despair but also its hopes and residual strengths, as a camera subject, would Brady be acknowledged by historians and artists as a founding figure in American photography. The rediscovery of Brady in that decade was accompanied, moreover, by another "discovery"— Lewis Hine, still active in the 1930s but belatedly recognized as having already produced a Brady-like corpus or archive, epic in scope and historic in significance, of the nation's troubled life in the first decades of the twentieth century. Hine, too, had taken illustrious Americans as his obligatory theme, but redefined the category to embrace working people, particularly manual laborers, particularly recent immigrants, and more particularly working children. In his "child labor" pictures made across the country, roughly from 1907 to 1917, Hine had revived and revised Brady's antebellum and Civil War projects, and in the process redefined the practice of American photographs, its social work and its aesthetic work, its content and its form.

Why did it take so long for Hine's radically reformative achievement to win recognition? Why even today is he still described as a "documentary" photographer, confined to that limiting category, as if his work consisted only of making illustrations for a future history textbook, rather than the making of a new order of social art in photography? We cannot enter directly into Hine's work, into its historical place, except through pathways indicated by these questions. For example, the matter of his recognition leads to questions about the instruments and institutions of fame, the forms of cultural authority through which decisions are made and communicated—decisions to exhibit, publish, interpret in certain ways. These in turn are based upon choices about value, standards of judgment, and about the status of the objects under consideration. Recognition depends upon an institutionalized community capable of conferring prestige upon photographers. Hine's acceptance by such institutions was delayed until the Depression decade, when new pressures upon the idea of worth in photography could not be resisted, pressures which required that art take notice of social conflict. The 1930s provided the conditions for the appearance of Hine as a historical figure.

Hine cannot be seen historically except in light of his reception and belated acceptance in the 1930s. He cannot be seen and understood as a maker of American photographs, a figure in the evolution of American photographs, except in light of the emergence of a field of serious photography after the heroic age of Brady, Gardner, and O'Sullivan. He cannot be seen and grasped except in light of Alfred Stieglitz. Ten years older than Hine, already established when Hine began his work in 1904, Stieglitz created a photographic "scene" in New York which reached the height of its clarity and power exactly during the years, before World War I, when Hine traveled the country photographing working children in fields, mills, mines, and city streets. Both a photographer and an arbiter of value in photography, Stieglitz built the first major institutions of art photography in America—his gallery known as "291," and his journal, *Camera Work*—institutions which took no notice of Hine, although Hine took notice of them. Both gallery and journal closed in 1917, but they had established both an idea of seriousness in photography and a method (small gallery exhibition and fine-art publication), which gained strength in the 1920s and provided the capital of theory and strategy (for example, winning access to metropolitan museum collections and exhibition spaces) upon which the expanding photographic community in the 1930s drew. Stieglitz, what he represented, provided the terms through which Hine gained his recognition

in the 1930s, and through which he has, on the whole, been seen and understood since.

By the same token, Hine provides a perspective upon Stieglitz, a view of the older man's achievement as an artist and an arbiter or impresario of the aesthetic practices he defined as "camera work." The perspective derives from the conditions under which Hine worked, quite different from the modes of artistic production associated with "291" or the established art world in general. Hine performed his artistic labors within the institutional framework of Progressive reform movements, structures which included organized networks of association, publications, systematic methods of investigation and communication, and an ideology which sought to control what were perceived as anarchic, destructive forces let loose in America by urban industrial capitalism. Progressivism was a movement of reform, not revolution; it saw itself as a liberal alternative to revolutionary change of the sort proposed by the socialist movement, which in these years, under Eugene Debs, had grown in size and influence. Many socialists participated in reform movements, but the thrust of the liberal outlook Hine endorsed was toward legislative change fostered by an enlightened and activated public opinion—correctives in the system in order to mitigate conflict in the name of presumed American values of equality, justice, and progress. Progressive reformers attempted to implement these ideals under the new conditions of mass immigration from non-English-speaking countries, which led to urban poverty and deprivation, deepening labor-capital conflicts, poorly managed and corrupt cities, a national legal system unresponsive to the needs of injured workers, exploited and abandoned children, working mothers. If the Civil War represented a life-and-death threat to the values Brady celebrated in his *Gallery of Illustrious Americans*, the social crisis to which Progressivism responded in the early twentieth century represented another (as would the Depression of the 1930s). And Hine can be seen as engaged in a project similar to Brady's in its ends, though thoroughly different in its methods: to promote a liberal idea of America through photographs in order to reshape reality in liberalism's image.

In light of Hine's photographic social work, Stieglitz's camera work takes on a sharper historical outline. The issues between them concern, broadly speaking, the notion of a photographic subject, the relation of the medium to American realities, and the effect of photographs upon their audiences. Hine's stance toward America was critical but hopeful—critical of social and economic injustices in view of conventional American values of common sense and fair play. His typical method was to show contradiction between the rhetoric and the reality of American

life—in regard to children, for example, or mothers, or working people. Stieglitz's stance is less simple to define: critical of business culture to the point of cynicism, but more attached to aesthetic, individualist alternatives than to social or political solutions. In the late teens and 1920s an influential group of intellectuals who found reformist liberalism too pragmatic, bureaucratic, and shamefully acquiescent in America's entry into the European war (in which Hine served as a Red Cross photographer) celebrated Alfred Stieglitz as an American idealist in the tradition of Emerson and Whitman, an advocate of freedom in the arts (he had championed modernist nonrepresentational art at "291") and of the autonomy of individuals. An inspiration to artists like John Marin, Arthur Dove, his wife Georgia O'Keeffe, the photographers Paul Strand, Ansel Adams, and Edward Weston, writers like Sherwood Anderson, William Carlos Williams, and Hart Crane, the critics Waldo Frank, Paul Rosenfeld, and Lewis Mumford, Stieglitz stood at the center of a movement which sought to produce a new American art and culture, a movement openly critical of the aggressive commercialism, hypocritical moralism, and empty conventionality of the reigning culture. Educated in Europe and a frequent traveler there in his youth, in 1921 Stieglitz wrote of himself: "I was born in Hoboken. I am an American. Photography is my passion. The search for Truth my obsession." In 1934 there appeared the extraordinary tribute, *America & Alfred Stieglitz: A Collective Portrait*.[2]

It is not Americanness that is in question between Hine's social work and Stieglitz's camera work. If anything, Stieglitz was more vocal, more programmatic in proclaiming himself an *American* artist. Nor is it liberalism. In her contribution to *American & Alfred Stieglitz*, the critic Elizabeth McCausland placed Stieglitz directly in what she described as the central American tradition of freedom: "Free to work, free to be himself, free to live without selling his soul, these are rough translations of the eloquent speech which Stieglitz has wielded for years as other men wield weapons."[3] To preserve basic American rights "from corruption" has been his goal. As early as 1912 the socialist intellectual and journalist Hutchins Hapgood had described Stieglitz's "291" as a place where "the voice of freedom has been quietly shouting in the wilderness," where all art is acceptable "provided it is animated with a sincere desire to see straight, to feel beauty and form directly, without an undue regard for convention, tradition, and authority." In the same year Stieglitz told a newspaper interviewer that his gallery was really a "laboratory"—a word with Progressive overtones of experiment and respect for science—based on revolt "against all authority in everything."[4]

Stieglitz shared with Hine a generally liberal-progressive outlook which valued change, experiment, and freedom. Their point of divergence was in their notions of the role of the artist and the social character of the art experience. For Stieglitz, the artist served the public by breaking old rules and founding new ones. "291" was a laboratory, he explained in an interview in 1912, for "testing the taste of the public."

> This work was a reflection of the social unrest which pervades the whole country. People are getting tired of the shibboleth, "Because this always has been it always should be." There is nothing so wrong as accepting a thing merely because men who have done things say it should be so. A genius is born and strives against existing rules until he overthrows them. Then people make rules founded in accordance with the ideas of that man, and when a new genius is born the fight between individuality and established custom begins all over again.[5]

Change derives from the artist-genius, and the public comes to "291" to stand in the aura of genius and its works, to have itself tested against the taste (the capacity to discriminate and appreciate) implied by those works on exhibit. "291" responded to "the social unrest," then, in a manner similar to that of the "expert" of Progressive social theory.

Hine spoke only diffidently about himself as an artist, but, as we shall see, based his conception of photography as social work on an aesthetic theory. Hine diverged from Stieglitz's romantic modernism in two key regards: he saw himself not as an individual genius breaking convention but as a working photographer performing a certain kind of cultural (and political) labor; he focused his work not on the photograph in exhibition but on the published image—not the single photograph as a fine print (its tonal values intact), but the reproduced image within an ensemble of images and words. The word "documentary," regularly applied to Hine's pictures, fails to capture the full character of his work and the consciously held theory informing it. Rather than "art" versus "documentary" photography, what distinguishes Stieglitz's camera work from Hine's social work are competing ideas of art itself, and of the cultural work of the camera in early-twentieth-century America.

In the 1930s Stieglitz saw his "battle for photography" won when New York's Metropolitan Museum of Art accepted photographs into its permanent collection, and the Museum of Modern Art mounted an exhibition in 1937 anticipating the hundredth anniversary of the medium in 1939. In that hundredth year Lewis Hine also enjoyed some of the fruits of acceptance. He was given a retrospective exhibition at the Riverside Museum, arranged by an alliance of old Progressive friends and younger critics who had just discovered him (including Elizabeth McCausland), many associated with the Photo-League, a New

York group of socially engaged photographers. Stieglitz allowed his name to appear among the sponsors, although it is not clear that he went to the showing. The event confirmed Hine's incorporation into the canon of the medium then being shaped, as the exemplary "documentary" photographer. His success was, in an important sense, also Stieglitz's success—for the exhibition and categorization confirmed the hegemony in the photographic community of a division between "art" and "documentary" photography, and the validation of museum exhibition as the supreme mode of conferring value (marketplace as well as aesthetic) on photographs. This bittersweet irony (in spite of the success, Hine would die in poverty within a year) suggests that viewing Stieglitz and Hine in the light of each other can produce a valuable perspective through incongruity, in Kenneth Burke's terminology, which will yield important insights into the work (and conception of work) of each, and of their responses to the unsettled times their careers spanned.

I

In 1899, three years after Brady's death, Alfred Stieglitz announced that something new had appeared in photography—a desire to make art rather than mere photographs. For the past ten years, he explained in an article on "Pictorial Photography" in *Scribner's*, pictorialism had captured the imagination of certain amateurs. Prominent member of the prestigious Camera Club of New York and editor of its periodical *Camera Notes*, the thirty-five-year-old Stieglitz was already a major force in American amateur photography, both as a photographer and as a spokesman for the new movement. Born in Hoboken, New Jersey, in 1864 into a wealthy German–Jewish merchant family, Stieglitz had been sent to Germany in 1882 to study engineering but soon took up photography instead, studied photo-chemistry with Hermann Vogel, traveled widely with a camera through France, Switzerland, and Italy, entered competitions, and won many prizes. Returning to New York in 1890 with a growing international reputation, he threw himself into amateur society activities, and briefly tried his hand as a partner in a photoengraving company but found business uncongenial. With independent means and a dominating, charismatic personality, he devoted the rest of his long life (he died in 1946) to winning the case for photography as a fine art. Since 1890 he had made pictures on the streets of lower New York, and had experimented in photographing in rain, fog, and snow, and at night.

Early in the 1890s, other photographers ventured into the same streets for different purposes—stereographic views for tourists, for

example, of the waterfront, Central Park, and the financial district. Commercial photographers made pictures of brownstones, street corners, and the interiors of shops and homes. The Staten Island photographer Alice Austen sought out street "types," peddlers, craftsmen, and immigrants. And the crusading Danish-born reporter Jacob Riis introduced something new. He undertook photographic expeditions in the slums of the city, not for commercial views but for social information. With the help of friends from the same amateur societies to which Stieglitz belonged, and often accompanied by police, he employed the dangerous technique of igniting an open pan of magnesium powder—crude precursor of the flashbulb—to photograph the squalid rooms of slum dwellers on the Lower East Side. His pictures were taken as sensational disclosures of hidden social facts. While Riis and Stieglitz both presented their pictures as lantern slides, Stieglitz at amateur society meetings, Riis in lectures to church and philanthropic groups as well as amateur photographers, the two men reached a wider audience through the medium of halftone reproductions: Riis in popular articles and books dealing with "the other half," Stieglitz in articles in both amateur journals and popular periodicals, stressing uses of the camera in securing picturesque views of the city.[6]

The parallel between the contrasting projects of Riis and Stieglitz in the 1890s—as far as we know, they never met, but they must have known of each other—suggests a context for the *Scribner's* article of 1899. The 1890s had begun with American society in the grip of a long crisis. For a dozen years the economy had fallen, creating hardship, especially for farmers and workers. Labor conflicts had grown sharp and frequently violent, as industrial workers increasingly resorted to the strike to defend their interests and win recognition of their unions. As conditions worsened, cities became a major focus of attention. Social conflict was most visible in cities—the contrast between slums and the ostentatious palaces of the very rich; new forms of recreation, night life, and pleasure challenging older moral values; women more visible in workplace and the public realm. Later in the decade, cities, particularly New York, also made visible new commercial forms: gigantic downtown department stores serviced the growing consumer desires of all classes; tall office buildings with electric elevators housed a new corps of laborers, "white collar" workers and their new implements of production, tools such as telephones and typewriters. And steel bridges, overhead electric wires, underground gas and water pipes, subway and elevated trains, announced a new technological age. Moreover, by the end of the decade, most large American cities were dominated by recent immigrants and

their offspring. In New York especially, immigrants from Southern and Eastern Europe poured into the crowded quarters of the lower city. To outsiders like Riis, the slums seemed a chaos of alien tongues, strange costumes and customs, foods, habits of child-rearing—a frightening caldron of poverty and despair. No wonder, then, that by the turn of the century the prominence of the city made many Americans, especially a new group of academic social scientists, aware of "society" as a "problem," and of the "social" as a new category of analysis, responsibility, and commitment.

In 1904, a young man from the Midwest began his own career in photography by taking a camera to Ellis Island. Lewis Hine was a teacher of nature to children of less recent, successful, and cultivated immigrant (mostly German–Jewish) families at the progressive Ethical Culture School on the Upper West Side of New York. His purpose in going to Ellis Island was to capture immigrants in their first experience of the Promised Land. Ten years Stieglitz's junior (he was born in 1874, in Oshkosh, Wisconsin), Lewis Hine would strike out in a direction of his own, not the sensational exposures of Jacob Riis (who by the turn of the century had abandoned photography) or the pictorialism of Stieglitz. He used the medium in the practice of "social work," a new profession which had replaced the volunteer philanthropy of the 1890s with systematic study of social problems. Social workers sought to relieve social pressures by combining direct help to the poor with legislative correction or "reform" of injustices such as child labor. Hine would make pictures to raise public awareness of social conditions among the working classes, and in the process he developed a new style of depicting city life, its working-class streets and homes. Shy, self-deprecating, but given to puns (he would refer to his pictures as "Hine-o-graphs"), Hine was the son of a small shopkeeper in Oshkosh who was killed in an accident in 1892. As a youth Hine had experienced hard times and had done hard labor in factories and shops and been a sweeper in a bank. Encouraged by Frank Manny, a teacher of education at the Wisconsin State Normal School where he took extension courses, Hine spent a year at the University of Chicago (1900–1) studying educational theory, perhaps with John Dewey. Meanwhile, Manny was appointed principal at what Hine would dub the "Ethical Informary," invited his young Oshkosh friend to come to New York to join the faculty, appointed him school photographer in 1903; the following year he accompanied him to Ellis Island. Hine left teaching in 1908 for a staff position with the National Child Labor Committee, one of the major social work organizations. Although, like Stieglitz, he briefly ran a business—the Hine

Photo Company (founded in 1908)—unlike Stieglitz he counted on assignments for a living, and in 1940, less than fifty years after Brady, died nearly destitute.

Between Hine's "social work" and what Stieglitz came to call "camera work," American photography split over a fundamental question: What made for "art" in photography? In his 1899 article Stieglitz declared that it was time to take picture-making amateurs seriously. "The real photography, the photography of to-day" was not represented by the merely accurate and technically perfect images of professionals, but was to be found among "those who loved art and sought some medium other than brush or pencil through which to give expression to their ideas." Love of art was essential, the only antidote to the apparent tyranny of the camera, a mechanical device, which gave photography a bad name among artists and critics. Pictorialists strove to redeem the aesthetic reputation of their chosen medium by proving they could impose their desire, their artistic vision, upon the mechanism. Not the means but the end mattered. Ultimately, they insisted, the camera was as irrelevant to the quality of the picture as the brush or pencil of recognized artists. Pictures made by photography were intrinsically no different from any other, Stieglitz argued, and deserved to be judged by aesthetic standards appropriate to pictures in any medium—just as pictorialist photographers deserved recognition as real artists.

Significantly, in this screed for an autonomous art of photography Mathew Brady goes unnoticed and unmentioned. "Pictorial photography," Stieglitz explained, "evolved itself out of the confusion in which photography had been born." Presumably, Brady and his colleagues in the early days of the medium occupy the lower end of the evolutionary scale, confused about the difference between technical means and aesthetic ends, between an accurate record and an expressive picture. In a draft section on the history of photography excluded from the *Scribner's* essay, Stieglitz referred to the early "apprenticeship" of the camera as a "slave, hand-maid, or helping friend" to "research, science, or art." With pictorialism, photography has now "come to her own, and in the strength of maturity taken her place among her sister arts."[7] Was it the commercialism of the early American daguerreotypists and wet-plate photographers which caused Stieglitz to pass over them without mention? In any case, he claimed no American forebears.

The *Scribner's* article cites an English authority, the photographer and writer Peter Henry Emerson, and refers to the acceptance of photographic pictures by the "Secessionists" of Munich, "the art-centre of Germany." Within a few years Stieglitz would break with the New York Camera Club, and seeking a freer hand outside the constraints of

organized amateur societies, he founded a secession movement of his own, the Photo-Secession, with a gallery at 291 Fifth Avenue and a publication, *Camera Work*, which issued fifty numbers from 1902 to 1917. With its elegant design, its tipped-in photogravures (a technique of transferring an image to a metal plate for printing in ink), its articles on the arts, aesthetics, and psychology, the journal was looked upon throughout the world as the acme of serious art photography. Sometime about 1906 Stieglitz made another crucial turn, this time toward modern European painting. He opened his gallery and the pages of *Camera Work* to works by Rodin, Matisse, Cézanne, Picasso, to Cubism and abstract art—meanwhile coming to champion a "straight" style for art photography, a style free of the darkroom manipulations, the blurring of focus and application of brush and pen marks to prints, which had characterized much of the Photo-Secessionist work.[8] In these years before World War I, Stieglitz provided a center, a focal point of modernism in the New York art world. Through "291," *Camera Work*, and museum exhibitions he organized, Stieglitz championed contemporary American photographers—Edward Steichen (for a while his collaborator at "291"), Clarence White, Gertrude Kasebier, Alvin Langdon Coburn, and in the final numbers of the journal, his young protégé, Paul Strand, who had been a student of Lewis Hine at the Ethical Culture School.

Yet, for all his dedication to founding an American art, Stieglitz never turned his attention to American predecessors in photography, never attempted to define and claim a nineteenth-century American tradition. The past of the medium implied by *Camera Work*—more a matter of naming precursors than a critical history—was confined to portraits by the Scotsmen David Octavius Hill and Robert Adamson and the Englishwoman Julia Margaret Cameron. No American daguerreotypes, no Civil War views, no Western views, no commercial city scenes, no work which did not look like premeditated art. Thus the paradox that the most ardent and influential American spokesman for photography as art propagated the notion, at least implicitly, that there was no photographic art in America of any importance before the self-conscious pictorialism he himself represented.

Stieglitz's influence on thinking about the history of the medium proved decisive. It appeared in the categories employed by Beaumont Newhall in his own widely influential books. In the five editions of his "history of photography" (the title changed several times from 1937 to 1982), "art" is set apart from "news," "scientific," and "documentary" versions of the medium. "Stieglitz brought America a message," Newhall wrote in his 1938 *Photography: A Short Critical History*—the volume is

dedicated to Stieglitz, whose "Grape Leaves and House, Lake George, New York, 1934," appeared as frontispiece. "Photography, he said, is capable of more than factual reporting. It can become a personal expression of one's emotional reactions to life, a potential art." Newhall describes Stieglitz's own photographs as "lyrics that penetrate beneath the surface." One of his famous New York pictures, "The Terminal," is "more than a record of a vanished scene; it is the essence of Winter in New York."[9]

Largely through Stieglitz's influence, a polarized language entered photography criticism: factual reporting versus personal expression; art versus document. As editor, collector, gallery keeper, and occasional curator, Stieglitz selected pictures which met criteria not only of form but of intention—pictures made deliberately for exhibition or display as art. His range stopped at the edge that divides intentional art from the unintentional—for example, whatever accidental or unconscious beauty or excellence of form or emotional power may appear in commercial, reportorial, and vernacular work such as newspaper images and stereographs. Morever, pictorialism in both its *fin de siècle* and modernist versions—in the blurred imitations of Impressionism at the turn of the century or the "straight photography" which replaced it—assumed that one had to *be* an artist, to possess a certain sensibility and genius, in order to make art. Only a conscious effort to defeat and transcend the factual report which lurks in all photographs can lead to art. An art of the literal and the useful seemed to the pictorialists a contradiction in terms.

While challenging people to think beyond the medium's function of conveying visual information, to expand their awareness of its "plasticity" as a medium of personal expression, Stieglitz also narrowed the range of aesthetic possibility, placing beyond the pale of serious consideration all work which did not display a pictorialist motive—and leaving a legacy of a polarized vocabulary of criticism. As we shall see in the following chapter, his legacy, ironically, proved a benefit to young photographers of the 1930s, for he provided something to rebel against. "It was he," wrote Walker Evans in 1969, "who forced 'art' into quotation marks and into unwonted earnestness"—an "aestheticism" which "engendered a healthy reaction."[10] Why could not a "documentary" photograph be considered a work of art *on its own terms*? Indeed, for the daguerrean and wet-plate craftsmen of the era Stieglitz scanted as "confusion," no split existed between aesthetic and documentary value, between art and craft. "I am a photographic artist," began an English story published in a popular American magazine in 1861—and added, as if in anticipation of turn-of-the-century pictorialism: "To prevent people from forming

a mistaken conception of me, I may as well state at once that I do not pride myself on being an *artist*—that, in fact, I consider the term, as applied to myself, all fudge. I am a photographer, and not a bad one. If you want clear, sharp, brilliant pictures, I am the man for you."[11] Wet-plate photographers thought of themselves as "skillful operators," as John Samson wrote in his article about Timothy O'Sullivan in 1869, who vied "with each other in the artistic excellence of their productions." To serve practical social functions in an artistic manner seemed to Brady and his colleagues no contradiction. Artist and photographer were interchangeable terms.

Stieglitz and his followers oversimplified the question of art in photography. Their real thrust lay not in their claim that photographs can be art pictures but in their legislation of what is and is not art, their identification of "aesthetic" with certain formulas, Symbolist, Impressionist, or modernist—and their isolation of the aesthetic from social functions. Identifying art with a certain look, they made camera work seem a matter of achieving that look, thus implying that the true history of the medium lay in the history of changing styles and techniques. "What a photograph does look like" and "what should a photograph look like," Peter Bunnell, a prominent historian of the medium, observed in 1980, are the questions which "underlie all thinking about photography since its conception early in the nineteenth century."[12] The premises of the fine-art movement conceived of the history of the medium as a history of styles, of changing looks and aesthetic intentions, isolated from social practices, cultural patterns, and institutional forms.

As a consequence, the Stieglitz tradition proves an unreliable guide to its own history. Rather than an avant-garde movement, pictorialism set its eye upon institutional recognition. While pictorialists extended the range of printing techniques in order to overcome the literalism of the unmodified report of the sharply focused lens, they constricted the choice of appropriate subjects to conventional themes and motifs—misty landscapes, wet streets, staged tableaus. In their imitativeness, as Ulrich Keller has argued, they actually looked backward, showed themselves to be aesthetic conservatives.[13] Moreover, their separation of "art" and "document" imposes a hierarchy of value which insulates their work from that of more practical-minded photographers like Lewis Hine, whose social purposes led to an expansion of subject matter and daring experimentation in technique. Hine's assignments often required him to test the possibility of picture making under severely unfavorable conditions. While Stieglitz and other pictorialists boasted of photographing in inclement weather and at night, Hine learned to use his camera in dimly lit textile mills in order to show barefoot children working at

the looms. He pioneered in the making of informal portraits of people at work in factories, homes, on the street—and in his stage-by-stage record of the construction of the Empire State Building in 1929, balanced himself precariously on steel beams high above the street. And, what has been little understood or investigated, he made and published his pictures with a distinct idea of aesthetic value and the place of art in social experience.

The pigeonholing of Hine as a "documentary" photographer exemplifies the reductive simplifications of the Stieglitz line in criticism and history. The polarized vocabulary of art and document cannot account for the originality and force of Hine's pictures. It also fails to account for the special qualities of Stieglitz's own pictures, which are better understood and appreciated when removed from the honorific category of art and viewed in light of the era in which they were made. The idea of fine art belongs to the institutional superstructure of presentation rather than to the inner character of Stieglitz's pictures. The same is true of Hine's rhetoric of "social photography." To define the issues which lie between the two practices requires that we recognize "art" and "document" as arbitrary terms that describe a way of looking at photographs, rather than qualities intrinsic to them. Put one of Hine's "human documents" (his term) of children working in mills on a museum wall, and it becomes "art." The definition is extrinsic and institutional. Cannot Stieglitz's picture of a street sweeper be considered a "document"? It all depends on where and how we view the image.

II

Lewis Hine typically presented his pictures in *The Survey* and other periodicals, in bulletins and posters for the National Child Labor Committee, in the form of "stories," images linked by titles, captions, and text. Not so in the case of Stieglitz, whose early city pictures bear titles like "The Terminal," "Winter—Fifth Avenue," and "Spring Showers"—words which raise the image to a certain poetic generality and invite responses on that level. But Stieglitz's pictures were not entirely free of contexts. His presentations often provided clues to an intended meaning, how his pictures should be understood in relation to each other. On several occasions in his later years he integrated his early pictures into one-man exhibitions in ways that suggest a meaning within the total body of his work. In 1920, looking back upon his early work as he prepared for his first retrospective show the following year, Stieglitz wrote to the critic Hamilton Easter Field:

My New York is the New York of transition. —The old gradually passing into the New. —You never saw the Series I did—beginning in 1892 and through 1915,—Not the 'Canyons' but the Spirit of that something that endears New York to one who really loves it—not for its outer attractions— but for its deepest worth—& significance. —The universal thing in it.[14]

The letter anticipates Stieglitz's effort in the exhibition the following year to convey a historical meaning for pictures made a decade or more earlier: "the New York of transition." He also suggests a trans-historical meaning, something deeper than "outer attraction"—a "universal" meaning. In the 1921 show itself Stieglitz made even more explicit a historical structure for the interpretation of the early work. He arranged the exhibition in roughly chronological categories to trace development, a continuity from the earliest to the most recent work. The category "Early Prints" includes eleven New York pictures from 1892 to 1910, followed by twenty-three portraits titled "The Days of '291'" and a separate group of nine pictures of tall buildings under the title "From the Back Window—'291'."

In another exhibition twelve years later, in 1932 at An American Place, he included a grouping of seventeen pictures called "Older New York Series" alongside a group of new pictures of midtown skyscrapers called "New York Series—1931." The new provides another context for the old. Several of the older pictures in the exhibition bore asterisks, and Stieglitz explains in a brochure note: "Photography has a history. No's marked * are shown not merely for the pleasure they might give, but as having a distinct place in that history. They represent pioneering in technical achievement—realizing what heretofore had been considered impossible to photography."[15] These include pictures made at night and during inclement weather. To the history of the city itself, its "transition," Stieglitz adds a technical history of the medium and his own place within it, thus enhancing the transitional theme in the entire series: from old to new city, from old to new techniques, from old to new pictures by Alfred Stieglitz. In his note to the 1932 exhibition, Stieglitz explained that he included "sufficient of the older New York, & other work some new & some old, to establish the continuity and underlying idea of the work as a whole."[16] "Work as a whole," the notion of an artist's oeuvre, provides coherence for these separate facets of meaningfulness, the three instances of transition. City, photography, artist, or subject, technique, expressivity—this unity conveys a general meaning, an interpretive form, that Stieglitz projected upon the body of his work: it presents as mutually dependent the histories of city, medium, and artist.

This is, of course, a retrospective view on Stieglitz's part, one which

64. (*Above*) "The Terminal,"
New York, 1893. Alfred
Stieglitz

65. "Winter—Fifth Avenue,"
New York, 1893. Alfred
Stieglitz

66. "Spring Showers,"
New York, 1901.
Alfred Stieglitz

has been frequently repeated by his admiring critics. To look at earlier contexts of presentation is to learn how differently Stieglitz conceived of the meaning of his city pictures at a time closer to when they were made and first shown. The backward look also helps us see evolving interconnections among the three key terms—artist, city, camera.

Like many amateur photographers at the time, Stieglitz in the 1890s had roamed the streets in search of "picturesque bits"—"metropolitan scenes," as he put it in his 1899 article, "homely in themselves" but "presented in such a way as to impart to them a permanent value because of the poetic conception of the subject displayed in their rendering."[17] Representing scenes already identified in the press and popular graphics as visual symbols of New York—Five Points, Fifth Avenue, Madison Square, Central Park—his turn-of-the-century pictures evoke a moment just before the explosive transformation of the lower city by the skyscraper and mass transport.[18] In the next decade, his emphasis would shift from picturesque effects to a critical (though ambiguously so) commentary on the changing skyline. It is worth observing here that Lewis Hine would take New York as a much different kind of subject. His city is less "New York" than "urban society." Although he made many hundreds of pictures in the city, Hine did not photograph "New York" as such but social categories such as street trades, home work in tenements, sweatshops, factories, working children, immigrants arriving at Ellis Island. As the site of working-class life, "New York" appears only incidentally—not as a spectacle of familiar sights or monumental forms, but as a survey of "conditions."

Stieglitz's New York pictures are among his best-known; their titles— "The Terminal," "Winter—Fifth Avenue," "Spring Showers," "The Flat-Iron"—offer associations with an era of hansom cabs, rain-swept plazas, and the romance of the first tall buildings. They also evoke a *kind* of image: somewhat misty, suggestive, evocative of a feeling beyond the precise subject of the picture. In later years Stieglitz spoke often about some of these pictures, and his stories create a folklore, a texture of interpretations—what he felt when taking "The Terminal," or waiting for hours in a snowstorm in 1893 for just the right moment to release the shutter on the scene which became "Winter—Fifth Avenue." Repeated again and again by historians and critics, these memories are like tinted lenses, coloring the images in the light of the author's retrospective account of his intentions and feelings. Transmuted into critical discourse, Stieglitz's stories provide a textual context for the New York pictures. Other contexts suggest other readings, suggest ways of counteracting the overdetermined influence of the Stieglitz discourse, suggest finally that the legibility of the New York pictures as meaningful

representations depends upon the specific structures of meaning in which we see them.

In their original appearance, we encounter them within quite different contexts, emitting different signals. They appeared, to begin, within a heuristic setting, examples of a kind of photography the city invited. Stieglitz's role in the 1890s as spokesman for pictorialism, public educator in the ways of fine-art photography, provided the most immediate context or mediation. He had crafted a role not unlike Brady's in the 1850s, as publicist and artist. With his brush mustache, piercing eyes, dark cape, he, too, would be the most widely photographed photographer of his day, the most celebrated figure of the camera *artiste*. Within the amateur-club ambiance, he devoted himself to promoting the fine-art idea by arranging exhibitions, editing journals, writing popular magazine articles—fashioning, in Ulrich Keller's apt words, "an honorific milieu" for pictorialist photographs.[19] Amateur photography clubs at the end of the century were typical of the middle-class clubs and societies which sprang up at the time around particular avocational interests like music, hiking, stamp collecting, local history. A style of earnestness marked such clubs, part of the middle-class "search for order" against the impending chaos (it was felt) of changing times. In their formal structure of officers, chain of command, delegated responsibilities, and a competitive system of honors and distinctions, such clubs mirrored both corporate businesses and Progressive reform organizations.[20]

Stieglitz's writings in this period sought to introduce the public to the artistic aims of pictorialists, those amateurs who aspired to recognition as artists and who looked with disdain on what they deemed the trite subjects and unsophisticated techniques of fellow amateurs. He explained that pictorialism married art to science, that pictorialists sought to reverse the apparent fate of the photograph as a mere mechanical product by showing that it could be a means of expressing an artist's intention—that it could overcome the threat of the machine to human will.[21] Far from rejecting science, pictorialists were "innovators," Stieglitz explained, constantly experimenting with chemicals, lenses, the effects of different conditions of light. "The photographic apparatus," he wrote, can be "pliant tools and not mechanical tyrants."[22] Science, in short, in service to art.

Practiced in the spirit of art, the medium can be "essentially plastic," Stieglitz noted, capable of registering the subtlest distinctions of individuality. "It is as easy a matter to recognize the style of the leading workers in the photographic world as it is to recognize that of the Rembrandts or Reynolds." The signs of style, of individuality, are found on the surface of the print, in its rendering of "tonal-values," and in its

"correctness of composition"—the first a mark of skill in reproducing atmospheric observations, the second a mark of mastery of the "laws" of art.[23] In a 1905 essay Stieglitz stressed balance, harmony, simplicity as the key elements of a well-composed picture.[24] He built his case for plasticity, for the expressive powers of the medium, on these two values: composition and tonal rendering. Above all else, composition and tone eliminated the signs which more than any other betrayed the role of the camera: random inclusiveness and sharpness of detail. "Microscopic sharpness is of no pictorial value," he stated in 1897.[25] Later, when the modernist "machine aesthetic" led to the doctrine of "straight photography," Stieglitz would change his mind about sharpness. But while the desired look of graphic art remained the slightly blurred and elegantly decorative effects of Impressionism, Symbolism, and Japanese prints then in vogue, Stieglitz endorsed tonal gradations in varying degrees of sharpness (advocated by Peter Henry Emerson as "naturalistic photography"). In addition, staging of vaguely medieval and Oriental scenes, manipulation of negatives and prints with local applications of chemicals, befogging in the development process to create Impressionist effects: such devices produced a look of art according to fashions of the day. The aim was to remove all signs of the mechanical origins of the photograph.

Stressing the control of the artist over his tools, Stieglitz joined pictorialism to the ideology of freedom and individual autonomy on which the arts-and-crafts movement also drew. The aim was to subordinate the machine, symbol of all that was wrong and inhuman in industrial society, to individual will. The reform ideology of Hine, as we shall see, protested the social effects of industrial capitalism, did not blame the machine as such but flaws in the system, and for the most part looked to collective rather than individual solutions—to legislation and corporate forms of reorganizing the industrial order to diminish conflicts. For the pictorialists, all that mattered was the final print, the individual image mounted, framed, exhibited. Subject matter, the scene or object depicted, no longer counted as much as the treatment, for the art picture represented "the feeling and inspiration of the artist" rather than the subject as such. This insistence that "treatment" rather than subject or content mattered most—in Allan Sekula's words, "the semantic autonomy of the photographic image"[26]—would save art photographers from the fate of unskilled factory laborers chained to their machines by ignorance and surrender of will. Composition, rendering of texture, control of tone—these technical features of the photograph, when made to appear deliberately and skillfully achieved, would thus represent the triumph of the artist's imagination.

Emphasizing the look rather than the content of the picture, pictorial photography came to mean misty atmospheres, fuzzy surfaces, exotic tableaus—or, in its genre and city views, "picturesque" effects. Stieglitz's own pictures tended to stay clear of the more extreme forms of chemical and physical manipulation which gave many pictorialist prints the look of engravings or paintings. But in presenting his city pictures, he typically employed the term "picturesque" to call up a familiar pictorial category. In the case of a certain subject matter—humble yet charming in its own right and thus fit for picturing—"picturesque" provided a flag under which amateurs made reconnaissance of city streets in search of pictures. In 1896 the *Journal of the Camera Club* reported under "Lantern Slide News" that "Mr. Stieglitz, in a set of New York street scenes, not only demonstrated the richness of the picturesque element in our own city but incidentally proved the effectiveness of his new Zeiss lens at short range, an objective he had ordered expressly for hand camera work."[27] The pictures appeared as examples of the triumph of art, its transformation of "low" subjects into picturesque images, and of science applied as a means to aesthetic pleasure. The same conjunction of technical and aesthetic mastery appeared in articles Stieglitz published in the 1890s on the hand camera, on night photography, and open-air portraiture. The 1897 article on the hand camera, for example, includes his oft-repeated account of the making of "Winter—Fifth Avenue," the "three hours' stand during a fierce snowstorm on February 22d, 1893, awaiting the proper moment"—"the first attempt," he claimed, "at picture making with the hand camera in such adverse and trying circumstances from a photographic point of view." The key to success was the artist's patience, his ability to predetermine the picture by "carefully" studying "the lines and lighting" and then waiting until "everything is in balance." An "element of chance" remains, for the balance may never appear, but study and patience impart to the snapshot the qualities associated with the artist's studio and the making of rehearsed scenes.

Could not the city thus be made into an open-air studio? In "A Plea for the Picturesqueness of New York," which Stieglitz published in *Camera Notes* in 1901, his friend Sadakichi Hartmann, a gifted if idiosyncratic critic of art and photography, chided pictorialists for their strange attraction to "studio orientality and medievalism." "Give to art the complexion of our time," he exhorted, "conquer the beauties of New York"—"dawn on the platform of an elevated railroad station," silhouetted trees and buildings surrounded by lights "mirrored in the wet pavements as in a sheet of water," the "gayety and vitality" of the crowds, "the gigantic parallelograms of office buildings and skyscrapers"

which "soar into the clear atmosphere like the towers, turrets and battlements of some ancient fortress, a modern Cathay." Photographers should "teach New Yorkers to love their own city as I have learned to love it, and to be proud of its beauties as the Parisians are of their city."[28]

The picturesque gave unity to Stieglitz's pictures, a group of which he issued in 1898 in a portfolio of twelve gravures as *Picturesque Bits of New York and Other Studies*. Combining New York scenes with those of Venice and Paris, of canals and boulevards, the portfolio makes the argument that New York is equally worthy of artistic treatment, equally beautiful. The pictures vibrate with atmosphere—fog, snow, streetlights reflected on wet pavements. The word "bits" suggests fleeting impressions caught by a highly selective eye, the crystallization of experience similar to the effects sought by Ezra Pound and Hilda Doolittle in the Imagistic poetry they would invent in the next decade. The critic Walter E. Woodbury said in his preface to the portfolio that, in "Winter—Fifth Avenue," "only so much is included as will stimulate the poetic imagination."[29] The driver of the hansom cab in that picture appears also in the form of a "bit"—a gesture of arm, a weight of body. The picture does not, like Hine's street images, show a person but a form harmonized with other forms.

Gathering fame in New York for his advocacy of pictorialism, his leadership in amateur societies, and his pictures, Stieglitz became newsworthy. In 1896 he told *The Photographic Times* that he had returned from Europe in 1890 in order to seek in New York a beauty comparable to that of Europe. Awarded many prizes for his portraits of street urchins and his genre scenes with peasants, he explained the appeal of such homely scenes: "Nothing charms me so much as walking among the lower classes, studying them carefully and making mental notes. They are interesting from every point of view. I dislike the superficial and artificial, and I find less of it among the lower classes. That is the reason they are sympathetic to me as subjects."[30] A pastoral conception of "low" subjects as more natural, real, honest, and sympathetic than "artificial" commercial society attached itself to the evolving narrative of his relations with his native city which would appear in his exhibitions of the 1920s and 1930s.

Meanwhile, "picturesque" remained the key interpretative concept for his city pictures. Cultural and ideological implications of the term for the larger middle-class public can be gathered from several appearances of these pictures between 1897 and 1903 in *Scribner's*. In just these years the journal published a number of illustrated articles demonstrating how photography can awaken people to new perspectives

in the city and to new feelings about its status as a place of beauty, providing new opportunities for visual recreation. While in the previous decade *Scribner's* had carried a significant number of articles on slums, settlement houses, and working women, by the turn of the century, emphasis had shifted to the city as such and to its opportunities for visual pleasure, particularly for the rising numbers of urban tourists. The explosive transformation then occurring in lower Manhattan, the rise of skyscrapers, of a new, jagged "skyline" (the term came into use in these years), and the growing congestion downtown, made the city seem as threatening to tranquillity and older perspectives as it was fascinating in its modernity. *Scribner's* played to both the fascination and the fear. The spate of articles on photography from Stieglitz's on "Pictorial Photography" to articles on aerial photography, night photography, telephotography, photography as a "handmaiden" to art as well as itself an art, was part of the journal's efforts to welcome the new century as an era of new pleasure-enhancing technologies, of delightful new mechanical instruments for seeing the city in unexpected ways: streets seen at tilted angles by cameras attached to kites or balloons, chimneys glimpsed from windows across the way and brought close through powerful lenses, a horsecar lumbering toward the camera during a snowstorm, the driver's arm arrested in midair.[31]

A number of essays offered walking tours of Manhattan, its waterfront, cross streets, and avenues, pointing out old landmarks and new buildings. "A city of great shows," remarked a writer in January 1900: "smart people," "beautiful houses," and "towering office-buildings and hotels." Yet, underlying the glow, we detect typically modern anxieties—a sense that in its rapid changes the city was losing its clarity, its familiar pathways, its older urbanity. How does the place hold together (if it does), where do its streets lead, what awaits around the corner? Between 1900 and 1910, lower Manhattan had become dense with new buildings that competed with pedestrians—workers and shoppers—for sidewalk space. Windows in tall buildings kept lit during the night hinted at mysterious doings, a part of the city which never slept. The old "walking city" of small manufacturing and family-owned shops was fast slipping away, and the new city seemed less coherent and intelligible to the eye. A labyrinth of tangled streets and man-made canyons in its lower regions of financial and manufacturing establishments, the city also held a Babel of strange tongues.

The city no longer seemed self-evident, and *Scribner's* sympathized. It focused, however, on the challenge not simply of getting around but of taking it all in, enjoying the spectacle—especially through the lens of a camera. In "The Walk Up-Town in New York" by the popular

writer Jesse Lynch Williams, the journal greeted the new century in January 1900 with a jaunty excursion, similar to a panorama, from the lower regions of the island, its quarters of work and business, to its upper, lofty realms of pleasure and comfort. Accompanied by thirty-three photographs, the article recounts a casual trip up the central arteries of Broadway and Fifth Avenue, each picture showing scenes mentioned along the way: an immigrant hotel in lower Manhattan, an accident on Broadway, the spire of Trinity Church, Madison Square, crowds of shoppers on Fifth Avenue. The pictures might be stereopticon slides accompanying a lecture, or stills from a "moving picture," the latest and very novel form of photography invented a few years earlier. Two themes converge: the city as a place to look at, and photography offering an urban vision, capable of arresting the energy of the street into unstaged images.

For readers in 1900, "The Walk Up-Town" exemplified a novel way of being in the city, or an older guidebook adopted and revised by new technologies of vision and print: moving on foot through its crowds with eyes open and camera in hand. Like the narrative, the pictures reveal the city as successive "shows," a place for just looking, without the need for an explanatory narrative. They offer the reader the vicarious experience of the worldly flaneur, the "connoisseurs in cities," as Williams says. He proposes this figure as a model of urbanity for his male readers, for whom downtown represents white-collar work. The walk uptown is the route home for the readers he addresses, a route through "crowded sidewalks, a continuous roar, intent passers-by, jammed streets, clanging cable-cars with down-towners dodging them automatically," toward the quiet of home and its pleasures: "The walk is just the right length to take before dressing for dinner." The narrative describes a portion of time stolen from both work and domesticity, an interval of male freedom, an "appetizing, worry-dispelling walk" made for delight alone, the delight of the eye.

> The walk up-town reaches from the bottom of the buzzing region where money is made to the bright zone where it is spent and displayed; and the walk is a delight all the way. It is full of variety, color, charm, exhilaration—almost intoxication, on its best days.

Prosperity is the inaugural note, and the "bright zone" of display and enjoyment the goal of the walk. Moving through space with a camera eye becomes a vicarious rise above the condition of salaried office labor, a fantasy of urbane freedom. The walk charts an allegorical journey from bottom to top, from business to pleasure, from work to leisure— a social geography of the changing city keyed to visual spectacle. But

the voyeuristic pleasures barely conceal the underlying fact that, instead of a unified whole, the city had become a series of separate, disjointed spaces brought together through the privilege of having a homeward destination uptown.

A similar motif appears in an article in March 1903: John Corbin's "The Twentieth Century City," interspersed with thirteen "Illustrations from Photographs by Alfred Stieglitz."[32] Less literally illustrative of the text, the pictures are nevertheless coded to fit its argument that New York has as much beauty to see as any Old World city, only it must be deliberately sought out with the eye of an artist. Printed in gray tones which accent the prevalence of mist, rain, snow, and night lights, each image appears within its own exhibition-like space, set apart from the text by a black border and an individual title. Although keyed to the text, the pictures do not actually illustrate sights and places mentioned, but represent a way of seeing and picturing the city. They illustrate the argument by example.

"The Twentieth Century City" describes a world reshaped by money. "Everywhere is new wealth," Corbin remarks during a stroll along Fifth Avenue, "that brings the exultant sense of power; everywhere are beautiful things, to buy which is the most concrete expression of this sense; everywhere is a world of people who live in an endless intoxication of gayety, to take part in which is the obvious end of having money and of spending it." How might the city itself be seen so as to satisfy this desire? "What our American cities most need to render them beautiful is an artist who will body forth to our duller eyes the beauties already there"—"the clean dull grays," for example, which offer "a joy in themselves as they merge with infinite gradations into profound darkness at the end of side streets, or leap into porcelain whiteness around the twin arc-lights of Fifth Avenue." Corbin portrays a dematerialized city in which social realities dissolve in a play of light. He might well have been looking directly at Stieglitz's pictures. The pictures offer examples of visual delectation as they follow the essay's itinerary up Fifth Avenue, until Corbin turns his attention to the luxurious shopping habits of the very rich. At this point the illustration shows a ragpicker above the caption "Prosperity," followed by a street worker in "Asphalters," a group of down-and-outers on park benches in "Battery Park—A Winter Morning," and two concluding industrial scenes: a railroad yard in "The Hand of Man," and smokestacks belching dark fumes on the shores of Brooklyn in "The Ferry—Thirty-fourth Street, East." Thus the final pictures, offering views of social contrast to the scenes Corbin describes on the same pages, seem to upset the correspondence between image and text. Are the pictures examples of how the city's discordant realities

67. "The Rag Picker," New York, 1893; titled "Prosperity" in *Scribner's*, March 1903. Alfred Stieglitz

68. "Asphalters," New York, 1893. Alfred Stieglitz

might be softened by art into picturesque beauty—examples of how to distance the city's darker realities by making art of them? Corbin's declared purpose is to teach the well-off how to see their city in the beautiful tones of suffused lights, of mist and fog and dusk. Is the irony of "Prosperity" meant to serve the same purpose, a way of incorporating knowledge of the city's "other half" without disturbing the pleasures of a vicarious shopping spree?

In any case, the presentation of Stieglitz's pictures channels whatever "free play" they are capable of exciting in viewers into the argument of Corbin's text. Their meaning here lies in their exemplification of how the "twentieth century city" can be seen in the camera as a place of beauty and charm. Later in his career Stieglitz reclaimed his pictures from such contexts. Yet the Corbin article shows how well picturesque conventions fit an affluent point of view toward New York emerging in the local media. While Stieglitz portrayed the artist as aloof from class interests and values, his later identification of himself with the city bore the marks of his own privilege, suggesting a social motive underlying his quest for picturesque city views. In conversations with Dorothy Norman in the 1930s describing how lonely and disconnected he felt on his return to America in 1890, he helps us see his early New York pictures as symbolic events, indirect expressions of a vocational and perhaps more deeply personal crisis. Hearing the Italian opera singer Duse one evening in 1893, he felt a sudden charge: "a contact existed between myself and America." The same feeling welled up a few days later when he saw in front of the old Astor House a driver watering his car horses, and on another occasion, a horsecar rambling through a snowstorm on Fifth Avenue. "The steaming horses being watered on a cold winter day, the snow-covered streets and the stagecoach in Winter–Fifth Avenue, my sense of loneliness in my own country, all seemed closely related to my experience when seeing Duse . . . America was saved for me. I was no longer alone."

> From 1893 to 1895 I often walked the streets of New York downtown, near the East River, taking my hand camera with me. I wandered around the Tombs, the old Post Office, Five Points. I loathed the dirty streets, yet I was fascinated. I wanted to photograph everything I saw. Wherever I looked there was a picture that moved me—the derelicts, the secondhand clothing shops, the rag pickers, the tattered and the torn. All found a warm spot in my heart. I felt that the people nearby, in spite of their poverty, were better off than I was. Why? Not because of a sentimental notion. There was a reality about them lacking in the artificial world in which I found myself and that went against my grain. Yet it was my business experience that drove me into New York's streets and so into

finding myself in relationship to America . . . Above all there was the burning idea of photography, of pushing its possibilities even further.[33]

Loathing and fascination: viewed retrospectively, the pictures symbolized alienation transfigured, a kinship to America discovered on the streets of New York during moments stolen from "business." By the 1930s, Stieglitz had firmly reconstructed the meaning of the pictures within the converging histories of the city, the medium, and the artist. Their earlier uses as evidence of aesthetic worth in a city of commerce were by now subordinated to their place within the artist's oeuvre, their representation of Stieglitz discovering himself, his camera, and his subject in the same act of looking upon an alien but restorative reality, restorative precisely because alien to the "artificial world" of commerce and industry.

III

"Now there are two ways to look upon your work," Beaumont Newhall wrote to Lewis Hine in 1938. "The most obvious is the documentary or historical approach—the other is the photographic."[34] The previous year Newhall, a curator at the Museum of Modern Art with a recent Harvard Ph.D. in art history, had mounted a didactic exhibition on photography and launched his career as the most influential historian of the medium of his generation. Hine, who was sixty-four years old, down on his luck, without sufficient work, feeling neglected, isolated, economically insecure, suddenly found himself "rediscovered" by a younger generation of critics as a pioneer in "documentary photography."[35] In 1938 the term was still novel, had come only recently into popular use. In that same year the Museum of Modern Art gave its first one-man exhibition of photographs by one of the new figures, Walker Evans, who called the show "American Photographs." In an article the same year Newhall had ventured a definition of "documentary" photographs as "factual" records made for "definite sociological purposes"—thus distinguishing them from fine art.[36] The important second edition of his history, an expanded version of the catalogue of his 1937 exhibition, appeared the same year (too late to carry any mention of Hine), as did Robert Taft's *Photography and the American Scene*. While Taft's book did not employ Newhall's strict categorization of kinds of photographs, it offered an inclusive "social history" of the medium.

Hine's "rediscovery" occurred, then, just at the moment when a quasi-

official history appeared side by side with the introduction of photographs into museums of art. How to explain and justify this new public role of the photograph in exhibitions of art? To guide public responses and help cultivate public taste, categorical distinctions were in order, and Hine conveniently fit one of the bills. Newhall and the writer Elizabeth McCausland cited his work in their efforts to fix a definition of the most troubling of the categories—the "documentary." How should the public respond to pictures such as those of Evans, Berenice Abbott, and others—a new kind of contemporary picture, neither "art" nor journalism, but a record of the lives of common people during the Depression. How to distinguish "record" from "fine art"? How to say what is and is not "photographic"? For McCausland, a champion of the socially aware "documentary" movements of the Depression decade, Hine was just what was needed: "a spiritual father," a direct link with Mathew Brady, whom she called the "lone hero" of a "tradition of content and purposive communication." "The rediscovery of Hine means," she states, "that the gap between Brady and the present has been bridged."[37] Hine was needed, she implied, precisely to clarify "the new esthetic of photographic—the documentary."

McCausland and Newhall organized a "retrospective exhibition" the following year at the Riverside Museum. In her preface to the exhibition catalogue, McCausland associated Hine with the frontier, with the "pioneer photographers" who joined the geological surveys, and described the camera as "native technology" like the cotton gin, sewing machine, and telephone. Hine represents the old America still questing for new worlds to "conquer," such as "the new frontier of human justice." In an article the previous year, Newhall had noted that, though Hine's pictures were "taken primarily as records," "the presence in them of an extraordinary emotional quality raises them to works of art."[38] To Hine himself he wrote: "Your work strikes me of excellent quality—possessing that straightforward, clean technique which I believe to be the only valid photographic style." McCausland praised his "intuitive approach." Hine represents the unconscious of "documentary," she explained, its unformulated, instinctual stage. If today "younger workers consciously integrate the social and esthetic elements," for Hine "the sociological objective was paramount; the esthetic attributes seem to have occurred almost casually."[39] Rather than "the self-conscious, aware artist," Hine is, "above all, a folk artist, a primitive, whose instincts functioned as an extra sense."[40] Only when viewed retrospectively does the art of his documents stand forth. "Not until it is on the wall, is one able to assess the full plastic value of the photographs"—values such as

distortion of perspective, simplicity of "lighting and modelling," "a solid construction of planes and volumes."[41] Thus the exhibition proves Hine's work to be really "photographic."

McCausland and Newhall misconstrued the actual intentions of Hine's work, simplified its social character, and distorted the relation of his formal techniques to the educational end he pursued. For example, McCausland referred to Hine's wish to educate the public thus: "The function of the document was to *teach* the public—in other words, educate the electorate to pass ameliorative legislation and thus better conditions."[42] In fact, Hine's educational theory aimed at something at once more general and more basic: to teach an art of *social* seeing, a process basic to what the teacher of his generation, John Dewey, called the "process of living."

In his *Pedagogic Creed* of 1897, Dewey pointedly contrasted the "evolutionary" character of education to those "reforms"—he called them "transitory and futile"—"which rest simply upon the enactment of law, or the threatening of certain penalties, or upon changes in mechanical or outward arrangements."[43] Dewey's creed became fundamental to Hine's photographic social work: a concern with the process of seeing within the larger process of social "betterment"—the more conscious use of intelligence to achieve a more rational collective life. Dewey wished to return art to the common experience of everyday life. Rather than be confined to the physical objects or "products" known as artworks, art should be considered, as he states in his 1934 *Art as Experience*, as a heightened form of experience itself—"what the product does with and in experience."[44] The emphasis on the effect of the object—any object—radically widens the range of definition of "esthetic" to include "the clarified and intensified development of traits that belong to every normally complete experience."[45]

Dewey's aim in his writing on art was to change "attitudes that make art something esoteric and that relegate fine art to a realm separated by a gulf from everyday experience." There are no emotions that are "aboriginally esthetic." "Esthetic emotion is native emotion transformed through the objective material to which it has committed its development and consummation."[46] The aesthetic experience of an artwork represents only a heightened form of all "normally complete experience"— "complete" meaning "consummatory," satisfying and self-contained. The theory gives teaching a particular task of restoring "continuity between the refined and intensified forms of experience that are works of art and the everyday events, doings, and sufferings that are universally recognized to constitute experience."[47] Neither esoteric nor unique, the artwork, then, should be understood as a special form of a common

and familiar activity: "It is no linguistic accident that 'building,' 'construction,' 'work,' designate both a process and its finished product. Without the meaning of the verb that of the noun remains a blank."[48]

By teaching, then, Hine meant an activity quite different from what McCausland attributes to him—merely informing the public about social evils. He also took art and aesthetics to mean more than technical or formal or stylistic devices. In several articles published between 1906 and 1908, before he left teaching in 1908, Hine had explored the uses and values of photography in the classroom. How might the camera be employed "as an indispensable adjunct to modern society," he asked.[49] Following Dewey's argument in *School and Society* (1899) "that education must rest upon experience, upon contact with and participation in the realities of life," he proposed four "educational possibilities" of "this new servant."[50] It aided learning by "appealing to the visual sense"; it taught the value of working together for "mutual benefit"; it instructed students in the discipline of a technique; and, most important, it gave students an appreciation of art and its relation to common experience. The "fundamental aim" was "to help the pupils to a better appreciation of good photography and how to attain it—in short, to give the artist's point of view, for, in the last analysis, good photography is a question of art."

As an example of this proposition Hine included in one article "A Tenement Madonna. A Study in Composition." He described his picture as "a study made by the instructor to represent maternity among the poor, following the conception used by Raphael in his 'Madonna of the Chair.' In every way possible the beautiful and picturesque in the commonplace are brought out." However stilted its manner, the picture underscores Hine's major point, that photography encourages children to open their eyes, trains them to see "the beauties to be found on every hand." Just as for Stieglitz, photography represented for Hine a way of putting beliefs to work. The study of art was not an end in itself, both felt, but a means to an enhanced life. "Progressive" teachers, as an editorial in *The Elementary School Teacher* put it in 1906, held that art should be "applied to the development of themes that belong to the present; to the embodiment of higher ideals than ever before—not of art alone, but of life as a whole."[51] Like Dewey, Hine felt that aesthetic experience was fundamental to all learning: "This sharpening of the vision to a better appreciation of the beauties about one I consider the best fruit of the whole work."[52]

Although a photographer, Hine continued to think of himself as a teacher—"merely changing the educational efforts from the school-room to the world," he remarked in 1938.[53] But once he plunged into social

VOLUME XXVI, No. 15 WEEK OF JULY 8, 1911

THE
SURVEY
SOCIAL CHARITABLE CIVIC

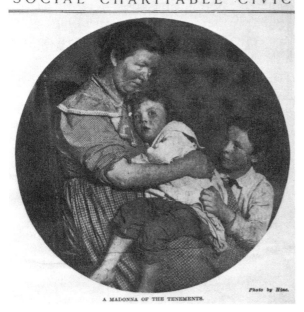

A MADONNA OF THE TENEMENTS. *Photo by Hine.*

69. "A Tenement Madonna."
Lewis Hine

70. (*Below*) "Family in Tenement,
New York City, 1910." Lewis Hine

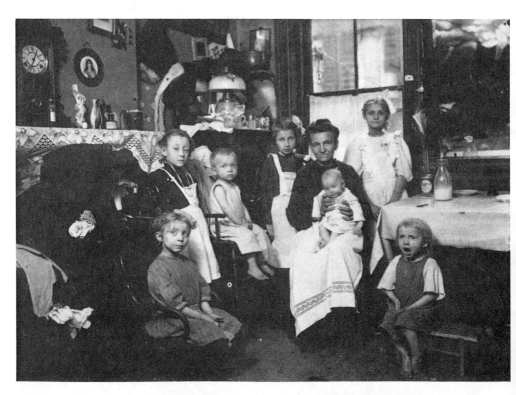

work—tentatively at first, as a freelance photographer in 1906–8, and as his regular vocation in 1908—he adopted another concept which would make a decisive difference in his evolving educational concept of the camera. What pictorialism represented for Stieglitz in the early phase of his career, the word "survey" would represent for Hine: an ideology of art. Not art in the sense of style, technique, or the look of pictures, but in the sense of social purpose and focus. In the field of social work just taking form in these years, "survey" meant a panorama of social facts gathered by trained investigators and presented to the public in word and image. At first the aesthetic implications of the term were inchoate; together with his editors, Hine worked out those implications and applied them in a consistent way.

The source of Hine's social vision lay in his experience as a teacher and a student of new educational theories. He left the Ethical Culture School in 1908, though he remained in close touch with his mentor Frank Manny, and signed up as a regular staff member of the National Child Labor Committee, responsible for field reports as well as photographs. At the same time he joined the staff of *Charities and the Commons*—beginning a lifelong collaboration with Paul and Arthur Kellogg. In the following year, 1909, the journal changed its name to *The Survey*.[54] Kellogg had already introduced a more attractive format, a new typeface, and more illustrations.[55] The new name reflected a new idea in the reform movement, a shift away from individual charity, from an appeal to rectitude and conscience, to a more systematic, rationalized, and, most important, *professional* approach to social problems. Indeed, the definition itself of what constituted a social problem shifted away from emphasis on pauperism, assumed to be the result of bad character and curable by private philanthropy, to systemic problems, such as child labor, which required legislative intervention and professional expertise.

Just previous to its change of name, *Charities and the Commons* had published a series of illustrated articles on the "Pittsburgh Survey," an unprecedented collective study of an American city. "A rapid close range investigation of the ranks of wage-earners in the American steel district," in the words of director and editor Paul Kellogg, the Pittsburgh Survey represented "a way of getting at the urban fact in a new way."[56] Sponsored by the Russell Sage Foundation and eventually published in six volumes between 1909 and 1914, the survey focused on wage earners at their places of work, their homes and neighborhoods, their schools and places of recreation. Taking economic realities as fundamental, the survey viewed the city not as a discrete phenomenon but as part of a larger system: "Society has developed into an organism like the human body, of which the city is the head, heart, and center of the nervous

system."[57] The Pittsburgh surveyors approached the city as a natural phenomenon, an organism consisting of separate but interrelated parts governed by invisible though deducible laws. If Clarence King had projected upon "nature" a social system shaped by struggle, competition, and constant upheaval, the social survey in Pittsburgh assumed "society" to be as objective as "nature," its rules and norms open to systematic investigation. The Pittsburgh surveyors sought to replace fictions and prejudices with documented facts, with hard figures and clear images of the industrial work force, its living and working conditions, the variety of trades and industries in the city, the state of its neighborhoods, its schools, its political system, and its economic order—data to help an informed public reorganize the city on a more efficient basis.[58]

At the basis of the survey lay a notion of *system*, a complex structure comprised of "workshop" and "community." By investigation and publicity—"to get at the facts of social conditions and to put those facts before the public in ways that will count"—the survey tried to persuade all citizens, but chiefly those with economic and social power, to act on behalf of "community," to forge cooperation between workers and managers.[59] Finding the city polarized between overworked, underpaid workers and a small group of absentee owners, the surveyors emphasized the dangers of discontent and the waste of resources—"the contrast between the prosperity on one hand of the most prosperous of all communities in our western civilization, with its vast natural resources . . . ; and, on the other, the neglect of life, of health, of physical vigor, even of the industrial efficiency of the individual."[60] The rhetoric envisioned a nation revived to old purposes—"a city set as it were on the hill of our material development" (in Kellogg's words), revitalized Pittsburgh might be "the precipitant of a new epoch of masterful humanism in the evolution of America's distinctive industrial metropolis."[61]

The Pittsburgh Survey reflected an important shift in public attitudes toward the visible city. "To make the town real—to itself," the project raised "publicity" to the level of prime importance: "luncheon meetings, newspapers, magazine articles, pamphlets, addresses, exhibits, special issues of *Charities and the Commons*, and books." "Survey" suggested not only a method of investigation but an emphasis on communication, a belief in "the efficacy of facts" and "in the ultimate benevolence of an informed public."[62] "Its very lack of color is a recommendation," stated the editors in the March 1909 issue which announced the change of title—a perfect fit with new attitudes and styles of thought among reformers themselves. "THE SURVEY will make particular and special and general examinations into living and working conditions; it will have a

comprehensive outlook, the viewpoint of the social worker; and it will base on this survey its recommendations for progress, for legislation."

When Hine joined the staff of the journal in 1908, he introduced himself in the following notice:

SOCIAL PHOTOGRAPHY

Lewis W. Hine, an experienced photographer who is in touch with social work, has joined the staff of Charities and the Commons to offer graphic representation of conditions and methods of work, through pictures for exhibits, reports, folders, magazine and newspaper articles, and lantern slides.

"Conditions and methods of work" refers to social work itself—documentation of the work of reform in the nation's troubled cities. The manner in which he would present his pictures—exhibits, reports, folders, articles, lantern slides for lectures—suggests that "graphic representation" included the medium of communication as much as the picture itself. Between 1906 and 1908 he had taken freelance assignments to photograph newsboys working at night in Philadelphia, slums in Washington for a book on the subject, and sweatshops in New York. He also worked briefly in Pittsburgh, photographing the life of steel-workers at Homestead—workplaces, homes, neighborhoods, and schools—and working women in various trades. The survey concept directed him toward particular subjects: not the city as such, but specific industries, specific activities, specific places expressive of the daily lives of workers. In New York, for example, his subjects would fall under the headings of sweatshops, home work, street trades. "Social photography" meant, in part at least, the literal social content of his pictures.

But "social" signified something more for Hine than factual content, more than the perceptible social datum. The point of view toward the status of social fact which evolves in his work (not just the work of picture making but of presentation, of interpretation of his own pictures) is the most interesting, difficult, and neglected feature of Hine's American photographs; it accounts for what is most important in his work, the way his pictures invite and demand a particular kind of participatory viewing. The typical power of Hine's pictures (best displayed in his child-labor images) derives not from their subjects alone, as the common notion of his "documentary" intentions holds. Nor from any narrowly formalistic factors, like composition and lighting. It arises from the total structure of the work, the presentation of images and texts which generates an idea of "social" more complex than, and in significant ways at odds with, the typical Progressive view of "society" as an ultimate value, a structure of relations which can be manipulated, its conflicts

71. "Evensong: Steelworker in Homestead, Pa., entertaining his boarders after the day's work— 1909." Lewis Hine

reconciled, on behalf of a common good. Hine's key word, "social," remains to be explored as the underlying term of his photographic work. Just as Stieglitz presented his images, early and late, as held together and made explicable by the term "art," Hine presented his under the heading of "social photography." What precisely did he mean, or what does his work mean, by this term? How does his practical sense of the word stand in relation to the practical sense of typical Progressive and reform understandings of "social"?

In one sense, the social aspect of his pictures lay in the media through which he presented them, the rich variety of layouts and combinations of image and text he created—in collaboration with the innovative editing of the Kelloggs—for periodicals and reports, montages assembled for exhibition posters, slides arranged for lectures.[63] "Social photography" meant that the photograph itself performed a social act, made a particular communication. Together with the Kelloggs, he experimented in an extraordinary variety of communicative forms— "every permutation of the picture-text marriage," observes historian Daile Kaplan: "photo montage, photo-story, photo mosaic, picture essay, centerfold, centerfold pull-out, accordion-fold leaflet, post card, and

Time Exposures"—the latter a title he used for a montage panel he introduced in 1914.[64] Each communication was a transaction, an exchange with an audience: graphic representations (including the media of presentation) offered in exchange for a response—a heightened, sympathetic awareness of the lives of others.

Between his first trip to Ellis Island in 1904 and his departure for Europe in 1918 to photograph American Red Cross war-relief programs in the Balkans, Hine made several thousand photographs, only a fraction of which appeared in print at the time. Most were made for the National Child Labor Committee, but Hine undertook other assignments in the same year. An undated (probably about 1912) *Catalogue of Social and Industrial Photographs* of the "Hine Photo Company" indicates the range of his subject matter in these years, and its predominantly urban character.[65] With its social categories—"Immigrants," "Women Workers at Work," "Men Workers at Work," "Incidents of a Worker's Life (Men and Women)," "Child Labor," and so on—its more than a hundred subtopics and over eight hundred sub-subtopics, the catalogue also

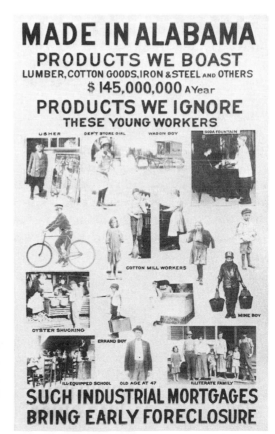

72. "Made in Alabama."
National Child Labor
Committee exhibition poster.
Photographs by Lewis Hine

shows the archival method underlying the editorial methods evident in the variety of presentations. It reveals a macro-structure of social meaning, a way of identifying individual pictures even before their use within a particular story or montage construction. Each image belonged to a larger picture and, understood that way, by its social identification, could thus evoke the whole for which it stood. Typical of reform uses of "social," there was always a larger picture, a fuller story, of which the particular image or pedagogical arrangement of images was a significant part. At the time of his retrospective show in 1939, which employed a much simplified version of the catalogue entries—"Ellis Island," "Child Labor," "Men at Work," "Life"—Hine had conceived of several series or "units" of his lifework under the heading "Life and Labor in America." Before his death he was able to complete two units for the New York Public Library, one on immigration (including the tracing of immigrants to their jobs and communities) and the other on child labor, both of which depict a process of changing patterns and values, a continuous history.[66] Society as a totality of related scenes of "life and labor," history as a continuum, and photography as social communication: these features of the Progressive "survey" remained fundamental to Hine's art.[67]

"I'm sure I am right in my choice of work," Hine wrote to Frank Manny in 1910, two years after joining the staff of the National Child Labor Committee. "My child-labor photos have already set the authorities to work to see 'if such things can be possible.' They try to get around them by crying 'Fake' but therein lies the value of the data and a witness. My 'sociological horizon' broadens hourly."[68] Written from the field, the comment gives a revealing slant on the pictures. In gathering evidence to be presented in the court of public opinion, Hine learned the nature of the beast he was up against: not only the deadening effects of the satanic mills on children and family life, but the connivance among mill owners, managers, inspectors, sometimes parents and children themselves, to pretend that all was well and natural. His "sociological horizon" broadened to take in what Progressive social theory understood as a complex social mechanism ridden with greed and selfishness.

The "sociological horizon" gave his photography a focus—not only a focus but a form, a form derived from its function. Hine learned that only irrefutable truth could sway "the authorities," truth delivered in a package combining images, words, and numbers (dates, names, places, ages, heights, hours of work, daily earnings). Thus the importance of getting the facts straight, and the signed testimony of a witness (sometimes his wife performed that role). The practical purpose of the NCLC

was to survey and publicize the facts of child labor. There were about two million children under sixteen in the work force at the time, and the committee's modest aim was to see that existing state laws were enforced. Investigation was conducted by region and industry, and Hine's itinerary anticipated the journeys of the Farm Security Administration photographers in the 1930s, throughout the Northeast, along the Atlantic and Gulf coasts, in the Deep South and the Midwest— looking for illegal child labor in textile mills, glass factories, coal mines, sweatshops and tenements, canneries and fisheries, on city streets and in beet, berry, and cotton fields.[69]

The project covered many tens of thousands of miles. The 1909 annual NCLC report described Hine as having made eight hundred photographs the previous year alone, photographs that were "of great value in furnishing visual testimony in corroboration of evidence gathered in field investigation." The evidence was often hidden, kept out of sight by nervous owners. Hine devised an ingenious set of tricks to elude the barriers. He pretended he was after pictures of machines, or passed himself off as a salesman. Often, one hand in his pocket made notes on ages and estimated sizes (difficult to imagine, but so he claimed, the buttons on his coat serving as a measure), while the other worked the camera. "Sneak" work was common, and so was physical threat: "I have a number of times been very near getting what was been coming to me from those who did not agree with me on child labor matters."[70]

The camera made visible what unrecognized social boundaries and, often enough, plain ignorance and myopia kept invisible. "In a city of this size," Hine wrote about Hartford, "35 newsgirls are not very noticeable to the passerby."[71] In his photo constructions he often targeted the self-engrossed passerby, indifferent adults often appearing in his street pictures as monitory examples of myopia. In his published reports he often called upon the reader to cross an imaginary social boundary: "Come out with me to one of these canneries at 3 o'clock in the morning. Here is the crude, shedlike building, with a long dock at which the oyster boats unload their cargoes. Near the dock is the ever-present shell pile, a monument of mute testimony to the patient toil of little fingers. It is cold, damp, dark."[72] In reports and features such as "Time Exposures," Hine gave voice to the mute testimony of such monuments.

Hine's pictures and writings share the desire to *disclose*. Hine's understated words, like Whitman's Civil War prose, evoke scenes of ravage and pain not unlike warfare. "There have been several accidents in this mill lately. A little twelve-year-old spinner recently had her leg broken by a doffer boy who ran into her with his doffing box. On the

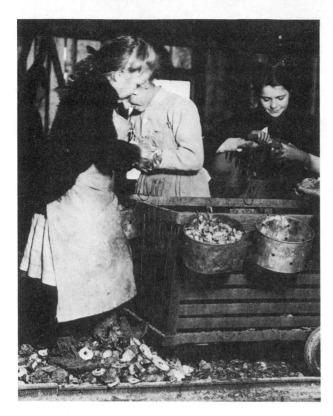

73. "Little Lottie, a regular oyster shucker, in an Alabama cannery . . . This is a common sight. Bayou La Batre, Ala., February, 1911." Lewis Hine

same day a woman had her finger taken off by her machine."[73] Or, with irony directed at the capitalist's concern with "cost": "We read with perfect composure that a fifteen-year-old breaker boy was smothered to death in a Pennsylvania coal shute; we forget to count the cost to a girl of long hours of work over a machine that is always calling for more, making her 'wish she could be a machine too.' "[74] Mechanization appears as the nightmare of children, a counterpoint to the pictorialists' fear of man's subordination to the machine. Each detail in Hine's prose (as in his pictures) becomes a monument, a reminder of human life. "The dreary cars are ready for them with their loads of dirty, rough clusters of shells, and as these shells accumulate under foot in irregular piles, they soon make the question of mere standing one of extreme physical strain. Note the uncertain footing and dilapidated foot-wear of that little girl." Always the effort is to bring into view what social divisions and rationalizations prevent people from seeing clearly, from admitting into their experience.

Thus far, it would seem that Hine's intentions as a teacher through photography were exactly as McCausland suggested: to expose social evils. But Hine understood, whether through Dewey or simply by the

logic of the survey mode or both, that factual information alone did not carry the whole story, did not suffice to make the telling of the story a social act. Instead, the social act lay in the communication. Hine developed methods of presenting his pictures as mute monuments seeking a voice in the viewer's imagination, a voice in dialogue. He enlarged the reformist idea of the social survey to embrace the *process* of communication itself, inventing presentational forms through which social information might become the viewer's own concrete experience— not facts "out there," in a distant realm, or facts to excite pity, but visual facts as the occasion for awakening the viewer's awareness of and imaginative empathy with the pictured others, and thus the viewer's own social being.

The theoretical basis of Hine's social photography lies less in the conventional Progressive idea of society as a manipulable ensemble of conflicting interests than in another notion developed within academic social science, the notion of "sociality." George Herbert Mead, one of Dewey's colleagues at the University of Chicago, defined sociality as the product of social interaction, of those acts by which individuals become distinct identities. According to Mead and Dewey, society shapes the

74. "Luther Watson of Kentucky is 14 years old. His right arm was cut off by a veneering saw in a box factory in Cincinnati, a month ago . . . November, 1907."
Lewis Hine

individual not by external pressure (the conventional view) but by a process of interaction, what Mead formulated in his "philosophy of the act." For it is only by engaging in imaginative dialogues with others, shaping oneself by developing habitual responses to imagined stimuli from others, that individuals emerge. "Sociality," explains Mead, "is the capacity of being several things at once"—of extending oneself by internalizing the voices of others, adopting their point of view as the condition for having a point of view of one's own.[75] For Mead, a social act occurs when a person engages in internal dialogue, takes on the role or point of view of the other, imagines it provisionally as one's own in order to respond to it. To foster exactly this exchange between the subject and the viewer of his pictures, and between himself and them, Hine attempted to enter his pictures into the internal experience of his audience, to awaken in them an imaginative response which would issue in a revised identity, one which now acknowledges the imagined voices of his pictured workers as part of one's essential social world. What he wanted to arouse was less "social conscience" than "sociality," a consciousness that society consisted of all the others with whom one interacts, imaginatively as much as materially.

This is not to say that Hine believed society to consist only of interactive processes and not of institutions and interests. Sociality belongs to the logic of his photographic practices more than to his ideological attachments. Social workers thought of their goals in more instrumental terms: making public a set of facts in order to provoke a set of actions. Conscience was part of their appeal, an appeal to the social as an ideal, an idea of harmonized conflict. Hine certainly accepted this goal of a well-running society held together by values beyond the reach of controversy or conflicting interests, a goal which assumed that "social interest" (the desire of all for harmony, efficiency, smooth operations) should and would prevail over partial self-interest or class interest. This remained his explicit view throughout his career, which explains why, in the 1920s, when the Progressive hope that America would realize its "promise" through an enlarged public commitment to what Dewey called "the Great Community" foundered on the realities of vastly enlarged corporate business power and sharpened struggles between labor and capital, his "Men at Work" projects of that decade seemed tepid and accommodating compared to his child-labor work. As we shall see, Hine remained "progressive" even after Progressivism had abandoned its more radical hopes for a Great Community.

But the *implicit* commitment of his early project pointed in another direction, toward an aesthetic of sociality rather than a politics of adjustment and manipulation. Thus we can say that, viewed in a

perspective of incongruity ("social" as a program for change in light of "sociality" as a process of consciousness), his work stands in an interestingly paradoxical relation to its explicit ideology. Maren Stange has brilliantly clarified this paradox by pointing out that, within the Progressive ethos, the *idea* of photography played a key role by allowing increasingly bureaucratized professional social workers to offer " 'scientific' exactitude . . . linked . . . metaphorically with the supposed neutrality of technical expertise."[76] Institutionalized programs of, say, housing reform and assistance to the poor sought to control solutions as much as meliorate suffering, to establish the authority of experts and specialists *through* melioration. Aiming to ease over rather than confront fundamental conflicts of interest and unequal social and economic power, the Progressive reform community, such as those who undertook the Pittsburgh Survey, proposed coalitions of social scientists, businessmen, labor leaders, and professional city managers, in the hope that the "social" would triumph over the waste and inefficiency (also key terms in the reform vocabulary) caused by uncontrolled self-interest. As a tool of presumably objective corroboration of the facts of social dysfunction, the camera contributed directly to the liberal-reform ideology.

Hine's reform photography shares in part—its overt ideological part—in a contradictory current of practices that reaches back to Peale's vision of the marriage of science and representational art in the grand enterprise of human self-definition through *natural* history and knowledge; to Agassiz's less enlightened wish to corroborate a social denial of universal species-being among humans through exact representation of natural fact; to the Civil War medical photographs which identify persons with wounds inflicted in the name of the state; to the use, in the Western survey, of the photograph to lend artistic validation to a scientific enterprise on behalf of aggressive exploitation—we can add Edward S. Curtis's project, contemporary with Hine's child-labor pictures, to join art to the science of the camera and the social science of anthropology to explain and justify the "vanishing" of North American Indians. But like the Zealy daguerreotypes, the medical mug shots, and especially O'Sullivan's survey views, Hine's pictures turn back upon themselves, make their own labor of interpretative picturing part of the image (its entire Gestalt), and thus make the overt ideology visible. What keeps his pictures alive even when viewed outside their original contexts is their continuing demand upon us for empathetic response to the inner humanity of the subjects as a basis for acknowledging our own—a form of photographing social victims unconsciously achieved by Zealy and refined into a practical theory of photographic art by

Hine. Neither Hine nor O'Sullivan rejected the respective survey assumptions of their work, but by attending more to the logic of their photographic work within those assumptions (in Hine's case, the logic of sociality) than to the political imperatives, they bring the assumptions to light. Their practical work discloses contradictions within their survey commitments. As Stange concludes, "The essential historical meaning and importance of Hine's achievement may be that it actually clarifies the process of reform by partly denying and opposing it in the very act of confirming and publicizing it."[77]

There is then, in Hine's early work, an implicit counterstatement to the Progressive reformist ideology he embraced—a subtle but nonetheless distinct resistance to the tendency of reformers to make objects of their underclass "cases." Hine never entirely freed himself of the reform outlook, and his counterstatement remained implicit, its implications for American photographs remaining for Walker Evans in the 1930s to develop into a practice shorn of any institutional political commitments at all (dramatized by his unease with the government agency for which he briefly worked). For Evans, as we shall see, an antinomian rejection of political liberalism, of its design upon the camera as a corroborator of social fact for the sake of controlled social change, was the precondition of his work, what allowed him to conceive a project of American photographs as deliberate counterstatement. Hine never wavered in his outlook, though on occasion expressed discomfort: "I have to sit down, every so often and give myself a spiritual antiseptic . . . Sometimes I still have grave doubts about it all. There is a need for this kind of detective work, but it is not always easy to be sure that it is all necessary."[78] Detective work was not his deepest purpose, though he accepted the necessity and traveled tens of thousands of miles, piling up tens of thousands of images, an accumulation of "facts" which themselves, he early recognized, were the problem. What to do with them? How to bring them to life?

In 1909, just reaching his stride, Hine delivered a paper at an annual meeting of the National Conference of Charities and Corrections on a panel devoted to "Press and Publicity." How to establish communication with the vast anonymous newspaper public was the explicit issue. Hine's title explains the aim of his talk: "Social Photography: How the Camera May Help in the Social Uplift."[79] "Servants of the Common Good," he declared, have a useful ally in the camera, an ally in their goal of reaching the "great public." When "the great social peril is darkness and ignorance," he asked, quoting Victor Hugo, " 'What then . . . is required? Light! Light in floods!' " "Let there be light" is the dictum of

the social worker, "and in this campaign for light we have for our advance agent the light writer—the photograph."

Just a year into his new career, Hine had already formulated a theory and a lexicon of social photography as the writing of social texts. It is in elucidating how this agent of light (and of writing as illumination) might help social uplift that he intimates, by the force of his examples, a possibility of discordance with the pragmatic goals of reform. One use of the camera is simply to gather evidence backed by "observations, conversations, names and addresses." This relies on the common belief that "the photograph cannot falsify." But another use relies on more than supplementary factual observation. This is the photograph which "makes an appeal" to the public, addresses their "sympathies," invites them to "interpret" the social fact as human experience. In one example, Hine flashed a slide "of a tiny spinner in a Carolina mill," and instead of citing her name, age, height, and so on, he proposed to "reinforce" the image with a passage from Victor Hugo about the "dismal servitude" imposed by unjust social systems. The text draws from the image its connotation as a symbol of a social reality. Sympathy can thus be expanded to understanding, to responsibility, a sense (literally, an experience) of being implicated in the reality of which the picture is a concrete rendering. In another example, Hine demonstrates another connotation, another passage from the particular to the typical—in this case the experience of viewing the image:

> Now, let us take a glance under Brooklyn Bridge at 3 a.m. on a cold, snowy night. While these boys we see there wait, huddled, yet alert, for a customer, we might pause to ask where lies the power in a picture. Whether it be a painting or a photograph, the picture is a symbol that brings one immediately into close touch with reality. It speaks a language learned early in the race and in the individual—witness the ancient picture writers and the child of today absorbed in his picture book. For us older children, the picture continues to tell a story packed into the most condensed and vital form. In fact, it is often more effective than the reality would have been, because, in the picture, the non-essential and conflicting interests have been eliminated.[80]

The picture "brings one immediately into close touch with reality," yet it mediates reality with a story, a screen of interpretation. The picture tells a story, but as Hine's own examples show, not with a single voice. It can be a story of name and age and place and size. It can be a story of social injustice the world over. It can be a story, the kind he tells here, of the picture itself, of its making or of its character.

Apparently, Hine felt no discordance between the use of images as

75. "Sadie Pfeifer, 48 inches tall, age not known, has worked half a year. She is one of the many small children at work in the Lancaster cotton mills, Lancaster, S.C. November, 1908." Lewis Hine

76. "A group of newsboys starting out in a snowstorm to sell papers, near Brooklyn Bridge 1:00 a.m. Sunday." Lewis Hine

evidence and as symbols. But his examples of fashioning a symbolic or connotative discourse for specific images pose the possibility of conflict between, say, the immediate "appeal" of an image and its larger implications. His accumulated pile of images makes the question of meaning urgent: how to connect the image somewhere, to make an *experience* of it which is also a meaning? Hine's 1909 lecture remarkably anticipates the semiotic analysis of the "rhetoric of the image" more than two generations later by Roland Barthes and others. The solutions he proposed in 1909 only partially resolve the contradiction Hine's work had already uncovered, a contradiction within the social work of the image between the power of its beguiling specificity and the open-ended possibilities of its rhetorical uses.

Hine's many schematic constructions of image and word seem to propose the simple answer of "backing" the image with other records. But as his examples of a connotational discourse indicate (the Hugo passage; the "picture is a symbol" section), backing with additional denotative facts alone only partially activates the social power of the image, its ability to enter and alter the viewer's *experience*. The image will always represent more than the manifest structure in which it appears, always seek further interpretation, further meaning. How to direct the viewer's experience of the image toward the larger ends of sociality while serving the immediate ends of practical reform—this unspoken problem in Hine's lecture would return in his later "Men at Work" project which represents not just a later phase in his work but a new phase in the politics of culture in America.

IV

For a moment in 1932 the cameras of Stieglitz and Hine converged on the same New York subject: the skyscraper. In that year Stieglitz exhibited at An American Place a group of twenty-nine new photographs titled "New York Series—1931": images of midtown buildings, including several under construction at Rockefeller Center, all made from a window high in the New York skyline.[81] In the same year Hine brought out his book *Men at Work: Photographic Studies of Modern Men and Machines*, about half of its fifty-some pictures showing men at work on the construction of the Empire State Building. Representing his project of the past decade, its emphasis on the "joy" and "satisfaction" of industrial labor rather than the oppression of child labor he had explored before 1917, the book celebrates workers as "men of courage, skill, daring and imagination" who imprint their "character" upon the city they help build.[82] Printed without captions but laid out with occasional text

explaining what a "derrick man" or riveter does, the pictures form an ensemble whose explicit message is that "cities do not build themselves, machines cannot make machines, unless back of them all are the brain and toil of men." An epigraph from William James's "The Moral Equivalent of War" links the message with the "progressive" outlook of Hine's early years:

> Not in clanging fights and desperate marches only is heroism to be looked for, but on every bridge and building that is going up today, on freight cars, on vessels and lumber-rafts, in mines, among firemen and policemen, the demand for courage is incessant and the supply never fails. These are our soldiers, our sustainers, the very parents of our life.

The book celebrates industrial workers as modern heroes, and the explicit message finds its realization in the display of the working body in motion, in acts of concentration, muscular coordination, balance, strength—a repertoire of spontaneous gestures that show the body's experience, skill, training. "Skyscraper" here signifies a job, a coordination of many jobs—not a polished shape against the sky, but an object constructed by specific skills and tools.

Precisely what Stieglitz's images do not show. In contrast to Hine's centering on the act of labor, the sky boy "swinging out," the foundation man hovering over his pneumatic drill, the riveters and bolt boys and masons, Stieglitz focuses rigorously on the rectilinear, on angles, overlapping forms, the play of shadows. His monuments seem to be without monumental meaning, weightless structures poised above the street, detached from the ground. Without text or narrative, the pictures are indeterminate, spectacles of ambiguity for the detached eye of the beholder. "From the Shelton Hotel," 1932, might be read as an image of contrasts, between completed and still incomplete steel-frame skyscrapers, between modern and traditional (masonry) methods and styles (the twin Gothic spires of the church, the Palladian window and cornice inconspicuous at the left). It might also be viewed as a study in contrasting light and dark, sun and shadow, white and black, and their respective moods or metaphoric registers. Or a projection of "photography" itself upon the scene: its signifying language of black and white, its ability to show certain things while withholding others.

Exhibited in 1932 along with Stieglitz's "Older New York Series" and his "Equivalents"—pictures of clouds presented as symbolic of a mood, a feeling, an inner melody or chord—the late skyscraper pictures follow the artist's quest for the city during forty years of unceasing change: horsecars in the 1890s, wet streets at night, clusters of skyscrapers viewed from the harbor, crowds massed on a ferryboat, tall buildings in construc-

77. "From the Shelton Hotel," 1932. Alfred Stieglitz

tion, and then the isolated trunks and tops of the new midtown buildings of the early 1930s. Taken as a group, Stieglitz's pictures define the city by icon, the outside look of places and things; no interiors except of galleries, no portraits except of friends and artists, few signs of the city as a diversity of regions and lives and kinds of work. Instead, repeated motifs or tropes—unmistakably "New York," images which evoke the city as a distinct place and time. the horsecar, the ferry, the plaza, the tall building.

Stieglitz's attraction to the changing New York skyline had begun at the turn of the century, and the exhibition in 1932 allows the viewer to trace the development from old pictures to new. Thirty years earlier, for example, he had photographed the Flatiron Building in a manner ostensibly different from his "straight," precisionist style of the early 1930s. The picture appeared in the 1932 exhibition as an example of a younger Stieglitz in an older New York—the image recontextualized to bring it into line with "transition," the overlapping discourses of self, city, and camera. But how did this picture appear originally?

In his 1903 *Scribner's* article on New York, Corbin had remarked that "the crudeness and the potentialities of our architecture afforded a fit symbol of the universal life of the city of the twentieth century," though

a fit symbol of *what* remained uncertain. Noting that all American cities were "rising bodily, constantly, fast," Lincoln Steffens remarked in 1897 in the same journal that "their climbing sky-lines are writing with reckless realism across the heavens the same great story of material; progress. It is time to read this writing of the walls."[83] But the writing often seemed illegible, and as such a threat to the hopes for stabilizing American cities into conflict-free communities. The architectural critic Montgomery Schuyler in August 1903 described the skyscraper as a "civic problem" of new proportions: "Like Frankenstein, we stand appalled before the monster of our own creation." In an essay of 1909 he described the monstrosities as "new commercial Babels," in want of a communal language both of design and civic responsibility.[84] Thus, the skyscraper aggravated a wider problem of perception: the difficulty of seeing the whole within its parts. For example, about the just-completed Flatiron Building across from Madison Square where the conjunction of Twenty-third Street, Fifth Avenue, and Broadway form a triangular wedge, Corbin says:

> There are times when the building seems no more than what it is called, a flat-iron, or, if a choice might be allowed in domestic implements, a clothes-pin that served to fix Fifth Avenue and Broadway on the line of Twenty-third Street. But there are times when it seems one of the most striking monuments of modern civic architecture—a column of smoke by day, and by night when the interior is lighted, a pillar of fires.

Without reference to the ambiguity present in the civic implications of the building, Corbin's language captures the difficulty of aesthetic definition: is it merely commonplace, another example of "crudity," or is it a monument, harbinger of a new world of forms? Neither view grasps the building as a social fact: what occurs within the structure, what it does within its real (and real estate) space.

This very building was already on its way to becoming a popular New York icon. By its remarkable height of twenty stories (300 feet), and its triangular shape, which made it seem, in the 1904 Baedeker, "the prow of a gigantic ship underway," the Fuller Building, or Flatiron, instantly became a favorite of pictorialist photographers like Stieglitz's colleagues Edward Steichen and Alvin Langdon Coburn, who depicted the looming tower silhouetted against branches in Madison Square across the street. Its designer, the Chicago architect and planner Daniel Burnham, had something else in mind for the shape of the building than to provide a romantic icon of the city. The popular image of a moving ship reflected a key motive in Burnham's design, its northward orientation toward the relatively undeveloped regions farther uptown: "like the prow of the financial district," writes the architectural historian Mario Manieri-Elia, "it

advanced toward the [uptown] city and towered over the surrounding construction, which reached only half its height. From this vantage it was also a herald of the future commercial development of midtown Manhattan."[85] It seems certain that Burnham, the leading figure in the City Beautiful movement, intended this building to herald a new restraint in New York architecture, to resolve the dilemma caused by the unruly and unregulated burgeoning of the skyscraper: he resolved it by accentuating in his design the relation between building and street, using the corner as a kind of hinge between the two perspectives of Fifth Avenue and Broadway. By emphasizing both the divergence and the convergence of the perspectives, the design sets the building firmly within its space, suggesting "an unlimited extension of its volume along the streets." Indeed, an idea or image of a radial city flows from the continuous lines and enclosed volume of the structure, making the building a potential node in an implied future design. Projecting an "ideology of institutional stability," notes Manieri-Elia, the building must "be considered a proposal for a new urban structure . . . a different image of the city"—one in accord with the image described by Schuyler in his 1903 essay: "We can imagine quarters and avenues in New York in which a uniform row of skyscrapers might be not merely inoffensive but sublime."

The Flatiron appears in the background of two of Stieglitz's pictures in the Corbin article, and at the center of the famous picture titled "The Flat-Iron." The picture was published first in *Camera Work* in 1903, accompanied by an essay and poem by Sadakichi Hartmann on the structure. Hartmann's "esthetical dissertation" argues that, conventional ideas aside, modern technological structures represent a new kind of intrinsic beauty, the beauty of the undisguised utilitarian structure designed without concession to traditional ideas of beauty. His poem speaks of it as "gaunt, austere," a "monstrous shape" that "soars in massive flight," and concludes by asserting that its beauty will soon be recognized:

> Iron structure of the time
> Rich, in showing no pretence
> Fair, in frugalness sublime
> Emblem staunch of common sense
> Well may you smile over Gotham's vast domain,
> As dawn greets your pillars with roseate flame,
> For future ages will proclaim
> Your beauty
> Boldly, without shame.

Hartmann's verse resolves the contradiction Corbin can only state, though, for both, ambiguity remains in the perception rather than the historical fact of the building.[86]

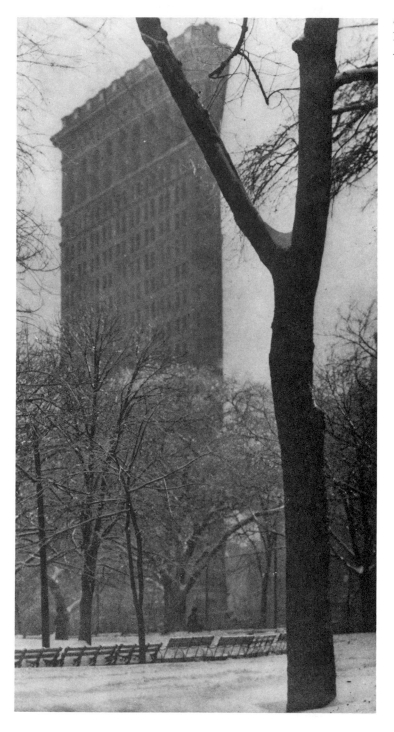

78. "The Flat-Iron,"
New York, 1902.
Alfred Stieglitz

Stieglitz's Flatiron sits well within the horizon of the Hartmann poem. Yet a detailed look at the picture reveals less certainty and tranquillity than may at first appear: the superimposition of the dark shape of the tree against the gray, mist-draped form of the building suggesting, for example, a contrast of tone that corresponds to the contrast between the building shaped in the image of a prow and the rooted tree representing only itself. Do tree and building stand for each other, the tree conferring upon the building its aura of "nature," of organism? Or is the tree in the foreground an ironic juxtaposition of the organic with the mechanical? Does the tree, often considered an emblem of the enduring, serve to monumentalize the Flatiron, or to diminish it? The uncertainties reflect the discourse in which Stieglitz presented the picture: a discourse unable to resolve ambiguous perceptions because it was unable to identify the origins of ambiguity in society itself, in the uses of the building and the social relations they manifest. A further sign of the invisible ideological structure of the picture appears in the isolation of the Flatiron, as if it stands alone but for the tree. The picture also stands alone, its structural ambiguities confirming its autonomy as a picture for exhibition—analagous in this sense to the self Stieglitz later described wandering the streets, part of the scene yet detached, aware at once of the filth and the beauty.

Stieglitz's next burst of city pictures came in 1910 and 1911, and their tone now is altered, the intimacy, balance, and atmospheric charm of "The Flat-Iron" lessened by the predominating darkness of a towering city and its distant conglomeration of forms. In 1911 he published in *Camera Work* a group of sixteen of his recent and older pictures with a note which states simply that "they represent a series of 'Snapshots' most of which were made in and about New York." An essay in the same issue by Alvin Langdon Coburn on "The Relation of Time to Art" includes some comments which may be taken as relevant to the New Yorkness or urbanity of the collection. Coburn had argued that because it makes possible "instantaneous, concentrated mental impulse" and a "seizing of the momentary vision," photography is the art "more suited to the art requirements of this age of scientific achievement than any other." The city demands such a medium. "Just imagine trying to paint at the corner of Thirty-fourth street, where Broadway and Sixth Avenue cross!" "Born of this age of steel," photography has "naturally adapted itself to the necessarily unusual requirements of an art that must live in skyscrapers, and it is because she has become so much at home in these gigantic structures that the Americans undoubtedly are the recognized leaders in the world movement of pictorial photography."[87]

An assemblage of varied figures, the 1911 group combines images of

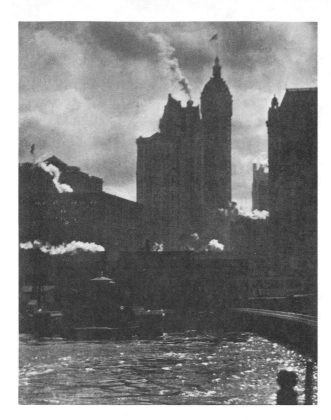

79. "The City of Ambition," New York, 1910. Alfred Stieglitz

the new technology—airplane and dirigible—with older images of the railroad, and concludes with two images of the earlier city era, "The Terminal" (1893) and "Spring Showers" (1901). The mixing of old and new pictures suggests Stieglitz's need or desire to temper the emphasis on the picturesque in the older images, to reedit them into a different setting. "City of Ambition" (1910) begins the series, its title bluntly expunging mere picturesqueness from this image of the lower city, which looks as if, in Henry Adams's description of the same harbor view as he saw it in 1905, "the cylinder had exploded, and thrown great masses of stone and steam against the sky." "The city had the air and movement of hysteria," Adams continues in the final chapter of his *Education of Henry Adams* (1918), "and the citizens were crying, in every accent of anger and alarm, that the new forces must at any cost be brought under control." Pictures like "City of Ambition" and "Old and New New York" (1910), which shows the skeletal frame of a rising structure looming mysteriously above a row of brownstones, are Stieglitz's own accents in this civic-minded outcry for control; the pictures can be seen as an aesthetic (and aestheticizing) complement to Progressive politics. "Old and New New York" condenses as well the logic of

the entire 1911 sequence, which presents older pictures in the new, nonpicturesque perspective of a critical (if detached) view of "ambition," of chaotic capitalist urges toward grandiosity. The old images find their place within a structure defined by the new point of view. They appear as the "older" pictures, pictures of transition. Thus the 1911 group creates a conceptual frame which suspends each image between two worlds: the actual city with its visible signs of inner change, and the artist's own history of changing perceptions, styles, motives, methods of work. Exhibited among the cloud and "intimate portrait" studies of the 1920s, the older city pictures were conceived once more as moments in a history of increasing isolation from the street, a turning away from the materiality of stone and steel toward nature's own body: the ephemeral moods of light filtered through cloud substance and, in the richly sensuous intimate portraits of Georgia O'Keeffe, the body's ineffable gestures of love and passion. When the physical city returns in the crystalline and precise late skyscrapers, the detachment is complete and final, the closure of a personal narrative: at once a judgment on the city and the summation of a vision. To say that the New York series, old and new, represent different facets of Stieglitz's self-declared alienation from commercial forces thrusting the skyscrapers higher and higher, reshaping the city according to the logic of the marketplace, is not to take from the pictures any of their richness, but instead to see them even more richly as figures of a particular and complex history.[88]

V

Hine's book *Men at Work*, also a summation, clarifies another sort of vision, another kind of practice. Rather than spaces and shapes viewed prismatically from a distance, Hine's city throughout his work consists of people at work and at play, in shops, homes, schools, and streets. His city consists of social spaces, of active figures, the bodies of men and women and children bearing their identities in posture, clothing, physiognomy: space and body as social texts. If Stieglitz's solitary eye finally obliterates human presence from the city, burying it as a symbolic cipher within the cryptic envelope of the skyscraper, Hine's eye climbed stage by stage with the skyscraper itself, tracing the specific human acts which constitute the Empire State Building. *Men at Work* depicts each particular gesture as a sign of social linkage, a coordination of acts which in their entirety construct the building and comprise the city. As Frank Manny remarked of the book, "modern men and machines come into vision like a series of motion pictures against the background of New York's skyscrapers." But the book is not simply an exaltation of

the industrial worker. Designed for children by layout, picture, and text, the book means to teach certain lessons about "the Machine Age"— that "cities do not build themselves." The design of the book as a series of pictures of working bodies in motion "against the background of New York's skyscrapers" is not fortuitous. The unfinished building in the foreground and the men fixing its parts in place serve to make visible the self-evident but often overlooked fact that cities are the products of labor.

The book is a teaching tool. More than individual pictures grouped together for visual appreciation and admiration, the book offers instruction—not just on "the dignity of labor" but on a way of seeing, on what to look for and what to see in the city's angular lines and crowded streets. Stieglitz's pictures ask us to look at and feel the accomplished skyline, to see it as if with new eyes. Hine's pictures, assembled as a book, would have us learn not just visible facts about men and machines but a new way of thinking about them, a new way of conceiving their relationship. Although the explicit message may seem to be exactly the reverse of the message of Hine's earlier pictures, a celebration of industrial labor rather than a condemnation of child labor, the book epitomizes the method of his work—and brings to a head the tension between practical reform and aesthetic education held in balance in Hine's child-labor pictures.

Men at Work summarizes Hine's major project of the 1920s, a project which reflects the accommodation of many Progressives to the illusion-shattering situation in America after World War I. Entry into the war in 1917 had came as a shock to reformers, a betrayal by Woodrow Wilson of his 1916 promise of neutrality. Many intellectuals, including John Dewey and Paul Kellogg, reluctantly accepted the inevitable and tried to keep reform issues alive before a distracted public. But the Armistice brought a nasty mood—a "Red scare," prolonged strikes, defeats in the courts and Congress of efforts to establish child-labor standards. And with the election of Harding in 1920, the astonishing slogan of "normalcy" appeared. In such an atmosphere, talk of reform seemed futile if not bizarre.

A new theme appeared among old survey reformers who had earlier advocated workers' rights and "industrial democracy," the theme of "industrial relations," of the worker's *place* within a system which was now taken for granted as fixed, stable, and "normal." Efficient operation of the industrial system, with due recognition of the human component: this became the 1920s version of the older Progressive hope for a revived American community. Rather than worry over strikes, wages, unionization, *The Survey* worried over the nature of work, effective planning,

new forms of industrial development and applications of electrical power. It stressed cooperation between workers and managers.

The predicament faced by Hine and his colleagues in the era of "normalcy" can be summed up this way. They arrived in the 1920s attached to the idea of an industrial system based on efficient productivity, a system which promised to raise standards of living and make consumption of goods a powerful democratizing force. Yet part of their commitment was to the non-economic, nonproductive ends of personal fulfillment and social democracy. They had earlier believed no essential contradiction existed between these goals and industrial capitalism, once capitalism was cleaned up and taught social conscience and responsibility. What they confronted in the 1920s was unexpected, an economic system now seeming larger, more powerful than the sum total of the individuals it comprised. The alliance forged in the war between corporate business and government now set the agenda for government policy, and industry's needs for higher productivity took highest priority. *Survey* continued to reject the socialist program of change through public ownership, continued to applaud Henry Ford's innovative genius, for example, while ridiculing his politics and "racial asperity." But now that their old cause of "efficiency" had been institutionalized within corporate industry itself in the form of engineers and managers trained in "scientific management" (Taylorism), what remained of the old issues was reduced to something like "the dignity of the individual." The happiness of the worker on the job, "Joy in Work" (in the words of *Survey*), emerged as the residue of the more dangerously critical concerns of the prewar movements.

In the climate of "normalcy," Hine conceived of a new photographic project. "The great problem of industry," he told *The Mentor* in an interview which accompanied a portfolio of "A Camera Interpretation of Labor" in 1926, "is to go a step beyond merely having the employer and employee 'get along.' The employee must be induced to feel a pride in his work."[89] Calling his work "interpretative photography" rather than "social photography," he redefined its educational purpose as a way of joining workers and managers (owners tended to disappear from the equation) in a happy accommodation to a situation of more limited hope than fired the reform imagination before the war.

As a result, Hine's pictures assumed a subtly different aesthetic aspect, returning to a note of moral realism, of universal "man" and the spiritualization of "labor," which had appeared in the 1909 lecture alongside his more difficult insights into the ambiguities of social images. Hine had concluded that lecture with a plea "for the intelligent interpretation of the world's workers" and read a passage from George

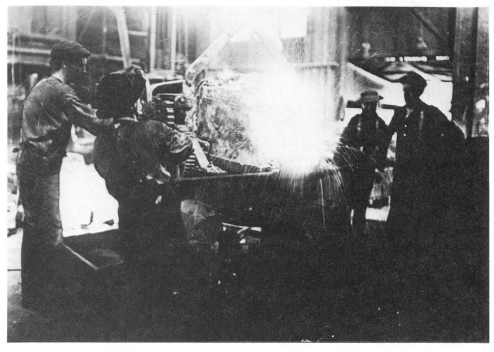

80. "Pouring steel (old way) in a small steel works in Pittsburgh, 1909." Lewis Hine

81. "The Hand of Man," Long Island City, New York, 1902. Alfred Stieglitz

82. "Boiler Maker," n.d. Lewis Hine

Eliot's *Adam Bede* which exalted in the lowly, the commonplace, the excluded: "Let art always remind us of them."

Hine made his adjustment to the 1920s by turning to an art of moral realism, an "interpretative" rather than a social photography. He had several shows at art galleries, made prints of exhibition quality, and spoke at length to reporters about his aims. Quoting from the *Evening Post*, a writer in the *Literary Digest* in 1920 discussed Hine's recently displayed pictures under the title "Treating Labor Artistically." The writer compared a Hine picture of an open hearth in a Pittsburgh steel mill, with the "commonplace title" of "Handling Hot Metal in a Pennsylvania Shop," to Stieglitz's famous "The Hand of Man." Stieglitz's picture, he observes, "was an adoption of principles employed by Whistler . . . The subject is comparatively nothing, and the treatment all." Hine does not aim as high, he continues, but often hits by sheer instinct: "It is remarkable how often the plates compose and qualify in pattern of lighting or pictorial arrangement." More important than this praise of Hine as an unconscious artist is the writer's account of Hine's current project. It is "to show the meaning of the worker's task, its effects upon him, and the character of his relation to the industry by which he earns a living." The photographs of workers engaged in their tasks "represent a new development in the movement to study the

human problem of men and women in modern industry." The writer reports Hine's plan to execute a series of prints and lantern slides to exhibit in factories, "both to the workers and the managers, a picture record of the significance of industrial processes and of the people engaged in them." These will be "photographic surveys of the human phase of industry, with its bearing on the whole social problem of labor relationships."[90]

" 'But do the workers you deal with understand what you are doing?' " the *Mentor* asked Hine in 1926. " 'Not all of them, naturally,' he replied. 'Yet,' he added, 'I have found many so-called human machines who had a genuine interest in the finer things of life. It is perfectly possible to direct that interest to their jobs—to make them see those jobs as "finer things" too.' " Hine shared a conviction with his reform colleagues that industrial work could be as satisfying as craftsmanship, could be a "finer thing," and the skilled industrial worker an artist. This dream had driven the prewar crusades.

But the retreat was not an abandonment of earlier Deweyean conceptions of aesthetic experience, but a redirection, a new emphasis. We can glean Hine's motive in his desire to help workers find "joy in work" from an important essay in 1926 by George Herbert Mead, "The Nature of Aesthetic Experience." Mead contrasts the "joy and satisfaction" which accompanies the making and appreciation of art, a delight in "successful accomplishment," with the "drudgery" of industrial labor.

> We see the routine and drudgery of countless uninterested hands and minds fashion in factories and mines the goods for which men give their wealth and themselves, and in the enjoyment of which men may be bound together in common interests which were quite divorced from their manufacture. Indeed, this is the definition of drudgery, the blind production of goods, cut off from all the interpretation and inspiration of their common enjoyment. It is the tragedy of industrial society that division of labor can interrelate and exploit the social nature of men's technical production so far in advance of their common fruitions, that all the earned significance of the work of our hands is foreign to its elaborate technique.[91]

A restatement of Karl Marx's theory of alienation without an account of the sources of the problem in the social relations of production, Mead's words make Hine's project comprehensible. The aim was not simply to ameliorate drudgery through art, but through aesthetic experience to help people come to a sense of the "whole" missing from their lives—to restore a sense of meaning to labor by viewing it as means toward a larger social end. Aesthetic experience, Mead implied, served as a utopian bench mark against which the alienating effects of industrial

capitalism could be judged and overcome. Mead's argument was a sophisticated theoretical effort to solve a problem by attacking its symptoms.

It is telling that in his "Work Portraits," as he sometimes called them, Hine resorted to methods that can only be called pictorialist portraiture: generally static head and shoulders compositions with Rembrandt-like lighting and tonal rendering of textures. By calling them "portraits," Hine designates their formal difference from the street scenes and factory interiors of the child-labor pictures. They are pictures not of work but of "workers," figures served up as virtual allegories of a thesis, that skilled workers can find joy in their labor by recognizing how their turn of a nut or bolt fits into the larger picture. Casting "Machine Age" workers in the guise of craftsmen, the Work Portraits claim, in their own guise as formal portraits, the same ideology of craftsmanship for themselves: an echo of Stieglitz's "camera work." Unlike the child-labor pictures, these portraits are not "backed" by verbal evidence, by an authenticating text. Individuals are rarely named except by type: brakeman, printer, assistant master mechanic, furnace repair foreman. Captions point toward a comparison between the present industrial task and an earlier craft phase of the same vocation: a "skilled machinist" is like a blacksmith shoeing a horse; "powermakers" are "of the ancient life of grooms, and hostlers, and veterinaries." Pre-industrial imagery pervades the captions, suggesting a controlling metaphor which connects industrial labor to those pre-industrial crafts interwoven with the everyday life in earlier, smaller, less impersonal communities. The emphasis falls upon skill—which leaves out of the picture the vast numbers of unskilled workers, the most replaceable and interchangeable (like machine parts) of the new corporate industrial order: doubly ironic in light of the skill-eroding consequences of the Taylorist time-study methods widely adopted in industries. The somber tonality of many of the Work Portraits may in fact register Hine's subliminal doubt about his own optimism.

In 1930 Hine undertook the job of photographing the construction of the Empire State Building, an assignment in which "Men at Work" took another turn. The aim remained a celebration of industrial skill as modern craft, but the assignment allowed Hine to return to photographing work itself, not as "portrait" but as activity. The drama of the project is itself an ingredient of the pictures. Hine climbed with the "sky boys" floor by floor, balancing his cumbersome equipment (he was already close to sixty years old) on girder after girder, swinging out in a basket at the hundredth floor for views from the top. The pictures are remarkable performances; they restore to his work the qualities of

spontaneity, of movement, of visual power, that charge the child-labor pictures with a unique energy. Moreover, the job provided exactly the focus Hine needed for the "Men at Work" project. These are not portraits but pictures of work itself, more convincing equivalents to the overt yet not quite convincing message of the Work Portraits, that human labor does count. Here Hine could follow a process culminating in a product: a building, a tower, a modern version of the cathedral. The building unfolds picture by picture—nothing mysterious or ominous like Stieglitz's skyscrapers, but something made with enormous skill and daring and courage. And if in the Work Portraits Hine came dangerously close to presenting himself in the pose of "artist-teacher," here he once again submerged his ego in his camera, placing himself through his camera within the scene of construction.

The Empire State pictures belong with Hine's most exciting, most satisfying work. Yet ambiguities remain unresolved. The pictures bracket the constructive heroism of labor in a way which isolates the making of the building from its context, both the economic context of the 1920s urban building boom, the grandiose (and in many minds, anti-civic) ambitions of real estate speculators, investors, and developers, and the cultural context in which the building functions as a commercial temple celebrating (or worshipping) empire. Commissioned by the managers of the building for publicity purposes, many of the pictures appear in *Men at Work*, a setting which clarifies even if it does not resolve contradictions at the heart of Hine's social photography.

In another remark about *Men at Work*, Frank Manny unintentionally put his finger on a central problem of social photography. "There are some social aspects suggested by these studies," he noted. "How are the lives of these men and their families conditioned by their work and [how] this work conditions the lives of others. Work on the Empire State building suggests Radio City and the complications these structures bring to previous investments, congestion, transportation, public works and loans—doing away with the slums."[92] If the Empire State series focused Hine's work, as Manny noted, "better than any previous undertaking," it also crystallized a difficulty at the core of social photography—the indeterminate character of social fact itself which Hine confronted in his 1909 lecture. There is the fact of labor, muscular forms, risk and adventure. There are also the social norms under which labor is performed—norms of ownership and power that shape the particularities of individual labor into a system of relations. Hine's text represses the norms, makes the system seem either inevitable or unimportant—certainly allows no inkling that the economic forces represented in the Empire State Building are about to collapse and traumatize

the nation. It seems enough for Manny that the book provokes the viewer to ask about "complications"; he responds like Hine's ideal reader. But does the book in fact resolve the dilemma of social photography Hine posed in his 1909 lecture, the dangerous indeterminacy of unanchored images?

Hine's particular solutions to the social ambiguity of the image make more sense when seen in light of the aesthetic premise of his pedagogical approach. Dewey's theory sharpens Hine's argument—particularly the theoretical distinction between "recognition" and "perception" in the experience of artworks. The recipient must be active, must "undergo" the experience of the creator who produced the art. "Otherwise, there is not perception but recognition." By recognition Dewey means "perception arrested before it has a chance to develop freely."

> In recognition there is a beginning of an act of perception. But this beginning is not allowed to serve the development of a full perception of the thing recognized. It is arrested at the point where it will serve some *other* purpose, as we recognize a man on the street in order to greet or to avoid him, not so as to see him for the sake of seeing what is there.[93]

Dewey's examples of recognition suggest the use of the image of social reform as similar evidence. It is satisfied "when a proper tag or label is attached." "It involves no stir of the organism, no inner commotion." Unlike perception, recognition is "too easy to arouse vivid consciousness."[94] Perception, on the other hand, requires a "an act of reconstructive doing," the viewer "undergoing" the experiences of the creator. By this creative act of reception, "consciousness becomes fresh and alive," and "the perceived object or scene is emotionally pervaded throughout." Emotion is not something *in addition to* seeing and hearing, but permeates and unifies the entire experience. As Hine did in his 1909 lecture, Dewey stresses the *act* of reception. "For to perceive, a beholder must create his own experience . . . Without an act of recreation the object is not perceived as a work of art."[95] Meanings are "imaginatively summoned" by the material artwork, challenging the recipient "to the performance of a like act of evocation and organization." Through perception the work completes itself, not in an overt act by the viewer (a vote, a petition), but in a performance, an undergoing in the imagination of the experience represented and embodied in the work of art.

To engage the viewer as a performer, to teach the picture as an aesthetic experience in Dewey's enlarged democratic sense of aesthetic, Hine contrived numerous pedagogical forms, exploring as much the limits of the camera as the plastic possibilities of pictures in series, in

montage, in story. His child-labor photographs are experiments: differential focus emphasizing subjects in the foreground, shadows setting off areas lit from separate sources, frozen movement, fragmented detail. The task was to "visualize" child labor in forms communicable as experience. To bring into view what normal social vision has been conditioned to ignore: this is the motive behind his technique. The ensemble of captions and layout, the juxtaposition of images and word on page or poster, put the observer right there, sharing the children's point of view, engaging in *someone else's* world. Experiments in what Moholy-Nagy described as the "logical culmination of photography"— the sequential series—Hine's constructions serve less as rhetorical enforcement of a message than as inducement to re-create a complex perception, a fusion of idea and feeling, of social fact and individual experience.[96]

Referring to its kinetic qualities, Manny described *Men at Work* as "an autobiography of [an] industry." Hine's work in its entirety can also be described as his own autobiography at the scene of his work. "One turns back and forth," Manny continued, "sensing with tactile and muscular, as well as visual, habits, case after case in the remarkable range of experiences its [the book's] creator has discovered and undergone." Dewey's terms "sensing" and "undergone" hold the key to Manny's response to the book—his re-creative perception of its author's experience. "One feels constantly," he adds, "the need of a companion series in which the artist himself would be shown in the multifarious devices and shifts necessary in getting at his splendidly selected compositions." Manny's call for a companion series shows how well he understood Hine's aesthetic purposes, for by arousing that felt need in a viewer, the book fulfills itself as communication: it creates in the viewer the need to put oneself in the place of the photographer—to place oneself in the picture in the imagined role of the photographer. The photographer, moreover, not as a disembodied eye but as a worker in a medium. "Sensing with tactile and muscular, as well as visual, habits," the viewer re-creates not only the ostensible subject, the riveters and derrick men, but the implicit subject: the labor of photography. The act of raising camera work to the surface of consciousness, making it the inner subject of the picture, is the final mark of Hine's aesthetic pedagogy, his social work. His subject, industrial work, permitted him to denote photography as a particular kind of *social* labor, to align his own work as technique with the work techniques he recorded. His "Men at Work" pictures tend to idealize work, and actually isolate it from social forces too complex for the camera to grasp, whereas the child-labor pictures tend to elicit a pause in their subjects' labor, the turn of

a head toward the camera. The camera becomes the beholder, and the pause interrupting the work becomes the formal equivalent of the thesis of the pictures: how unabsorbing, oppressive, deficient in joy and satisfaction is the enforced labor of children. Those frontal poses, the catching of an eye gazing back at the lens, as well as the occasional shadow of the photographer and his apparatus, put the working photographer in the scene: the labor of "investigation and research," of picturing what needed correction. The later pictures, in which Hine takes care not to reveal the camera within the scene, represent the opposite: the absorbing satisfactions of labor—a theme which satisfies Hine's own post-Progressive accommodation. The later flows from the earlier, not as a moral proposition alone (adult work can be good), but as the implied meaning by which the earlier pictures identify what is wrong in the scene before one's eyes. Less obtrusive in the later pictures, the act of photography is the equivalent of the acts it depicts: workers absorbed in the making of something which then stands as the record of the acts of labor undergone, experienced, in its production.

The Empire State series, Manny noted, consummates Hine's project: work and image become identical, the photographer's body as effectually present by implication (what the viewer *perceives*) as the bodies of the workers. "I have toiled in many industries and associated with thousands of workers," Hine remarked in the preface to *Men at Work*, as if lecturing to a class with slides. "I have brought some of them here to meet you." In a letter to Florence Kellogg, art editor of *The Survey*, Hine wrote in 1933 that "beyond mere illustration" his work pictures served as "a very important offset to some misconceptions about industry. One is that many of our material assets, fabrics, photographs, motors, airplanes and what-not 'just happen', as the product of a bunch of impersonal machines."[97] Slipping photographs into that list, Hine slyly insisted on a point he feared might be lost on Kellogg. Photography is also a form of toil.

"Get a camera," he urged his audience of reformers in Buffalo in 1909. "The greatest advance in social work is to be made by the popularizing of camera work, so these records may be made by those who are in the thick of the battle." If the "dictum" of social work is " 'Let there be light,' " then "in this campaign for light we have for our advance agent the light writer—the photograph." "I have had, all along as you know," he wrote to Manny the following year, "a conviction that my demonstration of the value of the photographic appeal can find its real fruition best if it helps the workers [e.g., social workers] realize that they themselves can use it as a lever even tho it may not be the mainspring of the workers. More than the specialists, we certainly need the many who can make practical use of the small (and often hidden)

83. "Riveter," 1929. Lewis Hine

84. "Derrick Man," 1929.
Lewis Hine

85. "Engineer," 1929. Lewis Hine

86. "The Spirit of Industry," 1929. Lewis Hine

amounts of photographic talent."[98] Hine did not disguise himself as an author in possession of an arcane craft. Presenting himself in picture and word in the role of author as producer lay at the heart of his pedagogical aesthetic.

Hine's aesthetic practice arose from a moment of hope among liberal Americans early in the century, a hope which reaches back to the enlightened rationalism of Jefferson's and Peale's revolutionary generation. It was a hope, in the early twentieth century, for "uplift" through the application of science and art to social problems. It expected that economic self-interest would give way to social or community goals. Hine fashioned his work in light of a configuration of ideas which proved brittle against the forces of self-interest the dangerous power of whose thrust it had repressed or refused to admit. Thus, like Progressive liberalism in general, Hine's social photography was caught up in a historical contradiction. It knew better than it admitted, continued to hope, as in the "Men at Work" project, against all odds that showing "the meaning of the worker's task, its effect upon him, and the character of his relation to the industry by which he earns his living," would bring about social harmony.

Yet liberalism alone does not account for the character of his work, as we see when we view it in perspective—the incongruous perspective provided by Stieglitz, and the longer perspective of the history of American photographs. Within the framework of the ideology which led him to social photography, Hine discovered the principle of sociality, a principle immanent within the liberal social theory but critical of the theory's own political limits. Sociality and Dewey's distinction between recognition and perception help us see what remains so radical, so radically ambiguous and radically challenging, in Hine's best work, the child-labor pictures. There, because the stance of reformer was already negative toward discrepancies between American rhetoric and American reality, he had no trouble locating his images among the real conflicts in American society. It was in this project that he discovered sociality and invented forms to produce it within a movement for social change. In his positive mode, which reflects liberalism's accommodation to the corporate world, Hine could not solve the problems raised by his practice of camera work as social work, could not locate his images among the contradictions of the social world—the full story of the Empire State Building, for example. There is a lesson in Hine—not only the persistent relevance of his idealism but that it may require a more complete negativity toward business culture to free the photographic image not only from the aestheticism of Stieglitz's camera work but from conflicts in liberal social work itself.

A Book Nearly Anonymous

Until history is interesting, it is not yet written.
—RALPH WALDO EMERSON, "Art and Criticism"

I

MATHEW BRADY reappeared in the 1930s as the progenitor, in Lincoln Kirstein's words in 1935, of a "classic vision." As writer, editor, and publisher of *Hound & Horn*, Kirstein awakened new interest in early American photography, especially Brady. In 1934, eleven Civil War photographs appeared in the journal, accompanied by an essay on Brady by Charles Flato.[1] The essay launched a revival, particularly among writers and artists, not only of the Civil War photographs but of early American photography as a whole. In the case of Brady, he reemerged as a symbolic figure. Flato got the facts of his career mixed up, and his role in the Civil War wrong. But his image of Brady helped a generation of photographers reorient themselves toward the medium and toward an explicitly American subject. As the Depression deepened, the very meaning and identity of the nation were questioned, and a concerted search began in scholarship as well as popular culture for American traditions. Rediscovered as *the* Civil War photographer, Brady became the avatar of such a tradition in photography. His legacy spoke eloquently at a time when the unity of America was again threatened— this time by social and class conflicts.

Though he errs in crediting Brady as the sole maker of the Civil War photographs published under his name, Flato offered the pictures as a lesson to contemporary photographers in the character of photography as an art of the real. The war pictures are "exemplars in American photography," he states, models of "the enormous possibilities of

simplicity and directness," "a source to be tapped." Without mentioning Stieglitz or pictorialism, Flato implicitly sets Brady against the heritage of *Camera Work*, and he does so by tossing off a thought which would be seized by certain contemporaries, that Brady's work was mainly *literary* in spirit. "Really a delineator of manners, of the ephemeral and all the universal that it indicates," Brady did not seek "unity of design but of effect." In his selection of detail, "he placed object against contrasting object, idea as opposed to idea, in closer proximity than a less literary-minded artist would have allowed proper."

As if describing a type rather than a person, an attitude toward the camera and through it toward the world, Flato writes:

> What he saw he saw concretely, yet always with justice and with a degree of sentiment apart from sentimentality; what he recorded he set down because it touched him, shocked his sensibilities or because the material intrigued him in a way that he was unable himself to define further than apprehending in it certain elements of a possible picture, of space, perspective or of light, and they appealed to him. His photographs give one to understand that he regarded the accidentally seen externals of life, the complete surface statement, of a photographic, as well as human, sufficiency, to see and experience them in the vigor of living from which they took existence. For himself, he was content to be curious.[2]

Extrapolating from the war photographs but with an unmistakable allusion to the present, Flato described Brady as "perceiving with a genius no less objective than his lens the presence of form and order and the deeper meaning of reality in the midst of a world that was become intensifiedly amorphous, confused and seeming unreal." The lesson to young photographers was clear in 1934 when the Depression was at its worst.

The following year Kirstein himself continued the lesson in a brief radio talk, "Photography in the United States"—the first considered treatment of the subject; indeed, the first serious effort to describe American photography as a subject in its own right. Concerned with correcting "some confusion as to the esthetics of photography," Kirstein said about Brady's war pictures that, "although primarily of historic interest," they "have the esthetic overtone of naked, almost airless, factual truth, the distinction of suspended actuality, of objective immediacy not possible, even if desirable, in paint." The Brady tradition disappeared before even becoming a tradition, Kirstein implied; it was displaced by the "art-photograph," which sought false prestige by imitating painting; but it reappeared in the "definite revival of objective clarity" and "emphasis upon purely photographic means" in the late numbers of *Camera Work* (he refers especially to the publication of Paul

Strand's New York pictures in 1917). And now, in 1934, "there are art-photographs of a different nature, scenes of human interest caught in the passage of time and events, scenes which by their tragic or comic typicality summon up a whole world of related reference—a locomotive, the prow of an ocean liner, crowds in city streets, ferry boats, or architectural curiosities as keys to an epoch, seen in the photographs of Berenice Abbott, Walker Evans and Ralph Steiner."[3] "Keys to an epoch" marks Brady now as the creator of a certain kind of *art*—not Brady's intent, though proceeding from his example.

Two works published in 1938, the year of Lewis Hine's rediscovery as Brady's heir, reveal a growing complication in the appraisal of Brady. In *Photography and the American Scene*, Robert Taft states that Brady "deserves rank as equal to the greatest historian of the American scene," though less for the Civil War pictures than for the earlier portraits. Taft expressed impatience with Flato: "I have no sympathy with some of the pseudo-critics of the modern day who see in any photograph bearing Brady's imprint the hand of the artist."[4] This animus derives perhaps from Flato's intellectualism, his contention that photographs show more than what is on the surface. While getting the biographical facts more or less straight, Taft's book delivers a Brady uncontaminated by interpretation or criticism, the meat stripped away to get to the bones. Beaumont Newhall's *Photography: A Short Critical History* (published late enough in the same year, 1938, to include Taft's book in its bibliography) also puts Brady in his place, respectfully, as the organizer of the Civil War enterprise rather than as a picture maker. Wishing "to construct a foundation by which the significance of photography as an esthetic medium can be more fully grasped," Newhall differs little from Taft in his view of the Civil War pictures: "inhumanly objective records," the pictures have an "appalling reality." "Every one of us, looking through a collection of these pictures, cannot help sensing the horrors and pathos of war."[5] In the hands of the historian and the art curator, Brady dissolves into no better than a factual reporter, perhaps not even a practicing photographer at all.

The year 1938 saw yet another interpretation of the Brady legacy, this time in a book of pictures, Walker Evans's *American Photographs*, with an essay by Kirstein.[6] Evans has his say on a native tradition by practicing it, while Kirstein's essay prods the reader to see its significance. The fruition of ten years of experiment and reflection, Evans's book presents more than a compilation of individual photographs; rather, a deliberate order of pictures, a discourse of images. In a remarkable congruence and collaboration, Kirstein's essay articulates in words the history and theory implicit in the book:

> Physically the pictures in this book exist as separate prints. They lack the surface, obvious continuity of the moving picture, which by its physical nature compels the observer to perceive a series of images as parts of a whole. But these photographs, of necessity seen singly, are not conceived as isolated pictures made by the camera turned indiscriminately here or there. In intention and in effect they exist as a collection of statements deriving from and presenting a consistent attitude. Looked at in sequence they are overwhelming in their exhaustiveness of detail, their poetry of contrast, and, for those who wish to see it, their moral implication. Walker Evans is giving us the contemporary civilization of eastern America and its dependencies as Atget gave us Paris before the war and as Brady gave us the War between the States.[7]

The book, Kirstein states, deserves a reading as attentive to detail and nuance—"intention, logic, continuity, climax, sense and perfection"—as the reading of poetry or fine fiction. Placing Evans in the company of writers—Baudelaire, Whitman, Flaubert, Henry James, Proust, T. S. Eliot, Dos Passos, Hemingway, William Carlos Williams, Marianne Moore, Hart Crane, and James Agee (Evans collaborated with the latter two)—Kirstein echoes Flato on Brady in saying that "Walker Evans's eye is a poet's eye. It finds corroboration in the poet's voice."[8]

Brady appears in the essay among the precursors of the "real" photographer, the "anonymous" artisans and "nameless artists" whose tradition is at odds with current practices in which "the idea of photographing an object has been frequently replaced, at least by the self-styled artist-photographer, with the capturing of indiscriminate surfaces, textures, patterns and promiscuous abstract or concrete objects." Kirstein explains what would have appeared in Evans's own words had an Author's Note he drafted been published: "The aim of the following picture selection is to sketch an important, correct, but commonly corrupted use of the camera." The "consistent attitude" to which Kirstein alerts the reader defines itself as much against as for certain kinds of camera work. Evans's draft continues by quoting Flato on Brady to "illuminate the attitude behind this choice of photographs."[9]

In the end Brady stands for only part of the significance of Evans's book—as the precursor of an idea of photography raised to a new level of awareness and accomplishment. The book speaks on many levels, in the voice of European and American modernism as well as the tradition for which "Brady" serves finally as eponym. But the fact that Evans evokes a native tradition while elucidating a modern conception of the art of photography contributes to the book's importance. The Brady tradition he evokes is that of the anonymous craftsmen responsible for the wooden houses and churches and signs the book pictures in the American landscape, and to which it joins its own craft—Evans's use,

for example, of a large-view camera style in an era of small-camera journalism. By its stylistic allusions to an older style of photography, the book creates a rich sense of history. "Evans was, and is, interested in what any present time will look like as the past," Evans himself states in an unpublished Author's Introductory Note for the reissue of *American Photographs* in 1962.[10] A sense of the past is not only one of his themes but a method.

In its unity and coherence, *American Photographs* represents a remarkable achievement—of a tradition as much as a personal triumph. The order of pictures in the book according to what Kirstein calls its "consistent attitude" or point of view calls for close, attentive reading, the study of each picture in itself and also in its place within the sequence. The book reflects Evans's struggles to define an art of photography against the grain of prevailing ideas in the 1930s. As much about photography as about America, the book brings its means and its ends, its method and its subject, into one focus. Neither word in his title, *American Photographs*, will prove as simple or as plain as it seems.

II

In his years of preparation, Walker Evans followed a path well traveled by American artists in the 1920s, from the Midwest to New York via Paris, from the comforts and discontents of well-to-do family life to a larger world of fuller, less predictable possibility.[11] Born in St. Louis in 1903 into a prosperous family which moved shortly afterward to an exclusive Chicago North Shore suburb, his father an advertising executive able to provide servants and private schools, Evans arrived in New York in 1927 after attending the Loomis School, Andover, and Williams College for a year, and after a lonely year in Paris. There, as an expatriate dreaming of being a writer, he acquired a taste for Baudelaire's fascination and disgust with modernity, and a reverence for Flaubert's religion of disinterested art. In New York, where his mother lived apart from his father, he took odd jobs, learned to keep himself steady and his dignity intact in the face of impecunity, and in 1928 took up the camera. "I was the young Bohemian artist," Evans remarked to an interviewer in 1971, "absolutely typical."[12] He won some recognition, had some things published and had small gallery shows, and decided upon the kind of photography he wished to practice. Writings from the early 1930s, fleeting remarks in surviving letters, a published essay of 1931, show him mulling over projects, laying plans and plotting courses, defining his goals against existing models of the photographer and the artist.

The 1931 essay, a review in *Hound & Horn* titled "The Reappearance of Photography," wears, in retrospect, the aspect of a lucky prophecy. "The real significance of photography," it begins, "was submerged soon after its discovery, lost in the "peculiar dishonesty of vision of its period."[13] Reviewing six new books, including Carl Sandburg's essay on Steichen (the poet's brother-in-law) and works by Atget, Albert Renger-Patzsch, and August Sander, Evans formulated a personal view of the medium, its history, its present situation, its possible future. The books under consideration represented directions to be disdained or admired. Like Walter Benjamin (there is no record Evans knew of him at the time) in his essay of the same year, "A Short History of Photography," published in Germany, Evans ridicules the pretensions of nineteenth-century "art" photography—"that fantastic figure, the art photographer, really an unsuccessful painter with a bag of mysterious tricks"—"by no means a dead tradition even now."[14] Benjamin also derided the blindness of such hopeless caricatures of artists, seeking approval before the very "tribunal" of judgment "overthrown" by the camera, by its replacement of the hand with the eye in the making of pictures. Evans agreed: the invention of photography was "an indirect hit" that linked "an already extant camera with development and fixation of image." By introducing "the element of time" into the making of images, the camera opened a new world of "chance, disarray, wonder, and experiment"—the same unexpected, novel disclosures Benjamin called the "optical unconscious."

Evans's essay focuses on the contrast between the "valid flowering" of contemporary experimental photography and the "American problem" as typified by Edward Steichen. Once Alfred Stieglitz's collaborator in the campaign for recognition of photography as art, Steichen had turned to fashion and commercial photography. His "general note is money, understanding of advertising values, special feeling for parvenu elegance, slick technique, over all of which is thrown a hardness and superficiality that is the hardness and superficiality of America's latter day, and has nothing to do with any person." Against Steichen's slickness Evans posed the personal lyricism of the recently discovered turn-of-the-century Parisian photographer Eugène Atget. Evans and Benjamin responded with a similar shock of recognition to the work both of Atget, who had hauntingly photographed the streets, shop windows, prostitutes, and ragpickers of Paris, and the German August Sander, who in the 1920s had set out to make of a collection of German "types." In Atget's explorations of Paris streets and Sander's systematic physiognomy, Evans found a return of "real significance" to the medium. While Benjamin sees Atget as a forerunner of Surrealism, Evans stresses his "lyrical understanding of the street, trained observation of it, special

feeling for patina, eye for revealing detail, over all of which is thrown a poetry which is not 'the poetry of the street' or 'the poetry of Paris,' but the projection of Atget's person." From Sander, to whom Benjamin attributed the discovery of "a new, immeasurable significance" in the human face, Evans draws a succinct statement of an impersonal program: "a photographic editing of society, a clinical process; even enough of a cultural necessity to make one wonder why other so-called advanced countries of the world have not also been examined and recorded." This is, he remarks, "one of the futures of photography foretold by Atget."

Atget, Sander, the negative example of Steichen's commercialism, of Stieglitz's authoritarian "artiness" (about which Evans commented frequently in later interviews), the positive charge of Paul Strand's "Blind Woman," which he saw in 1929 ("That's the stuff, that's the thing to do . . . It charged me up," adding: "But I'd already been in that and wanted to do that")—these highpoints in Evans's discoveries early in his career defined for him the possibilities of his own craft.[15] They define roles, ways of undertaking photography, orientations by which Evans located himself and laid his own plans for a contemporary art of photography.

Later in life Evans recalled a sense of isolation in the early 1930s; he felt that he rubbed against the grain of the most prestigious figures of the time (Stieglitz and Steichen), and yet that he was right in the path he chose. After the revival of his 1930s work in publications and exhibitions in the 1960s—the reissue of *Let Us Now Praise Famous Men* in 1960, of *American Photographs* in 1962, a Museum of Modern Art show, and a monograph by John Szarkowski in 1971—Evans depicted his earliest work as initial, intuitive probings.[16] "I was doing non-artistic and non-commercial work. I felt—and it's true—I was on the right track. I sensed that I was turning new ground. At least I thought I was mining a new vein, sort of instinctively knowing it but not in any other way aware of it."[17] "Non-artistic and non-commercial" define the field, the new ground, not yet broken and mapped. "I think I was photographing against the style of the time, against salon photography, against beauty photography, against art photography . . . I was a maverick outsider."[18]

It is important to stress that Evans thought of his direction as novel and untried, antagonistic to existing modes of salon and commercial prestige. In truth, he was less alone than he admits or remembers; his work won recognition quite early as part of a new current, as Kirstein's 1935 radio talk suggests.[19] But Evans's sense of himself as an outsider and an inventor sharpened his instincts, whet his appetite to make a personal mark. "Did you develop that consciously," asked an interviewer

in 1971 about the style which became Evans's distinctive mark. "Or did it just naturally—?" Evans replied:

> That's a very important matter too. That took time to establish. I was doing that instinctively because I thought that was the way I ought to be doing it but without thinking very much about it. And I also was very lonely in it because nobody thought of that or recognized it very much. Now it's been vindicated more than in most cases. I happen to be an artist who has been treated justly by time and by the world, that is, my own style has been established and credited to me. Lots of inventors, which a stylist is, don't get credit for their inventions. In this case I did, luckily.[20]

"That took time to *establish* [my emphasis]": the word defines the outer edge of Evans's rebelliousness, the conclusion of his artistic loneliness. The 1938 exhibition, the first one-man show by a photographer at the Museum of Modern Art, "established" him in his own mode, literally installed him within a place, settled the issue of who he was. It was the opening event of a "career." "Did it [the 1938 show] do anything as far as your photographic career was concerned?" Evans answered: "Oh, very much so. It was like a calling card. It made it. The book particularly was a passport for me. Sure. It established my style and everything. Oh, yes. And as time went on it became more and more important."[21] Establishment provided a calling card, a passport, a recognizable artistic identity. Evans understood the impersonal sociology of the event: "More than I realized it established the documentary style as art in photography. For the first time it was influential, you see. The Museum is a very influential place."[22] About the 1971 show, showered with praise by *New York Times* art critic Hilton Kramer, Evans commented: "Earlier there wasn't any Kramer to say, 'This is high art' . . . I mean I was already accepted by a small bunch of experts. But this put, not necessarily me— it isn't as personal as that—it put the kind of thing I'm doing in photography in a place—it's almost religion—where it deserved serious consideration."[23]

Evans's cool appraisal shows how well he understood the tactical skills necessary to implement his program. Documentary "art," he explained, "had a wrong reputation. It was dubious and not accepted by the respectable Establishment. That makes a hell of a lot of difference." Ten years later, established opinion had shifted to embrace his work. The following speaks to his situation in 1971 but reflects back upon 1938:

> But also part of me says: beware of this, don't accept acclaim; be careful about being established. There's the problem. How do you get around Establishment when something is establishing you? You're established when you're in these big museums. I find that quite a challenge. That's

why I'm going to do something with all these things [possibly the signs and ephemera he had collected for years], you find something else, establish that. Part of me doesn't want this to be established. It shouldn't be because it tames it. I think I'm going to do something that is not acceptable. To find acceptance is quite a thing.[24]

Thus Evans's dialectic of ambivalence, wanting acceptance, the recognition of his vocation, yet retreating from it—wary of success. The museum confers the identity, the status of artist. But recalling his early lonely rebelliousness, Evans also recalls its freedom, its essential anonymity.

He spoke often of photography as an impersonal yet paradoxically self-fulfilling individual act. "I now feel almost mystical about it. I think something was guiding me, was working through me. I really do." And: "Without being able to explain, I know it absolutely, that it happens sometimes, and I know by the way I feel in the action that it goes like magic—this is it. It's as though there's a wonderful secret in a certain place and I can capture it. Only I can do it at this moment, only this moment and only me. That's a hell of a thing to believe, but I believe it or I couldn't act."[25] "You become kind of a medium . . . some things are sort of done through you somehow. You are the agent."[26] Mystical, impersonal, anonymous at its deepest level: what need had an art such as Flaubert's of the vindication of the establishment? "I feel myself walking on a tightrope instead of on the ground. With the camera, it's all or nothing. You either get what you're after at once, or what you do is worthless."[27]

Evans's sense of himself in the early 1930s helps clarify what was at stake in *American Photographs* and the Museum of Modern Art exhibition the book accompanied. Pierre Bourdieu describes Flaubert's predicament in Paris in the 1850s in a way which may explain Evans's adulation of the French novelist. Young writers, Bourdieu explains, "had to invent that social personage without precedent—the modern artist, full-time professional, dedicated to his work, indifferent to the exigencies of politics as to the injunctions of morality, and recognizing no jurisdiction other than the specific norms of art."[28] Flaubert helped Evans see himself in a similar plight: a young artist-desperado, breaking with his class and his provincial upbringing, yet retaining good taste and urbanity, banding together with similar rebels in the metropolis, willing to suffer deprivation for the sake of forging a new art. What Flaubert did for the novel, then a despised form, Evans would do for photography. As Bourdieu puts it: "On the lowest and most trivial forms of a genre held to be inferior Flaubert imposed the most exacting demands that had ever been advanced for the noblest genre—poetry."[29] Flaubert states:

"There are neither beautiful nor ugly subjects and one could almost establish as an axiom, taking the point of view of pure Art, that there are no subjects, style by itself being an absolute manner of seeing things." Breaking the cherished genteel illusion that art represents morality, Flaubert performed a "revolution of the gaze," asserting "the power of art to constitute everything aesthetically." What Bourdieu says of Flaubert might be said also of Evans, that with his "exceptionally lucid consciousness" he "put himself so to speak in the position of pushing to their highest intensities all the questions posed by and in the field."[30]

The analogy extends to what has been called the "literariness" of Evans's clear, bright, and open pictures. With his eye for signifying detail, for the accidental revelations in juxtaposed objects, including written signs, and with his wit in laying one picture next to another, Evans set out to prove that apparently documentary photographs could be as complex as a fine piece of writing, as difficult and rewarding in their demands. *American Photographs* would be his major demonstration. Not just the picture but its place within a text of pictures, its role in a well-wrought sequence, would point to an original way of seeing things. It would also demonstrate the particular art of the camera, an adjustment of its lens to perform a clinical "editing of society" in one of the "so-called advanced countries of the world." Joining what Evans called in 1931 a "cultural necessity" with the necessities of his career, his struggle to preserve autonomy while seeking establishment, to express a personal vision in a style nearly anonymous, the book lets us gaze at the bruised American world of the Depression in a manner at once coldly objective and fiercely personal.

III

The literariness of *American Photographs* begins in its title. Apparently plain and unequivocal, the words pose a riddle: What *is* an American photograph? Photographs made in and of America, or expressive of America? And if both, what does this doubleness imply about each word, "American" and "photographs"? Is the title generic or thematic? In the first instance, "American photographs" would denote a classification, like an entry in an archive or file. In the second, the title would pose a problem of interpretation. A similar ambiguity is presented by the pictures themselves: do they depict self-evident facts, for example, or are there meanings which have to be pursued, imagined?

Musing over the title prepares the reader for what awaits in the pictures, eighty-seven selected from the one hundred on display at the Museum of Modern Art exhibition. "The pictures talk to us," wrote

William Carlos Williams, poet and friend of Stieglitz, in a review in *The New Republic*. "And they say plenty."[31] But they do so, Williams added, in a "list that has been prepared." An unsigned review in *Time*—very likely written by a friend of Evans, perhaps James Agee—agreed: "The photographs are uncaptioned yet arranged to be looked at in order."[32] The outward order is the division of the pictures into two untitled sections: the first, according to the book's jacket (the words are drawn from Kirstein's essay at the end of the book), "might be labeled 'People by Photography' "—"the physiognomy of a nation is laid on your table"; the second presents pictures "which refer to the continuous fact of an indigenous American expression, whatever its source, whatever form it has taken, whether in sculpture, painting or architecture."

In an essay written late in his life, Evans described photography as "the most literary of the graphic arts."[33] He speaks of such literary skills as "eloquence, wit, grace, and economy; style, of course; structure and coherence; paradox and play and oxymoron"—the restraint, exactness, and complexity, for example, of the prose of Ernest Hemingway and the poetry of Ezra Pound and Williams. The same qualities can be found in sequences of pictures. It is clear from his record of publication that Evans characteristically thought of his pictures as comprising sequences, forming an order in and of themselves. In his very first publication, a group of four images in *Creative Arts* in 1930 under the title "Mr. Walker Evans records a City's scene," the ensemble resembles a modernist poem, a collage of images arranged into a satire of the modern city. The group opens with a heading comprised of a typological burst of words—machine, profit, maximum, speed, camera. A note identifies Evans and explains that the heading "is intended to convey in symbolism—as it were, to typify—the blended babel of such a modern city's life." A montage of neon signs follows in "Broadway Composition," and then the witty "DAMAGED." "Hurry up please, it's time," in the caption for the final image, alludes directly to T. S. Eliot's *The Waste Land* (1922), which the sequence resembles in theme as much as method. Other parallels leap out. The blast of words in the heading recalls experiments by Evans's friend, the poet Hart Crane, for whose *The Bridge*, also published in 1930, he provided three images of the Brooklyn Bridge. "S.S. Leviathan" echoes the "Cutty Sark" section of that poem, in which there is a vision of Melville's whale hunt. The allusions to modern poems, the detached, bemused disapproval, the carefully plotted play of the images—Evans's intentions here seem perhaps too obvious. But the little poem in pictures shows that possibilities for an "editing of society" and for personal expression were as much on the young Evans's mind as the forging of a pictorial style.[34]

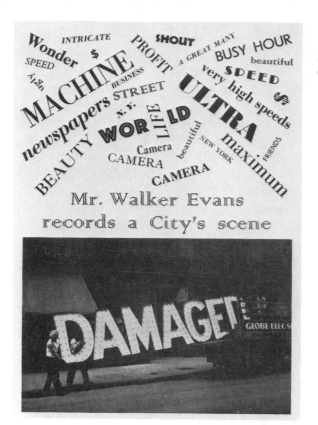

87. "Mr. Walker Evans records a City's scene," 1930. Walker Evans

88. "Broadway Composition." Walker Evans

89. " 'Hurry up please, it's time.' " Walker Evans

90. "S.S. Leviathan."
Walker Evans

The urban theme and the sequential method developed in a somewhat different manner three years later. An assignment came his way to spend a month in Havana in the late spring of 1933, making pictures for a book by the journalist Carleton Beals. *The Crime of Cuba* (1933) exposes the Machado regime as a cruel despotism, and calls on the United States Congress to end its tacit support.[35] Evans's portfolio of thirty-one pictures at the back of the work, which includes three pictures listed as "Anonymous Photograph" (probably from police files), supplements the text's portrait of poverty, corruption, military control, and unrest. Two of the "anonymous" pictures, one titled "A Document of the Terror," show murdered rebels; another shows jailed student "terrorists." The concluding image, "Wallwriting"—taken by Evans—shows revolutionary slogans scrawled on a city wall. Except for numbered titles on the blank page facing each image, no text intervenes to inform the pictures or explain the sequence, whose most evident order seems to be a series of social contrasts—elegance and shabbiness, pleasure and labor, wealth and poverty, begging mothers and fashionable prostitutes—leading to a closing section in which the bloody police images are intercut with Evans's own pictures of tough stevedores, patrolling soldiers, and the rebellion portended in the wall slogans. The effect is cinematic, a political montage.

These early publications show Evans's fascination with city life, its appealing energy and variety as well as its conflicts. In a letter to a friend in 1934 he asked: "What do I want to do? . . . I know now is the time for picture books. An American city is the best." Should it be Pittsburgh, he asked, or a smaller city like Toledo? "Then I'm not sure a book of photos should be identified locally. American city is what I'm after. So [I] might use several, keeping things typical." "American city," not a specific place but a kind of place. The letter continues with a list of picture categories which calls to mind Lewis Hine's "Catalogue of Social and Industrial Photographs," only seasoned with Evans's irony:

> People, all classes, surrounded by bunches of the new down-and-out.
> Automobiles and the automobile landscape.
> Architecture, American urban taste, commerce, small scale, large scale, the city street atmosphere, the street smell, the hateful smell, women's clubs, fake culture, bad education, religion in decay.
> The movies.
> Evidence of what people of the city read, eat, see for amusement, do for relaxation and not get it.
> Sex.
> Advertising.
> A lot else, you see what I mean.[36]

Nothing came of this plan in 1934, but *American Photographs* was evolving.

The following year Evans found exactly the opportunity he sought. It came in the unlikely form of a government job with a New Deal agency. In the summer of 1935 he signed on as Assistant Specialist in Information with the Division of Information of the Resettlement Administration, later known as the Historical Division of the Farm Security Administration (FSA). His career with the FSA would prove stormy and short-lived—he was let go in 1937—but long-lasting enough to provide the most creative period of his career. The politics of Evans's brief fling with the New Deal have been much discussed—his feisty insistence on independence, his disdain of bureaucracy and bureaucrats. More important was the chance to get on the road, to take the pictures he wanted, all expenses paid. "I am exceedingly interested in the undertaking," Evans wrote to an official before joining the agency, "which seems to me to have enormous possibilities, of precisely the sort that interest me."[37]

Despite the irritations, his roughly two years' traveling to cities and towns along the Atlantic Seaboard resulted in several thousand pictures. The FSA provided the material conditions for this work, not its purpose or rationale—at least as far as Evans was concerned. Of course, the agency owned the pictures he made, which eventually found their way into the FSA collection at the Library of Congress, but it did not control Evans's use of them. About seventy of the hundred pictures he exhibited in 1938, and roughly forty of the published pictures, belong to the FSA file. The rest were made earlier, in New England, New York (city and state), the South, and Cuba. Some were made during 1930–31, as part of a project of Lincoln Kirstein's to make a record of vernacular Gothic and classical styles in domestic architecture. Evans's eye and purpose had reached maturity before his government service. Indeed, his conception of a "photographic editing of society" showed Roy Stryker, head of the project, what kind of pictures to go after.[38]

American Photographs is in no sense a product of the FSA. But Evans's brief association with the agency has colored the reception of the book. It is often taken as an example of the project's documentary intentions. As Williams noted, the book offers "a record of what was in that place for Mr. Evans to see and what Mr. Evans saw there in that time."[39] To be sure, Williams added, "the total effect is of a social upheaval, not a photographic picnic." But while words like "wretchedness, disintegration, waste, chaos, decay" (all drawn from Kirstein's essay) are typical, as John Szarkowski points out, of even the most favorable notices, contemporary reviewers fastened on the idea of "record," document,

or inventory, referring both to the cumulative effect of the pictures and to their straightforward style.[40] "The photographer has put us on record," remarked documentary filmmaker Pare Lorentz. "If everything in American civilization were destroyed except Walker Evans's photographs," Carl Van Vechten said, "they could tell us a good deal about American life." Gilbert Seldes described the pictures as "verifiable statements. You could take one of them to a real estate man and say buy me this property; another to a marriage broker and say, I want to marry this woman."[41] Such reactions do capture a certain part of Evans's purpose: to make photographs which at least look like incontrovertible records of fact.

But only a part. Some reviewers also detected a less empirical intention, a meaning in "American photographs" beyond the inventorial style. The poet Archibald MacLeish says in the blurb for the book that the pictures "do much more than record one area of American experience. They make it speak."[42] Seldes, who also contributed to the blurb and had a chance to see the pictures uncaptioned, put it this way: "I got a strange sense of wandering through America, not knowing whether this rooming house was in New York or Birmingham, this auto junk heap in California or Vermont. The significant local detail is never missing; but the universal American feeling is always captured." Evans found "that something which is American cannot be eradicated from any part of the country." William Carlos Williams also saw a link between the local and the national, a process by which an accumulation of particular facts reveals an essence which so pervades the particulars that it "cannot be eradicated." The pictures "particularize," and by so doing they perform a near-religious function: "It is ourselves we see, ourselves lifted from a parochial setting. We see what we have not heretofore realized, ourselves made worthy in our anonymity." Many contemporaries found in the book an unrelieved wretchedness, but others felt an exaltation.

Since the 1960s, Evans has looked less like a social critic and more like a disinterested observer. In interviews in the 1960s and early 1970s (he died in 1975), Evans took pains to disown any practical political purpose in his Depression pictures. What provoked his often heated denials was the commonplace impression of the 1930s as an era of radical dissent and revolutionary politics. The reissue in 1960 of *Let Us Now Praise Famous Men*—a memoir by James Agee, published first in 1941, of three tenant families in Alabama, with photographs by Evans— had sparked new interest in the 1930s and its political passions. If any of Evans's work looks as if it may intend to arouse indignation, certainly these pictures of hard-pressed sharecroppers in Alabama fit that bill—

particularly in the 1960s, when many college students turned to the 1930s in search of a radical heritage. Evans's sharecroppers and Dorothea Lange's migrant workers had made the FSA seem to have mounted a campaign on behalf of the dispossessed—rather than doing what it more accurately was meant to do: be a publicity agency for New Deal farm programs, which on the whole favored the average farmer or the large "agribusiness" combines, more than the propertyless tenant farmers of the South.[43] In 1962 a second edition of *American Photographs* appeared, omitting Evans's introductory note from the 1939 edition, which declared the pictures free of "sponsorship or connection with the policies, aesthetic or political, of any of the institutions, publications or government agencies for which some of the work has been done." It was, in effect, the liberal social policies of the New Deal that Evans disclaimed in the 1930s, and extended that later to include all political intrusions upon the freedom of artists.

The stereotype of the 1930s as a decade fired up by ideological passion and conflict proves, on close examination, not really to have existed. Historian Warren Susman has shown that, contrary to the usual view, this was an era more of consensus than dissent. There was consensus among a broad range of Americans, regardless of political association, right, left, or center, that the "American Way of Life" (the phrase itself first came into popular use in these years) was endangered by economic failures at home and Fascism abroad. The Depression indicated that the nation had strayed from its true path as a result of poor adjustment to an unfamiliar industrial system. At the turn of the century, Progressive reformers had argued for new institutions, a rethinking of the concept of democracy—a new America released from old political prejudices and habits. John Dewey's term "reconstruction" typified the thinking of the period. In the 1930s, however, the cry was not so much for change as for "recovery," a return to basic values, to fundamental Americanism. What is special about the American people? What are their characteristic beliefs, their folk history, their heroes, their work patterns, and their leisure? More than ideological politics or the pragmatic social theories of Dewey, the keynote of the 1930s was the idea of *culture*, a search in the everyday life and memories of "the people" for what was distinctively American. "To seek and define America as a culture," Susman argued, typified the decade.[44]

Evans's concept of America cannot easily be defined by enlisting him in any particular camp, but it can be said that his work belongs within the general pattern Susman describes, the search for an authentic American culture and one's own Americanness, for that quality of nationhood which cannot be eradicated. That pattern included a wide

range of voices, purposes, and political programs, from the New Deal to "America Firsters," from advertising to political rhetoric to government-sponsored arts and theater projects. Nor were all participants in the quest in agreement on fundamentals. Some would celebrate; others would criticize and condemn. But the telling fact is that the period saw a resurgence of efforts to discover a "meaning" for the country—a mass desire for reassurance at a time of economic collapse and threatening developments overseas. In *On Native Grounds*, in 1942, the young Alfred Kazin (he was twenty-seven at the time) spoke of a welling-up among writers and artists of an urge "to recover America *as an idea*." Ravages of the Depression inspired a "drive toward national inventory." It started in reportage and "ended by reporting on the national inheritance." Evans's book belongs here, among what Kazin calls

> the vast granary of facts on life in America put away by the WPA writers, the documentary reporters, the folklorists preparing an American mythology, the explorers who went hunting through darkest America with notebook and camera, the new army of biographers and historians—here, stocked away like a reserve against bad times, is the raw stuff of the contemporary mass record.[45]

A collective need had erupted "to tag and index and literally possess the country"—just what Stryker encouraged in the FSA photographers.

Evans's interest in America's historical culture probably came first to life in architectural excursions in New England with Lincoln Kirstein, whetted further by his FSA tours through small towns North and South, where the nineteenth century survived in architectural styles, monuments, and the faces of people. But as his embrace of Brady in his 1938 draft of an Author's Note shows, his historical eye focused not just on remains of the past but on the present. In part the interest comes with the medium, for photography fosters just this attitude of viewing the present as if it were already past, a visible record of itself.

As Kazin remarks, the camera in the cultural movement of the 1930s played a role as complex as it was central.[46] With their illusion of immediacy, of reality caught "on the run," Kazin observed, photographs seemed the most fitting means of capturing the urgency of the period— "the central instrument of our time," Agee had declaimed in *Let Us Now Praise Famous Men*. Kazin wondered whether "the camera *as an idea*" was entirely salutary. However, he singles out Evans when he comments: "Few artists today have created anything so rich and meaningful." While the camera served as "an extraordinary medium for the sensitive

imagination," its influence on writers could be damaging. The medium's very ease and surface vividness invited passivity, caused "spiritual fatigue" before the colossal array of contemporary facts—"so stupendous and humiliating a disorder as the depression scene provided." "The real significance of the literary use of the camera," he observes, lay in the evasion of intelligence it prompted, an "obsession with the surface drama of the times" at the expense of deeper probings and more rigorous acts of imagination. Reproducing "endless *fractions* of reality," the camera made reality seem discontinuous, "only a collection of 'mutually repellent particles,' as Emerson said of his sentences." The notion of experience as "a succession of pictures on the mind" loses in coherence and intensity what it may gain in superficial vividness.[47]

Kazin's exemption of Evans helps place *American Photographs* in counterpoint to this tendency to substitute the camera for imagination and thought. In his unpublished Author's Note, Evans states that he intended the book's "consistent attitude" to represent a historical point of view, a corrective to "the journalism of the present" which is "so corrupt that its products in the field of photography are only sparsely and accidentally of any value whatever; and only in time, when removed from their immediate contexts." "There are moments and moments in history," he said, "and we do not need military battles to provide images of conflicts, or to reveal the movements and changes, or again, the conflicts which in passing become the body of the history of civilizations. But we do need more than the illustrations in the morning papers of our period." What is needed is Brady, and Evans quotes from Flato to "illuminate the attitude behind this [the book's] choice of photographs": "Human beings . . . are far more important than elucidating factors in history; by themselves they have a greatness aside from the impressive structure of history." Alluding to Brady's portraits, informal depictions of soldiers in the field as well as the more formal studio portraits, Evans seems to have his own Part One in mind, "People by Photography," and explains the intention of its pictures:

> And then one thinks of the general run of the social mill: these anonymous people who come and go in the cities and who move on the land; it is on what they look like, now; what is in their faces and in the windows and the streets beside and around them; what they are wearing and what they are riding in, and how they are gesturing, that we need to concentrate, consciously, with the camera.

It is not that the "anonymous" represent, as a sentiment of the period had it, the truer Americans, but that in anonymity, in the nameless

faces of buildings in Part Two of the book and in the people in Part One, lies the truer image of the "movements and changes," the "conflicts which in passing become the body of the history of civilizations."[48]

Rather than a society in need of change, *American Photographs* shows a culture in the grip of change. If, with Susman, we seek organizing symbols, icons, and myths through which the period reveals its inner life, they are here in abundance: images of manufactured happiness in advertising, political posters, billboards projecting Hollywood dreams into public spaces, Civil War monuments, forms of worship, and the ubiquitous automobile. But, "arranged to be seen in their given sequence" (Kirstein), the photographs differ from a mere "succession of pictures on the mind." Not by subject or by style—Lewis Hine, Berenice Abbott, Ralph Steiner, and others produced pictures quite similar in look—but by its intellectual content, what the book says and does not say, *American Photographs* differs from other books of contemporary images. Because the book eludes (except in the sense of opposing) the liberal politics which dominated the period, including its aesthetic discussion, what it says is not readily translatable. The book invites criticism, not paraphrase—a criticism prepared to reach beyond the usual discussions of style to the more fundamental and interesting question of point of view. For Evans discovered—and it has the force of an invention in photography—that the literal point of view of a photograph, where the camera stands during the making of the picture, can be so treated in an extended sequence or discourse as to become an intentional vehicle or embodiment of a cumulative point of view, a perspective of mind, of imagination, of moral judgment.

IV

Although *American Photographs* has no narrator in the ordinary sense of the word, there is a consistent attitude or point of view which serves the function of teller of the tale. It is the attitude of a historical observer, evident if only by the sheer amount of social information in each of the pictures: what the interior of a coal miner's shack looks like, or a street in the steel town of Bethlehem, Pa., or working-class houses in Willamantic, Connecticut. Such information might be understood as the stuff of research, gathered by an intelligently curious eye—not absolutely raw data, but not yet a historical discourse. The historical act of the book is as much editorial as investigative, a reconstructive interpretation of research. To emphasize, the editorial process does not, it hardly needs saying, diminish the importance of each picture, but puts it in a new light. Evans referred often to visual intelligence and little to the

editorial process—though, when speaking in 1971 of photography as "the most difficult of the arts," he added: "I think too that photography is editing, editing after the taking. After knowing what to take you have to do the editing."[49] No formula explains how the many sequences he published hang together; each invents its own principle, its own method and system. *American Photographs* makes do without captions; titles are placed at the end of each part—though, like signs in pictures, the titles often score a point: for example, "studio" in the opening title, and "relic" in the first and last titles of Part Two. Words play a role in the sequences, a visual as well as linguistic role (compare the hand-scrawled graffiti near the left pointing finger in "License-Photo Studio" with the lettering in "Roadside Stand near Birmingham, 1936," "Church of the Nazarene, Tennessee, 1936," and "Greek Temple Building, Natchez, Mississippi, 1936"), but not a generative role—that is, no words intervene in the system of relations between pictures, no text explains the order.

To speak of a "point of view" implies there is an author present in the work—one who might intrude or hide, address the reader directly or guide by indirection. An uncaptioned sequence of pictures suggests a hidden author, one who keeps out of the reader's way—like Flaubert or Henry James—but maintains a consistent point of view, a physical and moral perspective. The analogy cannot be exact, for what choices does the editor of photographs really have? Except for its denotations, what it is a picture of, a photograph can arouse widely varying interpretations, and thus, unless an editor anchors the image in an unambiguous caption, its meaning is too open and indeterminate to provide a reliably secure point of view. A photograph may seem to embody the "character" of the photographer, its quality of wit or judgment representing an individual vision. But the editor cannot rely on the viewer's understanding of a picture as if it were a voice, a word in a story or drama.

If the literary concept of point of view introduces an inherent difficulty for photographs, the mechanism of the camera offers an obvious concept of its own: the physical position the photographer selects to view a scene and take a picture. A clear and self-evident point of view appears in the photograph—indeed, it is identical to it—for the image cannot be separated from the perspective in which it is seen. Where the camera stands is usually unambiguous, a precise and particular place. The image *is* its own point of view—a simple but often neglected truth. To state the obvious: photographs transcribe, not "reality," but the world as it was seen and recorded. A photographer has no need to persuade a viewer to adopt his or her point of view, because the reader has no choice; in the picture we see the world from the angle of the camera's

partial vision, from the position it had at the moment of the release of the shutter.

How to create out of a group of pictures, each made from a particular perspective, a coherent discourse with a "consistent attitude": this was the problem Evans had earlier formulated and put to himself in 1938. It was, in a sense, the same problem faced by editors of photo-stories, the arrangement of images and words focusing on a current event or a topical issue—increasingly popular in new picture journals like *Life* and *Look*. By excluding words, and more important, by denying his reader the unities of time and place, Evans rejects this mode entirely. His sequences have nothing to do with chronology or place; the inclusion of a date with each title (from 1929 to 1936), and the juxtaposition of images made in different locations, defies the expectations of popular journalism. Each picture appears as a "now," as much in the present tense as in any other. Just as dates do not matter in the flow of images in Evans's book, neither do places. In the logic of the book, all places are "here." The book also disrupts any expectation that its pictures of here and now must be "news"; that is, topical, or scenes of current events. Evans's form accomplishes that removal from "their immediate contexts" which the drafted Author's Note claims must happen if journalistic "records" are to become "of any value whatever." To allay any suspicion that his pictures might be journalistic records, Evans removes them entirely from the normal context of chronological or spatial order.

A more subtle disruption and denial concerns the FSA. The present version of the file housed by the Library of Congress did not appear until the 1940s; it was designed by Paul Vanderbilt to provide social classifications arranged in an evolutionary order. From its start in 1935, the project faced the twofold problem of convenience and coherence. Intended to provide pictures for government and publicity purposes, the photographs were available to anyone at a small charge, and were widely circulated (often on Stryker's own initiative) in newspapers and picture magazines. The file offered categories of "subjects" cross-referenced by state, with a list of "suggestions for picture stories" such as "stories of groups of people," "crop stories," and "stories of places."[50] The convenience of magazine and newspaper editors, and the particular political needs of the Roosevelt Administration, dictated the form of Stryker's early filing system.[51] Following the commercial success of *You Have Seen Their Faces* (1937), by independent photographer-journalist Margaret Bourke-White and her writer husband Erskine Caldwell, a rash of picture-and-word books appeared between 1938 and 1941 on themes of rural poverty, the small town, the Negro, the condition of

agriculture—and in one case, Archibald MacLeish's *Land of the Free* (1938), accompanying a long poem, or "sound track," about the indomitable American spirit.[52] On the whole, such books drew on the FSA file for images of farmers struggling against drought, or citizens gathered in a small-town square—typical images of typical scenes. Such books reinforced the lesson of popular journalism, that pictures which looked like documents of the times be accompanied with captions, with explanations, with open appeals to the viewer's sympathy or anger. Evans's book, without captions, without the unities of time and place, without clear topics guiding the flow of the pictures, disappoints conventional expectations about these pictures, how they should appear and address their readers.

The point can be made graphic by looking at several uses of a particular image by Evans in publications over which he had no control. In 1938 his picture of a small cemetery in Bethlehem, Pa., with steel mills in the distance, appeared slightly cropped in Archibald MacLeish's *Land of the Free*—"a book of photographs," explained MacLeish, "illustrated by a poem."[53] Like each of the book's eighty-eight images (drawn mostly from the FSA collection), it occupied a glossy page by itself, bled vertically to the edges, without caption or identification (a list of captions and photographers appears at the end of the book), opposite a page of text:

> We wonder whether the great American dream
> Was the singing of locusts out of the grass to
> the west and the
> West is behind us now:
> The west wind's away from us.[54]

The image takes its place in a sequence of words and images, the governing theme of which is proclaimed in the poem's opening words: "We don't know . . . we aren't sure"—that is, the dubiousness of the American dream at a time typified by images of gaunt faces, resigned bodies, gnarled hands, ragged children, abandoned farms, police violence, and barbed wire.

Just preceding the Evans picture is a photograph of a Congregationalist church and graveyard: "We tell our past by the gravestones and the apple trees."[55] Just following it is a Russell Lee picture of a worried-looking farmer and two children, "on cutover land in Wisconsin": "We wonder if the liberty is done: / The dreaming is finished / We can't say / We aren't sure." The three images make up a coherent passage within the argument of the poem, a kind of stanza: the Bethlehem picture with its prominent rusticated cross (implying a Catholic cemetery and

91. File photograph, from Archibald MacLeish's *Land of the Free*

immigrants) and its compressed urban-industrial imagery serving as a bridge from the pleasantly familiar rural Connecticut scene (all in white, ancient lichen-covered slabs for grave markers) to the Wisconsin scene of depleted energy and belief. In that movement—from spire of traditional communal belief, to cross of stern judgment, to abandoned farmer and children and unpainted shack behind them—lies the meaning of "Bethlehem" in this setting: the alien hell between there and here, between then and now.

The following year the Bethlehem picture appeared in a quite different form, as the concluding image of a group of forty-one FSA pictures presented by Edward Steichen in *US Camera Annual* (1939). The pictures

92. Photograph by Walker Evans, from Archibald MacLeish's *Land of the Free*

93. Photograph by Russell Lee, from Archibald MacLeish's *Land of the Free*

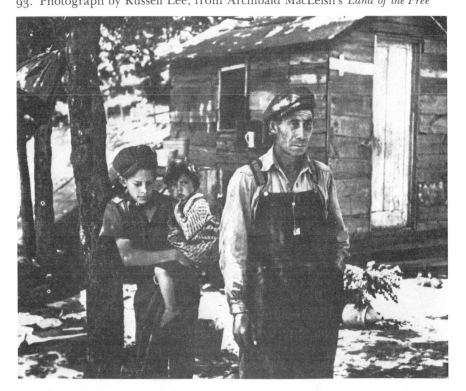

had appeared in a International Photographic Exposition held in New York that year to mark the hundredth anniversary of the birth of photography, taking their place within the history of the medium as, in Steichen's words, "the most remarkable human documents that were ever rendered in pictures."[56] Steichen explained "documentary" as pictures which "tell a story": "Have a look into the faces of the men and the women in these pages. Listen to the story they tell . . ." As if to enhance the story, or to provoke the reader, Steichen included actual writing on each image (except the first and the last), culled from the written comments submitted by viewers of the exhibition. The words display varying degrees of outrage, sympathy, sensitivity, and obtuseness: ". . . Next time play up the other side . . ." appears on the Russell Lee picture of four standing children at their grubby Christmas dinner; "Subversive propaganda," on Dorothea Lange's nursing migrant mother. The irony points the reader in the right direction.

Free of any explicit commentary, the Evans picture concludes the section in a double-page spread. "For sheer story telling impact," Steichen remarked, the Bethlehem photograph "picturing in parallel planes the cemetery, the steel plant and the home, would be hard to beat." Printed in deeply saturated blacks on heavy pulp stock and filling both pages, the picture is cropped at the bottom and top to make the cross seem even more dominant and even more ominous, like a prophetic message, than in the MacLeish version of the print.

Yet another use was made of the picture that same year. Roy Stryker and Paul H. Johnstone included it among nine images in a lecture given before the American Historical Association in 1939, identifying it in their text only as "Picture No. 8," which shows "housing and factory construction" and "speaks volumes about the unplanned growth of an industrial city, although the dramatic composition of the photograph makes it an example of a type that is interpretative as well as documentary."[57] Arguing for the value of photographic documents for historians, they note that in depicting an aspect "of the urban milieu of which the immigrant from a peasant culture has become a part," the picture "has an insistence for the historian that no verbal document can carry."[58]

"People often read things into my work," Evans would remark years later, "but I did not consciously put these things in the photographs."[59] In an unpublished note written in 1961 for a reissue of *American Photographs*, Evans stated:

> The objective picture of America in the 1930s made by Evans was neither journalistic nor political in technique and intention. It was reflective rather than tendentious and, in a certain way, disinterested.[60]

Disinterest is just what is purged from the image in the texts by MacLeish, Steichen, and Stryker. Such uses of FSA pictures in the 1930s and since have enforced the impression that all FSA pictures—indeed, the definition of FSA as such—had a story to tell about the hardship and heroism of the times. And each time, Evans's Bethlehem picture appears not as a work by Walker Evans but as an *FSA* photograph—a storytelling image of the Great Depression. Steichen mentions no photographer by name in his *US Camera* introduction; he subordinates "the work of individual photographers" to "the job as a whole," each image standing for the collective project rather than as individual vision. The list of names at the end of the article provides no information about the circumstances of the picture, what social conditions each photographer was at the time investigating.

In 1971 the Museum of Modern Art published another version of the Bethlehem picture in a monograph on Walker Evans accompanying an exhibition. Alone on a page surrounded by white space and facing a page of white, the image appears as Evans wanted it, as a picture in itself, in the setting of his own work.[61] In 1973 the same uncropped version appears in quite another kind of book, a Library of Congress catalogue of Evans's work for the FSA. The image is in two places in the catalogue—in a separate group of selected images, one to a page, meant to show Evans at his best, and also as a smaller image along with others made in Pennsylvania at the same time. In one case (as in the MOMA catalogue), the presentation testifies to Evans's status as an artist, the maker of single fine pictures; in the other, to his practice as a journeyman photographer creating a cumulative record of social observation.

The two versions, or conceptions—art and social document—are presented as distinct, antithetical: exactly the gap Evans wanted to bridge in *American Photographs*. His 1938 book negates the methods and styles of journalism, and of the stereotyped FSA. In *Let Us Now Praise Famous Men*, Agee's insistent denial that his prose fits any of the standard categories of "social protest" or "reportage" also concurs with Evans's intention in that book, as well as in *American Photographs*. In 1937 Agee submitted for a Guggenheim Fellowship extraordinary and perhaps half-serious "Plans for Work" for almost fifty projects. "Quite a bit of this work," Agee explained, "would be done in collaboration with Mr. Walker Evans who is responsible for some and collaboratively responsible for others of the ideas or projects mentioned." The projects include "An Alabama Record" ("as definitely a book of photographs as a book of words") and about half dozen more dealing with photographs. One is titled "A new kind of photographic show," and reads: "In which

photographs are organized and juxtaposed into an organic meaning and whole: a sort of static movie. Scenario for such a show furnished if desired." Among the proposals, most of them exuberantly original plans for re-creating objects and themes in popular culture, are several to collect and reassemble into collage form personal letters, news items, key words, color photographs, faces in news pictures, formal portraits, scraps of sound and rhythm. The point is to devise new ways to allow contemporary life to express itself, its voices, rhythms, and celluloid images. What Agee says about the Alabama project applies to the others: "The job is perhaps chiefly a skeptical study of the nature of reality and of the false nature of re-creation and of communication." The document rejects conventional journalism, politics, religion, and art, and holds out a hope for new forms, on the principle that no reality can ever be known, as popular journalism implies it can, in any definitive, complete, or permanently trustworthy way.[62]

The very openness of *American Photographs* implies skepticism toward closed forms and fixed meanings. The book invites its readers to discover meanings for themselves, to puzzle over the arrangement of pictures and figure out how and why they appear as they do. One of its ways of persuading the reader to put aside the traditional habits of viewing is to make the picture itself complex and ambiguous, to compel the reader to ponder its shapes and relations before leaping to the conclusion that the image is a simple record of a scene. The disjointedness of time and place also prevents the reader from taking the pictures as a simple story told through images. The book skips and jumps, building up a sense of a composite reality only partially represented in each image, a reality not of this or that place or time but of a larger, implied place and time fabricated out of the links and ties, the multiple cross-references and echoes of the images in their order—an America of the imagination. The layering of points of view as well as objects, faces, signs, and all the details that designate place and time challenges the reader to participate in that fabricating process.

V

The continuity of the images within each part resembles, as Agee's remark about a "static movie" suggests, the method of cinema. Evans's interest in film—particularly newsreels—extended to several experiments in the medium, and a number of abortive plans.[63] Whether or not he deliberately adopted cinematic devices in *American Photographs*, the resemblance holds a key to the book's form. In "A Dialectical Approach to Film Form" (1929), the Russian director and theorist Sergei

Eisenstein suggests a parallel between cinema and language which sheds light on Evans's techniques of juxtaposition:

> Now why should the cinema follow the forms of theatre and painting rather than the methodology of language, which allows wholly new concepts or ideas to arise from the combination of two concrete denotations of two concrete objects? Language is much closer to film than painting is. For example, in painting the form arises from the abstract elements of line and color, while in cinema the material concreteness of the image within the frame presents—as an element—the greatest difficulty in manipulation. So why not lean towards the system of language, which is forced to use the same mechanics in inventing words and word-complexes?[64]

The invention of "word-complexes" provided Eisenstein with a model for his concept of "montage"—"giving birth to concepts, to emotions, by juxtaposing two disparate events." Film differs from a book, however, by the speed and regularity of the flow of images, and thus the analogy to montage cannot be exact. In film, "each sequential element is perceived not next to the other but on top of each other. For the idea (or sensation) of movement arises from the process of superimposing on the retained impression of the object's first position, a newly visible further position."[65] The difference in apparatus between book and film does not invalidate the analogy, however, for in a *static* movie the effect of juxtaposing two images to produce an unarticulated but felt idea or emotion still obtains. The appeal of the film analogy for Evans very likely lay in the demand it places on the viewer to participate, to make the book a continuous, coherent event. As Eisenstein said, "the montage principle obliges spectators to create."[66]

Any grouping of images within the book can be taken as an example of Evans's adaptation of the montage device, which can be restated as a dialectical process of thesis giving rise to counter-thesis, together producing as feeling and/or idea an unseen, unstated synthesis. Each picture discloses a link to the next, a hint or germ of an antithetical image to follow. The reader is expected to remember each image fully, in all its details and nuances, for the most inconspicuous details become significant in echoes and allusions further on. What the pictures say they say in and through the texture of relations which unfold—continuities, doublings, reversals, climaxes, and resolutions.

The opening six images of Part One show how a consistent point of view emerges from an interplay of perspectives, a montage constructed of changing camera positions pulling together images themselves made up of other images.[67] The camera moves from a middle-distance shot of a single building to a close-up of a window display, a double head-

and-torso portrait from a fairly low angle, a medium close-up of a portrait drawing on a poster in a window, a full shot of the façade of a barbershop in a city block showing edges of the contiguous shops, and a fairly tight view of the interior of a barbershop. The point of view also moves between interiors and exteriors: the open door in "License-Photo Studio" fading to the view inside a window of "Penny Picture Display," repeated in "Political Poster, Massachusetts Village, 1929"; the door recurring in "Sidewalk and Shopfront" entering next the space of "Negro Barber Shop Interior." The shifts, particularly the sharp change in camera format—large-view camera in the close-up of "Penny Picture Display" to hand-held 35-mm camera in "Faces, Pennsylvania Town"—are expressive of the constructive role of the camera and its acknowledged presence at the scene it represents. They imply the camera's range of abilities, intensifying scrutiny of details, massing details into resonant patterns, and, in the sudden shift to "Faces," approximating (without fully penetrating) the inner point of view of its human subjects, each of whom in this instance peers beyond the edge of the frame, caught against a background of blurred faces (another indication of the camera's ability to fashion what and how we see) in a gesture of looking elsewhere. The Pennsylvania boys look as different from the people mugging into the mechanical eye of an automatic camera in "Penny Picture Display" as the vague, sightless eyes of Herbert Hoover differ from the frank, straightforward though slightly withdrawn and vaguely smiling look of the incomparable lady of the French Opera Barber Shop—"Ladies Neck Trim 15¢"—in "Sidewalk and Shopfront, New Orleans, 1933." And in "Negro Barber Shop Interior, Atlanta, 1936," we see not only additional portraits lying on their side on the newspaper page that serves as wallpaper, but actual mirrors to look at oneself parodied by the faces in "Penny Picture Display."

The changing camera perspectives relate what these six images are most obviously about: images and image making, from photographs to hand-drawn idealizing posters (including the seductive lady's head in the window to the left of the French Opera Barber Shop, who foreshadows Carole Lombard in "Houses and Billboards in Atlanta, 1936," as well as the theme of contrasting fantasies and realities, especially of a sexual nature) to image making directly on the body in the two juxtaposed (outside, inside) views of barbershops. The first three images concern photography explicitly; the following three expand and generalize the theme of the image to embrace other forms of image making.

We begin with "License-Photo Studio," whose shabby appearance raises a smile at the use of the word "Studio." This opening image strikes a chord rich in harmonies but not without dissonances. Its array

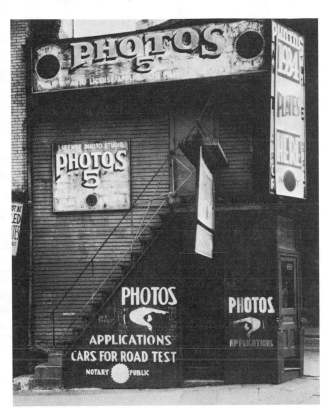

94. "License-Photo Studio, New York, 1934." Walker Evans I, no. 1

95. "Penny Picture Display, Savannah, 1936." Walker Evans I, no. 2

96. "Faces, Pennsylvania Town, 1936." Walker Evans I, no. 3

97. "Political Poster, Massachusetts Village, 1929." Walker Evans I, no. 4

98. "Sidewalk and Shopfront, New Orleans, 1933." Walker Evans I, no. 5

99. "Negro Barber Shop Interior, Atlanta, 1936." Walker Evans I, no. 6

of words (including the hand-scrawled "Come up and see me sometime" and "Tootsie Love Fina") and numbers, and the logo of the pointing fingers, makes the picture an unmistakable exercise in *reading*, a mixture of linguistic and visual notations. The form of the image demands attention exactly opposite in kind to that called for by auto-license identification pictures. The book opens by defining itself against one of its antagonists: the practice of using photographs not to *see* the world but to impose legal definitions upon it, definitions based on the faulty assumption that a photograph is an exact equivalent to an "identity." This book is for seeing as *reading*, Evans says in this opening picture, not for the instrumental purposes of photo-license pictures or for assigning equivalences. Nor is it for the purposes depicted in the following picture, in which the author appropriates similiar identification images for his kind of reading, making them part of his own ironic construction. The movement from the opening picture through the second to the third encapsulates the method of the book: from a conception of the photograph as mere identification to a subversion of that idea in the second image (where "Studio" cues our response to the wit in the event: a single picture made of, and commenting upon, many small pictures), to a picture free of writing and full of ambiguity, of the two boys looking elsewhere. Their glances beyond the frame of the image tell us that the world is wider and more full of circumstance than any photograph can show, that photographs cannot properly "identify" because they leave out too much, that reading has its limits and must take the arbitrariness of the picture's frame into account: an admission of contingency absent from the "studio" images implied or shown in the preceding pictures.

Moreover, a feeling of constriction, of claustrophobia, menaces the air in the first two images—that narrow doorway, those unexplained stairs leading to what seems to be a sealed door, those tiny pictures on display locked into place and looking so helpless. The third image offers relief: fresh air, movement, spontaneity, a photograph not of photo-graphs or images but of the world (with none of the internal frames of the others: doorways, windows, mirrors): people in their own image. Yet, as we look closely and think about it, the boys share a quality missing in the arcade display: even with the mugging, a naturalness that marks the undistinguished, anonymous characters who will fill Part One. The camera in the third picture, then, explores its kinship to as much as its difference from—a difference chiefly of self-consciousness and sophistication of intent—the cameras in the first two. Thus the opening three images declare a theme, a set of relations, a point of view

to be recapitulated, complicated, expanded, and deepened in the course of the book.

Part One, the longer of the two sections (fifty of the eighty-seven pictures), presents a more intricately composed sequence than Part Two. From the overture the book proceeds with the same deliberateness in pictures linked most explicitly by recurring motifs: automobiles, men and women, black and white, together and alone, interiors of living spaces, façades of houses (anticipating Part Two), lettered signs, and, most pointedly, drawings, photographs, billboards, some representing collective fantasies, some mass-produced, some handmade, all viewed as the coin of reality. To read this sequence is to engage in a drama of consciousness in the faces, gestures, signs, and objects which collectively people the pictures. It is a drama played out, moreover, within a political setting evoked by allusions to government power in "License-Photo Studio" and in the glimpse of a Herbert Hoover campaign poster in the opening sequence, in the interweaving of the American Legion and Cuban dock workers, the Havana policeman and Civil War monuments, a slickly advertised Santa Claus and the interior of a coal miner's shack—and in the sharply divided realms in which blacks and whites live, the heritage of a way of life, a social order, and an economy visibly decaying before our eyes. The front of a bank, telephone poles, Coca-Cola signs, railroad tracks, stereotypes of blacks on torn wall posters (compare the minstrel fantasies with what the photographs of actual people show)— form a pattern of power relations which sets the drama of awareness within a distinct historical moment.

Part One deepens in accumulated implications: lonely figures, empty beds, sullen houses blind and deaf to the comedy they enact against the seductive billboards they cannot see. The sequence makes its objects and its people speak to the eye in a voice the mind can only approximately translate, but the crescendo of feeling is unmistakable; it rises with the rhythm of the sequence until it falls with a crash in the final picture. The uprooted tree cutting across our view of the forlorn "Louisiana Plantation House" provides the cumulative emblem of the sequence. The fallen tree reminds us of a doomed civilization, and mocks the aura of romance still attached to the old-plantation South in the culture the book evokes—*Gone with the Wind* had come out (and won a Pulitzer Prize) in 1936.

From the opening to the concluding image of Part One, the reader is taken through one of the most finely modulated landscapes of antithetical relations, of dawning perception mixing horror and grace (not unlike Eliot's *The Waste Land*, the formative poem of Evans's

100. "Lunch Wagon Detail,
New York, 1931." Walker
Evans I, no. 9

101. "Parked Car, Small Town Main Street, 1932." Walker Evans I, no. 10

102. "A Bench in the Bronx on Sunday, 1933." Walker Evans I, no. 12

103. "Torn Movie
Poster, 1930." Walker
Evans I, no. 13

104. "Sidewalk in Vicksburg, Mississippi, 1936." Walker Evans I, no. 24

105. "Garage in Southern City Outskirts, 1936." Walker Evans I, no. 25

106. "Main Street of County Seat, Alabama, 1936." Walker Evans I, no. 26

generation) in American descriptive-narrative art—a contrast to the relatively harmonious succession of images in Part Two. "I need not tell you the reader needs a breather after picture #50," Evans wrote to the publisher of the 1962 reissue of the book.[68] If Part One moves from "Studio" to fallen tree, Part Two is framed in a different manner by images whose titles repeat a key work: "Stamped-Tin Relic, 1929" and "Tin Relic, 1930." The repetition of "relic" suggests less a passage than a cycle or recurrence, though the difference between the first image (of a discarded glistening sheet of crushed tin stamped with a classical ornament) and the last (of a dark circular form with an intact rosette) implies a significant if subtle change in tone. The opening image segues into the next part by the visual transformation of a conceptual motif: the relic found at a demolition site (the fragment of nailed lathing on the right) resembles the posture of the tree, though it refers to the columns of the house, in the final image of Part One. The image of the icon recapitulates the theme of house, structure, ornament, and the associations of the stamped classical motif (machine-made, brittle, false, yet reaching for something beyond itself: its pathos). Identified as

107. "American
Legionnaire, 1936."
Walker Evans I, no. 32

108. "Coal Dock Worker, 1932." Walker
Evans I, no. 33

109. "Minstrel Showbill,
1936." Walker Evans I,
no. 34

110. "Roadside Stand
near Birmingham, 1936."
Walker Evans I, no. 35

111. "Main Street Faces, 1935." Walker Evans I, no. 39

"relic," the image achieves a transformation of the previous image into its antithesis: what is lost and fallen, tree and deserted plantation, may now be recovered as something else, a memorial fragment of a missing whole.

The concluding image uses another motif. "Tin Relic, 1930" shows another found object in close-up, a swirling fragment of sharp-edged metal bearing a complete rosette, like a wildflower that escaped extinction, half its petals caught in bright, direct light, the other half, like the deep black which occupies most of the print just above it, in shadow: a flower reproduced in metal in turn reproduced on paper in the medium of black-and-white photography. Again the sequence places "the image" in the foreground, along with the crafts of reproduction it implies. Signs of handicraft show up in Part Two even more insistently than in Part One—progressively asserting themselves against industrialism, machine production, and standardized objects gathered chiefly at the beginning of the sequence in pictures of small industrial towns North

112. "Posed Portraits, New York, 1931." Walker Evans I, no. 40

113. "Couple at Coney Island, New York, 1928." Walker Evans I, no. 41

114. "Houses and Billboards in Atlanta, 1936." Walker Evans I, no. 47

115. "South Street, New York, 1932." Walker Evans I, no. 48

116. "South Street, New York, 1932." Walker Evans I, no. 49

117. "Louisiana Plantation House, 1935." Walker Evans I, no. 50

118. "Stamped-Tin Relic, 1929." Walker Evans II, no. 1

and South. Through successive camera perspectives, the opening images repeat and transform the falling motion of the conclusion of Part One, looking down in "View of Easton, Pennsylvania, 1936" and "View of Ossining, New York, 1930," and more steeply down in the two Bethlehem pictures (#5 and #6), leveling, then rising to a peak in the three images at the very center of the sequence. Two hand-built wooden churches in #17 ("Wooden Church, South Carolina, 1936") and #19 ("Negro Church, South Carolina, 1936"), whose pointed pediments repeat in the vernacular the towers and columns—true supports, invoking the column in its pure function—surround the central image, "Greek Temple Building, Natchez, Mississippi, 1936," an imitation building converted to the mysterious function indicated by the partly obscured, classically lettered sign reading "SIGNS" (another sign, "SCOTT," in the window). Two instances of a certain style and quality of aspiration teaching us to look, with sympathetic humor, at another. The three images form a central triptych or chord of harmonized tension which reverberates to the end of the sequence, reappearing in altered pitch in the reliquary rosette salvaged from the pit of darkness which surrounds it.

Following "People by Photography" in Part One, Part Two demonstrates a way, not by style alone but by literary construction, of peopling

a world of things by acts of the imagination. Part Two serves to recover a world of matter shaped by culture to human use—a fallen world of unredeemed (we might also say alienated) objects scattered in a fragmented landscape. It is a process of indirection and antithesis, a process of dialectic. The camera frees the objects of people in order better to show the presence of people, of labor in the forms of factory and shop and back yard. Not in themselves, by any intrinsic qualities, do the objects of this dissociated landscape rise into memory as relics, but by the act of the camera, which finds them in a certain perspective and reads them in a certain order. Objects come to life in Part Two, are returned to people and labor, expressions of their lives, not only in a fugue-like response or as a hope amid the forlornness on which Part One ends, but as a meditation on the place of the camera within this landscape.

Becoming visible in the overture, photography itself appears as a craft among crafts, inscriptive rather than mechanically transcriptive alone, or capable of converting transcript to writing—and at the same time a unique instrument whereby the world it depicts might become conscious of itself, "lifted," in Williams's words, "made worthy in our anonymity." This recurring word, "anonymity," lies at the heart of the

119. "Tin Relic, 1930." Walker Evans II, no. 37

120. "Part of Philipsburg, New Jersey, 1936." Walker Evans II, no. 2

121. "Birmingham Steel Mill and Workers' Houses, 1936." Walker Evans II, no. 11

122. "Factory Street in Amsterdam, New York, 1930." Walker Evans II, no. 12

book, of its view of both "America" and "photographs." In the same year that *American Photographs* appeared, the Southern Fugitive poet and critic John Crowe Ransom published in *The World's Body* an essay on Milton's *Lycidas* titled "A Poem Nearly Anonymous."

> Anonymity, of some real if not literal sort, is a condition of poetry. A good poem, even if it is signed with a full and well-known name, intends as a work of art to lose the identity of the author; that is, it means to represent him not actualized, like an eye-witness testifying in court and held strictly by zealous counsel to the point at issue, but freed from his juridical or prose self and taking an ideal or fictitious personality; otherwise his evidence amounts the less to poetry.[69]

In this touchstone of the New Criticism, Ransom turns a decadent romanticism against itself: the idea that art amounts to unconstrained expression of an emotional "self." In his comments on art Evans obviously subscribed to this modernist ideal of the selflessness of art, the disinterested surrender of the personality of the artist to craft, to the identity of the artwork itself. By "nearly anonymous" in regard to *Lycidas*, Ransom means that Milton departed at a few points of the poem from the rigors of his chosen form, injecting a more personal voice of

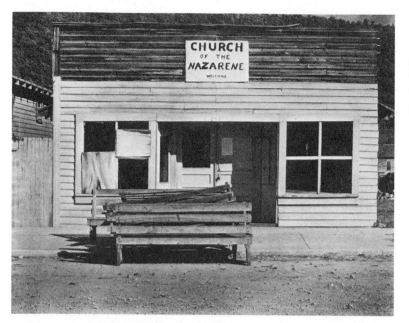

123. "Church of the Nazarene, Tennessee, 1936." Walker Evans II, no. 16

124. "Wooden Church, South Carolina, 1936." Walker Evans II, no. 17

125. "Greek
Temple Building,
Natchez,
Mississippi, 1936."
Walker Evans II,
no. 18

126. "Negro
Church, South
Carolina, 1936."
Walker Evans II,
no. 19

127. "Detail of Frame House in Ossining, New York, 1931." Walker Evans II, no. 29

128. (*Below*) "Butcher Sign, Mississippi, 1936." Walker Evans II, no. 31

129. "Maine Pump, 1933."
Walker Evans II, no. 32

rebellion against constraint, making of the poem a "strain of contraries" characteristic of strong art. The analogy applies to *American Photographs*, a book nearly anonymous, through the signs we detect in the final images of Parts One and Two of a symbolic gesture toward significant closure. In those images which beg for near-allegorical readings as cumulative images, Evans the man, the thinker, gains the upper hand over the photographer who strives to maintain the look of the anonymous craftsman—what Evans meant by "documentary style."

But Ransom's insight applies to more than the lapses we may find in the book's point of view. Anonymity is also the book's great theme—anonymity as the true character of the American. The theme mirrors the history of the book, the history it enacts within its time, by penetrating one of the period's most emotionally potent slogans, "the people," and disclosing what lies at its heart: a landscape within whose waste and ruin appear nameless artists of the commonplace and the everyday, artists of a down-to-earth spirituality. Evans raises anonymity to a theme by adopting the manner of the naïve and straightforward camera eye. He returns "photographs" to "American" by evoking the nameless craftsmen of the past, and by making their craft his own. The book's

America is not a fixed and final form but a series of acts and gestures toward the making of a place. In this, *American Photographs* evokes for itself not only a tradition of photography but a larger cultural enterprise, an intellectual as much as a literary and graphic tradition, which has taken America less as a place and a creed than as a process of becoming.

Walker Evans is like Emerson and Whitman in his eager receptivity to the natural facts of contemporary life, but he is also like Henry James in *The American Scene* in the acute skepticism with which he gathers impressions and assembles them into an order. The book proposes no immanent whole named America, as Evans's friend Hart Crane attempted in *The Bridge*, but a continuous meditation, similar to William Carlos Williams's in the *Paterson* books, upon the problem of coherence, how to make sense of the array of impressions gathered in each image and in their totality. The book exists as a complete act only in the reader's experience of making sense of the discontinuous but tightly knit flow of images. It is in the effort to achieve coherence that Evans's America lies—not a finished thesis but a continuous process, less an idea than a method.

The book talks to us, as Williams said, and what it says it says eloquently, with fluency and force. Its eloquence flows from its effort to cohere, from its having a story to tell: a story of how photographs can be seen and experienced as American, *perceived* (in Dewey's sense) as one's own story. Eloquence is "the essence of art," Kenneth Burke noted in *Counter-Statement* in 1931, because it is "simply the end of art." Burke's book, an effort to describe and defend a role for art in an age of mechanized "information," business values, and an increasingly administered society, is a useful counterpart to Evans's, engaging theoretically what Evans's engages practically. Anticipating Kazin a decade later, Burke argues that the "great influx" or "hypertrophy" of "information" through science and the mass media (including photography, though he does not say so) has resulted in a "corresponding atrophy of the psychology of form," a damaging diminishment of art into "the giving of information." Eloquence, which takes art from the point of view of "the psychology of the audience," provides an antidote, a way of restoring art to a political role by imagining a different kind of politics, one in which the eloquence of utterances is one (not the only) measure of their value. The end of art ought not to be information or emotion but the "conversion, or transcendence, of emotion into eloquence"—not a mirror of life but "a factor added to life." By its "psychology of form" (its strategies for eliciting its audience's participation), art can be "the humanistic or cultural counterpart of the

external changes brought about by industrialism, or mechanization," "a means of reclamation," "the corrective of the practical."[70]

The America of *American Photographs* is a product of, or the indeterminate possibility of, the book's "psychology of form." Evans's innovation lies in his discovery that photographs can be arranged in the form of a psychology, an eloquent address to interested readers. In one light Evans's pictures show a nation caught within oppositions and differences: past and present, country and city, white and black, male and female, wealth and poverty, power and impotence. In another light they offer by enactment an alternative to the commercial and instrumental methods of seeing which they oppose. In the form of the book they provide an alternative way of seeing and realizing America, making the nation real as one's experience. Aesthetic experience, as in Hine's more conflict-ridden methods of seeing and reading, becomes political experience, a way of defining oneself in relation to a collectivity. By making us perceive in each successive image the presence of a changing society and its history, and our implication in what and how we perceive, Evans practiced a political art of the photograph, not a program of reform but social observation and critical intelligence. And in its near-anonymity the book reclaims a history of its own. Just as its pictures require that we see a time and a place (and ourselves) in the light of history, it helps us recover a tradition of American photographs as a living presence.

Epilogue

An art may be of value purely through preventing a society from becoming
too assertively, too hopelessly, itself.

KENNETH BURKE, *Counter-Statement* (1931)

AMONG its several concerns, Walker Evans's *American Photographs* in-
cludes photography itself as a subject, a field of investigation. The book
reflects upon the tradition it stakes out for itself, upon the possibilities
and opportunities for an American art of the photograph—and invites
us to do the same. For photographers the book has been an inspiration
and an incitement—also a burden: a burden of originality. Evans taught
that photographic seeing could be, as Robert Frank once put it, a kind
of destiny. For scholars, critics, and historians, and for all interested
readers, Evans's book provides another kind of opportunity: to win
away from the myopic and stingy formalities of academic disciplines an
astonishingly rich and important body of American art. One of his
book's instigations is to reconsider the role of photographers as artists.

My own goal has been to explore the conditions of culture and politics
in which the separate projects which comprise American photographs
came into being. The medium was not born as a medium of art; it
became one within specific circumstances, and in America those circum-
stances included certain ideas and expectations about the role of the
representational arts in the Republic. American photographers came to
realizations about the capabilities of their medium in circumstances
shaped by history, a history their work in turn helps us better to see
and understand. So it is with all art, which, by its character as a
formalization of emotion and idea in relation to physical objects,
translates history into experience. The dialectic between artworks and

287

cultural process is no different in the case of photographs. Camera-made images have no special privilege as documents of culture. But they have their own resources, different in kind from those of paint or stone or ink and pen.

The story I have told in this book includes successive discoveries, under conditions of changing technologies as well as changing social forms, of capabilities in the medium for an art of actuality. The camera offered what seemed a new relation to the physical world, especially to its transitory nature and the illusory character of its surfaces. The photograph's mirror-like ability to capture the moment and preserve its uniqueness made the camera seem (as it still does) a near-magical device for defeating time, for endowing the past with a presence it had previously had only in memory. The immediacy of lived experience frozen forever and forever recoverable: this came to seem the domain of the photograph. How certain photographers fashioned from such a medium an American art of actuality, how they discovered in their medium resources for representing America as fact and idea, and the variety of their discoveries, of their points of view (rhetorical and aesthetic) toward the experiences they represented: this is what my reading of American photographs has attempted to show and explain.

Reading American photographs is also a way of reading the past—not just the scenes recorded and the faces immobilized into permanent images, but the past as culture, as ways of thinking and feeling, as experience. The external form of the story shows that from Brady to Evans the passage toward a self-conscious art of the camera has followed the contours of major social transformation and ideological adjustment. The history told here has not been a continuous narrative of a hundred years of cultural change, but a series of analyses of key moments defined by major photographic events and projects. What has been continuous between the separate parts is the persistence of certain ways by which Americans have attempted to grasp the meaning of their social lives, to make imaginative sense of their history as they lived and reflected upon it. A key term in this story of change and reflection has been the word "America" itself, the myths it has embodied and engendered, the meanings which have seemed intrinsic to it. America names a discourse in which the photographs discussed here have participated, a discourse whose inner tensions and contradictions they help clarify, help us better identify and understand. It is not so much a new but a clarifying light American photographs shed upon American reality.

Brady represents an age of heroic innocence, a belief in the transparency of the medium and in the steadfastness of a republican ideal in a society seemingly without barriers to success and eminence. But we

have seen at what expense of blindness and exclusion Brady held to his vision. As the activities shaping and governing American life grew more complex, more at odds with the innocent version of the myth—the Civil War is the first sign that what America repressed would take its revenge—certain photographers (O'Sullivan is the prime example) registered in their work a growing recognition that the work itself qualified the idea of its transparency, that the conditions of camera work had to be taken into account and incorporated in the pictures themselves. Thus, O'Sullivan placed the survey camera among the instruments of practical science, allowing the history and meaning of the Western surveys (the conjunction of "pure" science and imperial economic enterprise) to reveal their contradictions.

With Stieglitz, Hine, and Evans, alternative versions of self-consciousness appear in photography. This development, foreshadowed in O'Sullivan's Western work, is the consequence not just, as it is often taken to be, of the "modernist" movement in the arts but of new conditions of culture brought into existence by modernity. The theoretical self-reflections implied by the work of these three seminal figures are explained here as responses to change, strategies devised against the appropriation of the camera by the culture of consumption, information, and bureaucratic administration, against the idea of authority imputed to the image as if it were a value-free statement. The aura of scientific expertise often hid less neutral motives. While Stieglitz responded to this challenge by striving to free the image from its social content, thereby preserving the aesthetic from political appropriation (itself a political act with practical consequences for the institutionalization of "art" photography), Evans found a way of returning the image to everyday culture, employing what he called "documentary style" in the service of a psychology of form. Evans's book releases richness from each image by making the totality of images the condition for the reader's grasp of the individual image.

In what sense does the passage from Brady to Evans, as I have interpreted it here, answer to the book's epigraphs by Walter Benjamin and George Herbert Mead? Mead and Benjamin both view the act of writing history as an interpretation not so much of the past as such, but of the present. "To articulate the past historically does not mean," Benjamin observes in "Theses on the Philosophy of History" (1940), "to recognize it 'the way it really was' (Ranke). It means to seize hold of a memory as it flashes up at a moment of danger." Less apocalyptic, writing not on the eve of Europe's cataclysm but in the American 1920s, the pragmatist Mead nonetheless shares with the Marxist Benjamin the view that "the past that has to be found out, to be inferred," is elicited

by the present, by our "need to better comprehend the society of which we are a part." It is what we recognize as needs and dangers that give rise to what we see as history. Benjamin calls the past an "image": "The past can be seized as an image which flashes up at the instant that it can be recognized and is never seen again." Mead uses the word "perspective": "The past that is thus constituted is a perspective, and what will be seen in that perspective and what will be the relations between its elements, depends upon the point of reference." Image and perspective both imply sight and vision: an act of reading.

According to my point of reference, the history represented in American photographs belongs to a continuing dialogue and struggle over the future of America. It is a history of participation by photographers in the making of America, the illumination of its cultural patterns, the articulation of its social and political contradictions. The dialectical view of history gives us an American photography more richly American, more significant (this is my hope) as a past which interprets our present—past images as present history.

Notes

Prologue

[1] James E. McClees, *Elements of Photography* (Philadelphia, 1855), facsimile reprint, International Museum of Photography at the George Eastman House, 1974, 3–4. For an early history of the term "photography," see Joseph Maria Eder, *History of Photography*, tr. Edward Epstean (New York, 1945), 258–59.

[2] Helmut and Alison Gernsheim, *L. J. M. Daguerre* (New York, 1968), 86.

[3] Another problem was and is the ambiguous legal status of photographs. See Bernard Edelman, *Ownership of the Image: Elements for a Marxist Theory of the Law* (London, 1979), 37–67, for a discussion of how French law coped with determining whether photographs, being the product of a machine, qualified for copyright protection—whether the producers of machine-made images are also "authors." In Anglo-American law, standard copyright protection was extended to photographs as early as 1862 in Britain and 1865 in America. See Martha Gever, "Photography as Private Property: A Marxist Analysis," *Afterimage* 8 (Jan. 1981), 8–9. For a survey of recent legal decisions pertinent to photography, see George Chernoff and Hershel Sarbin, *Photography and the Law* (New York, 1977).

[4] Eder, 36–45. Also, Helmut and Alison Gernsheim, *The History of Photography, 1685–1914* (New York, 1969), 17–29. A valuable discussion of the camera obscura in seventeenth-century Dutch painting can be found in Svetlana Alpers, *The Art of Describing: Dutch Art in the Seventeenth Century* (Chicago, 1983), 27–33 *passim*. For a discussion of the role of the camera obscura and the lens in the development of perspectival drawing, see Joel Snyder, "Picturing Vision," *Critical Inquiry* 6 (Spring 1980), 499–526.

[5] Hubert Damisch, "Five Notes for a Phenomenology of the Photographic Image," in Alan Trachtenberg, ed., *Classic Essays in Photography* (New Haven, Conn., 1980), 287–390. For additional views on the conventionality of the photographic image, see E. H. Gombrich, "Mirror and Map: Theories of Pictorial Representation," in *Philosophical Transactions of the Royal Society of London* 270 (1975), 119–149; Peter Galassi, *Before Photography: Painting and the Invention of Photography* (New York, 1981); Heinrich Schwarz, "Forerunners and Influences," in William E. Parker, ed., *Art and Photography: Forerunners and Influences* (Rochester, N.Y., 1985), 109–18; and Joel Snyder, "Picturing Vision."

[6] Gernsheim, *History*, 95.

[7] Charles Baudelaire, "The Modern Public and Photography," in Trachtenberg, ed., *Classic Essays*, 83–89.

[8] Roland Barthes, "Rhetoric of the Image," *Image, Music, Text* (New York, 1977), 32–52.

[9] Quoted in Roger Stein, "Charles Willson Peale's Expressive Design: The Artist in His Museum," *Prospects: The Annual of American Cultural Studies* 6 (1981), 142. I am indebted

in many particulars to Professor Stein's invaluable detailed discussion of the painting. See also Charles Coleman Sellers, *Mr. Peale's Museum: Charles Willson Peale and the First Popular Museum of Natural Science and Art* (New York, 1980); and Edgar P. Richardson, Brooke Hindle, and Lillian B. Miller, *Charles Willson Peale and His World* (New York, 1982). Also relevant are Daniel Boorstin, *The Lost World of Thomas Jefferson* (New York, 1948), and Henry F. May, *The Enlightenment in America* (New York, 1976).

[10] Stein, 156.

[11] See Charles Coleman Sellers, "Portraits and Miniatures by Charles Willson Peale," *Transactions of the American Philosophical Society* 42, Part 1 (1952), 161.

[12] Stein, 155.

[13] I owe my understanding of this distinction to Alpers, *Art of Describing*, 26–71.

[14] Quoted in Sellers, 161.

[15] Allan Nevins, ed., *The Diary of Philip Hone, 1828–1851* (New York, 1927), 435; McClees, *Elements*, 5.

[16] *Corsair*, 13 April 1839, 70–72. A week later, on 20 April 1839, in a letter from Paris, the New York *Observer* published Samuel F. B. Morse's eyewitness account of Daguerre's invention.

[17] *Photographic Times* 15 (Sept. 11, 1885), 521.

[18] Jean Baudrillard, *Simulations* (New York, 1983), 153.

[19] Nathaniel Hawthorne, *The House of the Seven Gables* (Norton Critical Edition, New York, 1967; originally published 1851), 88.

[20] Hawthorne's "Monsieur du Miroir" conveys the mingled fascination and revulsion common in feelings about mirrors, whose "whole business is REFLECTION." *Mosses from an Old Manse* (Boston, 1892), 182–95. On mirrors in art, see Gombrich, "Mirror and Map"; Carol Armstrong, "Reflections on the Mirror: Painting, Photography, and the Self-Portraits of Edgar Degas," in *Representations* 22 (Spring 1988), 108–41; and Douglas Crimp, "Photography en abyme," *October* 5 (Summer 1978), 73–88.

[21] *American Journal of Photography* (1858–59), 223.

[22] Quoted in William Welling, *Photography in America: The Formative Years, 1839–1900, A Documentary History* (New York, 1978), 7.

[23] Edgar Allan Poe, "The Daguerreotype," *Alexander's Weekly Messenger* (Jan. 15, 1840), 2. A rich discussion of the cultural sociology of Poe's obsession with mirrors (of which his daguerreotype remarks are an instance) can be found in Robert H. Byer, *The Man of the Crowd: Edgar Allan Poe in His Culture* (forthcoming). The gist of his argument appears in "Mysteries of the City: A Reading of Poe's 'The Man of the Crowd,' " in Sacvan Bercovitch and Myra Jehlen, eds., *Ideology and Classic American Literature* (New York, 1986).

[24] Oliver Wendell Holmes, "The Stereoscope and the Stereograph," *Atlantic Monthly* 3 (June 1859), 748.

[25] Gernsheim, *History*, 257; and Eder, *History*, 381–85. See also Edward W. Earle, ed., *Points of View: The Stereograph in America, A Cultural History* (Rochester, N.Y., 1979); and William C. Darrah, *The World of the Stereograph* (Gettysburg, Pa., 1977).

[26] Sir David Brewster, *The Stereoscope: Its History, Theory, and Construction* (London, 1856), 2–3.

[27] Gernsheim, 255.

[28] Holmes, 744.

[29] "Sun-Painting and Sun-Sculpture," *Atlantic Monthly* 8 (July 1861), 14–15.

[30] Harvey Green, " 'Pasteboard Masks': The Stereograph in American Culture 1865–1910," in Earle, ed., 109–15; and Allan Sekula, "Traffic in Photographs," *Art Journal* 41 (Spring 1981), 21–23.

[31] I am grateful to Matthew Isenberg for calling this to my attention.

[32] Holmes, "The Stereoscope and the Stereograph," 747.

[33] Ibid., 748.

[34] *The New York Times*, 2 March 1988, A:12.

Chapter 1

[1] Welling, *Photography in America*, 7–15. Exhaustive information about the establishment of the daguerreotype in America can be found in Floyd and Marion Rinhart, *The American Daguerreotype* (Athens, Ga., 1981). See also the pioneering works by Robert Taft, *Photography and the American Scene* (New York, 1938), and Beaumont Newhall, *The Daguerreotype in America* (New York, 1961). Richard Rudisill, *Mirror Image: The Influence of the Daguerreotype on American Society* (Albuquerque, N.M., 1971), the first attempt to interpret the daguerreotype as a cultural force in America, remains an important touchstone. The best treatment of the daguerreotype portrait of eminent sitters is Harold Francis Pfister, *Facing the Light: Historic American Portrait Daguerreotypes* (Washington, D.C., 1978). Other published sources for the history of the daguerreotype in America can be found in the bibliographies of these works.

[2] On the 1837 depression, see Peter Temin, *The Jacksonian Economy* (New York, 1969); and Samuel Rezneck, "The Social History of an American Depression, 1837–1843," *American Historical Review* 40 (1934–35), 662–87.

[3] Welling, 41.

[4] Albert S. Southworth, "An Address to the National Photographic Association of the United States, Delivered at Cleveland, Ohio, June, 1870," *The Philadelphia Photographer* 8 (Oct. 1871), 320.

[5] Contrary to common belief, the practice of daguerreotypy never died out. See Grant B. Romer, "The Daguerreotype in America and England after 1860," *History of Photography* 1 (July 1977), 201–12.

[6] On itinerant painters and daguerreotypists, and the rapport between them, see David Jaffe, "One of the Primitive Sort: Portrait Makers of the Rural North, 1760–1860," in Steven Hahn and Jonathan Prude, eds., *The Countryside in an Age of Capitalist Transformation* (Chapel Hill, N.C., 1986), 103–38; and Grant B. Romer, "Letters from an Itinerant Daguerreotypist of Western New York," *Image* 27 (March 1984), 12–19, and "Noah North—Folk Artist" (forthcoming). Also, Diane E. Forsberg, *A Useful Trade: 19th Century Itinerant Portrait Artists* (Brattleboro, Vt., 1984). Also Newhall, *Daguerreotype*, chaps. 7–8.

[7] Hawthorne, *Seven Gables*, 91.

[8] T. S. Arthur, "The Daguerreotypist," *Godey's Book* 38 (May 1849), 352–55.

[9] Sigmund Freud, *On Creativity and the Unconscious* (New York, 1958), 148.

[10] Ibid., 147.

[11] See Sir James George Frazier, *The Golden Bough*, abridged ed. (New York, 1951), 220–25.

[12] Welling, *Photography*, 17.

[13] Reprinted in *Photographic Art-Journal* 1 (April 1851), 212.

[14] See, for example, Wendy Wick Reaves, "Portraits for Every Parlor: Albert Newsam and American Portrait Lithography," in Wendy Wick Reaves, ed., *American Portrait Prints* (Charlottesville, Va., 1984), 83–134.

[15] See Reese Jenkins, *Images and Enterprise: Technology and the American Photographic Industry, 1839–1925* (Baltimore, Md., 1975); Nathan Rosenberg, ed., *The American System of Manufactures* (Edinburgh, 1969); and David A. Hounsell, *From the American System to Mass Production 1800–1932* (Baltimore, Md., 1984).

[16] See Welling, *Photography*, 17–18, for John Johnson's account of secret experiments he undertook with Alexander S. Wolcott in 1840 to increase available light while protecting the eyes of the sitter, to prevent a glaring look in the portrait.

[17] Taft, *Photography*, 8; also Patrick J. Noon, "Miniatures on the Market," in John Murdoch et al., *The English Miniature* (New Haven, Conn., 1981), 206.

[18] On the influence of the daguerreotype on the painted miniature portrait, see Marcus Aurelius Root, *The Camera and the Pencil, or, The Heliographic Art* (Philadelphia, Pa., 1864), 140–41. On the daguerrean adaptation of miniature cases, see Rinhart, *American Daguerreotype*, 305–49.

[19] New York *Tribune*, April 10, 1854. Between the late 1840s and the mid-1850s, the number of commercial daguerreotypists rose sharply—938 listed in the 1850 census, 3,154 in 1860. With the market expanding rapidly—two million daguerreotypes produced annually by 1853, and three million by 1860—competition intensified not only among the established deguerreotypists but between "quality" and "cheap" studios. Surveying "the extent, in a pecuniary point of view," of the business of "Daguerreotype likenesses" in New York in 1850, S. D. Humphrey noted in his *Daguerreian Journal* (founded in 1850) 71 establishments, with 127 operators, including "11 ladies and 46 boys," with the expenses of rent and wages close to $100,000 a year, plus the cost of materials. *Daguerreian Journal* 1 (15 Nov. 1850), 49–50. In 1856 the *United States Mercantile Gazette* reported that Americans paid $15 million a year for daguerreotype portraits. Rudisill, *Mirror Image*, 198. The established studios, which charged about $2.50 for a sixth-plate portrait, were genuinely alarmed by the prospect of losing their share of this revenue to their competitors, who offered daguerreotypes for twenty-five cents! "We may almost look in vain to see our art elevated to its deservedly high eminence, until the public shall be enabled to discriminate between a fifty cent and a three dollar Daguerreotype," noted Humphrey. The profession should keep "pictures up to such prices as will demand respect." For an account of efforts starting in 1851 to form a "fraternal organization" of professional daguerreotypists to maintain standards of taste and prices, see Welling, *Photography*, 84–85. See also Jennifer Todd, "The Rigors of Business: Mathew Brady's Photography in Political Perspective," *Afterimage* (Nov. 1979), 8–12.

[20] Quoted in *The Classical Spirit in American Portraiture* (Providence, R.I., 1976), 84.

[21] W. S. Haley, *The Daguerreotype Operator* (New York, 1854), 45.

[22] *Photographic Art-Journal* 1 (April 1851), 215.

[23] Southworth, "Address," 321–22.

[24] Rembrandt Peale, "Portraiture," *The Crayon* 4 (1857), 44–45.

[25] Karen Halttunen, *Confidence Men and Painted Women: A Study of Middle-class Culture in America, 1830–1870* (New Haven, Conn., 1982), especially chap. 2, "Hypocrisy and Sincerity in the World of Strangers," 33–55. See also, on "the sentimental revolution" in the 1830s and 1840s, William R. Taylor, *Cavalier & Yankee: The Old South and American National Character* (New York, 1963).

[26] Quoted in Ibid., 47.

[27] *Daguerreian Journal* 2 (Nov. 1851), 374.

[28] Root, *Camera and Pencil*, 43–44, enforces the point by quoting a story told by the editor of a photographic journal about "the late Daniel Webster." "Mr. Webster was visiting a friend, and while waiting in the parlor, his thoughts became abstracted, and perhaps not of the most pleasant kind, for a little girl, running into the room, shrieked violently on catching sight of him, and it was with the utmost difficulty her nervous excitement could be calmed. By this time, the expression of Mr. W's face had changed, and the moment the girl looked at him again she rushed into his arms and caressed him, as if he had been her father."

[29] Marmaduke Sampson, *Rationale of Crime, and Its Appropriate Treatment*, Eliza Farnham, ed. (New York, 1846).

[30] "The Rogues' Gallery," *American Journal of Photography* 9 (1859), 75–77.

[31] Southworth, "Address," 318–19.

[32] Edward Waldo Emerson and Waldo Emerson Forbes, eds., *Journals of Ralph Waldo Emerson, 1841–1844* (Boston, Mass., 1911), 110–11.

[33] See Jenkins, *Images*, 10–35.

[34] E. Anthony, *A Comprehensive and Systematic Catalogue of Photographic Apparatus and Material* (New York, 1854), viii.

[35] Root, *Camera and Pencil*, 26–27.

[36] For example, Frederick Hunter, *The Daguerreotype; or Love at First Sight* (Boston, Mass., 1849), in which the hero falls in love with a daguerreotype which turns out to be that of the wife of a college classmate. Another example is A. Mortimer Cleveland, "The

Daguerreotype," *Ballou's Pictorial Drawing-Room Companion* 15 (17 July 1858), 38–39, in which Fred is smitten by an image of the mysterious Alice, who turns out years later to be Annie, sister of his good friend, whom he then marries. There are many other instances of the daguerreotype as a sentimental and erotic symbol in popular writing. I am indebted to an excellent unpublished study by Susan Williams, "Exploring the Shoe Box: Images of the Daguerreotype in American Popular Fiction."

[37] Augustine Joseph Hockney Duganne, *The Daguerreotype Miniature; or, Life in the Empire City* (Philadelphia, Pa., 1846). Labor reformer as well as novelist and poet (sheet music of his songs was illustrated by lithographs after daguerreotypes by Plumbe), Duganne was a friend of the popular city novelist and radical George Lippard. His connection with Plumbe indicates the enthusiastic interest in the daguerreotype among city writers and artists. I thank David S. Reynolds for sharing information about Duganne.

[38] "The Magnetic Daguerreotypes," *The Photographic Art-Journal* 2 (June 1852), 353–59.

[39] *Lyttle's Living Age* 9 (June 1846), 551; reprinted from *The Christian Watchman*, June 1846. Arthur, ibid.

[40] Sources for Brady's life are not always reliable. I have drawn on James D. Horan, *Mathew Brady: Historian with a Camera* (New York, 1955); Dorothy Meserve Kunhardt and Philip B. Kunhardt, *Mathew Brady and His World* (Alexandria, Va., 1977); Roy Meredith, *Mathew B. Brady: Mr. Lincoln's Camera Man* (New York, 1974); Josephine Cobb, "Mathew B. Brady's Photographic Gallery in Washington," *Records of the Columbia Historical Society* 53–56 (1953–56), 28–69; Robert Taft, "M. B. Brady and the Daguerreotype Era," *American Photography* 29 (1935), 486–98, 548–60. In addition, an unpublished 1954 essay by Paul Vanderbilt (Paul Vanderbilt Papers, Archives of American Art), on the Library of Congress collection of more than three hundred daguerreotype portraits made by the Brady studio, contains valuable information. I am grateful to William F. Stapp for his generous advice and information.

[41] George A. Townsend, "Brady, the Grand Old Man of American Photography," New York *World*, April 12, 1891, 26.

[42] For information about Edward Anthony, see Jenkins, *Images and Enterprise*, 10–35. By 1846 John Plumbe, who began as an itinerant in 1840, had established an astonishing chain of branches in some eleven cities, including Paris, London, and Liverpool. He advertised "Free Exhibition" at the "Plumbe National Daguerrean Gallery and Photographic Depots." In the same year this redoubtable entrepreneur issued from Philadelphia a prospectus "for a new and magnificent pictorial work entitled the National Plumbeotype Gallery"—"a daily Portrait of some interesting public character," in the form of a lithographic copy printed "on fine quarto paper, constituting an appropriate ornament to the centre table, etc., etc." Anticipating Brady's project of making and collecting such images, Plumbe described the forthcoming daily sheets as comprising portraits of "Presidents of the United States, Vice Presidents, Heads of Departments, Members of Congress, Statesmen, Judges, Lawyers, Divines, Officers of the Army, Authors, Editors, Physicians, Poets, Artists, Musicians, Distinguished Strangers, etc., etc." Plumbe managed to issue about a month's worth of daily portraits in 1847 before his precipitous fall into bankruptcy, his retreat to Dubuque, a fling in the California gold fields—and suicide in 1857. He left behind a few daguerreotypes (the best-known are a handful of splendid architectural views of Washington) and a few tantalizing traces of a fascinating, abortive career. See Alan Fern and Milton Kaplan, "John Plumbe, Jr. and the First Architectural Photographs of the Nation's Capital," *Quarterly Journal of the Library of Congress* 31 (Jan. 1974), 3–20.

[43] Alexis de Tocqueville, *Democracy in America*, 2 vols. (New York, 1945), 2:106.

[44] See especially Allan Stanley Horlick, *Country Boys and Merchant Princes: The Social Control of Young Men in New York* (Lewisburg, Pa., 1975). Carroll Smith-Rosenberg gives a vivid account of the new way of life encountered by country boys who became, like Brady at the Stewart department store, clerks in New York: "The demographic profile

of this new generation of clerks changed as radically as the positions they filled. Country boys, new to commerce, new to cities, they brought few skills. It was feared they felt few loyalties. No longer regular members of merchants' households, they found lodgings in the cities' hotels and boardinghouses. They ate in restaurants, drank in saloons, sought sex in irregular alliances. They floated outside conventional social institutions and morality. Transient, marginal, replaceable, they constituted a novel phenomenon in a changing economy. They were at one and the same time frightened and frightening figures." *Disorderly Conduct: Visions of Gender in Victorian America* (New York, 1985), 81. See also Edward Pessen, "The Egalitarian Myth and the American Social Reality: Wealth, Mobility, and Equality in the 'Era of the Common Man,' " *American Historical Review* 76 (Oct. 1971), 989–1034.

[45] C. Edwards Lester, "M. B. Brady and the Photographic Art," *The Photographic Art-Journal* 1 (Jan. 1851), 36.

[46] Taft, *Photography*, 488. On Page, see Joshua C. Taylor, *William Page: The American Titian* (Chicago, 1957).

[47] Joshua Reynolds, *Discourse on Art* (New York, 1965; originally published 1797), 53. For discussion of controversies in eighteenth-century England over portraiture, see Edgar Wind, *Hume and the Heroic Portrait: Studies in Eighteenth Century Imagery* (Oxford, 1986). Robin Simon, in *The Portrait in Britain and America* (Boston, 1987), 49, points out that many painters, Morse among them, expected photography to free portrait painting from its primary function, thought to be demeaning to artists, of recording likeness. See Neil Harris, *The Artist in American Society: The Formative Years, 1790–1860* (New York, 1966), especially "The Burden of Portraiture," 56–88 *passim*, regarding the struggle of artists for legitimacy in the antebellum era.

[48] Oliver W. Larkin, *Samuel F. B. Morse and American Democratic Art* (Boston, Mass., 1954), 32. See also Paul J. Staiti, "Ideology and Politics in Samuel F. B. Morse's Agenda for a National Art," in *Samuel F. B. Morse: Educator and Champion of the Arts in America* (New York, 1982), 7–53.

[49] Quoted in Taylor, 225–26. See Simon, 132–33, on uses of the camera obscura by portrait painters.

[50] Quoted in Newhall, *Daguerreotype*, 83. The original letter is among the Samuel F. B. Morse papers at the Library of Congress.

[51] *Photographic Art-Journal* 1 (1851), 136.

[52] Lester, "Brady," 37.

[53] *American Phrenological Journal*, May 1858, 66.

[54] Lester, 37–38.

[55] *The New York Times*, 6 Oct. 1860.

[56] *Harper's Weekly*, Nov. 14, 1863.

[57] See Neil Harris, *Humbug: The Art of P. T. Barnum* (Boston, Mass., 1973), especially chap. 3, "The Operational Aesthetic," 59–89.

[58] *Humphrey's Journal* 5 (1853), 1.

[59] E. K. Hough, "Expressing Character in Photographic Pictures," *American Journal of Photography* 1 (15 Dec. 1858), 212–13.

[60] Root, *Camera and Pencil*, 48.

[61] "Brady's New Photographic Gallery," *Frank Leslie's Illustrated Newspaper*, 5 Jan. 1861, 106.

[62] "A Broadway Valhalla; Opening of Brady's New Gallery," *The New York Times*, 6 Oct. 1860; *Harper's Weekly*, 14 Nov. 1863.

[63] *Photographic Art-Journal* 1 (Jan. 1851), 63.

[64] *Gallery of Illustrious Americans* (New York, 1851). The title continues: "Containing the Portraits and Biographical Sketches of Twenty-Four of the Most Eminent Citizens of the Republic since the Death of Washington." "Twenty-Four" represents the original plan; sales did not warrant going on after the first year. 1851 is the date of the bound volume of the twelve prints issued monthly in 1850. Each print was accompanied by *Fly Leaf of*

Art and Criticism, "A Semi-Monthly Journal, C. Edwards Lester, Editor," with reviews of the previous month's portrait culled from the national press, articles and poems, and advertisements; it was numbered serially.

[65] The most important predecessor of Brady's *Gallery* was the National Portrait Gallery of lithographs published from 1833 to 1839 by James Barton Longacre and James Herring. See Gordon M. Marshall, "The Golden Age of Illustrated Biography: Three Case Studies," in Reaves, ed., 29–82. Also, Robert G. Stewart, *A Nineteenth-Century Gallery of Distinguished Americans* (Washington, D.C., 1969).

[66] See William F. Stapp, "Daguerreotypes onto Stone: The Life and Works of Francis D'Avignon," in Reaves, ed., 194–231.

[67] See Estelle Jussim, *Visual Communications and the Graphic Arts: Photographic Technologies in the Nineteenth Century* (New York, 1983). Also, Neil Harris, "Iconography and Intellectual History: The Half-Tone Effect," in John Higham and Paul A. Conkin, eds., *New Directions in American Intellectual History* (Baltimore, Md., 1979), 196–211.

[68] Walter Benjamin, "The Work of Art in the Age of Mechanical Reproduction," in Hannah Ahrendt, ed., *Illuminations: Essays and Reflections* (New York, 1968), 219–53.

[69] Quoted in Jaffe, "Portrait Makers," 123. For an acute discussion of political uses in these years of family imagery, particularly of "fathers," see George B. Forgie, *Patricide in the House Divided: A Psychological Interpretation of Lincoln and His Age* (New York, 1979), 4–5 *passim*.

[70] Taylor, 97. On Washington and his image as a symbol, see Daniel Boorstin, *The Americans: The National Experience* (New York, 1965), Part VII, "Search for Symbols," 325–90; Barry Schwartz, *George Washington: The Making of an American Symbol* (New York, 1987), especially Part II; and Michael Gilmore, "Eulogy as Symbolic Biography," in *Studies in Biography*, Harvard English Studies 8 (Cambridge, Mass., 1978), 131–57; and Forgie, 22 ff. Forgie, 121, quotes Emerson, who "hung a portrait of Washington in dining room" in 1852: "I cannot keep my eyes off it."

[71] Compare Forgie, 53: "Yet for the fathers to die literally was in a way hardly to die at all. If anything, their departure only served to lengthen their lives." Lester, *Fly Leaf* 4:25, writes about the death of Calhoun in 1850 as if it justified the *Gallery*: "An illustration was thus afforded, by that painful event, of the value of these portraits, and when, one by one, the illustrious men, whose names here appear, are taken from their scenes of eminence, and of glory, for their final reward, these memorials of them will become fragrant with the sanctity which belongs to the names of the departed."

[72] Roland Barthes, *Camera Lucida: Reflections on Photography* (New York, 1981), 97.

[73] On the roles of Webster, Clay, and Calhoun in the crisis of 1850, see Merrill D. Peterson, *The Great Triumvirate: Webster, Clay, and Calhoun* (New York, 1987), 415–93.

[74] Peabody staff member Elinor Reichlin, who discovered the daguerreotypes, discusses them in "Faces of Slavery," *American Heritage* 28 (1977), 4–5. The Zealy images are discussed in the context of Western anthropological views of native peoples in general, in Melissa Banta and Curtis M. Hinsley, *From Site to Sight: Anthropology, Photography, and the Power of Imagery* (Cambridge, Mass., 1986), 57–58. Zealy was apparently well known in New York. In 1852 Henry Snelling published a six-stanza poem by "M.M." dated August 18, 1851, titled "To Mr. Zealy, the Distinguished Artist, in Return for the Present of my Husband's Daguerreotype": "My husband's picture to the life, / O bless the art to which I owe it," etc. Snelling comments: "Our friend, Zealy, of Columbia, S.C., is peculiarly favored of the Muses." *Photographic Art-Journal* 3 (April 1852), 257. Further information about Zealy can be found in Rinhart, *American Daguerreotype*, 416. For Agassiz, see Edward Lurie, *Louis Agassiz: A Life in Science* (Chicago, 1960).

[75] Reichlin, 5.

[76] Ibid., 4. The "separate creation" doctrine had been propounded in an influential work by Samuel George Morton, *Crania Americana, or, a Comparative View of the Skulls of the Various Aboriginal Nations of North and South America* (Philadelphia, Pa., 1839). Agassiz admired Morton and in 1853 contributed "Natural Provinces of the Animal World and

Their Relation to the Different Types of Man" to a volume in his honor. In the essay he says: "I am prepared to show that the differences existing between the races of men are of the same kind as the differences observed between different families, genera, and species of monkeys or other animals; and that these different species of animals differ in the same degree one from the other as the races of men." Agassiz, who would become America's leading antagonist to Darwin, believed these differences were fixed for all time, "instinctively directed by the All-wise and Omnipotent, to fulfill the great harmonies in Nature." J. C. Nott and George R. Glidden, *Types of Mankind*, 2nd ed. (Philadelphia, Pa., 1855), lxxiv–lxxvi.

[77] Sheldon Nodelman, "How to Read a Roman Portrait," *Art in America*, Jan.–Feb. 1975, 31–33.

[78] Ibid., 33.

[79] See Madeleine B. Stern, "Mathew B. Brady and the Rationale of Crime: A Discovery in Daguerreotypes," *The Quarterly Journal of the Library of Congress* 31 (July 1974), 127–35.

[80] Michel Foucault, *Discipline and Punish* (New York, 1977), 200.

[81] Stephen Jay Gould, *The Mismeasure of Man* (New York, 1981), 46–47.

[82] Farnam, ed., *Rationale of Crime*, xvii.

[83] Ibid., 17. Compare Holmes almost twenty years later ("Doings of the Sunbeam," 11): "Go through a 'rogues' gallery' and observe what the faces of the most hardened criminals have in common."

[84] *Philadelphia Photographer*, 1864, 117–18.

[85] Root, *Camera and Pencil*, 44.

[86] Horace Traubel, *With Walt Whitman in Camden*, 6 vols. (New York, 1914), 3:552–53.

[87] "Scenes and Sights of Broadway—Thursday Feb. 19," Brooklyn *Evening Star*, 20 Feb. 1846, 2:4. The article is signed "O.P.Q.," a pseudonym Whitman often used in the *Star*. I am indebted to Ruth Bohan for sharing this with me.

[88] Walt Whitman, *The Gathering of the Forces*, Cleveland Rodgers and John Black, eds., 2 vols. (New York, 1920), 2:113–17.

[89] See Miles Orvell, *The Real Thing* (Chapel Hill: University of North Carolina Press, forthcoming), for an excellent discussion of Whitman's incorporation of the gallery experience in his poetry.

[90] Charles Eliot Norton, *A Leaf of Grass from Shady Hill, with a review of Walt Whitman's Leaves of Grass*, Kenneth B. Murdock, ed. (Cambridge, Mass., 1928). Originally in *Putnam's Monthly*, Sept. 1855. Like Henry James, who also derided the poet at first, Norton would come to praise Whitman. I have profited from an unpublished paper by Joel Porte, " 'Take Me as I am or Not at All': Whitman's Competent and Emblematic Likeness," and am grateful for his sharing this with me.

[91] *Gathering of Forces*, 116–17.

[92] Traubel, 2:77–78.

[93] " 'Leaves of Grass'—An Extraordinary Book," Brooklyn *Daily Eagle*, 15 Sept. 1855.

[94] Traubel, 2:506.

[95] Gabriel Harrison, "The Dignity of Our Art," *Photographic Art-Journal* 3 (April 1852), 231. See Grant B. Romer, on Gabriel Harrison: "The Poetic Daguerrean," *Image* 22 (Sept. 1979), 8–18.

[96] S. J. Burr, "Gabriel Harrison and the Daguerrean Art," *Photographic Art-Journal* 1 (March 1851), 169.

[97] See George Knox, *The Whitman–Hartmann Controversy* (Frankfurt, Germany, 1976), 115–22.

[98] Ed Folsom, ed., " 'This Heart's Geography's Map': The Photographs of Walt Whitman," *Walt Whitman Quarterly Review* 4 (Fall/Winter 1986–87), 3.

[99] Karl Mannheim, "The Problem of Ecstasy," *Essays on the Sociology of Culture* (London, 1956), 239–46.

[100] I thank William F. Stapp for calling this to my attention.

[101] Emory Holloway, ed., *Pictures: An Unpublished Poem* (New York, 1927).

Chapter 2

[1] *Humphrey's Journal* 12 (1861–62), 133. Quoted in Horan, *Brady*, 39.

[2] Horan, 39. See William A. Frassanito, *Antietam: The Photographic Legacy of America's Bloodiest Day* (New York, 1978), 29–32.

[3] Reprinted in *The Photographic Journal*, Dec. 15, 1862, 184. See *The Documentary Photograph as a Work of Art* (Chicago, 1976), especially Doug Munson, "The Practise of Wet-Plate Photography," 33–38, and Joel Snyder, "Photographers and Photographs of the Civil War," 17–22. On earlier war photography, see Gernsheim, *History*, 266–74.

[4] Paul Valéry, "The Centenary of Photography," in Trachtenberg, ed., *Classic Essays*, 191–98.

[5] Frassanito, 14–18, attributes these images to Alexander Gardner.

[6] Carl von Clausewitz, *On War*, ed. and tr. by Michael Howard and Peter Paret (Princeton, 1976), especially Books One and Two, "On the Nature of War" and "On the Theory of War."

[7] See Randolph Starn and Loren Partridge, "Representing War in the Renaissance: The Shield of Paolo Uccello," *Representations* 5 (Winter 1984), 33–65.

[8] James M. McPherson, in *Battle Cry of Freedom: The Civil War Era* (New York, 1988), 332–33, writes vividly about the "amateurism and confusion" of the early phases of the war, the "romantic, glamorous idea of war" which many Americans held, North and South, and the failure of leaders on both sides to "foresee the kind of conflict this war would become—a total war, requiring total mobilization of men and resources, destroying these men and resources on a massive scale, and ending only with unconditional surrender." As if with a momentum of its own, the war would expand toward the "absolute" dimension described by Clausewitz.

[9] Sidney Kaplan, ed., *Battle-Pieces* (Amherst, Mass., 1972).

[10] Nathaniel Hawthorne, "Chiefly about War Matters" [signed "By a Peacable Man"], in *Tales, Sketches, and Other Papers* (Boston, Mass., 1892), 336.

[11] Walt Whitman, *Specimen Days*, in *Leaves of Grass and Selected Prose*, John Kouwenhoven, ed. (Modern Library, New York, 1950), 635.

[12] Quoted in Kaplan, ed.; Norton, xxxvi–xxxix; Howells, xli–xliv.

[13] C. Edwards Lester, *Light and Dark of the Rebellion* (Philadelphia, Pa., 1863), 14.

[14] A. J. Russell, *Anthony's Photographic Bulletin* 13 (July 1882), 213.

[15] *War Memories* (Hartford, Conn., 1890), 19.

[16] Clarence C. Buel and Robert U. Johnson, eds., *Battles and Leaders of the Civil War* (New York, 1888). The illustrations for these volumes were wood engravings made from negatives in what was known as the Rand–Ordway collection. They had once belonged to Brady, then to the suppliers and publishers E. and H. T. Anthony, who had attached them in a judgment suit against Brady. For a lucid account of the tangled pathways by which collections of Civil War photographs came into private and government hands, and the distinctions among the collections, see Paul Vanderbilt, compiler, *Guide to the Special Collections of Prints & Photographs in the Library of Congress* (Washington, D.C., 1955), 19–24.

[17] For an excellent discussion of Crane's "revision" of the popular view of the war, see Amy Kaplan, "The Spectacle of War in Crane's Revision of History," in Lee Clark Mitchell, ed., *New Essays on "The Red Badge of Courage"* (New York, 1986), 77–108.

[18] Harold Frederic, *New York Times* Supplement, 16 Jan. 1896, 22. On Muybridge's experiments tracking the motion of horses, people, and other creatures, see Gernsheim, *History*, 435–37.

[19] Oscar Handlin, "The Civil War as Symbol and as Actuality," *Massachusetts Review* 3 (Autumn 1961), 135.

[20] Francis Trevelyn Miller, ed., *The Photographic History of the Civil War*, 10 vols. (New York, 1912), 1:16. For interesting details, including reminiscences, of Civil War photographers, see Henry Wysham Lanier, "Photographing the Civil War," 1:30–54. Compare the 1912 collection with William C. Davis, ed., *The Image of War 1861–1865*, 6 vols. (Garden City, N.Y., 1981–84). See Jan Zita Grover, "Philosophical Maneuvers in a Photogenic War," *Afterimage* 10 (April 1983), 4–6.

[21] Handlin, 143.

[22] Miller, ed., 1:30.

[23] Ibid., 1:60.

[24] Ibid., 1:15.

[25] *Frank Leslie's Pictorial History of the Civil War* 1 (New York, 1862). See Jan Zita Grover, "The First Living-Room War: The Civil War in the Illustrated Press," *Afterimage* 11 (Feb. 1844), 8–11.

[26] Lester, 271.

[27] See George M. Frederickson, *The Inner Civil War: Northern Intellectuals and the Crisis of the Union* (New York, 1965).

[28] The most meticulous research yet done on who took what photograph where is by Frassanito. In addition to *Antietam*, see his *Gettysburg: A Journey in Time* (New York, 1975), and *Grant and Lee: The Virginia Campaigns, 1864–1865* (New York, 1983).

[29] Meredith, *Brady*, 117.

[30] In May 1865, Brady filed for an injunction in a Washington, D.C., court, claiming that a P. J. Bellow "has published, sold, exposed for sale and otherwise disposed" of copies of a photograph made by Brady and protected by copyright. In June the court ruled for Brady. This is one of the earliest, perhaps the first, recorded litigations in America regarding the copyright of photographs. William Gladstone generously called this to my attention. Supreme Court of the District of Columbia, June 7, 1865, No. 444, Equity Document 7.

[31] Josephine Cobb, "Alexander Gardner," *Image* 7 (1958), 130. The copyright of photographs during the Civil War years was not a clear-cut matter. In 1867 Gardner admitted in a legal deposition that "Photograph by A. Gardner" may mean no more than that the image in question was copied in his studio, perhaps by an assistant. Cobb concludes (136) that "photographers in the 1860s did not consider the making of the negative in the same sense of authorship in which we hold it today."

[32] Frassanito, *Gettysburg*, 15, 59.

[33] A good survey of Civil War drawings can be found in William P. Campbell, *The Civil War: A Centennial Exhibition of Eyewitness Drawings* (Washington, D.C., 1961). Also, Herman Warner Williams, Jr., *The Civil War: The Artists' Record* (Boston, Mass., 1961).

[34] Taft, *Photography*, 223.

[35] *The Photographic Journal*, 15 Dec. 1864, 185.

[36] *The New York Times*, Oct. 20, 1862.

[37] *Brady's National Historical Collection* (New York, 1869), 4. This document contains Brady's petition to Congress for sale of his collection. Gardner submitted a similar petition the same year. See Cobb, "Gardner," 127. He stated that "during that period he photographed all the important scenes and incidents which in the aggregate compose the only history of the Rebellion in that form and are known as *Gardner's Photographic Incidents and Memories of the War for the Union.*" See *Catalogue of Photographic Incidents of the War, from the Gallery of Alexander Gardner* (Washington, D.C., 1863).

[38] *Catalogue of Card Photographs Published and Sold by E. & H. T. Anthony* (New York, 1862) lists 554 of "Brady's Photographic Views of the War," 13–16.

[39] Quoted in Ibid.

[40] Dolph Sternberger, *Panorama of the Nineteenth Century* (New York, 1977), 13.

[41] Holmes, "Stereoscope," 742.

[42] Ibid., 746, 748.

[43] Taft, *Photography*, 141 ff.

[44] "Doings of the Sunbeam," 11.

[45] "My Hunt after 'The Captain,' " *Atlantic Monthly*, Dec. 1862, 738–64.

[46] See Frederickson, *Inner Civil War*, 33–34.

[47] "Doings of the Sunbeam," 12.

[48] Ibid., 2.

[49] Both are available in Dover paperbacks: *Gardner's Photographic Sketch Book of the Civil War* (New York, 1959); Barnard's *Photographic Views of Sherman's Campaign* (New York, 1977).

[50] *Photographic and Fine Art Journal* 8 (May 1855), 158.

[51] Cobb, "Gardner," 127–36. The Whitman references appear in Traubel, *With Walt Whitman*, 3:234, 346.

[52] *Harper's Weekly*, 8 Dec. 1866.

[53] *Photographic History*, 1:149.

[54] See John S. Patterson, "A Patriotic Landscape: Gettysburg, 1863–1913," *Prospects* 1982, 315–33.

[55] In what follows, I am indebted to an excellent unpublished paper by Danna Blesser.

[56] Information about Russell's prewar career is from Susan Danly, "Andrew Joseph Russell's The Great West Illustrated," in Susan Danly and Leo Marx, eds., *The Railroad in American Art: Representations of Technological Change* (Cambridge, Mass., 1988), 93–94. For Russell's Civil War activities, see William Gladstone, "Captain Andrew J. Russell: First Army Photographer," *Photographica* 10 (Feb. 1978), 7–9; Joe Buberger and Matthew Isenberg, "Preface," *Russell's Civil War Photographs* (New York, 1982); Thomas Weston Fels, *Destruction and Destiny: The Photographs of A. J. Russell* (Pittsfield, Mass., 1987). I am much obliged to William Gladstone for his generosity in sharing with me his research on Russell and his wide knowledge and unfailing judgments on many issues related to Civil War photography.

[57] The full title is formidable: Herman Haupt, *Photographs Illustrative of Operations in Construction and Transportation as Used to Facilitate the Movements of the Armies of the Rappahannock, of Virginia, and of the Potomac, including Experiments Made to Determine the Most Practical and Expeditious Modes to be Resorted to in the Construction, Destruction and Reconstruction of Roads and Bridges* (Boston, Mass., 1863).

[58] See Richard D. Brown, *Modernization: The Transformation of American Life, 1600–1865* (New York, 1976), 159–86; Carl Degler, "The Two Cultures and the Civil War," in Stanley Coben and Lorman Ratner, eds., *The Development of an American Culture* (Englewood Cliffs, N.J., 1970), 92–119; George M. Frederickson, "Blue over Grey: Sources of Success and Failure in the Civil War," in Frederickson, ed., *A Nation Divided* (Minneapolis, Minn., 1975), 57–80.

[59] *Photographic History* treats the subject of "colored troops" under the heading "The Lighter Side," 9:173–84. On blacks in Civil War photographs, see William Gladstone, "The 29th Connecticut Colored Infantry," *Military Images*, May–June 1981, 16–27; Jackie C. Parker and William Gladstone, "James Monroe Trotter," *Negro History Bulletin* 45 (Dec. 1982), 95–96.

[60] A letter dated November 30, 1987, from Richard J. Sommers, archivist-historian, Department of the Army, to William Gladstone, confirms that the figures in the photograph (which was taken by John Reekie) are "a detail of Negro soldiers who in April, 1865, buried corpses left on the battlefield of Cold Harbor from the previous June." My thanks to William Gladstone for permission to cite this letter. Plate 46 also shows blacks in a crowd near a railroad line at the "Provost Marshal's Office, Aquia Creek, Va." Are they "contraband" (liberated slaves), workers, or troops? Gardner equivocates: among the applicants for passes to Washington he mentions officers, soldiers, and "negroes, anxious to get up to Washington to spend the generous wages (twenty-five dollars a month, besides rations and quarters) paid by the Quartermaster's Department." He concludes:

"As an instance of the variety of character, the writer has seen upon that dock, not only specimens of almost every European race [sic], Africans and Indians, but Chinamen, dressed in army blue, and to all appearances good soldiers."

[61] Melville, *Battle-Pieces*, 103. Page numbers in text refer to this edition.

[62] See Michael Rogin, *Subversive Genealogy: The Politics and Art of Herman Melville* (New York, 1983), 259–87.

[63] Eric Foner, *Politics and Ideology in the Age of the Civil War* (New York, 1980), 16–32. See also Leonard P. Curry, *Blueprint for Modern America: Nonmilitary Legislation of the First Civil War Congress* (Nashville, Tenn., 1968). For a study of antebellum values of "character" as Northern ideology, and the extent to which soldiers' views of themselves on both sides reflected the way of life they thought they were defending, see Michael Barton, *Goodmen: The Character of Civil War Soldiers* (University Park, Pa., 1981).

[64] *Specimen Days*, 579.

[65] Ibid., 583.

[66] Ibid., 588.

[67] See Stanley B. Burns, *Early Medical Photography in America (1839–1883)* (New York, 1983), Part 6, "Civil War Medical Photography," 1444–69; William Gladstone, "Medical Photography in the Civil War," *Photographica*, 8–9. Also, Alison Gernsheim, "Medical Photography in the Nineteenth Century," *Medical and Biological Illustration* 11 (1961), 85–92, 147–56.

Chapter 3

[1] I have consulted the copy in the Beinecke Library, Yale University. Other copies are at the New York Public Library and the Bancroft Library, University of California at Berkeley. See Francis P. Farquhar, "An Introduction to Clarence King's 'The Three Lakes,' " in *Sierra Club Bulletin* 24 (June 1939), 109–20 (including text). Also, Thurman Wilkins, *Clarence King* (New York, 1958), 120. While the photographs are not attributed in the book, most are unmistakably by O'Sullivan. One, however, is sometimes attributed to A. J. Russell—the picture of King mimicking a mountain climber, "Taking Breath" (No. 5 in the book). Russell had briefly joined the King party in the Uinta Mountains in August 1869, and another photograph which appears on a mount with his name is of the very same site. It is a scene showing the rigors of mountain photography: a group of men carrying equipment up a steep rock. One of the men is King; another is very likely O'Sullivan. King is dressed in the same attire as in "Taking Breath"—strong evidence that both pictures were made on the same occasion. The scene recorded in this picture suggests the kind of playfulness and improvisation evident in several of the *Three Lakes* photographs. See Weston Naef and James N. Wood, *Era of Exploration: The Rise of Landscape Photography in the American West, 1860–1885* (New York, 1975), 67, 204.

[2] Henry Adams, *The Education of Henry Adams* (Boston, Mass., 1918), 311–13. Adams here describes his meeting with King when he visited the 40th Parallel Survey in the field in 1871. They became and remained lifelong friends, John Hay filling out the threesome. See David H. Dickason, "Henry Adams and Clarence King: The Record of a Friendship," *New England Quarterly* 17 (1944), 229–54. *Clarence King Memories* (New York, 1904), published by the Century Club of New York to honor King after his death, includes tributes by John Hay, William Dean Howells, and Henry Adams.

[3] Clarence King, *Mountaineering in the Sierra Nevada* (Lincoln, Neb., 1970; original ed. Boston, Mass., 1872), 66, 70, 75.

[4] See William H. Goetzmann, *Exploration and Empire: The Explorer and the Scientist in the Winning of the American West* (New York, 1966), 430–66; and Richard A. Bartlett, *Great Surveys of the American West* (Norman, Okla., 1962), 123–215.

[5] A. A. Humphreys to Clarence King, 21 March 1867, Record Group 57, Geological Survey of the 40th Parallel, National Archives.

[6] Adams, *Education*, 312.

[7] Ibid., 309; Goetzmann, 437–38, 593–94; George M. Wheeler, *Address before the American Geographical Society* (Washington, D.C., 1874), 18.

[8] Henry Adams, "King's Fortieth Parallel Survey," *North American Review*, July 1871, 205; George P. Merrill, *The First Hundred Years of American Geology* (New Haven, Conn., 1924), 530.

[9] See George Stewart, *Names on the Land: A Historical Account of Place-Naming in the United States* (New York, 1945), 6–10, 333, 341, 353.

[10] From his camp in the Wasatch Mountains in July 1869, King transmitted to Humphreys a map of the United States "with errors marked in red ink." He suggests revising a number of names and retaining others. King to Humphreys, 15 July 1869, Record Group 57, Geological Survey of the 40th Parallel, National Archives.

[11] King, *Mountaineering*, 75.

[12] Ibid., 239.

[13] John Wesley Powell, *Report on the Methods of Surveying the Public Domain to the Secretary of the Interior* (Washington, D.C., 1878), 15. Powell's jeremiad tone suggests he may be projecting some of his own contempt—he was a leading advocate of public planning for industrial development of the West—for the Gilded Age spectacle of private property riding roughshod over American communal values. Yet Indians remain "savages," and Powell wanted only a more effective system of instilling European culture, respect for work and law, than the government's military and "reservation" policy implied: "Savagery is not inchoate civilization; it is a distinct status of society, with its own institutions, customs, philosophy, and religion; and all these must necessarily be overthrown before new institutions, customs, philosophy, and religion can be introduced. The failure to recognize this fact has wrought inconceivable mischief in our management of the Indians." See Francis P. Prucha, *American Indian Policy in Crisis: Christian Reformers and the Indians, 1865–1900* (Norman, Okla., 1976). Also relevant is Henry Nash Smith, "Clarence King, John Wesley Powell, and the Establishment of the United States Geological Survey," *Mississippi Valley Historical Review* 24 (June 1947), 37–58.

[14] See Alexander B. Adams, *The Disputed Lands* (New York, 1981).

[15] *Mountaineering*, 37–40.

[16] Ibid., 226–27.

[17] Ibid., 245.

[18] Josiah Dwight Whitney, *The Yosemite Book* (New York, 1868), 15–18. Whitney also wrote a brief treatise on place names: *Names and Places: Studies in Geographical and Topographical Nomenclature* (Cambridge, Mass., 1888).

[19] Naef and Wood, *Era of Exploration*, 12.

[20] See Leo Marx, "The Railroad-in-the-Landscape: An Iconological Reading of a Theme in American Art," in Danly and Marx, eds., 183–208, for a compelling discussion of ambivalence in mid-nineteenth-century American artists toward a natural terrain that seemed at once to represent pristine nature and to invite settlement, development, and inevitable pollution. A key word in the American response to social change, "landscape" needs to be understood as a historical construct rather than a generic term of fixed meaning. See Rosalind Krauss, "Photography's Discursive Spaces: Landscape/View," *Art Journal*, Winter 1982, 311–19.

[21] Thomas Moran and Albert Bierstadt especially. See Barbara Novak, *Nature and Culture: American Landscape and Painting 1825–1875* (New York, 1980).

[22] Rick Dingus, *The Photographic Artifacts of Timothy O'Sullivan* (Albuquerque, N.M., 1982), xiv.

[23] A view argued vigorously in Joel Snyder, *American Frontiers: The Photographs of Timothy H. O'Sullivan, 1867–1874* (Millerton, N.Y., 1981). See also Naef and Wood, *Era of Exploration*, 125–36; and Amy R. Weinstein Meyers, *Sketches from the Wilderness: Changing Conceptions of Nature in American Natural History Illustration, 1680–1880* (Yale University dissertation, 1985), 259–319.

[24] Quoted in Dingus, 51. As Robert Byer properly pointed out to me in correspondence,

Moran's views cannot be taken as typical of this period. Many cultivated Americans, including Clarence King, embraced the quite opposite view held by the English critic John Ruskin opposing picturesque rearrangement in landscape painting, maintaining that beauty lay in truthful or exact picturing of natural topography. See Ruskin on Claude Lorrain in *Modern Painters* I (1843).

[25] John Szarkowski, *The Photographer and the American Landscape* (New York, 1963), 3.

[26] "Photographs from the High Rockies," *Harper's New Monthly Magazine* 39 (Sept. 1869), 465. The article is indexed under John Samson—perhaps a pseudonym for O'Sullivan.

[27] Snyder, 7.

[28] Whitney, "Geographical and Geological Surveys," *The North American Review* 111 (July 1875), 48–49.

[29] F. V. Hayden, *Sun Pictures of Rocky Mountain Scenery* (New York, 1870), n.p.

[30] 43rd Congress, 1st Session, House of Representatives Report No. 612, *Geographical and Geological Surveys West of the Mississippi* (Washington, D.C., 1874), 35–36. In a private letter in 1879 Powell remarked about Hayden that he had his own fame too much in mind and had "frittered away splendid appropriations upon work which was intended purely for noise and show—in photographs," etc. Quoted in Smith, "King," 53n.

[31] Whitney, *Yosemite Book*, 12.

[32] Quoted in George M. Wheeler, *Progress-Report upon Geographical and Geological Explorations and Surveys West of the One Hundredth Meridian in 1872* (Washington, D.C., 1874), 11. Wheeler responds to doubts about the usefulness of photography in areas that require more exactitude than the "descriptive fields of geology and natural history—departments," he writes, "where, as is well understood, we are obliged to leave the field of exact [i.e., mathematical] science." In these fields the "good" of photographs lies in "that which is of general interest as expressive of the scenic features of specified areas." The "special value," he adds, "that comes from a geological series of photographs results in the determination of a relative comprehension of the size and contour of the rock-beds and of the general features of the topography of the country." He anticipates, however, that "by the application of skilled labor and the refinement of instruments"—improvements whereby "a value" may be given "to the horizontal and vertical measurements upon a photographic plate"—photographs will provide just the exactitude necessary. With "faith that this matter may be so far advanced from its present stage as to secure these features," he urges that "as soon as possible, a permanent photographic unit be attached," for such a unit "would annually increase these branches of the survey, and may be made of large practical value in the preparation of material for the publication of maps and illustrations" (11–12). Joel Snyder cites part of this passage in his effort to enlist survey scientists in support of his thesis that photographs have no inherently superior capacity to render accurate and "objective" views and are thus no different in kind from pictures made by other means—and misconstrues Wheeler to mean that "photographs are useful only in those areas of investigation that are not concerned with 'exact science.' " But, unmistakably, Wheeler means to defend the medium's capacity for exactitude precisely against arguments like Snyder's. Joel Snyder, "Aesthetics and Documentation: Remarks Concerning Critical Approaches to the Photographs of Timothy H. O'Sullivan," in Peter Walch and Thomas Barrow, eds., *Perspectives on Photography: Essays in Honor of Beaumont Newhall* (Albuquerque, N.M., 1986), 144–46.

[33] Excellent accounts and important interpretations of visualization in the earth sciences can be found in Martin J. S. Rudwick, "The Emergence of a Visual Language for Geological Science 1760–1840," *History of Science* 14 (1976), 149–95; and Roy Porter, "The Terraqueous Globe," in G. S. Rousseau and Roy Porter, eds., *The Ferment of Knowledge: Studies in the Historiography of Eighteenth-Century Science* (London, 1986), 285–324. See also Barbara Maria Stafford, *Art, Science, Nature, and the Illustrated Travel Account, 1760–1840* (Cambridge, Mass., 1984).

[34] *Harper's New Monthly Magazine*, 470.

[35] See "O'Sullivan Albumen Prints in Official Publications," compiled by Jonathan Heller, in Snyder, *American Frontiers*, 117.

[36] Clarence King, *Systematic Geology* (Washington, D.C., 1878), 2–4.

[37] Snyder, "Chronology," 114–15.

[38] *Harper's New Monthly Magazine*, 475.

[39] Ibid.

[40] George Dimock, *Exploiting the View: Photographs of Yosemite & Mariposa by Carleton Watkins* (North Bennington, Vt., 1984), 9–16. The fullest study of Watkins is Peter E. Palmquist, *Carleton E. Watkins: Photographer of the American West* (Albuquerque, N.M., 1983); see 9–10. For a valuable survey of San Francisco photographers, interpreted in light of urban history, see Rodger Birt, *Envisioning the City: Photography in the History of San Francisco, 1890–1906* (Yale dissertation, 1985).

[41] Kevin Starr, *Americans and the California Dream, 1850–1915* (New York, 1973), 183.

[42] Ibid., 12.

[43] Whitney, *Yosemite Book*, 57–58.

[44] Ibid., 63.

[45] See Earl Pomeroy, *In Search of the Golden West: The Tourist in Western America* (New York, 1957), especially on the railroad car and luxury hotels as aids to spectators, 3–30.

[46] King, *Mountaineering*, 149.

[47] Samuel Bowles, *Our New West* (Hartford, Conn., 1869), 374. See Dimock on how idealizations obscured the natural and economic effects of more rapacious uses of natural resources in Mariposa. Interestingly, Bowles traveled in the summer of 1868 in the company of A. J. Russell, who the following year briefly joined the King party and O'Sullivan in the Uinta Mountains. See Danly, 98; and Russell, "On the Mountains with Tripod and Camera," *Anthony's Photographic Bulletin*, Vol. 1 (1870), 33–34. It was on this occasion that Russell must have made (or participated in the making of) the picture discussed in note 1, and perhaps the picture of King "taking breath" in *Three Lakes*.

[48] King, *Mountaineering*, 133–34, 143.

[49] Ibid., 152.

[50] Ibid.

[51] Ibid., 184.

[52] Clarence King, "Catastrophism and Evolution," *American Naturalist* 11 (Aug. 1877), 339–470.

[53] King, "The Falls of Shoshone," *Overland Monthly* 5 (Oct. 1870), 381–85.

[54] Ibid., 196.

[55] Goetzmann, 437; Wilkins, *King*, 94–96.

[56] Wilkins, 95.

[57] James D. Hague, *Mining Industry* (Washington, D.C., 1870), n.p.

[58] See Rodman W. Paul, *Mining Frontiers of the Far West, 1848–1880* (Albuquerque, N.M., 1963), 56–86.

[59] Adams, "King's Fortieth Parallel Survey," 206.

[60] One motive was to encourage rationalization of the industry, of its system of ownership as well as its technical processes. James Hague says (100): "The subdivision of the workable portions of the lode among so many independent owners, has not only given rise to much expensive litigation, but has doubtless increased the cost of development, multiplying the expenses of administration, the outlays for machinery, and other requisite equipment of the mines, and in various ways involving expenditures that would be avoided under more comprehensive or consolidated management." In a similar vein, consistent with the reformist outlook developing among upper-class Eastern intellectuals, King remarked (457–58) that development of the "practically inexhaustible supply of coal" in the Green River Basin was hindered by a land-ownership policy confused by Mormon land claims of ambiguous legality on one hand and, on the other, by the habit of the Pacific Railroad Company, an "already overloaded monopoly," to claim whatever it desired of the public

domain. "Until a survey is made defining clearly the possessions of the Pacific Railroad Company, or else an act is passed by Congress declaring the whole belt open to pre-emptions, no thorough development can be applied to the coal system."

[61] Ibid., 160.

[62] Richard E. Lingenfelter, *The Hard-Rock Miners: A History of the Mining Labor Movement in the American West, 1863–1893* (Berkeley, Calif., 1974), 31–65.

[63] King, *Mining Industry*, 87.

[64] See Lingenfelter, 3–30; Mark Wyman, *Hard Rock Epic: Western Miners and the Industrial Revolution, 1860–1910* (Berkeley, Calif., 1979), especially chap. 4, "Betrayed by the New Technology," 84–117. Also Ronald C. Brown, *Hard-Rock Miners: The Intermountain West, 1860–1920* (College Station, Tex., 1979), especially Appendix B, "Accidents and Injuries Typical in Hard-Rock Mining," 173–76.

[65] Allan Sekula, "Photography Between Labor and Capital," in Benjamin H. D. Buchloh and Robert Wilkie, eds., *Mining Photographs and Other Pictures, 1948–1968* (Halifax, Nova Scotia, 1983), 230–31.

[66] Quoted in Lingenfelter, 13.

[67] O'Sullivan's mining pictures are not, however, the first made in the American West. Though only a handful remain, Carleton Watkins made photographs in the California gold fields and mining towns in the early 1860s; and even earlier, the San Francisco daguerreotypist Robert H. Vance assembled three hundred images, including some of gold mining, which were exhibited in New York in 1851. A contemporary description of Vance's pictures, long lost, mentions working miners along with topographical and city views of the gold-mining region. "Mr. Vance's California Views," *Photographic Art-Journal* 2 (Oct. 1851), 252–53. See also Palmquist, 8–11, Plates 19—20, and especially Martha A. Sandweiss's "Foreword," xii–xiii. I am indebted to Ms. Sandweiss for calling these details to my attention.

[68] Paul, *Mining Frontiers*, 72.

[69] *Mining Industry*, 2.

[70] See Henry Nash Smith, *Virgin Land: The American West as Symbol and Myth* (Cambridge, Mass., 1950), chap. 16, "The Garden and the Desert," 174–83.

[71] King, *Systematic Geology*, 12.

[72] Of Plate XXVI, King writes that "it gives a very correct idea of the general appearance of the larger Ragtown lake," when in fact the print conflates two photographs (Nos. 31–32) into a single image, in the process eliminating one of the standing figures (153). For geologists, a useful illustration in any medium might be both "correct" and "general." King and Emmons chose for lithographic reproduction in their volumes only a small number of these pictures, those which show particular objects with clarity, and none which show objects under direct observation.

[73] I am grateful for Joel Snyder's clarification, that the full body does not appear in the negative. See Snyder, 46.

[74] King, *Systematic Geology*, 528.

[75] Ibid., 2–3.

[76] Ibid., 6–9.

[77] Quoted in Wilkins, *King*, 44. See 44–45 for King's love of Ruskin and his participation, before leaving for California in April 1863, in the Society for the Advancement of Truth in Art, a group of aesthetic Ruskinites led by art critics Clarence Cook and Russell Sturgis. For more about the influence of Ruskin in these years, particularly among scientists, see Roger Stein, *John Ruskin and Aesthetic Thought in America, 1840–1900* (Cambridge, Mass., 1967). The place of aestheticism in the social thought and attitudes, especially during the Civil War, of Eastern upper-class intellectuals is touched upon in a number of studies— Frederickson's *Inner Civil War*, for example—and deserves a full-scale study.

[78] Gould, *Ever Since Darwin: Reflections in Natural History* (New York, 1977), 147–52; and *Time's Arrow, Time's Cycle: Myth and Metaphor on the Discovery of Geological Time* (Cambridge, Mass., 1987), especially 115–32. See also recent critiques of uniformitarianism in

Claude C. Albritton, Jr., et al., eds., *Uniformity and Simplicity: A Symposium of the Principle of the Uniformity of Nature* (New York, 1967).

[79] King, "Catastrophism and Evolution," 450–51.

[80] Ibid., 468–70.

[81] The congruence of vision in King and O'Sullivan is ably argued in Richard Wilson, *American Vision and Landscape: The Western Images of Clarence King and Timothy O'Sullivan* (University of New Mexico dissertation, 1979).

Chapter 4

[1] Horan, *Brady*, 87.

[2] Waldo Frank et al., eds., *America & Alfred Stieglitz: A Collective Portrait* (New York, 1934). For Stieglitz's life and career, see Sue Davidson Lowe, *Stieglitz: A Memoir/Biography* (New York, 1983).

[3] Elizabeth McCausland, "Stieglitz and the American Tradition," in Frank, 227–32. The evolution of the nineteenth-century distinction in America between fine and useful arts has not been studied closely, nor has the role of Kantian aesthetic theory in this distinction. See Neil Harris, *The Artist in American Society: The Formative Years, 1790–1860* (New York, 1966); and Joshua C. Taylor, *The Fine Arts in America* (Chicago, 1979).

[4] Cited in Dorothy Norman, *Alfred Stieglitz: An American Seer* (New York, 1973), 114–15.

[5] Quoted in ibid., 116.

[6] The first prominent publication of both Riis and Stieglitz occurred a decade apart in *Scribner's Magazine*: Jacob Riis, "How the Other Half Lives: Studies Among the Tenements," 6 (Dec. 1889), 643–62; Alfred Stieglitz, "Pictorial Photography," 26 (Nov. 1899), 528–37 (reprinted in Trachtenberg, ed., *Classic Essays*, 115–23). On Jacob Riis, see Alexander Alland, *Jacob A. Riis: Photographer and Citizen* (Millerton, N.Y., 1974); Maren Stange, *"Symbols of Ideal Life": Social Documentary Photography in America, 1890–1950* (New York, 1988); Peter B. Hales, *Silver Cities: The Photography of American Urbanization* (Philadelphia, Pa., 1984), 161–218; Ferenc M. Szasz, "The Camera and the American Social Conscience: The Documentary Photography of Jacob A. Riis," *New York History* 55 (1974), 409–36; Sally Stein, "Making Connections with the Camera: Photography and Mobility in the Career of Jacob Riis," *Afterimage* 10 (May 1983), 9–15. For other photographers working on city streets in these years—Alice E. Austen in New York, Sigmund Krausz in Chicago, and others—see Hales, 221–76.

[7] "Photography of Today. Discovery of Photography," undated, unsigned typescript, Alfred Stieglitz Collection, Beinecke Library, Yale University.

[8] See Roberty Doty, *Photo-Secession: Stieglitz and the Fine Art Movement in Photography* (Rochester, N.Y., 1960); and William Innis Homer, *Alfred Stieglitz and the American Avant-Garde* (Boston, Mass., 1977).

[9] Beaumont Newhall, *Photography: A Short Critical History* (New York, 1938), 63–64.

[10] Walker Evans, "Photography," in Louis Kronenberger, ed., *Quality: Its Image in the Arts* (New York, 1969), 206.

[11] "A Photographer's Story," *Lyttel's Living Age* 70 (14 Sept. 1861), 675.

[12] Peter Bunnell, ed., *A Photographic Vision: Pictorial Photography, 1889–1923* (Salt Lake City, Utah, 1980), "Introduction," 1.

[13] Ulrich F. Keller, "The Myth of Art Photography: A Sociological Analysis," and "The Myth of Art Photography: An Iconographic Analysis," *History of Photography* 8 (Oct.–Dec. 1984), 249–75, and 9 (Jan.–March 1985), 1–38.

[14] 16 Nov. 1920, Stieglitz Collection, Beinecke Library, Yale University.

[15] "127 Photographs by Alfred Stieglitz," An American Place, Feb. 15–March 5, 1932, Stieglitz Collection, Beinecke Library, Yale University.

[16] Ibid.

[17] "Pictorial Photography," in Trachtenberg, ed., *Classic Essays*, 122.

[18] See Wanda Corn, "The New New York," *Art in America*, July–Aug. 1973, 59–74.

[19] Keller, "Myth," 256.

[20] See F. C. Beach, "Modern Amateur Photography," *Harper's New Monthly Magazine* 128 (Dec. 1888–May 1889). Much has been written about amateur pictorialism, but little about the actual forms and activities of the amateur clubs and their place, as another response to changing conditions (growth of leisure time, changed notions of meaningful activity, transformations in family structure, etc.), in the extraordinary profusion at the turn of the century of middle-class clubs based on extra-vocational interests. On pictorialist clubs, see the following exhibition catalogues: Anthony Bannon, *The Photo-Pictorialists of Buffalo* (Buffalo, N.Y., 1981); William Innes Homer, *Pictorial Photography in Philadelphia: The Pennsylvania Academy's Salons, 1898–1901* (Philadelphia, 1984); Mary Panzer, *Philadelphia Naturalistic Photography, 1865–1906* (New Haven, Conn., 1982). See Reese V. Jenkins, "Technology and the Market: George Eastman and the Origins of Mass Amateur Photography," *Technology and Culture* 16 (Jan. 1975), 1–19.

[21] See Walter Benn Michaels, *The Gold Standard and the Logic of Naturalism* (Berkeley, Calif., 1987), 217–44, for a shrewd analysis of Stieglitz's argument for an intentional art of photography, and the paradoxical view of the machine this entailed.

[22] Trachtenberg, ed., *Classic Essays*, 119.

[23] Ibid., 122.

[24] "Simplicity in Composition," from Eastman Kodak Company, *The Modern Way of Picture Making* (Rochester, N.Y., 1905); reprinted in Bunnell, ed., *Photographic Vision*, 170–71.

[25] "The Hand Camera—Its Present Importance," *The American Annual of Photography and Photographic Times Almanac for 1907*; reprinted in Sarah Greenough, ed., *Alfred Stieglitz: Photographs & Writings* (Washington, D.C., 1983), 184.

[26] Allan Sekula, "On the Invention of Photographic Meaning," *Artforum* (Jan. 1975), 39. Also Alan Trachtenberg, "Camera Work: Notes toward an Investigation," *Massachusetts Review* 19 (Winter 1978), 834–58. On the arts and crafts movement, see Eileen Boris, *Art and Labor: Ruskin, Morris, and the Craftsman Ideal in America* (Philadelphia, Pa., 1986). Also valuable for understanding the American development is Peter Stansky, *Redesigning the World: William Morris, the 1880s, and the Arts and Crafts* (Princeton, N.J., 1985).

[27] *Journal of the Camera Club* (1896), n.p.

[28] Sadakichi Hartmann, "A Plea for the Picturesqueness of New York," *Camera Notes* 4 (July–April 1900–01), 97.

[29] *Picturesque Bits of New York and Other Studies* (New York, 1897). For an account of aesthetic views shared at the time by pictorial photographers and painters, see Wanda Corn, *The Color of Mood: American Tonalism 1880–1910* (San Francisco, Calif., 1972).

[30] "Alfred Stieglitz and His Latest Work," *Photographic Times* 28 (April 1896), 161.

[31] Between 1897 and 1896, *Scribner's* regularly published articles and fiction on the urban poor, including the original Jacob Riis illustrated article, and several discussions of New York tenement houses: "The Poor in Great Cities" (April 1892), "Life in New York Tenement Houses" (June 1892), "The New York Tenement-House Evil and Its Cure" (July 1894), "Salvation Army Work in the Slums" (Jan. 1895), "The New York Working Girl" (Oct. 1896). Toward the end of the decade, a new note appears in titles like "The Water Front of New York" (Oct. 1899), "The Walk Up-Town" (Jan. 1900), and "The Twentieth Century City" (March 1903), the latter two illustrated with photographs. Between 1897 and 1903, photography was linked to the scenic pleasures of the city in articles like "Night Photography" (1897), with illustrations by Stieglitz (who also provided the pictures in the March 1903 article); "Telephotography" (Nov. 1899); "New York at Night" (March 1900). Two other photographic articles are worth mentioning—Sidney Allen (Sadakichi Hartmann), "The Camera in a Country Lane" (June 1902), and Edward S. Curtis, "Vanishing Indian Types," (May 1906, June 1906). About this time the journal also took up the potential threat of the skyscraper to customary urban amenities. I am indebted to

Annette L. Benert, whose unpublished essay "Re-forming the City: The Function of Architecture in *Scribner's Magazine*, 1887–1914," provides valuable insight and data.

[32] John Corbin, "The Twentieth Century City," *Scribner's* 33 (March 1903), 259–71.

[33] Quoted in Norman, 39.

[34] Newhall to Lewis Hine, Feb. 1938. Copy, Elizabeth McCausland Papers, Archives of American Art. See Beaumont Newhall, "Lewis W. Hine," *Magazine of Art* 31 (Nov. 1938), 636–37.

[35] Hine was rediscovered once again twenty years later, first in Robert Doty, "The Interpretative Photography of Lewis W. Hine," *Image* 6 (May 1957), then by Judith Mara Gutman, *Lewis Hine and the American Social Conscience* (New York, 1967), and *America and Lewis Hine: Photographs 1904–1940*, Foreword by Walter Rosenblum, Biographical Notes by Naomi Rosenblum, Essay by Alan Trachtenberg (Millerton, N.Y., 1977).

[36] Beaumont Newhall, "Documentary Approach to Photography," *Parnassus* 10 (March 1938), 3–6. His *Photography: A Short Critical History*, published the same year, does not use the word "documentary" and does not mention Lewis Hine. The term "documentary" first came into prominence in regard to film. See the collection of writings by John Grierson, *Grierson on Documentary* (London, 1966), Forsyth Hardy, ed., especially "First Principles of Documentary," 145–56, particularly the brief critique of the Kantian aesthetic, 156.

[37] Undated typescript with heading *Art Digest*, "A Documentary Pioneer," Elizabeth McCausland Papers, Archives of American Art.

[38] Newhall, "Lewis W. Hine," 636–37.

[39] "Portrait of a Photographer," *Survey Graphic* 27 (Oct. 1938), 502.

[40] "Two Exhibitions of a 'Photographic Season'," *Springfield Sunday Union and Republican*, 8 Jan. 1939.

[41] Undated typescript with heading *Art News*, "Lewis W. Hine," Elizabeth McCausland Papers, Archives of American Art.

[42] Typescript, 5 Sept. 1935, "Lewis W. Hine, Social Photographer," Elizabeth McCausland Papers, Archives of American Art.

[43] John Dewey, "My Pedagogic Creed," *Selected Educational Writings* (London, 1966), 48.

[44] John Dewey, *Art as Experience* (New York, 1958), 3.

[45] Ibid., 46.

[46] Ibid., 78–79.

[47] Ibid., 3.

[48] Ibid., 51.

[49] Lewis Hine, "Photography in the School," *Photographic Times* 40 (Aug. 1908), 227–30; "The School Camera," *Elementary School Teacher* 6 (1906–7), 343–47.

[50] Lewis Hine, "The School in the Park," *The Outlook* 83 (1906), 719.

[51] *Elementary School Teacher* 6 (1906–7), 562.

[52] "The School Camera."

[53] Undated typescript, "Notes on early influences—L. W. Hine," Elizabeth McCausland Papers, Archives of American Art.

[54] For an explanation of the choice of "Survey," see "To Change the Name of Charities and the Commons," *Charities and the Commons* 21 (March 27, 1909), 1251–54.

[55] See Daile Kaplan, *Lewis Hine in Europe: The Lost Photographs* (New York, 1988), 32–33.

[56] "Field Work of the Pittsburgh Survey," *The Pittsburgh District* (New York, 1914), 492. See Clarke Chambers, *Paul U. Kellogg and the SURVEY* (Minneapolis, Minn., 1971); James Weinstein, *The Corporate Ideal in the Liberal State, 1900–1918* (Boston, Mass., 1968); and Trachtenberg, "Essay," in *America and Lewis Hine*, 118–37.

[57] Kellogg, 493.

[58] See Stange, "Symbols," for an excellent discussion of the concept and practice of publicity in the Pittsburgh Survey.

[59] Kellogg, 495.

[60] Edward T. Devine, "Pittsburgh the Year of the Survey," in *The Pittsburgh District*, 3–5.

[61] Kellogg, 493.

[62] Ibid.

[63] Kaplan, *Hine*, 34–36.

[64] Ibid., 44.

[65] *Catalogue of Social and Industrial Photographs*, Hine Photo Company, n.d. George Eastman House.

[66] In "Plans for Work," Oct. 1940—part of his application for a Guggenheim Fellowship a month before he died (he had made two earlier unsuccessful applications)—Hine proposed "a series of photo-studies dealing with the life of representative individuals of foreign extraction"; he would "follow" selected immigrants and record "their home-life, their work-life, community and recreational contacts and participation in fraternal, cooperative and trade union organizations." George Eastman House.

[67] Correspondence between Lewis Hine and H. M. Lydenberg, director, New York Public Library, Aug. 1938. Hine wrote a "General Statement" for the "immigration" section, which reads in part: "It was during the period of America's great industrial expansion that foreign laborers came to work in our steel mills, factories and mines. They came eagerly and hopefully to cut out new lives for themselves. The need for cheap unskilled labor was readily satisfied by the willing millions who came yearly, and it was their coming which made possible the rapid development of America . . . To the immigrant, America meant a chance to work and earn money; to live in freedom, to educate one's children and become part of a new humanity. For many, however, the hope and the reality came into conflict. The dirty slum areas, the sweat shops and the segregation brought a new kind of pain. Many resented being called greenhorns and longed for the green fields of the old country. But for all, America meant a new kind of tolerance and freedom." George Eastman House.

[68] "Notes on early influences."

[69] See Verna Posever Curtis and Stanley Mallach, *Photography and Reform: Lewis Hine & the National Child Labor Committee* (Milwaukee, Wis., 1981).

[70] Lewis Hine, "Tasks in the Tenements," *Child Labor Bulletin* 3 (1914–15), 95.

[71] Copy of typescript, "Street Trades of Connecticut," National Child Labor Committee Papers, Library of Congress.

[72] "The Child's Burden in Oyster and Shrimp Canneries," *Child Labor Bulletin* 2 (1913), 106.

[73] "Present Conditions in the South," *Child Labor Bulletin* 2 (1913), 21.

[74] "The High Cost of Child Labor," *Child Labor Bulletin* 3 (1914–15), 63.

[75] Charles W. Morris, ed., *Works of George Herbert Mead*, Vol. 3, *The Philosophy of the Act* (Chicago, 1938), 610–13.

[76] Maren Stange, " 'Symbols of Ideal Life': Technology, Mass Media, and the FSA Photography Project," *Prospects* 11 (New York, 1987), 83.

[77] Ibid.

[78] "Notes on early influences."

[79] *Proceedings*, National Conference of Charities and Corrections (June 1909); reprinted in Trachtenberg, ed., *Classic Essays*, 109–13.

[80] Ibid., 111. See Trachtenberg, "Camera Work," 836–42.

[81] The most complete collection of these pictures is at the National Gallery, Washington, D.C.

[82] Lewis W. Hine, "The Spirit of Industry," *Men at Work: Photographic Studies of Modern Men and Machines* (New York, 1932; reprinted 1977). The book is dedicated to Frank A. Manny. An acknowledgment indicates that most of the pictures were made under the auspices of industrial corporations—General Electric Company, Pennsylvania Railroad, and Sperry Gyroscope among them.

[83] Lincoln Steffens, "The Modern Business Building," *Scribner's* 22 (July 1897), 37–61.

[84] Montgomery Schuyler, "The Evolution of the Skyscraper," *Scribner's* 46 (Sept. 1909), 257–71.

[85] Mario Manieri-Elia, "Toward an 'Imperial City': Daniel H. Burnham and the City Beautiful Movement," in Giorgio Ciucci et al., *The American City, from the Civil War to the New Deal* (Cambridge, Mass., 1979), 1–121, 69–70.

[86] Sadakichi Hartmann, "The 'Flat-Iron' Building An Esthetical Dissertation," *Camera Work* 1 (1903), 36–40. I am grateful to Gordon Sands for his generous and illuminating response to an earlier version of my analysis of the Flatiron photographs.

[87] Alvin Langdon Coburn, "The Relation of Time to Art," *Camera Work* 36 (1911).

[88] In 1915, partly because of growing infirmity, Stieglitz redefined his relation to city subjects once more, abandoning the street for an upper-story window. Now he aims his camera at buildings. Titles give precise information about subject and location: "From the Back-Window, '291,' Building in Construction" (1915–16). The titles indicate that Stieglitz now conceives of his pictures as belonging to particular groupings—a mode he would develop further in his work of the 1920s, the "Equivalents," and the collective portrait of Georgia O'Keeffe. The series implies his abandonment both of the hope embodied in the delicate balance of "The Flat-Iron" and of the picturesque perspective of the Corbin collaboration.

[89] "A Camera Interpretation of Labor," *The Mentor* 14 (Sept. 1926), p. 45. See Trachtenberg, "Essay," for the view that Hine's "Men at Work" project in the 1920s represented a vain effort to use the camera against Taylorism, to point up the degradation of work which had intensified in that decade. For the view that "by this time Hine's camera was that of management," see Peter Seixas, "Lewis Hine: From 'Social' to 'Interpretive' Photographer," *American Quarterly* 39 (Fall 1987), 405. See also Guy Alchon, *The Invisible Hand of Planning: Capitalism, Social Science, and the State in the 1920s* (Princeton, N.J., 1985).

[90] *Literary Digest* 67 (Dec. 1920), p. 32.

[91] George Herbert Mead, "The Nature of Aesthetic Experience," *The International Journal of Ethics* 36 (July 1926), 383–84.

[92] Typescript of a review by F. A. Manny, George Eastman House. I was unable to determine if this review was ever published. I am indebted to an excellent unpublished paper by Susan Meyer on the relation of text and images in *Men at Work*.

[93] John Dewey, *Art as Experience* (New York, 1958), p. 52.

[94] Ibid., p. 53.

[95] Ibid., p. 54.

[96] "A New Instrument of Vision," in Richard Kostelanetz, ed., *Moholy-Nagy* (New York, 1970), 54: "The series is no longer a 'picture,' and none of the canons of pictorial esthetics can be applied to it. Here the separate picture loses its identity as such and becomes a detail of assembly, an essential structural element of the whole which is the thing itself. In this concatenation of its separate but inseparable parts a photographic series inspired by a definite purpose can become at once the most potent weapon and the tenderest lyric."

[97] Lewis Hine to Florence Kellogg, 17 Feb. 1933. Copy, Elizabeth McCausland Papers, Archives of American Art. The letter continues: "I have a conviction that the design registered in the human face through years of life and work, is more vital for purposes of permanent record, (tho it is more subtle perhaps) than the geometric pattern of lights and shadows that passes in the taking, and serves (so often) as mere photographic jazz."

[98] "Fifty Years of Preparation."

Chapter 5

[1] Charles Flato, "Mathew B. Brady, 1823–1896," *Hound & Horn* 7 (Oct.–Dec. 1933), 35–41. On the remarkable if brief career of this journal of ideas, literature, the arts, and politics, see Leonard Greenbaum, *The Hound and Horn: The History of a Literary Quarterly* (The Hague, 1966); and Mitzi Berger Hamovitch, ed., *The* HOUND & HORN *Letters* (Athens, Ga., 1982).

[2] Flato, 40.

[3] Lincoln Kirstein, in Holger Cahill and Alfred H. Barr, Jr., eds., *Art in America in Modern Times* (New York, 1934), 85–90. Ralph Steiner would turn his attention to film and advertising (while continuing as a serious still photographer); Abbott and Evans worked along parallel lines in the 1930s. In her ambitious documentation of New York (sponsored by the WPA), Abbott fused the Brady tradition with the approach of Eugène Atget, the Parisian photographer of streets, homes, shopfronts, and parks, whom she had met before his death in 1926. Abbott came into possession of many of Atget's negatives and prints, and was instrumental in introducing him to the United States. Flato mentions Atget as sharing with Brady "a love of the suggested durable in the passing trivial." In 1939 Abbott published *Changing New York*, a book documenting New York street life and buildings, with texts by Elizabeth McCausland, whose enthusiasm for Lewis Hine she shared. Abbott's book, reissued as *New York in the Thirties* (New York, 1967), is the product of a program similar to Evans's, though different in important ways. The similarity of intention—in both cases, a deliberate rejection of the school of Stieglitz—indicates the importance of the rediscovery of Brady, Atget, and Hine for younger photographers in the 1930s. A comparison of the texts, which I do not undertake here, would clarify critical differences and help place each of these figures, whom Kirstein links as representatives of a new kind of art photography in 1934. For her life and career, see Hank O'Neal, *Berenice Abbott: American Photographer* (New York, 1982). For an excellent discussion of the 1930s project, see Michael G. Sundell, "Berenice Abbott's Work in the 1930s," *Prospects* 5 (New York, 1980), 269–92; and for a close critical analysis of the 1930s book, see John Raeburn, " 'Cultural Morphology' and Cultural History in Berenice Abbott's *Changing New York*," *Prospects* 9 (New York, 1984), 255–91.

[4] Taft, *Photography*, 55–61.

[5] Newhall, *Photography* (1938), 48–50.

[6] Walker Evans, *American Photographs* (New York, 1938).

[7] Kirstein, *American Photographs*, 192–93.

[8] Ibid., 194.

[9] *Walker Evans at Work* (New York, 1982), 151.

[10] Ibid.

[11] Biographical data is drawn from John Szarkowski, "Introduction," *Walker Evans* (New York, 1971).

[12] "Tape-Recorded Interview with Walker Evans, Oct. 13, 1971, Interviewer: Paul Cummings," typescript, Archives of American Art. Permission of Walker Evans Estate.

[13] Walker Evans, "The Reappearance of Photography," *Hound & Horn* 5 (Oct.–Dec. 1931), 125. The books under discussion include works by Atget, Sander, and Steichen.

[14] Walter Benjamin, "A Short History of Photography," *Literarische Welt*, 1931; reprinted in Trachtenberg, ed., *Classic Essays*, 199.

[15] Letter to Hans Skolle, 28 June 1929: "I came across that picture of Strand's blind woman and that really bowled me over. But I'd already been in that and wanted to do that. That's a very powerful picture. I saw it in the New York Public Library files of *Camera Work*. That's the stuff, that's the thing to do. Now it seems automatic even, but it was quite a powerful picture. It charged me up." *Walker Evans at Work*, 24.

[16] James Agee and Walker Evans, *Let Us Now Praise Famous Men* (New York, 1941; reprinted 1960).

[17] Cummings, "Interview," 12.

[18] Ibid., 11–12.

[19] See "Exhibitions," *Walker Evans*, 188–89.

[20] Cummings, 34.

[21] Ibid., 33.

[22] Ibid., 34.

[23] Ibid., 26–27.

[24] Ibid., 28.

[25] Leslie Katz, "Interview with Walker Evans," *Art in America*, April 1971, 87.

[26] Typescript interview with Walker Evans by Arnold Crane, 7 Dec. 1969, 4. Archives of American Art. Quoted with permission of Walker Evans Estate.

[27] Katz, "Interview," 86.

[28] Pierre Bourdieu, "Flaubert's Point of View," *Critical Inquiry* 14 (Spring 1988), 551.

[29] Ibid., 556.

[30] Ibid., 558–59.

[31] William Carlos Williams, "Sermon with a Camera," *The New Republic* 96 (12 Oct. 1938), 282.

[32] "Recorded Time," *Time* 32 (3 Oct. 1938), 43.

[33] "Photography," in Kronenberger, ed., *Quality*, 170.

[34] "Mr. Evans Records a City's Scene," *Creative Arts* 2 (Dec. 1930), 453–56.

[35] Carleton Beals, *The Crime of Cuba* (Philadelphia, Pa., 1933), "With 31 aquatone illustrations from photographs by Walker Evans." It has been thought that Evans was in Cuba in 1932. A recently discovered letter from Evans to Beals of June 25, 1933, reveals that he indeed went to Cuba in 1933. The letter also makes clear Evans's responsibility for the specific order (and titles) of the photographs in Beals's book.

[36] "Unfinished letter to Ernestine Evans," Feb. 1934, *Walker Evans at Work*, 98.

[37] Ibid., 112.

[38] "I saw his pictures," recalled Roy Stryker. "I walked at night with him and talked to him. He told me about what the photographer was for, what a photographer should do, and he gave me his rationale for pictures." Quoted in Thomas H. Garver, "Just Before the War" (Balboa, Calif., 1968), n.p. See Jack Hurley, *Portrait of a Decade* (Baton Rouge, La., 1972), 13–15.

[39] Williams, "Sermon."

[40] Szarkowski, *Evans*, 15.

[41] Pare Lorenz, "Putting America on Record," *Saturday Review of Literature* 19 (17 Dec. 1938), 6; Carl Van Vechten, "Born to Use a Lens," New York *Herald Tribune Books*, Oct. 16, 1938; Gilbert Seldes, "No Soul in the Photograph," *Esquire* 10 (Dec. 1938), 121, 242–43.

[42] Quoted in an excellent unpublished essay by Lew Andrews, "The Sequential Arrangement of Walker Evans," from which I learned a great deal. I thank Professor Andrews for generously allowing me to see this essay and cite it. I am also indebted to an unpublished essay on the complex meanings of "social documentary" in Evans's work of the 1930s: "Walker Evans—Enigma and Reality," by Hartmut Taube, whom I thank.

[43] See Sidney Baldwin, *Poverty and Politics: The Rise and Decline of the Farm Security Administration* (Chapel Hill, N.C., 1968). Also, Maren Stange, " 'The Record Itself': Farm Security Administration Photography and the Transformation of Rural Life," in Pete Daniel et al., *Official Images: New Deal Photography* (Washington, D.C., 1987), 1–5.

[44] Warren Susman, *Culture as History: The Transformation of American Society in the Twentieth Century* (New York, 1984), 157.

[45] Alfred Kazin, *On Native Grounds* (New York, 1942), 381.

[46] Advances in miniaturization of cameras, in speed of films and lenses, and the founding of new picture magazines like *Life* and *Look*, together with the expansion of the film industry after the introduction of sound in the late 1920s, produced a new visual culture. Its effects were immediate in the expanded uses of photography for mass persuasion by the crisis government in Washington (as well as advertisers), and for public

education by documentary artists. Recognizing the new powers and range of the image, the New Deal subsidized a remarkable number of photographic projects, of which the FSA is but the best-known. See Daniel et al., *Official Images*. For rhetorical uses of the media under the guise of documentation, in the 1930s, see William Stott, *Documentary Expression in Thirties America* (New York, 1973).

[47] Kazin, *Native Grounds*, 387.

[48] *Walker Evans at Work*, 151.

[49] Katz, "Interview," 86.

[50] Trachtenberg, "From Image to Story: Reading the File," in Carl Fleischauer and Beverly W. Brannan, eds., *Documenting America, 1935–1943* (Berkeley, Calif., 1988), 43–73.

[51] See Stange, " 'Symbols of Ideal Life.' "

[52] Margaret Bourke-White and Erskine Caldwell, *You Have Seen Their Faces* (New York, 1937); Archibald MacLeish, *Land of the Free* (New York, 1938). Another important book of photographs and text drawn from images made for the FSA is Dorothea Lange and Paul Schuster Taylor, *An American Exodus: A Record of Human Erosion in the Thirties* (New York, 1939; reprinted New Haven, Conn., 1969).

[53] MacLeish, 89.

[54] Ibid., 83.

[55] Ibid., 82.

[56] *US Camera Annual, 1939* (New York, 1938), 44.

[57] Caroline Ware, ed., *The Cultural Approach to History* (New York, 1940), 328–29.

[58] Ibid., 330.

[59] Hank O'Neal, *A Vision Shared* (New York, 1976), 60.

[60] *Walker Evans at Work*, 151.

[61] Szarkowski, *Evans*, 143.

[62] Robert Fitzgerald, ed., *The Collected Shorter Prose of James Agee* (Boston, Mass., 1968), 131–48.

[63] The *Time* review ("Recorded Time") mentions the influence on Evans of "the movies by Von Stroheim and Vertov." Letters to Jay Leyda in 1934, in Tamiment Library, New York University, tell of several film projects.

[64] Sergei Eisenstein, "A Dialectical Approach to Film Form," in Jay Leyda, ed. and tr., *Film Form* (New York, 1949), 60.

[65] Ibid., 49.

[66] Eisenstein, "Word and Image," in Jay Leyda, ed. and tr., *The Film Sense* (New York, 1947), 31–36.

[67] See Alan Trachtenberg, "Walker Evans's America: A Documentary Invention," in David Featherstone, ed., *Observations* (Carmel, Calif., 1984), 56–66.

[68] Quoted in Andrews, "Sequential Arrangement."

[69] John Crowe Ransom, *The World's Body* (New York, 1938), 2.

[70] Kenneth Burke, *Counter-Statement* (New York, 1931; 2nd ed., Chicago, 1957), 29–44.

Credits

For permission to use the following pictures I should like to thank:

1. The Pennsylvania Academy of Fine Arts, Philadelphia. Gift of Mrs. Sarah Harrison (The Joseph Harrison, Jr., Collection)

2. The Houghton Library, Harvard University

8–11. The National Portrait Gallery, the Smithsonian Institution, Washington, D.C.

4, 20, 35–37, 48–51, 52–63. The National Archives

6–7, 19, 21–22. The Library of Congress

12–15. The Peabody Museum, Harvard University

17, 29–34, 44–47, 53, 66, 78–79, 81. The Beinecke Rare Book and Manuscript Library, Yale University

18. Department of Rare Books—the Trent Collection, William R. Perkins Library, Duke University Library

23–28, 69–70. Rare Books and Manuscripts Division, the New York Public Library, Astor, Lenox, and Tilden Foundation

73–76, 80. Lewis Hine Collection, United States History, Local History and Genealogy Division, the New York Public Library, Astor, Lenox, and Tilden Foundation

38, 40–43. The William Gladstone Collection

52. The J. Paul Getty Museum

64–65. The Metropolitan Museum of Art, Gift J. B. Neumann, 1958 [58.577.20]

77. The Metropolitan Museum of Art, Alfred Stieglitz Collection, 1949 [49.55.6]

70, 82–86. The George Eastman House

87–90, 94–129. The Walker Evans Estate

For permission to quote from manuscript sources, I would like to thank:

The Alfred Stieglitz Collection. Beinecke Rare Book and Manuscript Library, Yale University

Interview with Walker Evans, Archives of American Art. The Walker Evans Estate

Index

photographs as reconstruction of, xv–
xvii, 73–75, 77–81, 83, 88–89, 256; as
"sacred" memory, 77, 79, 96; value of
photographs as, xiii–xv, xvi–xvii, 6, 60
History: The Last Things Before the Last
(Kracauer), xiv
history painting, 35–36, 84; war photog-
raphy and, 73, 74
Holmes, Oliver Wendell, 16, 17–20, 81;
photographs-as-money metaphor of,
18–20; on photography industry, 92–
93; on stereoscopic images, 88–89; on
war and war images, 90–92, 111
Homer, Winslow, 84
Hone, Philip, 13
Hoosac Tunnel, 107
horse in motion, sequential pictures of, 78
Hough, E. K., 40–41
Hound & Horn, 231
"House and Billboards in Atlanta, 1936"
(Evans), 260
House of the Seven Gables, The (Hawthorne),
13, 23–24, 25, 32, 52–53, 59
Howells, William Dean, 76–77
"How to Read a Roman Portrait" (Nodel-
man), 54
Hudson River landscape school, 128
Hugo, Victor, 206, 207
Humphreys, A. A., 121, 133, 146
Humphrey's Journal, 72, 73
" 'Hurry up please, it's time' " (Evans), 241

illustrious Americans, portraits of, 28,
45–52, 56, 58
immigrants, immigration, 164, 166, 170–
71, 200
Incidents of the War (Brady), 82, 85
Indians, North American, 125–27, 205;
cultural attitude toward land among,
125
industrial capitalism, social democracy
and, 218–19
industrialization, 218–19; Civil War as
prototype for, 105, 109–10, 114–15;
photographs of, 149–53
industrial workers, 106–10, 204, 209–10,
217–18, 224–30
"Inspection of Troops at Cumberland
Landing, Pamunkey, Va., May, 1862"
(Gardner), 97–98
Inspiration Point, 139–40, 142
International Photographic Exposition,
256
interpretative photography, 219–21

Jackson, William Henry, 121, 128
James, Henry, 251, 284
James, Henry Sr., 26
James, William, 210
Jefferson, Thomas, 155
Johnson, Francis Benjamin, xvi

Johnstone, Paul H., 256
Journal of the Camera Club, 183

kaleidoscope, 17
Kaplan, Daile, 198
Kasebier, Gertrude, 173
Kazin, Alfred, 248–49, 284
Keller, Ulrich, 175, 181
Kellogg, Arthur, 195
Kellogg, Florence, 227
Kellogg, Paul, 195, 196, 218
King, Clarence, xvi, 119–43, 148, 152;
acts of naming by, 124–25, 153; on
geological history, 160–62; on Great
Basin, 154–58; on North American In-
dians, 125–26; on perception and
knowledge, 140–42; on Shoshone Falls,
135, 142–43
Kirstein, Lincoln, 231, 232–34, 237, 241,
245, 248, 250
knowledge: Greek theory of, 17; percep-
tion and, 140–42
Kracauer, Siegfried, xiv–xv, xvi
Kramer, Hilton, 238

labor, laborers, *see* workers
Land of the Free (MacLeish), 253–54
landscape painting, 36, 128–30, 160
landscape photography, 128–30
Lange, Dorothea, xvi, 247, 256
Lawrence studio, 66
lawyers, 28, 63
Leaves of Grass (Whitman), frontispiece to,
61–65, 67
Lee, Russell, 253, 256
Lerebours, N. P., 24, 26
Lester, C. Edwards, 37, 45, 48–52, 53,
59; on "sacred" memory of war, 77, 79,
81
Let Us Now Praise Famous Men (Agee), 237,
246, 248, 257
Leutze, Emmanuel, 74
Library of Congress, 245, 252, 257
"License-Photo Studio" (Evans), 251, 260–
64
Life, 252
Light and Dark of the Rebellion (Lester), 77
Lincoln, Abraham, 72, 83, 84, 94, 115,
135; Brady portraits of, 39; First Inau-
gural Address of, 81
Linnaean system, 8–9, 10
"literariness," photographic, 240–44,
248–49
lithography, daguerrean reproduction
and, 45, 46
London Stereoscopic Company, 17
Look, 252
Lorentz, Pare, 246
"Louisiana Plantation House" (Evans), 265
Lowell, James Russell, 76
Luminist landscape school, 128